Lindsey,

I went to this exhibit in Nashville Nov. 20, 2010.

Love,
Dad

BIRTH OF IMPRESSIONISM

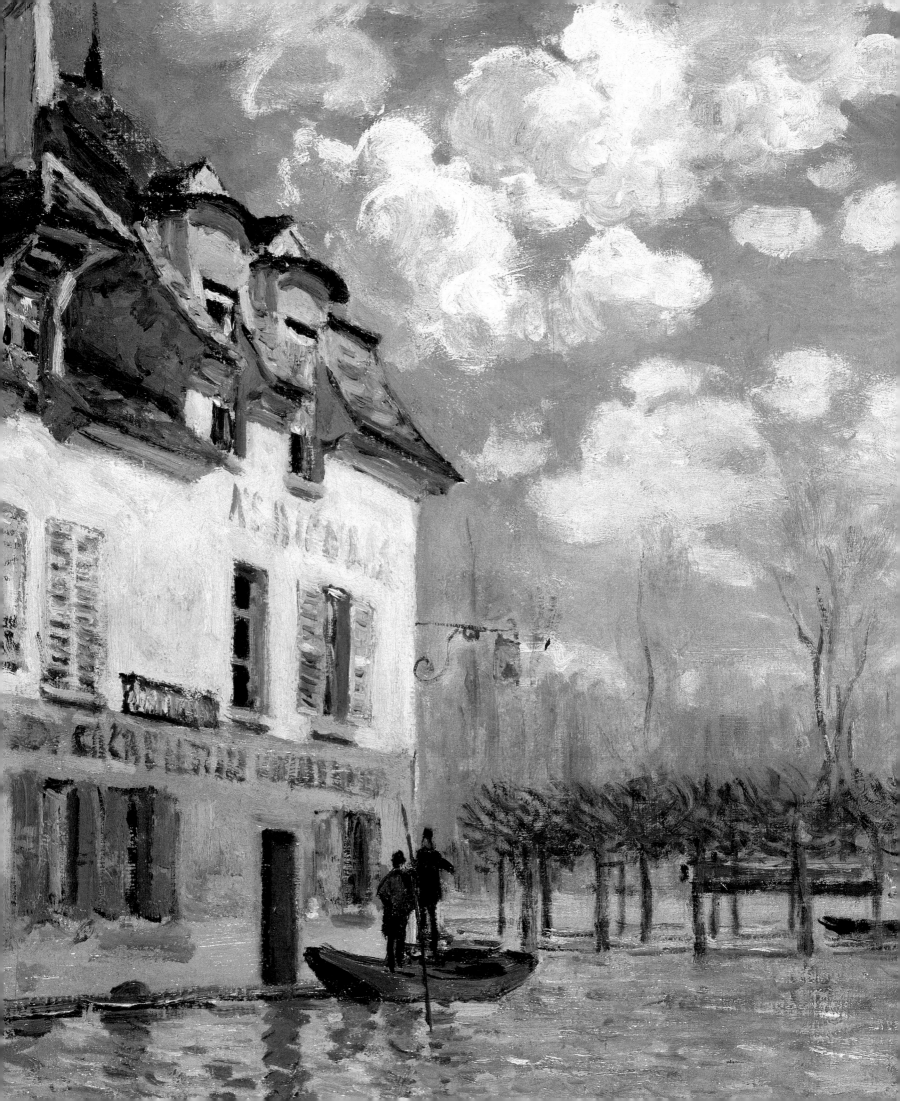

BIRTH OF IMPRESSIONISM

◉

MASTERPIECES FROM THE MUSÉE D'ORSAY

PROJECT CURATED BY
GUY COGEVAL, STÉPHANE GUÉGAN, AND
ALICE THOMINE-BERRADA

Additional contributions by
Krista Brugnara, Dominique Lobstein, María López Fernández, Charles S. Moffett,
Lynn Federle Orr, and Eric Zafran

◉

Fine Arts Museums of San Francisco

DelMonico Books · Prestel
Munich Berlin London New York

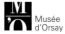
Musée
d'Orsay

CONTENTS

PLATES THROUGHOUT

Commentary by *Melissa Buron, Lynn Federle Orr*, and *Tess White*

CLAUDE MONET
Rue Montorgueil, Paris (*La rue Montorgueil*), 1878
Detail of cat. 82

Works of art are made to be seen by all, to travel across the world and across the ages. The universal nature of masterpieces precludes any one person owning them. They belong to everyone. The role of a museum is to preserve and maintain the works, to see that they are shared and circulated.

To this end, the Musée d'Orsay has for many years organized ambitious projects. For 2010, during the major renovation program of some of its galleries, the museum has organized a traveling exhibition of part of its collections in several countries that have long-standing associations with France, especially at a cultural level. Exceptionally, the Fine Arts Museums of San Francisco have decided to host two successive exhibitions, thus creating a veritable "Orsay Year" in San Francisco.

The first exhibition presents the sources, the birth, and the transformations of Impressionism around 1874, the date of the inaugural exhibition of the group that included Eugène Boudin, Cézanne, Degas, Monet, Berthe Morisot, Pissarro, and Renoir. The exhibition begins and ends with Manet, recalling the influence of Spanish art, the part played by the École des Batignolles, the legacy of Courbet and Millet, the Impressionist adventure, and the evolution of academic art, and it aims to reconstruct the unity of this period.

The second exhibition presents the stylistic development of the great Impressionist painters after 1886, the date of their last collective exhibition, and evokes the turning point that occurred around 1900, when the avant-garde encountered the renaissance of decorative murals. The works of Monet, Cézanne, Van Gogh, Gauguin, Toulouse-Lautrec, Seurat, Le Douanier Rousseau, Bonnard, and Vuillard bear witness to this revival.

Each of these two shows brings together masterpieces that, once they return to the Musée d'Orsay, will almost certainly never be lent out again for exhibition all together. I hope that they will excite the interest of the American public in order to strengthen further the links between our two countries.

FOREWORD

JOHN E. BUCHANAN, JR.
DIRECTOR OF MUSEUMS, FINE ARTS MUSEUMS
OF SAN FRANCISCO

⊙

GUY COGEVAL
PRESIDENT, MUSÉE D'ORSAY

⊙

The Fine Arts Museums of San Francisco and the Musée d'Orsay are proud to present the initial installment of what is certain to become one of the premier cultural events of the decade. *Birth of Impressionism: Masterpieces from the Musée d'Orsay* is the first of two consecutive exhibitions drawn from the Orsay's incomparable collection that are traveling to the Fine Arts Museums' de Young in 2010. Rarely do renovations at the world's greatest museums create an opportunity for those collections to travel beyond their home cities. Refurbishment and upgrading of the Orsay's Impressionism and Post-Impressionism galleries have provided just such an occasion, allowing museumgoers outside France to thrill to the artistic riches of the world's foremost collection of nineteenth- and early-twentieth-century French painting. Given San Francisco's longtime commitment to exhibiting and collecting Impressionism and other great movements of European art, we are extremely excited that the de Young will be the only venue in the world to present both Orsay exhibitions.

The first exhibition, *Birth of Impressionism*, focuses on the tumultuous period of the 1860s and 1870s, when social and political events in France influenced and were reflected in the art and politics of the state-run Salon. More than one hundred canvases by famous masters provide an overview of the contentious artistic community that gave rise to the innovators of the "New Painting." In addition to providing a marvelous survey of Impressionism, the exhibition guides visitors through the world of the Paris Salon, the exhibition venue of choice and necessity for aspiring artists of the period. The evolution of the Impressionist style is traced via seminal works of the period, providing an unparalleled visual experience possible only when the most important repository of nineteenth-century French art opens its vaults.

The second installment of our celebration—*Van Gogh, Gauguin, Cézanne, and Beyond: Post-Impressionist Masterpieces from the Musée d'Orsay*, opening at the de Young in September—explores

the major artistic developments that sprang forth in the wake of Impressionism, including beloved paintings by the Neo-Impressionists, Symbolists, and Nabis.

It has been a great pleasure and honor for our institutions to collaborate on these unique, once-in-a-lifetime exhibitions. We would especially like to thank our enthusiastic fellow commissioners of the exhibitions, Orsay curators Stéphane Guégan, Sylvie Patry, and Alice Thomine-Berrada and Fine Arts Museums curator Lynn Federle Orr. In Paris, Olivier Simmat, Jean Naudin, and Isabelle Loutrel have been particularly helpful along the way. The de Young presentations were accomplished with the invaluable input of Krista Brugnara, Melissa Buron, Therese Chen, Bill Huggins, Bill White, and the entire Marketing and Design team, to name just some of the staff involved. For their work on this lavish catalogue, overseen by Ann Karlstrom and Karen Levine at the Fine Arts Museums, we thank our trade copublishing partners, Mary DelMonico and Prestel; editor Elisa Urbanelli; designer Bob Aufuldish; translators Alison Anderson and Rose Vekony; proofreader Dianne Woo; indexer Susan G. Burke; and all of the authors who contributed to this volume. We are also grateful to our colleagues at the only other venues to host these marvelous Impressionist works from the Musée d'Orsay: Daniel Restrepo Manrique, Pablo Jiménez Burillo, and María López Fernández of the Fundación MAPFRE, Madrid; and Susan Edwards and Mark Scala of the Frist Center for the Visual Arts, Nashville.

These remarkable exhibitions and catalogues would have been impossible without the extraordinary patronage of Bank of America and Jeannik Méquet Littlefield. We thank the entire Littlefield family for helping to facilitate their sponsorship of the exhibitions. Crucial additional support has been provided by Hope Aldrich and David Spencer, Athena and Timothy Blackburn, the William K. Bowes, Jr. Foundation, J. Burgess and Elizabeth B. Jamieson, the George Frederick Jewett Foundation, the Koret Foundation, Barbro and Bernard Osher of the Bernard Osher Foundation, the San Francisco Auxiliary of the Fine Arts Museums, Susan and James R. Swartz, Douglas A. Tilden, Diane B. Wilsey, and many other generous sponsors and supporters. The exhibition is also supported by an indemnity from the Federal Council on the Arts and the Humanities.

THE MUSÉE D'ORSAY: A SHORT HISTORY

GUY COGEVAL

ALICE THOMINE-BERRADA

⊚

It is to Charles Boucher, seigneur d'Orsay, councillor at Parliament, and provost of the Paris merchants, that the museum owes its name. In 1704 he was charged by Louis XIV to build a stonework quay planted with trees.[1] This particular stretch of riverbank, visible from the Louvre and the Tuileries, had been poorly maintained and was full of unsightly floating timber yards; the aim was to improve the king's view of the site. The neighborhood had acquired a certain nobility at the beginning of the seventeenth century: the gardens belonging to Marguerite de Valois, queen of Navarre and the former wife of Henri IV, were adjacent to the quay. In the eighteenth century, the construction of prestigious *hôtels particuliers* such as the Hôtel de Salm (1782–1788) confirmed the quarter's aristocratic character. In 1751 the stables for the royal coaches, providing transportation to Versailles, Saint-Germain, Fontainebleau, and Compiègne, moved into one of these *hôtels*, the Hôtel d'Egmont. During the French Revolution, the coach houses were transformed into barracks.

In 1810 Napoléon decided to build the Palais du Quai d'Orsay, next to the barracks, for the ministry of foreign affairs. He entrusted the project to the architect Jacques Charles Bonnard, who upon his death in 1818 was replaced by his student Jacques Lacornée. In 1835 the building, a typical example of Renaissance-inspired Neoclassicism, was allocated to the court of accounts and the state council. In May 1871, during the violence of the Paris Commune, the building was destroyed by fire, and for more than twenty years its picturesque ruins were a familiar feature of the riverbank. In the turbulent political atmosphere of the early Third Republic, the state was unable to find a new use for the ruined building, once the seat of a bygone regime.

In the end, fate decided that a railroad station, one of the most emblematic monuments of the Industrial Revolution, would occupy the site. The station was built in anticipation of the 1900 Exposition Universelle, the fifth world's fair, organized in Paris. The fair, an international showcase for industrial and artistic production, spread principally to the west of the city center, which underwent a profound transformation with the construction of the Pont Alexandre III, the Petit and Grand Palais, and finally the Gare d'Orsay.

In 1896 the Compagnie d'Orléans took initial steps with the ministry of public works to extend its rail lines along the Seine, toward the center of Paris, and to build a new station on

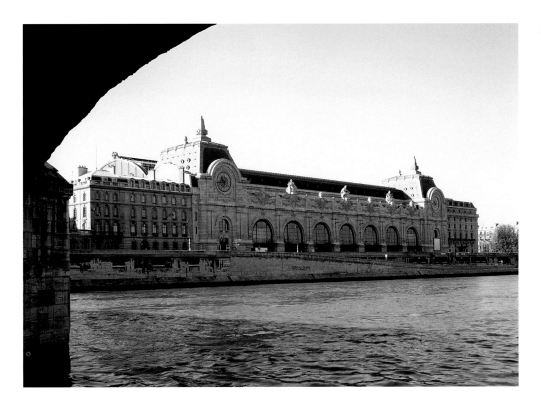

FIG. 1 The Seine facade of the Musée d'Orsay, 1986

the Quai d'Orsay exclusively for passenger traffic. The following year the company obtained permission to buy the ruins of the Palais d'Orsay and the adjoining barracks. The parliamentary debate over the sale of the property was not excessively contentious, but it did provide an opportunity for a deputy who was also an architect, Émile Trélat, to voice his opinion. A recent station project for the Esplanade des Invalides had alarmed defenders of Old Paris who were eager to preserve the view along the river. Trélat thus emphasized the necessity of ensuring some form of control over the new railway development.

In response, the ministry appointed a commission in charge of overseeing the design of the station. The railway company, however, had already requested a number of engineering studies and had sought advice from the architect Eugène Hénard. Hénard, who expressed his desire for a station that featured metal and tile prominently in its design, did not want to take part in the competition, whose program imposed a style in keeping with the surrounding buildings, particularly the Louvre and the Tuileries. In the end the Compagnie d'Orléans consulted three architects: Victor Laloux, who had worked for the firm on the Tours train station (1896–1898); Lucien Magne, who had spontaneously offered his services; and Henri Jean Émile Bénard, who in 1899 would win the international competition for the architectural plan of the Berkeley campus of the University of California.[2] Laloux's design, which the ministry finally chose in April 1898, was outstanding for its coherent plan and harmonious proportions. Laloux was forty-eight years old at the time and had already established his reputation. Awarded the Grand Prix de Rome in 1878, he had designed, in his native town of Tours, the basilica of Saint-Martin (1886–1890), the Hôtel de Ville (1896–1903), and the station. Since 1890 he had been in charge of a studio that trained some six hundred architects, including one hundred or more Americans.

The opening of the Exposition Universelle imposed a tight deadline; the building was inaugurated on July 14, 1900, less than two and a half years after Laloux's selection. His design stood out prominently in comparison with the earlier Paris stations located outside

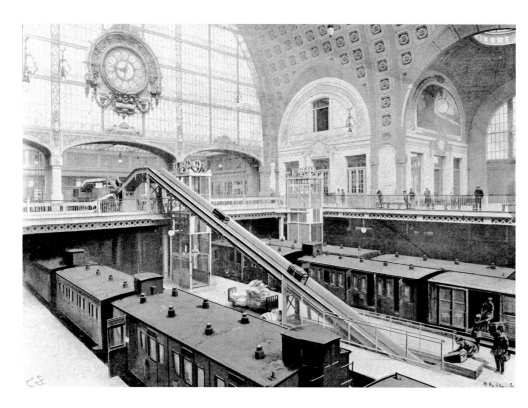

FIG. 2 The Gare d'Orsay station platforms circa 1900, from *L'Illustration*, September 15, 1900

the city center. Following the example of the Gare de l'Est, these were massive buildings with expansive glass-and-iron facades that clearly indicated their industrial purpose. Laloux opted for a more discreet approach, in keeping with the historical character of the surroundings. He ingeniously arranged the station's hotel around the passenger lobby, masking the gable of the great glass shed covering the rails. From the quay, the metal structure of the enormous arrivals hall was also hidden behind a stone building (see fig. 1).

With its monumental arcade framed by two pavilions, the stone facade echoed the grandeur of the Louvre, directly across the Seine. Its abundant ornamentation illustrated the building's purpose: in addition to two huge clocks and an inscribed list of cities served by the trains, three female allegorical sculptures, representing Bordeaux, Toulouse, and Nantes, rose from the facade. This was the entrance for departing passengers, who were guided through a progression of interior spaces: a barrel-vaulted porch, a monumental lobby with seven cupolas, and finally a vast, barrel-vaulted hall illuminated by large openings and terminated at each end by a glass-and-iron tympanum. The architect conceived the design to be reminiscent of ancient Roman thermal baths. The use of electric locomotives, cleaner than those powered by steam, allowed for interior tracks. The merging of innovation and tradition was reinforced by the presence of the latest technology—elevators, hoists, conveyor belts (fig. 2)—alongside the vast reception areas of the luxurious station hotel, the Palais d'Orsay. The 320-room hotel was decorated by renowned artists of the day: Adrien Moreau-Néret and Pierre Fritel (the ballroom), Gabriel-Joseph-Marie-Augustin Ferrier (the restaurant), and Jean Joseph Benjamin-Constant (the reading room).

For more than forty years the Gare d'Orsay was a busy, bustling place. More than two hundred trains per day linked passengers with the Paris suburbs and central and southwest France. However, the station ultimately became obsolete. Its size proved inadequate for increased rail traffic, and the platforms were too short for international trains. In 1939 the Gare d'Austerlitz was once again made the line's main station, and by 1950 the Gare d'Orsay was used

only for suburban trains. The hotel began to lose its luster, while the station, dispossessed of its primary function, was put to other uses: a reception center for prisoners and deportees after World War II, a warehouse for the donations made to Abbé Pierre during the winter of 1954, a film set for Orson Welles's *The Trial* in 1962, a parking lot, and a shooting range. In the early 1960s the station was slated for demolition. Laloux's decorative architecture was too extreme for the modernist tastes of the era, and SNCF (the French national railway service), which had owned the property since the country's rail companies merged in 1939, wanted to build a luxury hotel on the site. In 1961 SNCF launched a design competition that enabled Le Corbusier, for one, to imagine an immense rectilinear block of twenty-five stories surmounted by a restaurant with a panoramic view of the Seine. After a long delay in the 1960s due to hesitation about the use of the site, construction on the winning project, by Coulon and Gillet, was about to start when the city stepped in to halt it. Although SNCF obtained authorization to demolish the station in December 1970, in February 1971 the city refused to grant the building permit. The recent demolition of Les Halles had inflamed public opinion, prompting the authorities to ease up on radical redevelopment plans in Paris.

In the years that followed, the building's aesthetic and urban qualities were gradually reappraised, and it benefited from measures to protect French heritage monuments. While it continued to serve a variety of tenants (the Renaud-Barrault theater company, an auction house), serious debate about the adaptive reuse of the building had begun: should it house the ministry of finance, the École du Louvre, a central airport terminal, a visitors' center, or a school of architecture? The idea of turning it into a museum garnered the most votes.

The planning for a national museum of modern art, set to open in 1977 in a new building in the Beaubourg quarter, fueled debate over the redistribution of the nation's collections. The aim was to provide a prestigious setting for not only twentieth-century art but also earlier works that did not fall under the jurisdiction of the Louvre (whose chronological survey ended with Romanticism). These in-between works were not being shown to their advantage; they were scattered among the Musée du Jeu de Paume, the Palais de Tokyo, museums outside Paris, and storerooms. In 1973 President Georges Pompidou made the official decision to convert the Gare d'Orsay into a museum of nineteenth-century art, and in 1977 the plan was ratified by President Valéry Giscard d'Estaing, who opened the design competition the following year.

The contract was awarded to a team consisting of Pierre Colboc, Renaud Bardon, and Jean-Paul Philippon, all young architects in their thirties. Their project was chosen for both the quality of its design and its respect for Laloux's original architecture. The architects relocated the entrance from the quay side of the building to rue de Bellechasse, where a large glass awning welcomed visitors. The collections were exhibited in the spaces along each side of the great hall and under the roof. In 1981 the Italian architect Gae Aulenti was commissioned to design the interior; Aulenti was already well known at the time and her reputation was subsequently confirmed with numerous other museum projects, among them San Francisco's Asian Art Museum (opened in 2003). Her additions to the Orsay interior, characterized by rigorous, geometric forms executed in refined materials, were deliberately distinct from the station's architecture (see fig. 3).

With the renovation of the station progressing, fuller consideration was given to the nature of the collections to be housed in the new museum. The initial focus on nineteenth-

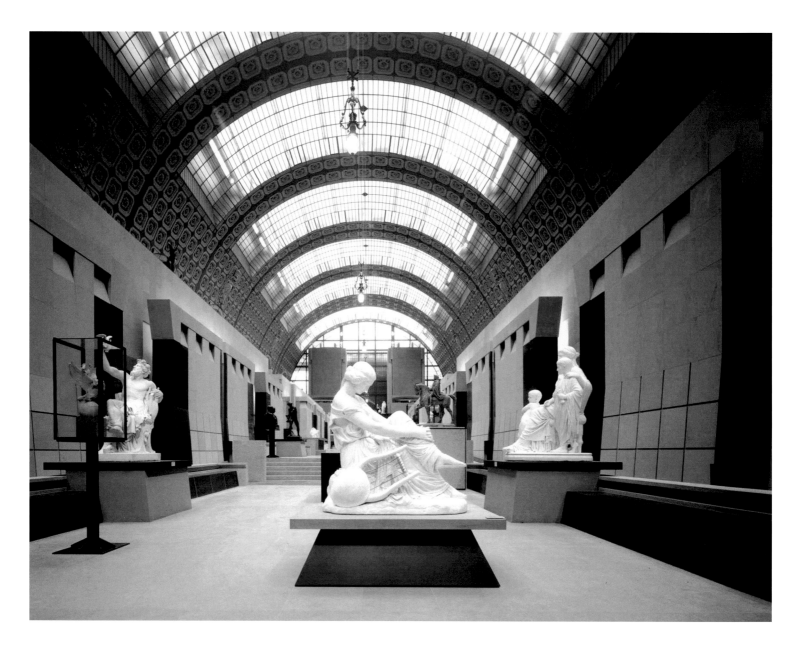

FIG. 3 View of main floor of the Musée d'Orsay
after Gae Aulenti's renovation, 1986

century art was finally extended to cover the period from 1848 to 1914, beginning with the rise of industrialized society, as reflected by the birth of Realism, and ending on the eve of World War I, with Cubism. Most of the works came from the Musée du Luxembourg. Established in 1818 by Louis Philippe to exhibit contemporary artists, the Luxembourg's collection was enriched throughout the nineteenth century by state purchases from the official Salon. It was therefore devoted principally to academic landscape, history, and genre painting. By the end of the century, a wave of gifts allowed the museum to display work by more innovative artists, including representatives of the Barbizon School, Realists, and Impressionists. In 1890 the museum acquired Édouard Manet's *Olympia* (1863, fig. 21) through a donation by a group of subscribers. Further additions to the collection were made through a famous bequest by the painter Gustave Caillebotte (1896) and gifts from the son of stockbroker Étienne Moreau-Nélaton (1906), the businessman Alfred Chauchard (1909), and the financier Isaac de Camondo (1911).

As the holdings of the Musée du Luxembourg grew, space became extremely limited. By the 1880s discussion was under way to find a new location for the museum. Several decades later a partial solution was found: in 1922 works from foreign schools were transferred to the Jeu de Paume. Eventually, the 1937 Exposition Universelle provided the opportunity to build a sizable new museum, the Musée National d'Art Moderne du Palais de Tokyo, which opened its doors in 1947. At that point the collections were divided once again, with the Impressionist paintings moved to the Jeu de Paume. The renovation of the Gare d'Orsay brought the collections together at last; they were joined by new acquisitions and gifts as well as artworks retrieved from storage. Fifteen years after the station's rescue, on December 1, 1986, President François Mitterrand inaugurated the new museum. The prophecy made by the military artist Jean Baptiste Édouard Detaille during the 1900 Exposition Universelle had come true: "[Orsay] station is superb and it looks just like a Palace of Fine Arts, and our Palais des Beaux-Arts [the present-day Grand Palais] looks just like a station; I would suggest to Victor Laloux to do a swap, if there's still time."[3]

Translated from the French by Alison Anderson

NOTES

1 The section of the quay where the museum is located lost the name Quai d'Orsay in 1947, when it was renamed Quai Anatole France.

2 Bénard later refused to make revisions to his plan, and the project was turned over to the fourth-place winner, architecture professor John Galen Howard.

3 Jean Baptiste Édouard Detaille, journal entry for May 22, 1900.

INTRODUCTION

STÉPHANE GUÉGAN

ALICE THOMINE-BERRADA

◦

He knows how to convey his impressions.
ÉMILE ZOLA ON JULES BASTIEN-LEPAGE, 1879

As a challenge, or a game, let us try to summarize the artistic life of Paris in the 1870s and early 1880s by naming a few key events: the rejection of Édouard Manet's *The Fifer* from the Salon of 1866; the death of Frédéric Bazille in uniform in 1870; Gustave Courbet's exile in July 1873; the first of the eight Impressionist exhibitions in 1874; the installation of Pierre Puvis de Chavannes's decorative paintings at the Panthéon in 1877; the triumph of Jules Bastien-Lepage's *Haymaking* in 1878; the hanging of Adolphe-William Bouguereau's *Birth of Venus* at the Musée du Luxembourg in 1879; the termination of state involvement in the Salon in 1881; the reappearance of James Abbott McNeill Whistler's *Arrangement in Gray and Black, No. 1: Portrait of the Painter's Mother* at the Salon des Artistes Français in 1883. As significant as these events were at the time, many no longer have the same evocative power today. Some have dimmed in our collective memory, while others continue to shine brightly.

Any exhibition must attempt to unite its featured artworks while providing a new interpretation of the ties and tensions that underlay its subject and gave it strength—all the more so when it aims to illuminate a particular moment rather than a movement. In the planning of this particular exhibition, Manet very quickly emerged as the central figure. He was there from the point of departure to the end of the journey, present for every one of the era's significant milestones. A well-connected man hounded by his desire for Salon acceptance, a close collaborator of Claude Monet and Edgar Degas who was reluctant to exhibit alongside them, the perfect link between the liberal evolution of the Second Empire and the republican renaissance of 1879 to 1883: the "painter with the black cat"—as he was caricatured in the press—embraced all the potential of his era.

For a very long time art historians, out of an understandable desire to favor aesthetic innovation, have oversimplified this era in the history of French painting. In order for Manet to lead straight to the avant-garde of the twentieth century, and for the Impressionists and Paul Cézanne to be seen as decisive innovators along the path of modernism, these artists had to be

emancipated from their era and projected toward our own. Modernity, in the time of art historian John Rewald, was read backward. By rejecting this formalist, reductive approach to the art produced from 1866 to 1883, recent research has reversed that perspective and attempted to recapture the period for itself, as a heterogeneous whole, rather than focus on merely its sources or its supposed heritage. This exhibition and catalogue would be unthinkable without this change of viewpoint. We have sought to open this project to a number of contemporary approaches, from institutional and political analyses to gender studies.

Rather than isolating the "moderns" from their contemporaries and ignoring certain convergences, we propose a different view that considers Impressionism in the context of the death of the Salon. The rich variety of stylistic voices and their artistic sources provides our story line. To take one well-documented example, Bazille's correspondence with his family shows that in the mid-1860s the young artist from Montpellier was as interested in the academic painter Hippolyte Jean Flandrin as he was in Jean-François Millet, Courbet, and Manet. Charles Gleyre's instruction was as important to Bazille as it was negligible to his cohorts Monet, Alfred Sisley, and, above all, Pierre Auguste Renoir. It is hardly astonishing that these four musketeers, trained by the Néo-Grec master, were less affected than other Parisian painters by the enthusiasm for Spanish art. One might also point to the fact that a renewed interest in the eighteenth century influenced Manet and Courbet as much it did Henri Léopold Lévy. In short, these painters confronted an art world that today may seem anarchical but was actually as protean as the aesthetic lines dividing them. Our resolute aim here is to avoid the sort of revisionism that, thirty years ago, accompanied the rehabilitation of the academic painters. Instead we offer a collective vision of the period, acknowledging a wide-ranging cast of characters without ignoring what sets great artists apart from lesser ones. Comparing them certainly does not mean confusing them.

The exhibition's narrative journey thus begins with the Salon's contenders and successes of the 1860s and 1870s, without which we cannot comprehend the notorious difficulties of Manet and the Impressionists. The achievement of French academic painting is exemplified by Salon triumphs such as Lévy's monumental *Sarpedon* (1874), which resonates with the style of the age of Louis XV, and Bouguereau's equally imposing *Birth of Venus* (1879), in which the tradition of idealized beauty and contour persists in a spectacular and excessive way.

Works by Manet provide the fulcrum between establishment artists invested in the Salon system and the artists of the avant-garde. A testament to the stylistic ambiguities of the end of the Second Empire, Manet's paintings not only bear the stamp of past artists (and not only Diego Velázquez and Francisco de Goya) but also reveal a debt to his contemporaries' treatment of colors, as well as the realism of their expression and/or subject matter. The Spanish style that so greatly inspired Manet had been in vogue since the 1830s; the diverse works of Henri Regnault, Théodule Ribot, Whistler, and even Émile-Auguste Carolus-Duran bear witness to the broad influence of Spanish art in Paris at that time. But the fact remains that Manet's singular approach quickly designated him the involuntary leader of the École des Batignolles, the name given in 1869 to the young artists who gathered around the creator of *Olympia* and *The Fifer*, that major, charismatic work that was refused by the Salon. Drawing from numerous sources such as Manet, Courbet, and the landscape artists of the Barbizon School, the members of this informal group made their first attempts to capture on canvas the ephemeral quality of light and the perception of a fleeting moment.

Not long after the École des Batignolles came together, political unrest had a major impact on the Parisian art scene. The moving works that have been selected to illustrate the "Terrible Year" (September 1870–June 1871) record the memory of the bloody period of the Franco-Prussian War and the Commune. Artistic circles in Paris were profoundly affected by the deaths of Bazille and Regnault and by Courbet's exile. In the beginning of the 1870s, as the Republic gradually took hold in a deeply wounded country, the situation in the art world seemed all the more striking for its pluralistic, hybrid nature.

At the Salon, academic painting could be no longer divided into the usual categories. Alongside the baroque expression of Lévy and the satiny nudes of Bouguereau, the poetry of Gustave Moreau and Puvis de Chavannes paved the way for Symbolism yet remained attentive to present-day concerns. The Salon also felt the influence of Realism, which by the mid-1870s had been accepted, adapted, and transformed. Jules Adolphe Aimé Louis Breton, Bastien-Lepage, and even Jean-François Raffaëlli successfully expanded Millet's *épopée des champs* (epic of the fields), producing monumental, heroic representations of the rural world.

At the same time, Gustave Caillebotte was creating the first of his images of the urban proletariat, *The Floor Scrapers*, which was refused by the Salon of 1875. Caillebotte presented it the following year at the second exhibition of the Impressionist painters, who in 1874 had decided to show their works independently of the Salon. The Impressionist exhibitions marked the emergence of the "New Painting," a term employed by Louis-Émile-Edmond Duranty in 1876 to describe the avant-garde movement. Monet, Sisley, and Renoir, approaching their thirties, were at the height of their art and turning more and more frequently to an idea espoused by Charles Baudelaire: that artists should capture their transitory experiences of the modern, ever-changing world. Whereas Monet was the greatest virtuoso, Sisley created a gentle, discreet art displaying more rigor in composition; and Renoir, mesmerized by the female body and taken with rendering life's pleasurable activities, became known for his blurred brushstroke and Venetian palette. Forging a different path, in which the effects of light were used to convey the solidity of elements rather than their ephemeral quality, the Impressionism of Camille Pissarro and Cézanne, who worked continually side by side, stood apart for its firm structure and astonishing gravity. The art of Berthe Morisot, who had shown regularly at the Salon until participating in the first Impressionist exhibition, testifies to the position attained by women painters by this time. Morisot was Manet's close friend and sister-in-law, and her style had considerable impact on his late work. Her paintings, many depicting women and children, were sometimes restrained and at other times imbued with a more ebullient charm. The elegantly dressed modern woman, portrayed earlier by Alfred Stevens and James Tissot, and scenes of contemporary bourgeois life were the primary themes of the New Painting. The work of Degas—whose broad range of subjects included the private worlds of dancers and laundresses, the racetrack, and the secret speculations of the stock market—epitomizes the marriage of modern imagery and innovative technique.

Our reexamination of this era cannot end without a reconsideration of Manet's last works. In spite of the controversy he inspired (or perhaps because of it), by the turn of the decade Manet had become, in retrospect, the leading figure of the artistic avant-garde. However, although he had begun using lighter colors under the influence of his Impressionist friends, he continued to pursue a very personal path, bypassing the study of nature and retaining the

imprint of the masters of his pantheon and the themes of Romanticism. By the time of his death he was considered, wrongly, to be the first Impressionist, although he had never exhibited with the group, preferring the official battleground of the Salon. His final canvases serve as a definitive indication of the extreme permeability of art in the years between 1860 and 1880. It was the landscape artist François-Louis Français, whose work had been sanctioned by the Salon since the 1850s, who ushered Manet, on January 16, 1882, to the rank of Chevalier de la Légion d'Honneur.

Since opening in 1986, the Musée d'Orsay has been engaged in the reevaluation of the art and culture of the 1870s. The way we envisage it, modernity no longer resembles a closed circle, as it had for most of the twentieth century. We recognize the deep-rooted connection between the conception of each of our paintings and its public debut. Our essential vocation remains an examination of the second half of the nineteenth century in all of its artistic and stylistic diversity, placing Manet next to Thomas Couture, Courbet next to Jean Louis Ernest Meissonier, and Moreau next to Degas because their paths did, in fact, cross. The wealth of masterpieces contained in this exhibition—made possible by the partial closing of the museum in 2010—confirms the singular position that the Musée d'Orsay occupies in the art world's international arena.

Translated from the French by Alison Anderson

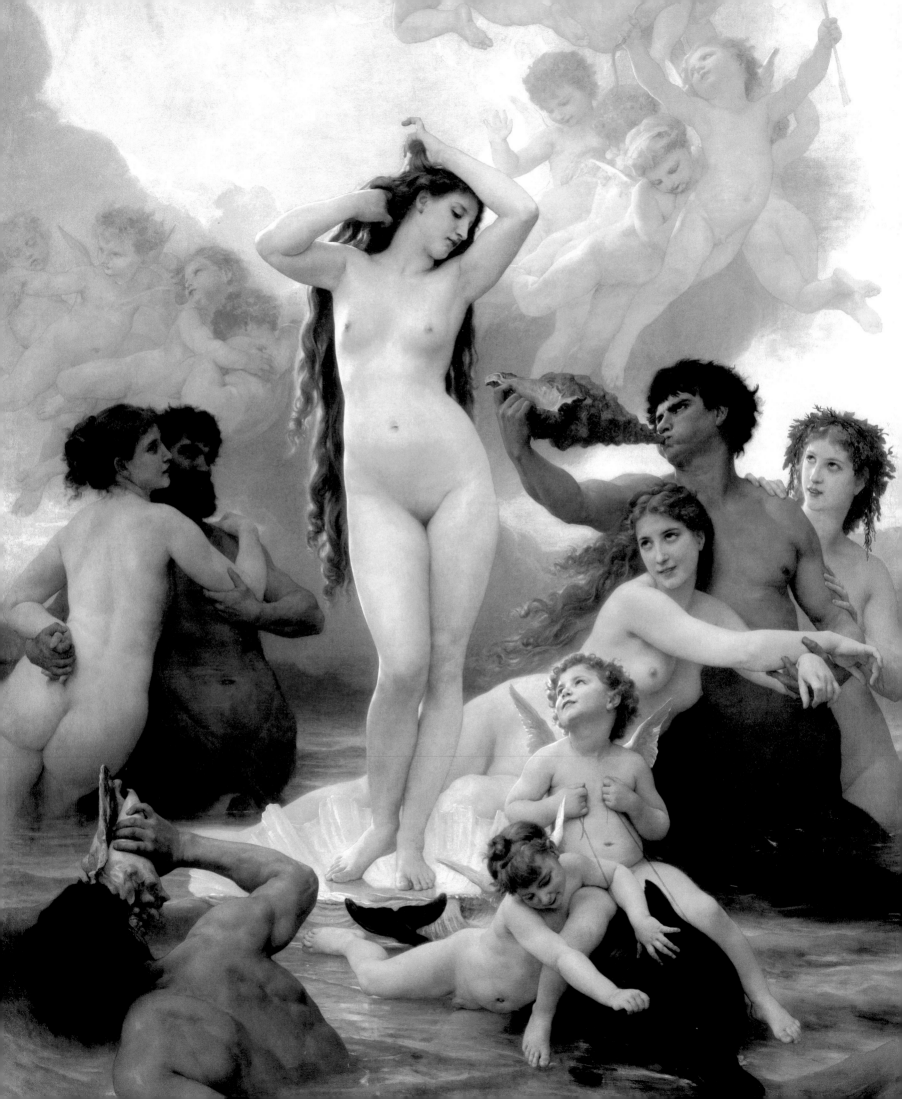

DIVERSITY AND DISCONTENT IN NINETEENTH-CENTURY FRENCH PAINTING

ERIC ZAFRAN

·

SEEKING THE SALON

In 1869 the aspiring young painter Frédéric Bazille wrote to his parents on learning the results of his and his friends' submission of works to that year's Salon:

> The Jury wreaked havoc among the canvases of the four or five young painters we like. Only one of my canvases was accepted, that of a woman. Except for Manet whom they no longer dare reject, I am among the least badly treated. Monet was entirely rejected. What pleases me is that there is real animosity directed against us. The fault lies entirely with Mr. Gérôme, who treated us like a band of madmen, saying that he felt it his duty to keep our paintings from being shown.[1]

From our present vantage point, when the Impressionists have achieved immeasurable fame, we may well wonder at the reasons behind this animosity displayed by Gérôme. Jean-Léon Gérôme was appointed a professor at the École des Beaux-Arts in 1863, was elected to the Institut de France in 1865, and became one of the most successful academic painters and sculptors of the era. Nonetheless, today he is considered of interest primarily for his Orientalist subjects. To understand the tension between establishment figures such as Gérôme and the French avant-garde, we could review the whole history of nineteenth-century painting in France, which can be seen as an ongoing struggle between progressive young artists and conservative older ones. However, if we want to try to pinpoint a turning point in this conflict it may be best to look at the year 1863. Napoléon III deemed that there was some justification for resentment on the part of the artists rejected from the 1863 Salon and ordered that a Salon des Refusés be opened in the adjoining galleries of the Palais d'Industrie, where the Salon was held. Thus, in addition to the 2,217 works on display in the approved Salon that year, there were another 781 (and probably more) "rejected" works on public view—certainly a staggering number of pictures to take in.

The contrast between the two sections was plainly evident. Émile Zola, a great defender of the younger generation, observed in the rather biased account given in his 1886 novel *L'oeuvre* (*The Masterpiece*):

> There was nothing [in the approved Salon] to recall the lively riot of *their* Salon, with its fresh colors and its exaggerated rendering of bright sunlight. It was one long succession of gold frames filled with shadow, black, ungraceful shapes, jaundiced-looking nudes in gloomy half-lights, all the paraphernalia of Classical Antiquity, historical subjects, genre paintings, landscapes, everyone thoroughly soaked in the train-oil of convention. Every picture oozed unfailing mediocrity; every one showed the same dingy, muddy quality typical of anaemic, degenerate art doing its best to put on a good face.[2]

As Zola noted, the official Salon presented a wide variety of subjects and styles. There was a surfeit of nudes, such as Alexandre Cabanel's *Birth of Venus* (purchased by the emperor; fig. 4), as well as characteristic landscapes and peasant scenes by Jean-Baptiste-Camille Corot, Jean-François Millet, and Théodore Rousseau. The Salon des Refusés included works by several artists who would later become notable, such as Henri Fantin-Latour, Johan Barthold Jongkind, Alphonse

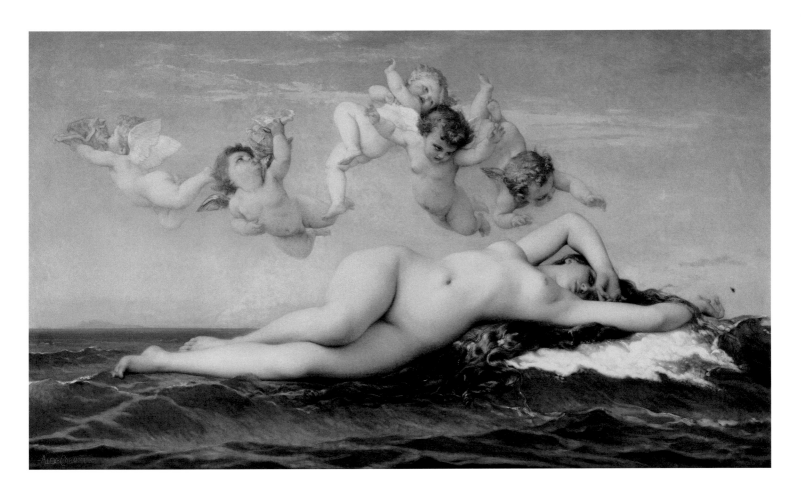

Legros, Henri-Joseph Harpignies, Félix Bracquemond, Camille Pissarro, Pierre Auguste Renoir, and Paul Cézanne. But the greatest attention was focused on two progressive works: James Abbott McNeill Whistler's *The White Girl*, previously rejected by the British Royal Academy but on the whole well received in Paris, and Manet's highly controversial *Luncheon on the Grass* (see figs. 5, 20). The latter's public display provided the latest in a long line of shocks to the official approach to painting and propelled Manet, rather against his wishes, to the role of leading provocateur of the "modern." Manet's work was shocking to contemporary conservative sensibilities for both its content and its technique, but to fully appreciate why, it is necessary to understand the workings of the state-run Salon and to grasp the stylistic variety of the artists exhibited. As Joseph Sloane has written in his classic account:

> In spite of certain lapses, exclusions, and abstentions, the Salon exhibitions afforded an unparalleled opportunity for seeing what was being done by nearly every painter of consequence in the country, and seeing it all at the same time and place. Artists of every kind wanted their work to be shown since the Salon was the gateway to recognition. . . . The Salons were enormous and confusing, but they were also very valuable and nearly always furnished adequate grounds for a fair judgment as to the general state of art.[3]

It was this desire for Salon recognition, which resulted in sales, and the approbation conferred by acceptance in the Salon, at least until about 1880, that drove artists to compete furiously for admission—particularly in this period before private dealers, who could promote individual

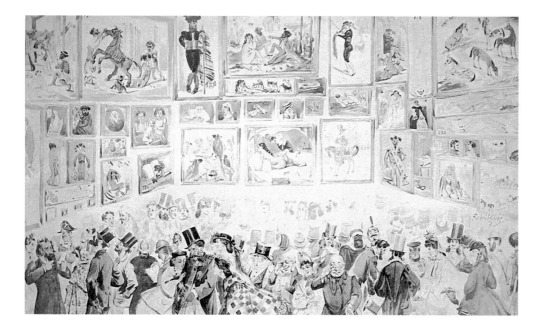

FIG. 5 Édouard Manet's *Luncheon on the Grass* (fig. 20) and a variety of Spanish-inspired paintings are among the artworks satirized by Fabritzius in this caricature of the 1863 Salon des Refusés.

artists, became well established. This struggle for validation runs like a leitmotif through the lives of all French painters, but for the Impressionists it was an especially contentious issue, often conflicting with their desire to exhibit as an independent group. Manet, always longing for official success, consistently refused to exhibit with the Impressionists and instead conducted an ongoing challenge to the artistic establishment with his submissions to the Salon. Others, such as Renoir, participated in both arenas. However, Renoir felt compelled to defend his Salon showings, writing to the dealer Paul Durand-Ruel in March 1881:

> There are scarcely fifteen collectors capable of liking a painting without the backing of the Salon. And there are another 80,000 who won't buy so much as a postcard unless the painter exhibits there. That's why every year I send in two portraits, however small. The entry is entirely of a commercial nature. Anyway, it's like some medicine—if it does you no good, it will do you no harm.[4]

The Salon—an annual or biennial event depending on political circumstances—was held under the aegis of the Académie des Beaux-Arts, established in 1795 after the dissolution of the Académie Royale de Peinture et de Sculpture, which had been founded in 1648 and presented the first exhibition of works by its member artists in 1665. The exhibition was opened to the public for the first time in 1725, and beginning in 1737 it was held in the Salon Carré of the Louvre, giving rise to the term *Salon.* By the nineteenth century there was an established, yet always fractious, arrangement in which the Académie oversaw both the École des Beaux-Arts, where budding art students received their training, and the Salon exhibitions, participation in which had been opened to all artists for the first time in 1791.[5] The jurors who chose the participants in the Salon were mostly members of these institutions, having themselves progressed through the rigorous academic process of study, which entailed copying from casts and live models and mastering drawing and perspective. After 1870 artists who had exhibited in previous Salons took part in electing the jury, which made the selection a bit more democratic and, as a result, opened the Salon to newer trends.

FIG. 6 **HENRI GERVEX**
The Salon Jury (*Une séance du jury de peinture*), 1885
Oil on canvas
117 3/4 × 165 in. (299 × 419 cm)
Musée d'Orsay, RF 726

Artists who did not gain entry to the École sought out private ateliers or academies, where established masters provided training in the basics needed to pursue a career in the arts. One's teacher was often key to obtaining official recognition. Thus Manet spent some unhappy time in the atelier of Thomas Couture before establishing his own studio in 1856. Monet, after he arrived in Paris in 1859, went first to the Académie of the painter Suisse,[6] where he met Pissarro, and then in 1862 entered the atelier of Charles Gleyre, an academic master who had triumphed at the 1843 Salon with his allegorical *Lost Illusions* yet became one of the few studio heads who encouraged some freedom of thought among his students. It was there that Monet met Renoir, Alfred Sisley, and finally the more affluent Bazille. While attending the Académie Suisse, Pissarro also befriended Cézanne, who was hoping in vain to gain entry to the École. Edgar Degas, who dropped out of the École, enrolled in the studio of Louis Lamothe, a pupil of Jean-Auguste-Dominique Ingres.

Sometimes it was not a formal financial relationship but an informal paternalistic connection that brought a student and a teacher together. Young painters were fortunate when they met sympathetic older masters who could give them practical career advice. Thus Pissarro painted with Corot and for a time referred to himself as a student of the older painter; Monet

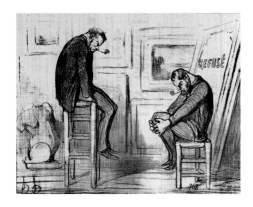

learned from Jongkind, Constant Troyon, Gustave Courbet, and Eugène Boudin; and Renoir was inspired by a chance meeting with Narcisse Virgile Diaz de la Peña in Barbizon.

Each year those wishing to exhibit at the Salon were usually allowed to present a certain number of works for consideration. The jury would review the submissions, voting their approval by raising their arms or umbrellas, as depicted in an 1885 painting by Henri Gervex (fig. 6). Naturally the jurors would favor works in their own manner and by their own students, and there was often vote swapping to ensure an entrant's place. A process of *charité* also developed by which each juror could save one rejected work. The rejected works were stamped *REFUSÉ* on the back and returned (creating the depression evident in an 1855 caricature by Honoré Daumier, fig. 7). The jury also selected the various prize and medal winners and recommended which works should be purchased by the state or emperor. Once an artist had won a medal, he or she was deemed *hors concours* (as finally happened with Manet in 1881), and from then on was automatically accepted at the Salon.

After the works were admitted, a special committee was entrusted with the thankless task of hanging the multitude of pictures: sometimes alphabetically, sometimes according to content, and other times by size. Having cleared the hurdle of acceptance, artists often complained about the bad locations allotted to their canvases on the crowded, tightly hung walls. Bazille commented on the placement of his painting in the Salon of 1869 in another letter home: "My work is installed in the worst possible place, but at least I am in the room reserved for my initial instead of being in one of the large back rooms."[7] Showy frames and brilliant varnishes (often applied on the preview day) helped bring attention to poorly situated paintings.

When the Salon opened, the public thronged to it, as did reviewers of all sorts, ranging from skilled writers like Théophile Gautier, Charles Baudelaire, and Zola to a whole miscellany of dilettantes and hacks. Aside from singling out distinguished individual masters or trying to find younger artists to praise or disparage, the easiest approach to dealing with the immense array of artworks on view was to divide them into categories by subject. This reflected the long-established hierarchy in the art of painting, which favored figural subjects and idealizations of the human form. However, during the nineteenth century the various categories increasingly overlapped, challenging the rigidity of the system. In addition, a major shift in art patronage—as the growing bourgeoisie replaced the state, the church, and the nobility—affected trends in painting genres. Not surprisingly, the newly moneyed middle class preferred paintings of subjects and of a size suitable for their homes to those designed for palaces, city halls, or churches.

THE CATEGORIES OF PAINTING

At the top of the artistic hierarchy, at least in theory, was *la grande peinture* or *la peinture d'histoire*—large-scale academic paintings of heroic historical, religious, or mythological themes—which was regarded as having an elevated moral purpose. Works of this type also served a conservative political end and were encouraged by the state. They were ultimately derived from the study of ancient and Renaissance art or the more recent and now-canonical works of Jacques-Louis David. The tradition established by David had been continued in different ways by the Romantic and Neoclassical schools, represented by Eugène Delacroix and Ingres, respectively. Mythological subjects, aside from the occasional Oedipus, appeared much less

FIG. 8 Henri Léopold Lévy's *Sarpedon* (cat. 8) on display at the Salon of 1874

frequently and became less convincing in the era of photography. They devolved into an end-less series of cloying nymphs, sexy Venuses, androgynous cupids, and hairy satyrs—or, in the case of Henri Léopold Lévy's 1874 *Sarpedon* (cat. 8), the centerpiece of one crowded Salon wall (fig. 8), a pastiche of nude forms abstracted from the history of art on display in the Louvre.

One aspect of *la grande peinture* that gradually became a separate category unto itself was the painting of the nude. Ingres, in idealized works such as *The Spring*, completed in 1856 (Musée d'Orsay), set a precedent; as the century progressed it is fair to say that the mythological–allegorical context became less pronounced, and an element of pure eroticism came to the fore. It is not by chance that in Gervex's 1885 scene of the Salon jury the painting under consideration is a bold nude, especially in light of the fact that his own *Rolla* had been refused in 1878 on the grounds of indecency. This erotic taste is pronounced in the assortment of vaguely mythological figures gathered together in the present exhibition. Jules Joseph Lefebvre's *Truth* (cat. 3), presented at the Salon of 1870, provided a stripped-down model for the more matronly Statue of Liberty by Frédéric Auguste Bartholdi and was criticized by the avant-garde writer (and friend of Manet's and Bazille's) Zacharie Astruc as "cold and monotonous."[8] The figure in Elie Delaunay's *Diana* of 1872 (cat. 4) looks like a frozen statue. Perhaps the ultimate is *Birth of Venus* (cat. 1), Adolphe-William Bouguereau's 1879 homage to Raphael. Bouguereau, who had labored long and hard to achieve perfect mastery of drawing and color, manages to make his chaste poster-girl subject seem peculiarly tasteless. But he wasn't alone in revamping this popular mythological subject. We have already mentioned the 1863 Salon submission by Cabanel—like Bouguereau, a student of the Neoclassical master François-Édouard Picot—which depicts the same theme but in this case with a debt to François Boucher.

It was their high finish and mythological subject matter (or at least their titles) that made these works acceptable to Salon juries and the conservative public, whereas Courbet's nudes were too realistic by half (see cat. 23). Likewise, the nude in Manet's *Luncheon on the Grass* was

considered shockingly out of place in the company of fully dressed gentlemen, and his *Olympia* (fig. 21), shown at the Salon of 1865, was all too obviously a prostitute lacking conventional charm (except perhaps in the boudoir). Zola was nearly alone in recognizing it as a masterpiece, while Gautier wrote perceptively, "Here is nothing but the desire to attract attention at any price."[9] Manet having set a standard for modern painters, his younger Impressionist friends were not to be denied their nudes. This is evident in Bazille's painting of his own atelier (1870, cat. 60), where one can see prominently on the studio wall not only a large homage to Courbet but also Bazille's nude *Fisherman* and *The Toilette*, a painting featuring nearly naked white and black women that was submitted to but rejected by the Salon jury in 1870.[10] Renoir, too, indulged a love of naked flesh, be it male, as in *Boy with a Cat* (1868, cat. 61); or female, as in *Study: Nude in the Sunlight* (1875, Musée d'Orsay), shown in the second Impressionist exhibition of 1876, or *Diana*, which he mistakenly hoped would get admitted to the Salon of 1867. Degas, who had struggled early on with classical history subjects employing nudes derived from antiquity, such as his 1860 *Spartan Boys and Girls* (National Gallery, London), later created, with his many female bathers, a gallery of modern nudes. Finally there was Cézanne, who progressed from tormented allegories of writhing nudes to profound, heroic treatments of the nude bather out of doors, with all erotic content effectively removed.

In the late nineteenth century, the grand tableaux tradition evolved in the hands of two quite different artists, Pierre Puvis de Chavannes and Gustave Moreau, both of whom were influenced by Théodore Chassériau. Each developed a distinctly personal manner of painting allegorical, religious, and mythological themes. Their visionary imagery laid the groundwork for the future generation of modern Symbolists. Puvis's style developed as wall painting, characterized by flat, simplified forms that made interpretation easy. His idiom was simultaneously decorative, timeless, archaic, heroic, and poetic; it could even be political, as in the two images of the siege of Paris included here (cats. 30–31). Puvis, who became immensely famous, was extremely tolerant and supportive of diverse younger artists. Bazille, for example, was happy to write his parents that his painting in the 1869 Salon had received "some very flattering compliments, among them one from Mr. Puvis de Chavannes."[11] Moreau's work was just the opposite of Puvis's—elaborate and heavily worked in both texture and symbolic meaning. Although Moreau initially won praise, his increasingly imaginative and original paintings, such as *Jason* of 1865 (cat. 5), were not well received.[12]

Another branch of *la grande peinture*, religious subject matter, continued to be a mainstay of artists in France, a deeply Catholic country, in the progressively secular nineteenth century.[13] As with history painting, in the first half of the century both Ingres and Delacroix had set very different paths in religious art, and likewise both Puvis (especially in church decoration) and Moreau made their own decidedly personal contributions. Even Gérôme occasionally dabbled in religious themes, as in his rather remarkable *Jerusalem (Golgotha): Cosumatum Est* of 1867 (Musée d'Orsay). But, oddly enough, it was Bouguereau, the master of kitschy eroticism, who may have been the most profoundly spiritual of his peers. He, like Paul Jacques Aimé Baudry, decorated churches, but his Catholic faith is most evident in a number of large independent religious works such as *Virgin of Consolation* (cat. 2), shown in the Salon of 1877. Here again, Bouguereau employed Raphaelesque prototypes to create images of weighty, tearful sobriety that sometimes veer into sentimentality.

At the opposite extreme from Bouguereau's refined imagery are works with a decidedly earthy, Realist approach that portray religious themes in an almost lugubrious manner. The first painting of this type purchased by the state was Isidore Pils's large *The Death of a Sister of Charity* (1850, Musée d'Orsay), which combines a contemporary spiritual event with a concern for social issues. Its brushy realism owes a clear debt to the tenebrism, or dark tonalities, of seventeenth-century Spanish art, a popular source of inspiration for many French artists during this period, including Léon Bonnat, who would eventually become renowned as a portraitist but caused a sensation at the Salon of 1865 with his *Saint Vincent de Paul Taking the Place of a Convict* (Church of Saint-Nicolas-des-Champs, Paris). Likewise this trend can be seen in the moving religious paintings of Jean Jacques Henner, and it is very much present in *The Martyr Saint Sebastian* (cat. 14) of arch-Realist Théodule Ribot. The ultimate, however, in dark religious drama was work by Gustave Doré.[14] Having produced the century's most popular book—his illustrated Bible of 1865—Doré began submitting to the Salon and displaying on his own, usually to negative reviews, tremendous, rapidly executed multifigure biblical scenes. Of the modern generation, only the somewhat more staid Manet set out to do traditional religious subjects. For his efforts—his *Dead Christ and Angels* (Metropolitan Museum of Art, New York) and *Jesus Mocked by the Soldiers* (fig. 26), shown respectively at the Salons of 1864 and 1865—he was pilloried. His work, clearly based on Old Masters in the Louvre, was found to be vulgar, too intense, and lacking the requisite high finish—not to mention antireligious.

ORIENTALISTS AND BATTLE PAINTERS

Two other specialized types of subject matter also grew out of the interest in the past and were transformed into modern versions of history painting. Orientalism developed as a result of European artists traveling to ever more distant realms, such as North Africa and the Near East, for inspiration. The seemingly barbaric lands of Egypt, Algeria, and Morocco had been a source of fascination since earlier in the nineteenth century, when Delacroix and Gustave Flaubert provided glimpses of the exotic culture and topography of these colonial outposts.[15] The tradition of visiting and recording the sensuous sites was continued by a number of Salon artists, especially Gérôme, as in his clearly erotic *The Bath* (ca. 1880–1885, fig. 9). The interest was even carried on into the younger generation by Renoir, who painted figures in Algerian dress in the 1870s, well before he actually visited the country in 1881.

Scenes of noble battles had been standard fare in French painting and filled the vast galleries at Versailles. But it was the Franco-Prussian War of 1870–1871 that inspired a younger generation to take up military subjects. Jean Louis Ernest Meissonier may be considered the father of this school, having begun with his rendering of Napoleon's historic military campaigns; such scenes were brought up to date by his student Jean Baptiste Édouard Detaille and the battle specialists Alphonse de Neuville and Étienne Prosper Berne-Bellecour. Military subjects easily transitioned into scenes of rubble and destruction, especially those stemming from the siege of Paris and the Commune of 1871, as seen here in works by Meissonier, Georges Jules Victor Clairin, and Doré (cats. 27–29).[16] Once again Manet gave a radical twist to an established tradition, this time of military subjects, when he imagined on canvas the death by firing squad of Emperor Maximilian in Mexico. His debasement of a supposedly noble endeavor did not endear the painter to conservative hearts and was therefore refused by the Salon of 1869.

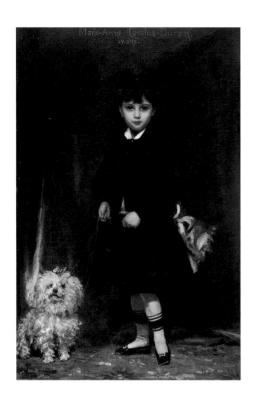

FIG. 10 ÉMILE-AUGUSTE CAROLUS-DURAN

Marie-Anne Carolus-Duran (The Artist's Daughter)
(Portrait de sa fille), 1874

Oil on canvas

51 1/4 × 33 1/2 in. (130.2 x 85.1 cm)

Fine Arts Museums of San Francisco, museum
purchase, Mildred Anna Williams Collection, 1941.26

OTHER GENRES: LANDSCAPE, PORTRAITURE, AND STILL LIFE

The genres of painting that did not fall under the category of elevated subject matter were regarded by traditionalists as "the secondary arts."[17] Yet the Salons were replete with landscapes, portraiture, and still lifes. In the early nineteenth century, landscape was still being presented in the noble, balanced, and polished tradition established by the seventeenth-century masters Nicolas Poussin and Claude Lorrain. But this approach would soon be under siege. Presiding over the genre of landscape painting for most of the mid- and late nineteenth century was the patriarchal figure of Corot, a great independent who emerged from Realist beginnings as a master of hazy, dreamlike settings that could easily incorporate mythological, religious, or secular themes. His tolerant support of younger artists was legendary. In contrast to the artistic and personal calm of Corot was the vigor of Courbet, evident in his many depictions of nature (see cat. 24). His land- and seascapes were, of course, just one aspect of his multifarious pursuits. It was the artists of the Barbizon School, as well as Courbet, who made the most concentrated challenge to the now-outmoded Sublime aesthetic. Painters such as Millet (cats. 17–19), Charles François Daubigny, Diaz, and Rousseau attempted to introduce to landscape painting rougher textures rendered with a sense of spontaneity. They often met with great opposition. Their work was criticized as "revolutionary" or "undermining,"[18] and they struggled financially. Once they were finally accepted, these artists, especially Daubigny, helped pave the way for the Impressionists.

Of the other significant genres or categories of painting that were likewise of interest to both traditional and modern artists, two remain to be mentioned: portraiture and still life. With portraits one can usually distinguish between officially commissioned examples and less formal renderings of an artist's friends. Only occasionally did a portrait, usually because it was of some very important person, provoke a great deal of attention at the Salon. This was the case in 1869 when the extraordinary young painter Henri Regnault displayed his *Juan Prim, October 8, 1868* (cat. 9). Regnault, like so many French artists of the period, was drawn to Spain and Spanish subjects. Commissioned by Prim, the painting shows the heroic general on horseback as he arrived in Madrid to lead a popular uprising against the monarchy. The composition was derived from a long line of equestrian portraits but was rendered in a bold, vigorous manner, which made it a Salon success—though not with Prim, who rejected it as too ugly. Sadly, the talented artist was killed early in the Franco-Prussian War. The state purchased this portrait for the Musée du Luxembourg in 1872.

Much more representative of traditional society portraiture were works by artists such as the ever-eclectic Cabanel (cat. 11); Bonnat, who became the preferred choice for rich Americans visiting France; and Émile-Auguste Carolus-Duran, who after first pursuing other subjects soon fell into portraiture as a lucrative career. Carolus-Duran's *Lady with a Glove* (cat. 13), a portrait of his wife shown at the same Salon as Regnault's *Prim*, was recognized by some critics as an elegant but rather superficial rendering.[19] It nevertheless won a medal, was purchased by the state for the Musée du Luxembourg, and launched the artist's career. His later subjects included not only his daughter, seen in a charming 1874 Salon painting (fig. 10), but also his friend and fellow painter Manet, who supposedly remarked that he was "in despair because he could not paint atrocious pictures like Carolus-Duran."[20] Manet, however, painted quite splendid portraits,

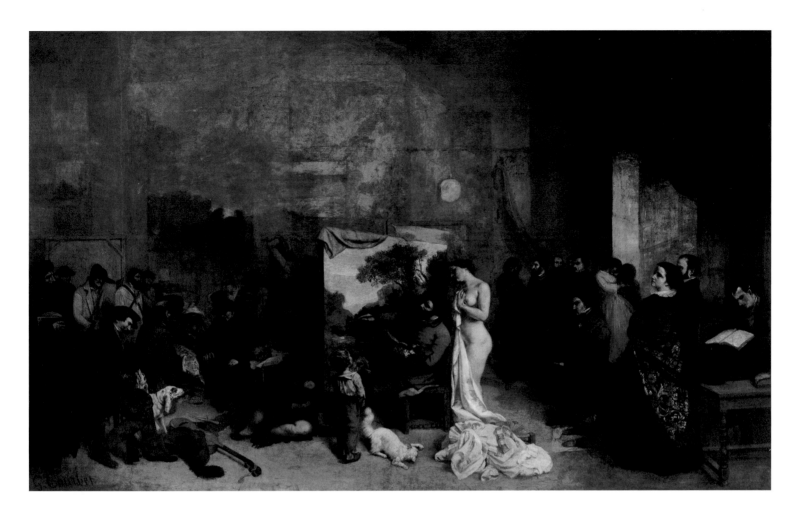

FIG. 11 **GUSTAVE COURBET**

The Painter's Studio: A Real Allegory Determining a
Period of Seven Years of My Artistic and Moral Life
(*L'atelier du peintre: Allégorie réelle determinant une*
phase de sept années de ma vie artistique et morale),
1854–1855
Oil on canvas
142 1/8 × 235 3/8 in. (361 × 598 cm)
Musée d'Orsay, RF 2257

especially of his friends and family, in his own distinctive modern manner (see cats. 33–38, 42). The Impressionists—including Renoir, who would do the occasional commissioned portrait—also found one another (and themselves) to be quite suitable subjects (cats. 62–63, 66–67).

In fact, by a curious coincidence Manet appears as the focal point in two quite different group portraits of 1870, both now in the collection of the Musée d'Orsay and on display in the present exhibition. Three years after Bazille demonstrated that he could capture individuals in a disturbingly real and frozen manner (see his *Family Reunion* [cat. 59], shown at the Salon of 1868), he produced a more fluid view of activity in his studio (cat. 60), mentioned previously for its abundance of nudes. The painting may owe its conception to Courbet's famous allegory of his studio (fig. 11), but without its allegorical trappings and self-promotion. There is some uncertainty about the identification of the men depicted. From the left, Sisley or Renoir, Monet or Zola, Astruc or Monet, and Manet (in hat) look at the work of the tall Bazille, who was actually painted in by Manet; at the far right appears Edmond Maître. Full of activity, Bazille's canvas presents a stark contrast to the hushed, rather prim arrangement of dignified gentlemen in a painting by Fantin-Latour titled, after the Parisian neighborhood in which both he and Manet lived, *A Studio in the Batignolles* (cat. 47), which won the painter a third-class medal at the Salon of 1870. Here the presiding artistic presence is not a turbulent Courbet nude but rather a calm classical statue. Manet sits demurely at the easel in his studio in the company of fellow artists Renoir, Bazille, and Monet and the writers Maître, Astruc, and Zola. Fantin-Latour, like his good friend Manet, would never jeopardize his position in the art world by exhibiting with the

Impressionists. He produced a steady stream of rather austere portraits (see fig. 27, cats. 58, 67), until, seeming to tire of the effort they required, he devoted his attention to musical allegories and floral and fruit still lifes.

Perhaps because of his many years as a portraitist, Fantin-Latour brought a special quality to his flower paintings (see cat. 68), imbuing them with not only a colorful realism but also an individual personality. As with landscape and portraiture, there was a long-established Salon tradition of still-life painting, which had never been regarded as one of the highest achievements but became increasingly popular for domestic settings. Painters such as Courbet, Ribot, François Bonvin, and Antoine Vollon all employed a dark, realistic manner—growing in part out of the legacy of Jean-Siméon Chardin—to invest humble foods and objects with a haunting presence. Paintings of fish, such as examples by Courbet and Vollon in this exhibition (cats. 25–26), may have set a precedent for the younger generation, including Manet. Bazille's first work accepted by the Salon in 1866 also depicted a fish, and in the late 1880s Sisley painted a surprising composition of a sparkling pike.[21] In 1867 Bazille and Sisley, working side by side, each took on the distinct challenge of painting birds—a rather old-fashioned composition of a dead heron and other birds. Renoir did a portrait of Bazille at work on his vertical canvas (cat. 63); Sisley's horizontal treatment is also in the present exhibition (cat. 64). Both artists did a splendid job of capturing the downy texture of the feathers. For Manet, rapidly rendered still lifes were almost a recreational diversion from his grander compositions. There is nothing more charming than his little single *Asparagus* of 1880 (cat. 43). For Manet's younger colleagues such as Adolphe Monticelli (cat. 102) and especially Cézanne (cat. 99), still life became a much more serious and even obsessive pursuit. Cézanne stated that his goal was "to astonish Paris with an apple."[22]

PAINTERS OF MODERN LIFE

There was yet another broad category of painting pursued by Manet and his younger colleagues that set them apart from the lofty aims of their academic predecessors. It was described as "scenes of modern life" in an essay by Baudelaire published in 1863. Although, the poet-critic focused primarily on the painter and illustrator Constantin Guys, his phrase came to be applied to a whole group of artists who depicted Realist imagery.[23] As we have previously observed, the lines between historical and contemporary everyday subjects were becoming increasingly blurred. For example, one type of figurative subject treated by a wide variety of artists was classified under the term *paysanneries*, or depictions of peasants or rustic folk, a form of rural Realism that parallels the urban imagery advocated by Baudelaire. A huge distinction was made between Courbet's seemingly brutal portrayals and the more ennobling, sympathetic ones of Millet (see cat. 20). Courbet, although with great panache, seemed only to present the externals; he was thought to lack the transformative imagination of Millet, who was able to raise the humble peasant to mythic status. Others, such as Jules Adolphe Aimé Louis Breton (cat. 21), Jules Bastien-Lepage (cat. 22), and Léon-Augustin Lhermitte followed in Millet's footsteps, albeit with less convincing sympathy. Jean-François Raffaëlli, a student of Gérôme's who later allied himself with the Impressionists, also turned to producing realistic but touching depictions of peasants after his Breton subject, *The Family of Jean-le-Boiteux, Peasants from Plougasnou* (cat. 16), was praised at the Salon of 1877. Among the full-fledged Impressionists, Pissarro identified most strongly with the downtrodden and often included farmworkers in his rural landscapes (see cat. 93).

While peasant life maintained a nostalgic appeal, the true subjects of modern life were scenes of the vibrant city of Paris, to which the rural population flocked in ever-increasing numbers. For example, Jean Alexandre Joseph Falguière's *Wrestlers* (cat. 15), shown at the Salon of 1875, is an extreme portrayal of brutal, rough-hewn figures in an urban setting. The painter won a second-class medal for this work but also criticism for his unidealized treatment of a trivial subject, and he soon retreated to being a full-time sculptor.

More representative of the genre of painting advocated by Baudelaire were depictions of the comfortable world of the modern middle class, featuring all the accoutrements of contemporary fashion. Women, noted Baudelaire in his essay,[24] were often at the center of these compositions, as seen in luxuriant examples by Alfred Stevens (cat. 49), James Tissot (cat. 56), and even in Whistler's *Arrangement in Gray and Black, No. 1: Portrait of the Painter's Mother* (cat. 69). Degas, who had asked Tissot to participate in the Impressionist exhibition of 1874, found his chief subjects at the ballet and the racetrack, two typically bourgeois diversions. Mary Cassatt and Berthe Morisot both made everyday family scenes, especially of mothers and children, their particular focus (see cat. 48). But perhaps none of the Impressionists equaled Gustave Caillebotte in presenting contemporary urban scenes on a grand scale, as seen in remarkable compositions such as *The Floor Scrapers* (1875, cat. 50), *The Pont de l'Europe* (1876, fig. 37), and *Paris Street: A Rainy Day* (1877, Art Institute of Chicago). From the time he first met Monet in 1873, this wealthy artist-collector, the group's last true adherent, kept the Impressionists alive financially.

THE STRUGGLE OF THE AVANT-GARDE

Throughout the nineteenth century, there was a continual stylistic progression in the Paris Salons from a highly finished surface to a looser treatment, and from high-minded and even noble subjects to more mundane, everyday concerns. The greatest struggle for the avant-garde artists was to get their work seen by the public and the critics. To accomplish this they often had to go outside the established Salon system. Courbet was one of the first artists to stage a solo exhibition. At the time of the 1855 Exposition Universelle he presented a private showing of his works, his Pavilion of Realism. Both he and Manet repeated this approach in 1867. Following their rejection from the Salon of 1859, Fantin-Latour and Ribot likewise exhibited their works along with examples by Whistler and Legros in the studio of the genre and still-life painter Bonvin. It is not surprising, therefore, that by 1869 the younger generation was thinking along the same lines. Bazille wrote his parents:

> I will never be annoyed again as I have this year, because I will never send anything again to the Jury. It is really too ridiculous for a considerably intelligent person, to expose himself to administrative caprice, especially if medals and prizes hold absolutely no interest. A dozen talented young people agree with what I have just said. We have therefore decided that each year we will rent a large studio where we will exhibit our works in as large a number as we wish. We will invite any painters who wish to send us work. Courbet, Corot, Diaz, Daubigny and many others whom you may not know have promised to send work and heartily support our idea. With these people and Monet, the best of all of them, we are certain of success.[25]

This plan, however, soon had to be abandoned, as not enough money could be raised for the enterprise. Then, unfortunately, the outbreak of war and Bazille's untimely death in 1871 put the venture on hold; it was not until 1874 that the group show of the Société Anonyme des Artistes at last took place. As is well documented, this and the future showings of the group were not well received. For example, when the American writer and critic Henry James reviewed the second Impressionist exhibition at Durand-Ruel's gallery in 1876, he concluded, "None of [the group's] members show signs of possessing first-rate talent, and indeed the 'Impressionist' doctrines strike me as incompatible, in an artist's mind, with the existence of first-rate talent."[26]

Such conservative attitudes continued to be prevalent late into the nineteenth century. Only shortly before his death in 1883 was Manet finally given the much-desired state honor of a nomination to enter the Légion d'Honneur, where Meissonier, Cabanel, Gérôme, Puvis, Bouguereau, and a host of other old-guard artists had long been ensconced. Then in 1893, when Caillebotte's collection of paintings by the Impressionists was left to the French state with the stipulation that the works be exhibited in the Musée du Luxembourg, the long-simmering animosity of the old guard burst forth once again in the person of the academic painter Gérôme, who pointedly stated:

> I do not know these gentlemen, and the only thing I recognize of this bequest is the title. Does it not contain paintings by Mr. Monet and Mr. Pissarro? For the government to accept such filth would be a sign of great moral decline.[27]

In the end a compromise was worked out, and only a portion of the bequeathed works entered the national collection. Another battle, waged by Monet in 1890, was to get Manet's *Olympia* purchased by subscription for the state. He was ultimately successful in this endeavor and by the end of his own life would have his monumental *Water Lilies* compositions accepted as a new form of civic decoration. Thus, as had happened so often before, the artists who started out as the avant-garde became the new status quo. No wonder that by the late nineteenth century a younger generation of artists, led by Gauguin and others, had come to the fore to challenge the subjects and styles of its predecessors.

NOTES

1. Quoted in *Frédéric Bazille and Early Impressionism*, ed. J. Patrice Marandel and François Daulte (Chicago: Art Institute of Chicago, 1978), 179. The painting of a seated woman, known as *The View of the Village*, is now in the Musée Fabre, Montpellier.

2. Émile Zola, *The Masterpiece*, trans. Thomas Walton (Ann Arbor: University of Michigan Press, 1968), 132.

3. Joseph Sloane, *French Painting: Between the Past and the Present* (Princeton, N.J.: Princeton University Press, 1951), 28–29. See also Gerald M. Ackerman, "The Glory and Decline of a Great Institution," in *French Salon Paintings from Southern Collections*, ed. Eric Zafran (Atlanta: High Museum of Art, 1982), 10–20.

4. Quoted in Bernard Denvir, *The Chronicle of Impressionism: An Intimate Diary of the Lives and World of the Great Artists* (New York: Thames and Hudson, 2000), 21.

5. See Patricia Mainardi, *The End of the Salon: Art and the State in the Early Third Republic* (New York: Cambridge University Press, 1993), 9–15ff.

6. There is some debate as to whether Suisse's vocation was as a painter or a former model. See John Rewald, *The History of Impressionism* (New York: Museum of Modern Art, 1973), 40.

7. Marandel and Daulte, *Frédéric Bazille*, 180.

8. See Dianne W. Pitman, *Bazille: Purity, Pose, and Painting in the 1860s* (University Park: Pennsylvania State University Press, 1998), 44.

9. Denvir, *Chronicle of Impressionism*, 36.

10. Marandel and Daulte, *Frédéric Bazille*, 14, ill.

11. Ibid.

12. Sloane, *French Painting*, 172.

13. See Michael Paul Driskel, *Representing Belief: Religion, Art, and Society in Nineteenth-Century France* (University Park: Pennsylvania State University Press, 1992).

14. See Eric Zafran, *Fantasy and Faith: The Art of Gustave Doré* (New York: Dahesh Museum of Art; New Haven, Conn.: Yale University Press, 2007), 65–83.

15. See MaryAnne Stevens, "Western Art and Its Encounter with the Islamic World," in MaryAnne Stevens, ed., *The Orientalists: The Allure of North Africa and the Near East* (Washington, D.C.: National Gallery of Art; London: Weidenfeld and Nicholson, 1984), 15–22.

16. For more on "The Terrible Year," see Alice Thomine-Berrada's essay in this volume.

17. See Mainardi, *End of the Salon*, 15.

18. See John Sillevis, *The Barbizon School* (The Hague: Haags Gemeentemuseum, 1985), 52.

19. *Équivoques: Peintures françaises du XIXe siècle* (Paris: Musée des Arts Décoratifs, 1973), unpaginated.

20. Quoted in Rewald, *History of Impressionism*, 401.

21. The painting by Bazille, *Still Life with Fish*, is now in the collection of the Detroit Institute of Arts; the painting by Sisley, *The Pike*, is now in the collection of the Wadsworth Atheneum, Hartford.

22. Quoted in Michael Doran, ed., *Conversations with Cézanne* (Berkeley: University of California Press, 2001), 6.

23. See Charles Baudelaire, *The Painter of Modern Life and Other Essays*, ed. Jonathan Mayne (London: Phaidon, 1964), 1–40.

24. Ibid., 29–34.

25. Marandel and Daulte, *Frédéric Bazille*, 180.

26. Henry James, *The Painter's Eye: Notes and Essays on the Pictorial Arts*, ed. John L. Sweeney (Madison: University of Wisconsin Press, 1989, 114–115.

27. See James Harding, *Artistes Pompiers: French Academic Art in the Nineteenth Century* (London: Academy Editions, 1979), 19; and Rewald, *History of Impressionism*, 570 and 572.

DIVERSITY AND DISCONTENT

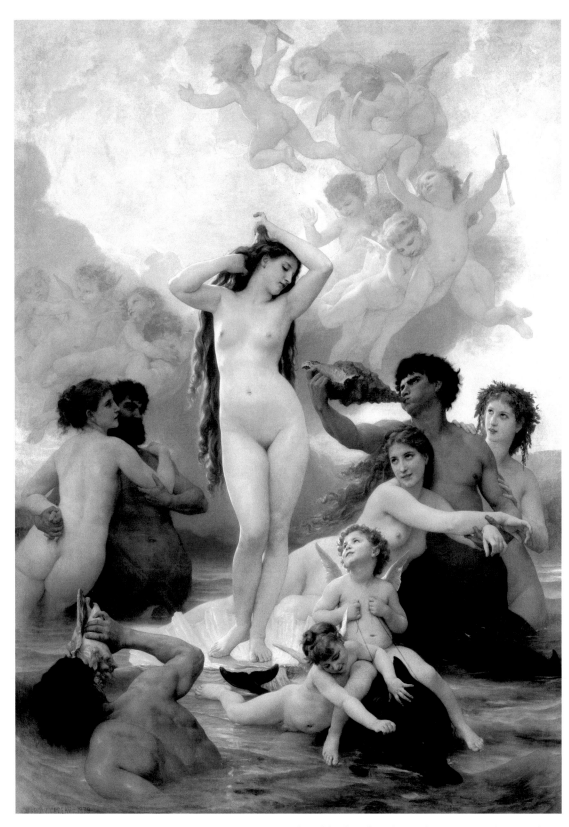

1

ADOLPHE-WILLIAM BOUGUEREAU
Birth of Venus (*Naissance de Vénus*), 1879
Oil on canvas
118 1/8 × 84 5/8 in. (300 × 215 cm)

Selected for the Salon of 1879, this monumental picture demonstrates several tenets of academic painting—controlled brushwork, classical subject matter, and a fascination with the idealized nude. In contrast to the exuberance of his *Venus*, Bouguereau's *Virgin of Consolation* is reduced to three tragic figures. Purchased by the French government from the 1877 Salon, it underscores the continued taste for religious subjects. The melancholy painting may have biographical significance, as Bouguereau's wife and infant son both died in 1877 (an older son had died in 1875).

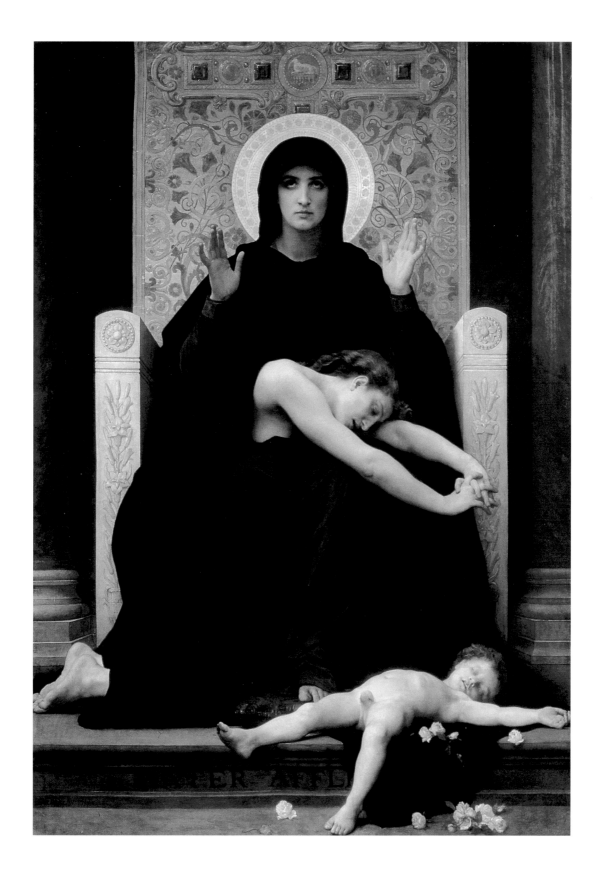

2

ADOLPHE–WILLIAM BOUGUEREAU
Virgin of Consolation (*Vierge consolatrice*), ca. 1877
Oil on canvas
80 3/4 × 57 7/8 in. (205 × 147 cm)

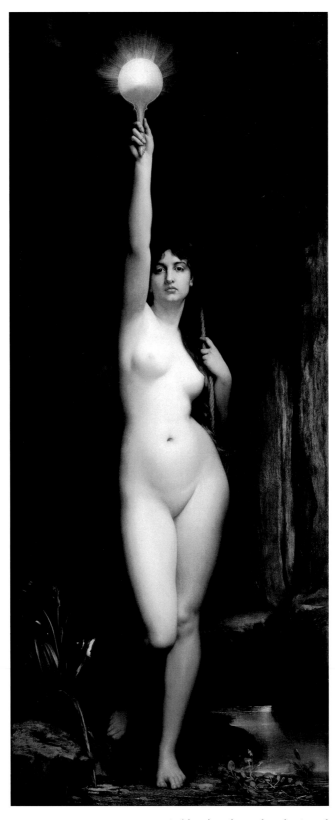

3

JULES JOSEPH LEFEBVRE
Truth (*La Vérité*), 1870
Oil on canvas
104¼ × 44 in. (264.7 × 111.8 cm)

Lefebvre's archetypal academic nude was exhibited at the Salon of 1870. The figure's mirror, which reflects symbolically the world as it is, and her detached expression classify the subject as an allegory of ideal virtue. Her elongated body shows the influence of Italian Mannerism, which Lefebvre studied after winning the prestigious Prix de Rome in 1861. Although the idealized nudes of Lefebvre and his main competitor, Bouguereau, were derided by later generations, they were celebrated at the time.

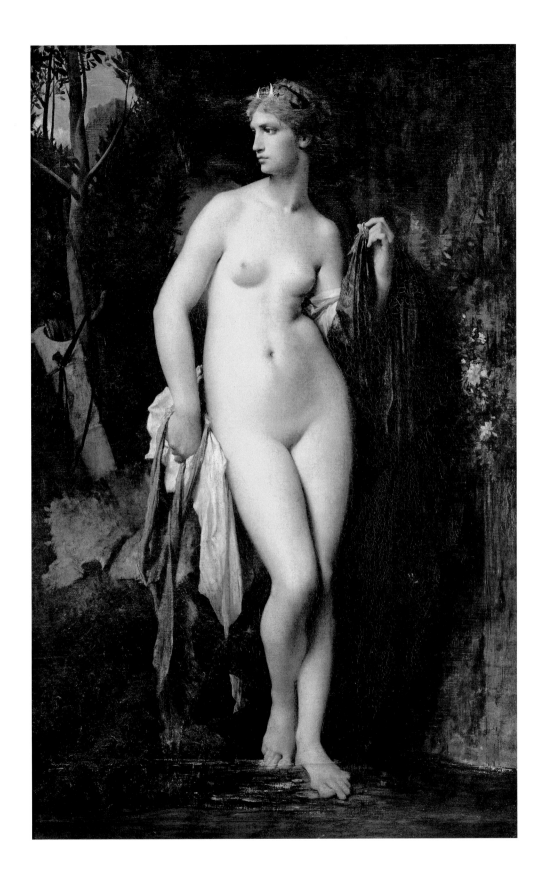

4

ELIE DELAUNAY

Diana (Diane), 1872

Oil on canvas

57 7/8 × 37 in. (147 × 94 cm)

DIVERSITY AND DISCONTENT

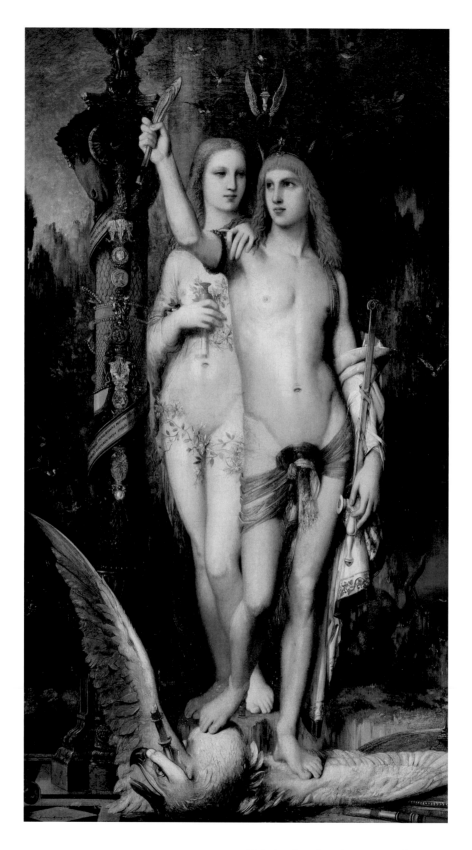

5

GUSTAVE MOREAU
Jason, 1865
Oil on canvas
80 × 45 ⅜ in. (204 × 115.5 cm)

Exhibited at the Salon of 1865, Moreau's depiction of Jason and Medea underscores the artist's early reliance on academic conventions. The tragic story of doomed lovers caught in a clash between love and ambition originated in Greek mythology, notably with Euripides' play *Medea*, in which Medea murders her children after being abandoned by their father, Jason. Moreau was made an *officier* of the Légion d'Honneur in 1883 and elected to the Académie des Beaux-Arts in 1888.

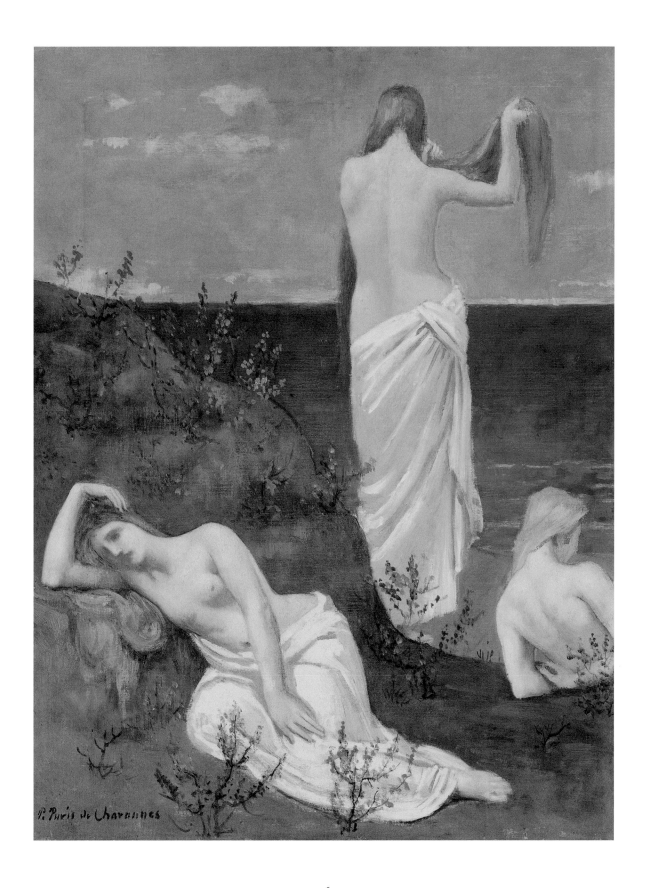

6

PIERRE PUVIS DE CHAVANNES

Young Girls at the Seashore (*Jeunes filles au bord de la mer*), ca. 1879
Oil on canvas
24 × 18 ½ in. (61 × 47 cm)

7
GUSTAVE MOREAU
Galatea (Galatée), ca. 1880
Oil on panel
33 5/8 × 26 3/4 in. (85.5 × 66 cm)

Galatea was both applauded and criticized for its sensu-
ality. Selected for Salon exhibition in 1880, this evoca-
tive and mysterious picture was a triumphant success
for the artist, yet it also marked his last appearance
at this venue. Drawn from Ovid's *Metamorphoses*, the
subject of this picture is the myth of Beauty (Galatea)
and the Beast (the cyclops Polyphemus). Moreau pre-
sents the essence of the story in a profusion of elaborate
details, rendered in richly worked paint that appears
almost like enamel on the surface of the canvas.

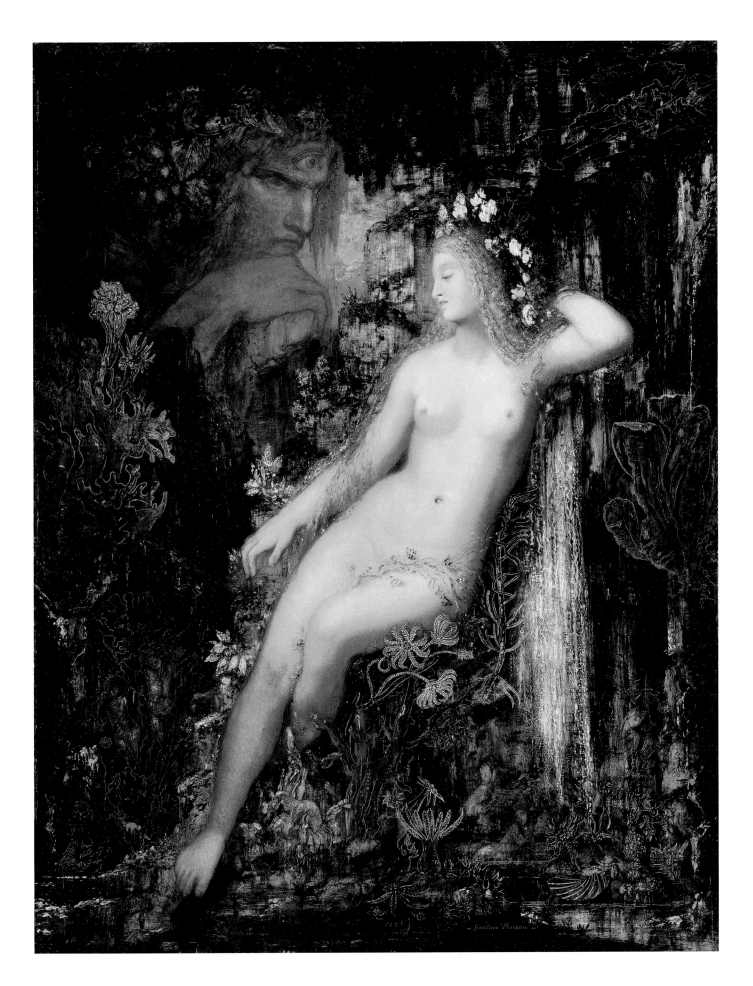

THE SALON: ANCIENTS AND MODERNS

DOMINIQUE LOBSTEIN

The 1855 Exposition Universelle presented a platform for an international competition that confirmed Paris as the capital of art. Henceforth, an artist could not be considered worthy if he had not been crowned by the Parisian jury; by the same token, art lovers could be absolutely sure of their choices if they made their purchases during that most important of art events in the capital: the Salon, held in May and June under both the Second Empire and the Third Republic.[1]

Today's artists have a number of ways to reach their public, including self-promotion and the services of a dealer. However, throughout the nineteenth century, French artists relied on the Salon as the only effective avenue to recognition. The Salon selection process served to weed out inferior artworks, but it also allowed the art establishment to control who among the talented artists came to official and public notice. Artists competed not only for exhibition exposure but also for access to the state or private patronage that a spot on the Salon walls could bring. Thus, the Salon system exacerbated the natural tensions between established and emerging artists and between conservative and avant-garde factions, recasting the perennial battle between the Ancients and Moderns (see fig. 12).

Behind the scenes at the lofty exhibition, which was met each year by a stream of reviews published in newspapers the world over, there was certainly no lack of friction—as became increasingly obvious between 1860 and 1880. The main sticking point, and the source of multiple amendments to the Salon's bylaws, was the jury-selection process. Every year new protests arose. The separate organization of exhibitions exclusively for those who had been rejected—the Salons des Refusés in 1863, 1864, and 1874—and the liberalization of eligibility requirements that ensued did nothing to resolve the problems that divided the artists, organizers, and critics. After 1872 and through the end of that decade, artists who had not first submitted to the official Salon would find their attempts at innovation stopped in their tracks.

Edmond Turquet, appointed undersecretary of state for fine arts in the late 1870s, came up with a drastic reform in 1881, placing the fate of the exhibition in the hands of artists elected from the ranks of the Société des Artistes Français. The initiative failed, however, and led soon thereafter to the breakup of the Salon into numerous competing events. In the meantime,

traditionalists and modern artists exhibited side by side and did not necessarily subscribe to the philosophical divide that scholars have conferred on them over time.

In the 1860s and 1870s, the *grand genre*—mythological, religious, or historical painting—met with the approval of the Académie and École des Beaux-Arts and remained a leading criterion for exhibition. Given the enduring nature of academic models and references to tradition, there were several paths to choose from when approaching this genre. There are sharp contrasts, for example, between Elie Delaunay's *Diana* of 1872 (cat. 4), clearly influenced by the *Venus de Milo*, which had arrived at the Louvre in 1821, and Adolphe-William Bouguereau's 1879 *Birth of Venus* (cat. 1), which reflects the artist's stay in Italy and his fascination with Raphael's *Triumph of Galatea* (1511) at the Villa Farnesina. Likewise, Bouguereau's *Virgin of Consolation* (ca. 1877, cat. 2), whose rigorous composition is reminiscent of Michelangelo, borrows from antiquity via the Renaissance. Iconographic sources were numerous for the large-format canvases in which the administration delighted, including Henri Léopold Lévy's *Sarpedon* (cat. 8), which it purchased in 1874. In a diagonal composition of swirling clouds reminiscent of an Italian Baroque or Neoclassical religious tableau, the artist reinvented a mythological scene in which Hypnos (Sleep) and Thanatos (Death) seem to be carrying the body of the deceased not to the land he had conquered but to a consoling Zeus with features of the Eternal Father. The work of artists such as Delaunay, Bouguereau, and Lévy was highly representative of the academic instruction that other painters were beginning to subvert from within through their iconographic and formal choices.

This was the case, for example, with the unexpected syncretistic motifs in works by Gustave Moreau shown at the Salon of 1865. In *Jason* (cat. 5) a wealth of decorative references, heavily influenced by the etchings and illustrations that the painter avidly accumulated from all sorts of publications, complement the models' juvenile bodies. Although certain collectors adulated Moreau, he was angered by the critical reception of his work. He often refrained from participating in the Salon, stopping altogether after his submission of *Galatea* (cat. 7) in 1880. Here, beneath the gaze of the cyclops Polyphemus, light seems to glide over the Nereid's mother-of-pearl body, which shimmers amid an abundance of flora painstakingly reproduced from marine botanical plates that Moreau consulted at the Muséum d'Histoire Naturelle. In Moreau's interpretation of the myth, the monster, described in ancient texts as ferociously jealous, stares melancholically at a pearl surrounded by watery, venomous wonders.

Pierre Puvis de Chavannes also had a very distinctive approach in his interpretation of the *grand genre*. For some time he had been experimenting with the technical specificities of mural painting. His avant-garde style tended to disconcert art lovers; the colors in his easel paintings seemed too pale, the light flat. Critics censured his synthesis of forms, which he had inherited from Jean-Auguste-Dominique Ingres's graphic principles, for its lack of unity and for breaking with well-established academic traditions. *Young Girls at the Seashore* (ca. 1879, cat. 6) is a perfect example of a painting that another master could have simply slapped together, combining a few antique motifs according to accepted principles. But everything about this work is innovative, from the high horizon line to the strangely serpentine figure in the foreground. The critics lobbed the same accusations at Puvis's allegories of war, *The Balloon* (1870, cat. 31) and *The Pigeon* (1871, cat. 30). Despite their brown tones and simplified compositions of superimposed, flat planes, the paintings conveyed a great deal of power and emotion. The

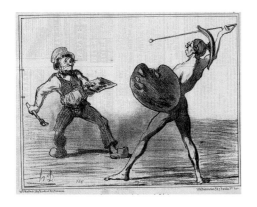

FIG. 12 **HONORÉ DAUMIER**
Battle of the Schools—Idealism and Realism (*Combat des écoles—L'Idéalisme et le Réalisme*), from *Le Charivari*, 1855
Lithograph on newsprint
8 ¼ × 10 ¹¹/₁₆ in. (20.9 × 27.1 cm)
Fine Arts Museums of San Francisco, museum purchase, Achenbach Foundation for Graphic Arts Endowment Fund, 1996.45

FIG. 13 **ALFRED SISLEY**
Avenue of Chestnut Trees at La Celle-Saint-Cloud
(*Allée de châtaigniers à la Celle-Saint-Cloud*), 1865
Oil on canvas
50 3/4 × 81 7/8 in. (129 × 208 cm)
Musée du Petit-Palais, Paris, Inv693

impact of these allegories was much stronger than that of the symbolic figure at the center of Jules Joseph Lefebvre's *Truth* (cat. 3), painted for the Salon of 1870. *Truth* was a pure product of the École des Beaux-Arts; Delaunay's *Diana* was merely a variation on Lefebvre's work, conceived in the studio according to a purely formulaic style.

As the years went by, despite the brilliant success enjoyed by those who were able to renew the *grand genre*, mythological, religious, and historical canvases had to compete increasingly with a new type of genre painting: evocations of everyday life. Executed in a small format better suited to the interiors of the new apartment buildings constructed in the wake of Baron Haussmann's transformation of Paris, these canvases were seen in ever-greater numbers on the walls of the Salon. *The Bath* (cat. 49), painted around 1867 by the Belgian artist Alfred Stevens, is a work that today might be too readily classified as academic, given its subject matter, its realistic details such as the man's watch in the soap dish, and the rapid technique that left brushstrokes visible (the still life on the lower right is a veritable symphony in white). At the time, however, it was more disappointing to the critics than Berthe Morisot's *The Cradle* (1872, cat. 48), which garnered praise when it was presented at the first Impressionist exhibition in 1874.[2]

The shift from tradition to innovation was particularly palpable in the realm of landscape painting. Landscapes had been included at the Salon since the early 1850s, and they enjoyed the same exponential prestige as paintings of everyday life. Idealized landscapes, the direct descendants of those by Nicolas Poussin, would soon make way for a Realist approach, heralded by the growing success of Théodore Rousseau and Jean-François Millet. The execution of landscapes, facilitated by technological innovations such as paint in tubes and portable easels, allowed painters to see nature differently and to escape the traditional formulas applied to composition and light. Thus, before 1870, among the idyllic landscapes produced in the studio (which were becoming increasingly rare), several views by Camille Pissarro and Alfred Sisley were hung at the Salon; Sisley's *Avenue of Chestnut Trees at La Celle-Saint-Cloud* (1865, fig. 13), for example, was presented in 1868.[3] Inspired by Frédéric Bazille and Claude Monet, whose *Women in the Garden* (fig. 14) was painted for the Salon of 1867, younger artists soon began to introduce

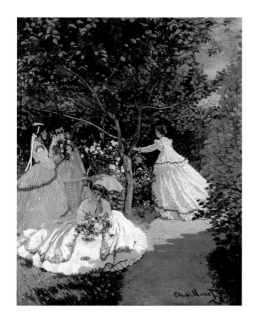

FIG. 14 **CLAUDE MONET**
Women in the Garden (*Femmes au jardin*), 1867
Oil on canvas
100 ³/₈ × 80 ³/₄ in. (255 × 205 cm)
Musée d'Orsay, RF 2773

human figures into their landscapes, creating a new type of genre painting in which fragmented brushstrokes and the painterly effects of abundant light enlivened vibrant scenes.[4]

The onset of war in 1870, the suspension of artistic events in 1871, and subsequent Salon reforms that sought to restrict the number of exhibited works all served to diminish the diversity of artistic expression at the Salon. However, the trend toward Naturalism, which stressed aesthetic advances, turned to the work of Édouard Manet as a model for the development of themes that subverted timeworn genres while cleverly melding these advances with the grand tradition.[5] In 1880 Émile Zola offered this description of the Salon, looking back at the previous twenty years:

> Every year there are fewer school paintings, academies of men and women served up to the public with a mythological label, with classical, historical, romantic subjects, paintings forced by tradition to take a black view of things; and gradually we are seeing full-length figures dressed in the current fashion, painted outdoors, worldly or popular scenes, the Bois de Boulogne, Les Halles, our boulevards, our private lives. It is a rising tide of modernity, irresistible, that is gradually prevailing over the École des Beaux-Arts, the Institut, and all their formulas and conventions.[6]

That year the Salon, which conferred the ultimate emblem of acceptance, exhibited works by Pierre Auguste Renoir and Monet. At the following Salon, in 1881, Manet finally received a second medal in recognition of his work and as acknowledgment of his role in renovating French painting.

Translated from the French by Alison Anderson

NOTES

1. For more on the Salon system and its exhibitions, see Eric Zafran's essay in this volume and Dominique Lobstein, *Les Salons au XIXe siècle: Paris, capitale des arts* (Paris: La Martinière, 2006).

2. According to J. Prouvaire in *Le Rappel* of April 20, 1874, who wrote, "Nothing is more true, more tender, than a young mother . . . bending over a cradle where a pink child is falling asleep, gently visible beneath a pale cloud of muslins."

3. For more on this painting, see Chantal Georgel, *La Forêt de Fontainebleau, un atelier grandeur nature* (Paris: Musée d'Orsay, 2007), 99–101.

4. See Andrea P. A. Belloli, ed., *A Day in the Country: Impressionism and the French Landscape* (Los Angeles: Los Angeles County Museum of Art, 1984).

5. See Serge Lemoine and Dominique Lobstein, *Jules Bastien-Lepage: 1848-1884* (Paris: Musée d'Orsay, 2007).

6. Émile Zola, *Le Voltaire*, June 21, 1880.

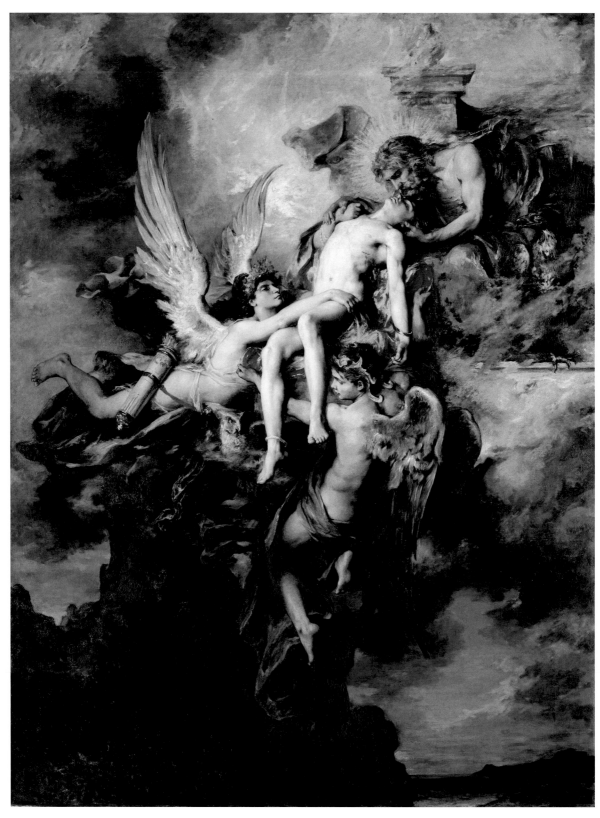

8

HENRI LÉOPOLD LÉVY
Sarpedon (*Sarpédon*), 1874
Oil on canvas
120 ¼ × 92 ⅞ in. (305 × 236 cm)

Here Lévy presents the type of conventional subject matter favored by the jurors at the Salon. Based on Baroque prototypes, the painting's complex composition and grand, theatrical presentation of a heroic scene from classical legend are emblematic of the academic style. As recounted in Homer's *Iliad*, the Greek warrior Patroklos killed Sarpedon, son of Zeus, on the battlefields of the Trojan War. Rescued by the god Apollo, Sarpedon's body was delivered to its burial place by Hypnos (Sleep) and Thanatos (Death).

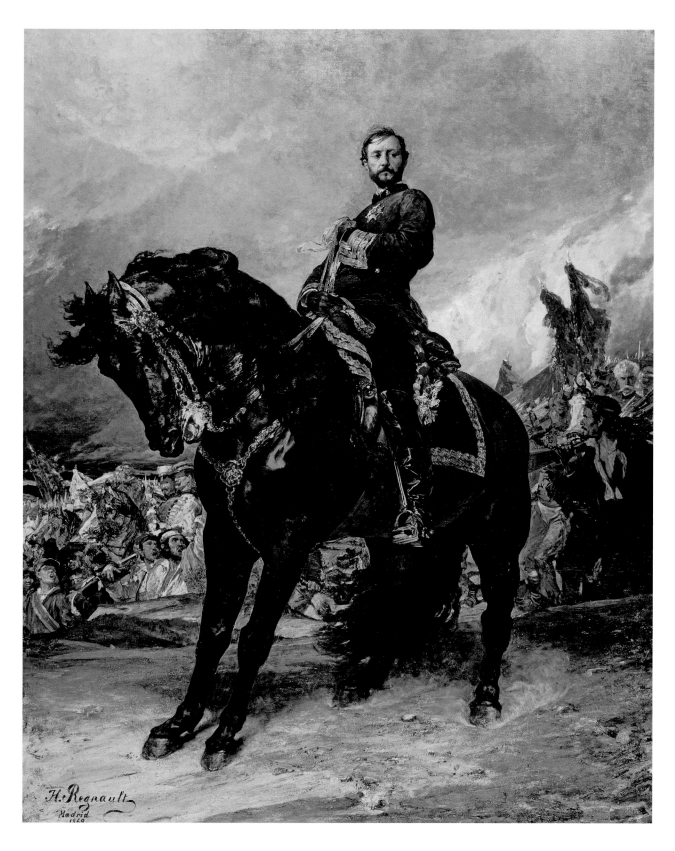

9

HENRI REGNAULT

Juan Prim, October 8, 1868 (*Juan Prim, 8 Octobre 1868*), 1869
Oil on canvas
124 × 101 5/8 in. (315 × 258 cm)

This dramatic portrait is one of the most important paintings completed during Regnault's tenure in Madrid during the liberal revolution of 1868. Although General Prim commissioned it, he was not satisfied with the picture and refused to accept it. Regardless, it was a great success at the Salon of 1869. Having received the Prix de Rome in 1866, Regnault was consequently exempt from military duty. However, he volunteered for service in the Franco-Prussian War and was killed at age twenty-seven.

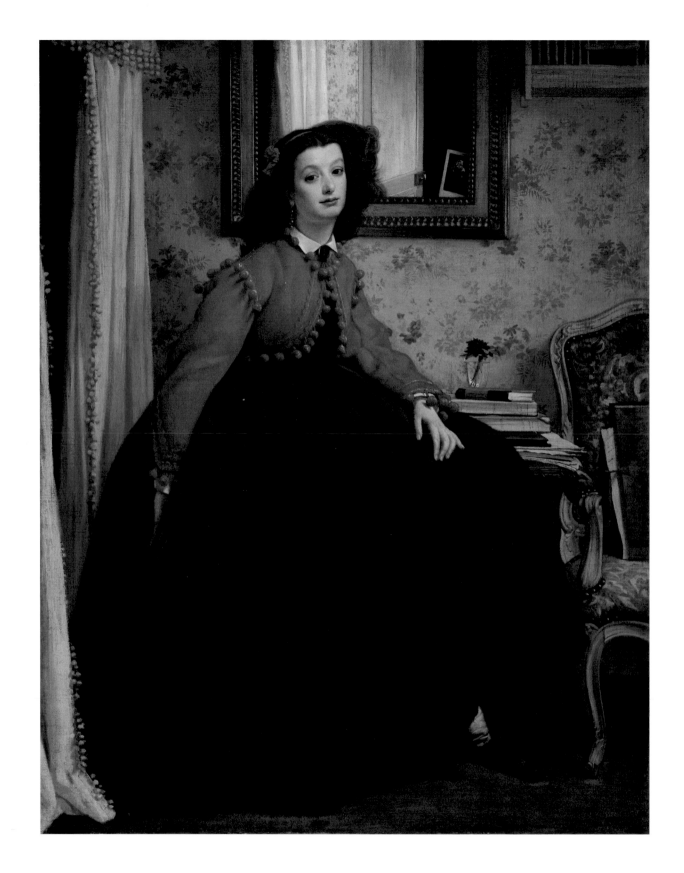

10

JAMES TISSOT
Portrait of Miss L.L. (*Portrait de Mademoiselle L.L.*), 1864
Oil on canvas
48 ⅞ × 39 ⅛ in. (124 × 99.5 cm)

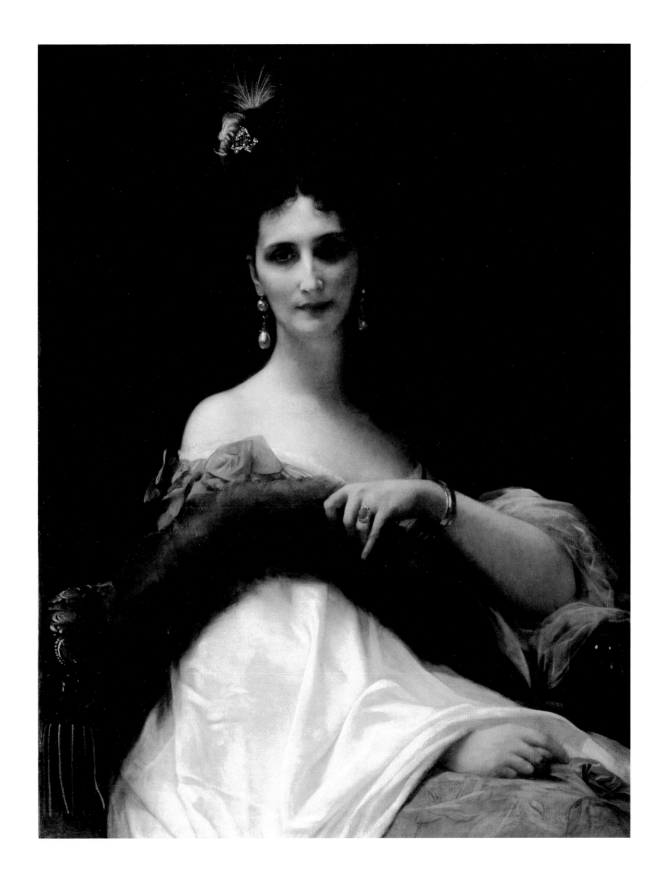

11

ALEXANDRE CABANEL

Countess Keller (*La comtesse de Keller*), 1873

Oil on canvas

39 × 29 ⅞ in. (99.2 × 76 cm)

DIVERSITY AND DISCONTENT

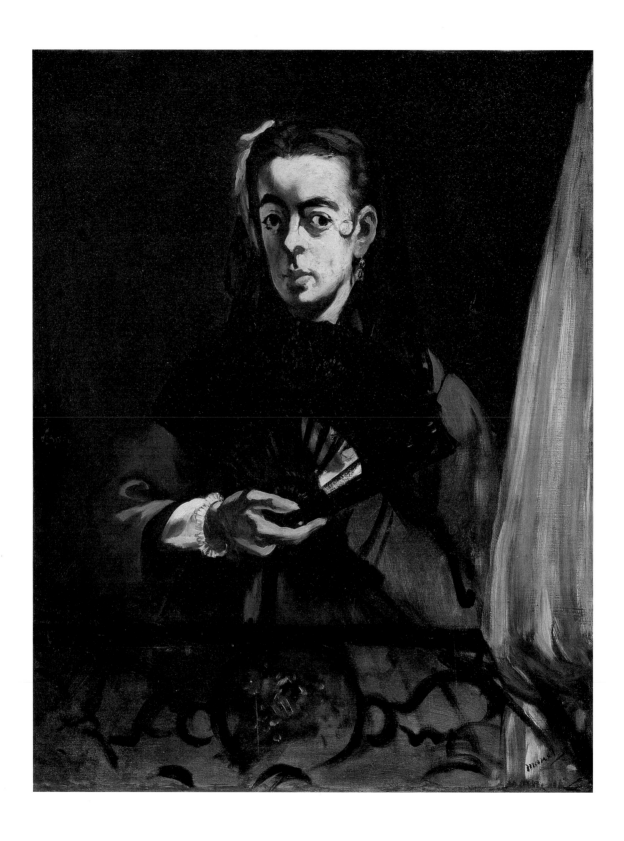

12
ÉDOUARD MANET
Angélina, 1865
Oil on canvas
36 ¼ × 28 ¾ in. (92 × 73 cm)

13
ÉMILE–AUGUSTE CAROLUS–DURAN
Lady with a Glove (*La dame au gant*), 1869
Oil on canvas
89 ¾ × 64 ½ in. (228 × 164 cm)

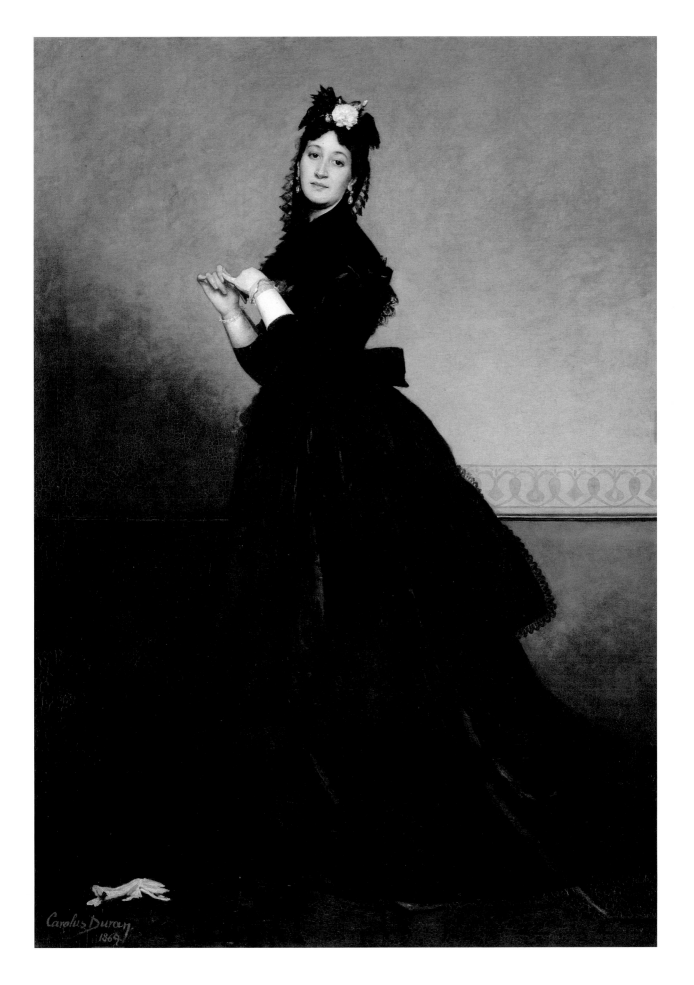

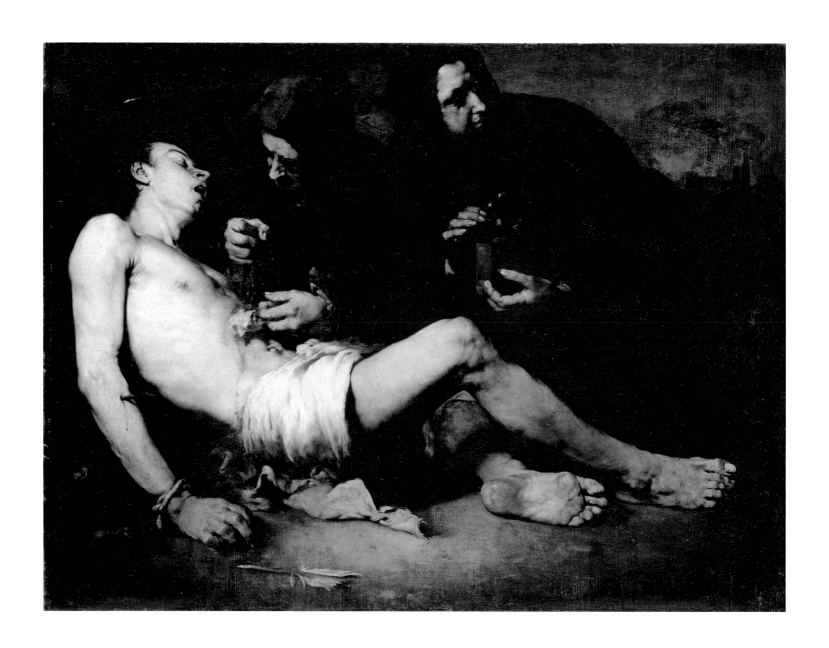

14

THÉODULE RIBOT

The Martyr Saint Sebastian (*Saint Sébastien, martyr*), before 1865
Oil on canvas
38 ¼ × 51 ⅛ in. (97 × 130 cm)

Purchased by the French state after the 1865 Salon, Ribot's depiction of Saint
Sebastian is one of his most successful paintings. His artistic source is readily
identifiable as Jusepe de Ribera. This seventeenth-century Spanish artist, active in
Naples, patterned his coarse figural idiom after Caravaggio, the Italian artist who
first popularized the dramatic tonal contrasts that became fashionable once again
with Manet and others. The brutal realism of the religious narrative differs strik-
ingly from the polished idealization of more academic paintings of the time.

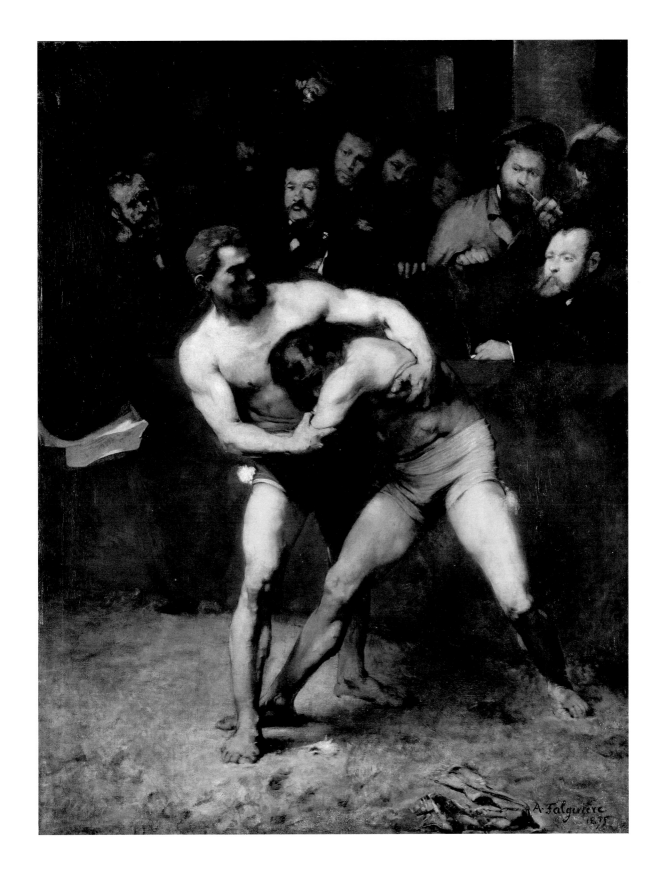

15

JEAN ALEXANDRE JOSEPH FALGUIÈRE

Wrestlers (*Lutteurs*), 1875

Oil on canvas

94 1/2 × 75 1/4 in. (240 × 191 cm)

16

JEAN–FRANÇOIS RAFFAËLLI

The Family of Jean-le-Boîteux, Peasants from Plougasnou
(*La famille de Jean-le-Boîteux, paysans de Plougasnou*),
1876
Oil on canvas
74 5/8 × 60 5/8 in. (189.7 × 154 cm)

This picture of a Breton peasant family marked a defini-
tive shift in Raffaëlli's style away from the academic
mode and toward Realism. His Realist images are not
picturesque; rather, they convey detailed truths about
his marginalized subjects. Raffaëlli called his approach
caractérisme, which he defined as simultaneous expo-
sure of a subject's essential nature and the artist's state
of mind. Although Raffaëlli's style was dissimilar from
that of the Impressionists, through Degas' insistence,
examples of his work were included in their group
shows of 1880 and 1881.

REALISM: THE LEGACIES OF MILLET AND COURBET

DOMINIQUE LOBSTEIN

❀

The year 1848 was pivotal in the political, economic, and social history of nineteenth-century Europe. It also signaled a transformation of the artistic landscape at the fringes of the still thoroughly entrenched Académie des Beaux-Arts: the recognition of Realism and the gradual disappearance of Romanticism. Following the revolution that removed Louis Philippe from the French throne, a number of factors helped the Realist current gain a wider audience. The first juryless Salon, in 1848, and numerous state commissions allowed some of the artists who had hitherto been excluded from the official exhibition, including Théodore Rousseau, to exhibit their works at last.[1]

Jean-François Millet had been honored at the Salon on several previous occasions, and, despite the attacks of certain critics, he became a regular exhibitor. Over time his paintings attracted the attention of collectors. *The Sheep Meadow, Moonlight* (ca. 1872, cat. 19) belonged to two great advocates of Realism, first Émile Gavet (who already owned an exceptional collection of pastels by the artist) and then Alfred Chauchard (a generous donor to the exemplary Barbizon holdings in the collection of the Musée d'Orsay). Public recognition would be a long time coming, however; it was only after Millet's death, at the estate sale of May 11, 1875, that the government acquired his *Church at Gréville* (cat. 18). This late work was begun in 1871 in Gréville and finished in 1874 in Barbizon. Millet had fled to Gréville, a hamlet in Normandy not far from his birthplace, during the Franco-Prussian War and the Commune. The painting evokes a sense of the passage of time, the existence of the ancient church in counterpoint to the contemporary peasant returning from the fields.

The antithesis to *The Church at Gréville* is a work from the end of Millet's life: *Normand Milkwoman on Her Way to Gréville* of 1874 (cat. 20). Bearing a similarity to the artist's sculptures of peasant women working the fields, this unfinished painting represents a compositional type that experienced a long popularity. A number of Millet's successors employed the same concept, including Jules Adolphe Aimé Louis Breton in his *Harvester* (cat. 21), presented at the Salon of 1877. Breton's life-size figure fills the entire height of a relatively narrow canvas. Depicting the figure from below, silhouetted against the low horizon, the artist imbues the peasant woman with heroic monumentality.

FIG. 15 **GUSTAVE COURBET**
After Dinner at Ornans (*L'après-dinée à Ornans*),
1848
Oil on canvas
76 ¾ × 101 ⅙ in. (195 × 257 cm)
Musée des Beaux-Arts, Lille, France, Inv. P. 522

Influenced by Japonisme and photography, this variation of the painter's vantage point in relation to his subject became a standard practice. Thus the modern manipulation of pictorial space was not solely an innovation of the New Painting. It can also be found in *Haymaking* (1877, cat. 22), presented at the Salon of 1878 by Jules Bastien-Lepage, who is generally regarded as the founding father of Naturalism in painting. Illustrating lines by the poet André Theuriet, this depiction of country life attracted the attention of a considerable number of critics, including Émile Zola.[2] *Haymaking* demonstrates the artist's ability to combine techniques learned at the École des Beaux-Arts with the approach favored by the Impressionists, incorporating innovative influences as diverse as photography and Japanese prints. Bastien-Lepage conveyed the fast-disappearing agrarian foundation of French society, a world that much of the contemporary urban populace had begun to look upon as a land of milk and honey.

Presented at the Salon of 1877, a year before *Haymaking*, Jean-François Raffaëlli's *Family of Jean-le-Boîteux, Peasants from Plougasnou* (1876, cat. 16) does not adhere to this idealized vision of rural life. Only the right-hand side of the painting has survived; Raffaëlli cut off the other half, which depicted a child and the man partially visible on the left, before the canvas was accepted for an exhibition at the Musée du Luxembourg in 1911. The forceful colors, brushstrokes, and composition—in which strongly lit, shadowless, and expressionless forms stand out violently against a plain wall—offer a dark vision of rural life, one that seems devoid of hope. Still a young artist under the influence of his master Jean-Léon Gérôme when he painted the canvas, Raffaëlli soon responded to the call of the Impressionists. Taking part in the Impressionist group exhibitions of 1880 and 1881, he adapted his work to the standards and trends of the New Painting. Any search for the lineage of Raffaëlli's austere vision is bound to include the work of Gustave Courbet, the other great Realist to benefit from the transformation of the post-1848 art world. Rejected from the official exhibition on several occasions, Courbet eventually received a state commission to produce *After Dinner at Ornans* (1848, fig. 15), which was praised by the critic Champfleury when presented at the Salon of 1849.[3] Courbet quickly

FIG. 16 **GUSTAVE COURBET**
A Burial at Ornans (*Un enterrement à Ornans*),
1849–1850
Oil on canvas
124 × 263 in. (315 × 668 cm)
Musée d'Orsay, RF 325

gained support from a number of journalists and art lovers and increased his production, starting with *A Burial at Ornans* (1849–1850, fig. 16) and *The Painter's Studio: A Real Allegory Determining a Period of Seven Years of My Artistic and Moral Life* (1854–1855, fig. 11), both of which he displayed in his so-called Pavilion of Realism during the 1855 Exposition Universelle in Paris. A brochure sold at the entrance to the pavilion defined the founding principles of the Realist movement, speaking strongly against what the Académie des Beaux-Arts called the *grand genre*:

> I consider the artists from one century to be radically incompetent at reproducing the events of a preceding or future century, in other words, at painting the past or the future. That is what I mean when I say I reject historical art applied to the past. Historical art is, by its essence, contemporary.

He also identified the appropriate sources of inspiration for a painter:

> Imagination in art consists in knowing how to find the most complete expression of an existing thing, but never in supposing or creating the thing itself. Beauty is to be found in nature, and can be met in reality, in the most diverse forms. The moment one finds it, it belongs to art, or rather to the artist who knows how to see it. From the moment that beauty is also real and visible, it contains in itself its artistic expression.[4]

Courbet went on to enjoy great success, even if it was partly due to the scandal that his monumental genre paintings created. In addition to his major canvases, he undertook a series of easel works that were snapped up by collectors.[5] He also produced a great number of landscapes (views of the Normandy coast and the forests and springs of Jura, his native region), still lifes, and depictions of female nudes. *Nude with Dog* (cat. 23)—painted between 1861 and 1862, despite the date of 1868 that Courbet gave the canvas when it was first publicly exhibited,

in Ghent—was likely intended as an homage to the saucy canvases of Jean-Honoré Fragonard, which were recently reintroduced by the influential critics Edmond and Jules de Goncourt.[6] However, unlike Fragonard, Courbet did not confine his subject to the private confines of the bedroom; he set the scene within an expansive landscape on the shore of a lake. Courbet was reviving a type of composition popular during the Renaissance, as seen in Titian's *Venus and the Lute Player* (ca. 1565–1570, Metropolitan Museum of Art, New York). Unlike his predecessor, however, Courbet aimed not to convey ideal beauty but rather to portray someone specific— most probably Léontine Renaude, his mistress from the early 1860s.

Not long after painting this nude, Courbet discovered the Saintonge region of western France. A friend, the writer and critic Jules-Antoine Castagnary, introduced him to Étienne Baudry, a rich republican who invited Courbet to his château in Rochemont. There the painter began to produce still lifes bursting with flowers, a common academic subject to which Courbet gave new vitality. Subsequently, particularly during and after his imprisonment following the Commune, Courbet devoted himself to depictions of flowers and fruit, pungent variations on the vanitas theme of the transience of life.

The Trout (1873, cat. 25) represents another category of still life that Courbet handled in a typically Realist manner. Provisionally liberated in 1873, Courbet returned to the Franche-Comté near Ornans, where he painted the unusually large trout that the sons of his friend Marcel Ordinaire caught in the Loue River. These outsize, lifeless creatures, their gills spotted with blood, have nothing to do with their seventeenth-century Dutch antecedents, with the eighteenth-century work of Jean-Siméon Chardin, or with the more traditional variation on the theme exhibited by Antoine Vollon at the Salon of 1870 (cat. 26). Courbet's fish carries a potent symbolic charge. Onto this work the artist projected the memory of his months in prison, as confirmed by another version of the painting (Kunsthaus Zürich) upon which Courbet inscribed, in red letters, *In vinculis faciebat* ("made in bondage"). Confronted with the increasing ascendancy of Realism, first writers and then artists gradually refocused their ideas on the spiritual life of man, preparing the way for a new chapter in art history: Symbolism, a movement in which the supporters of academic art would face off once more against those who had a more modern vision of creativity.

Translated from the French by Alison Anderson

NOTES

1 Chantal Georgel, *1848: La République et l'art vivant* (Paris: Musée d'Orsay, 1998).

2 Émile Zola, "Lettres de Paris: Nouvelles artistiques et littéraires (Le Salon de 1879)," *Le Messager de l'Europe*, July 1879.

3 Champfleury, "Le Salon de 1849," *La Silhouette*, July 22, 1849.

4 Excerpts from the catalogue *Exhibition et vente de 38 tableaux et 4 dessins de l'oeuvre de M. Gustave Courbet*, with a foreword, "Le Réalisme," by Gustave Courbet (Paris: Imprimerie de Morris, 1855).

5 Sarah Faunce and Linda Nochlin, *Courbet Reconsidered* (Brooklyn: Brooklyn Museum of Art, 1988); and Jörg Zutter, *Courbet, artiste et promoteur de son oeuvre* (Paris: Flammarion, 1998).

6 Edmond and Jules de Goncourt, *L'art au XVIIIe siècle* (Paris: E. Dentu, 1875).

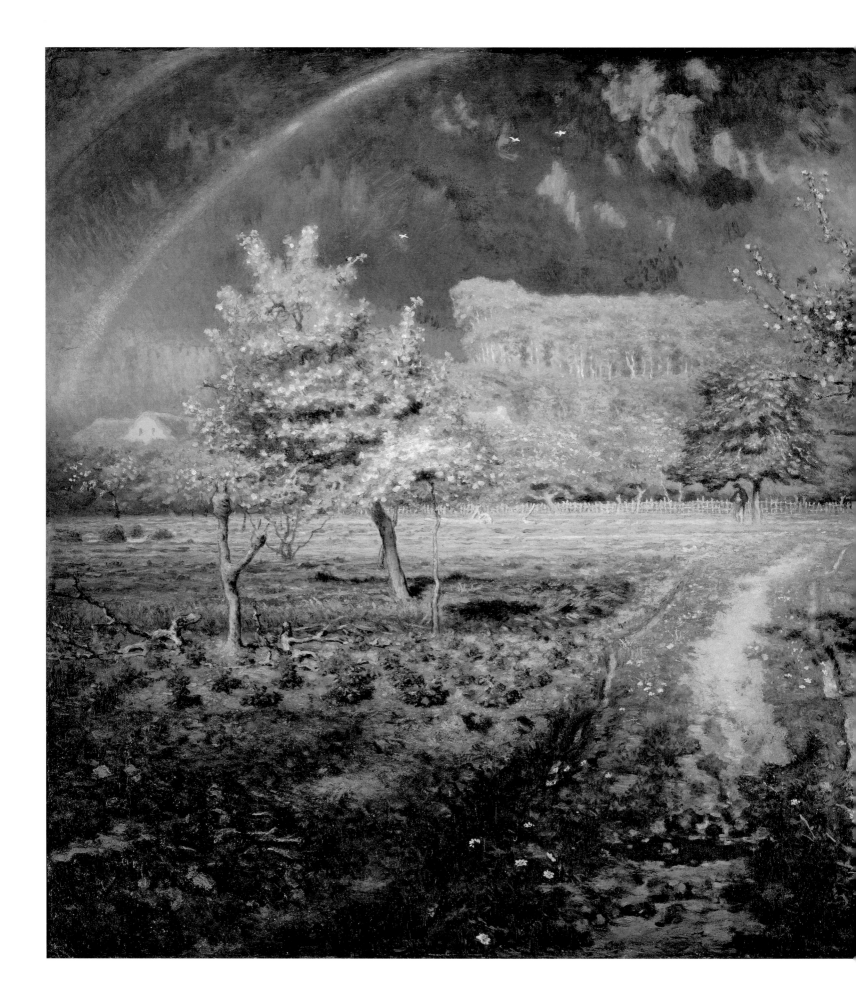

17

JEAN−FRANÇOIS MILLET
Spring (*Le printemps*), 1868–1873
Oil on canvas
33 7/8 × 43 3/4 in. (86 × 111 cm)

Commissioned in 1868, near the end of Millet's career, *Spring* is part of an unfinished series depicting the four seasons. Having finally achieved critical success in the 1860s, Millet was paid twenty-five thousand francs by Frédéric Hartmann to undertake this project. He addresses the landscape with lively brushwork, particularly in the dramatic rendition of light and shadow. Poetic meditations on the relationship between man and nature were typical of the Barbizon School, of which Millet was a leader.

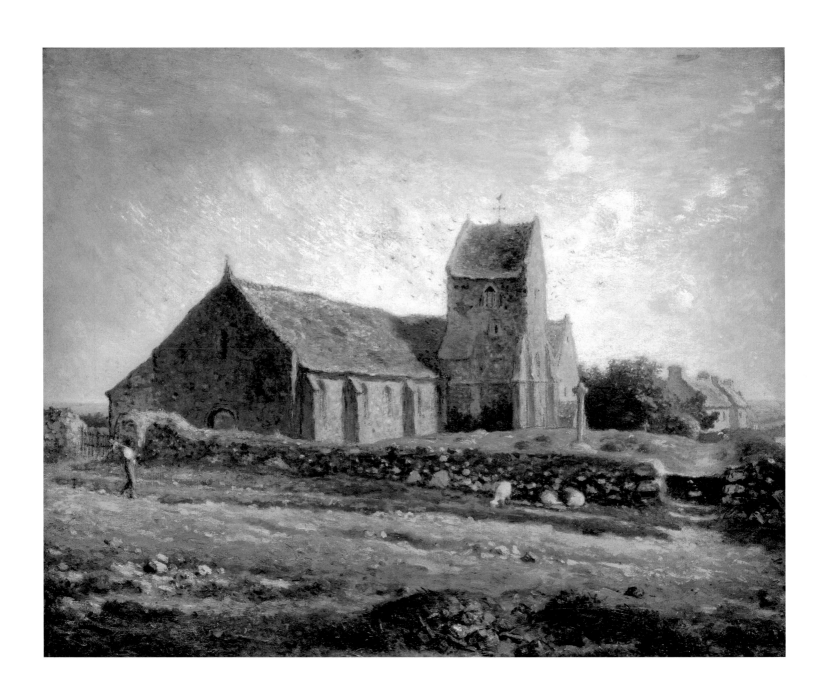

18

JEAN-FRANÇOIS MILLET

The Church at Gréville (*L'église de Gréville*), 1871–1874
Oil on canvas
23 5/8 × 28 7/8 in. (60 × 73.4 cm)

Hoping to escape the Franco-Prussian War and the Paris Commune, the aging Millet returned to his birthplace in Normandy. There he was inspired to record the emblematic places of his childhood. This painting's power resides in the evocation of a timeless landscape unadulterated by modernity, a place of reassuring permanence and security. Millet's vivid palette and atmospheric landscapes resonated with a younger generation of painters and may have inspired the earliest Impressionist experiments. Van Gogh and Cézanne are both known to have admired this picture.

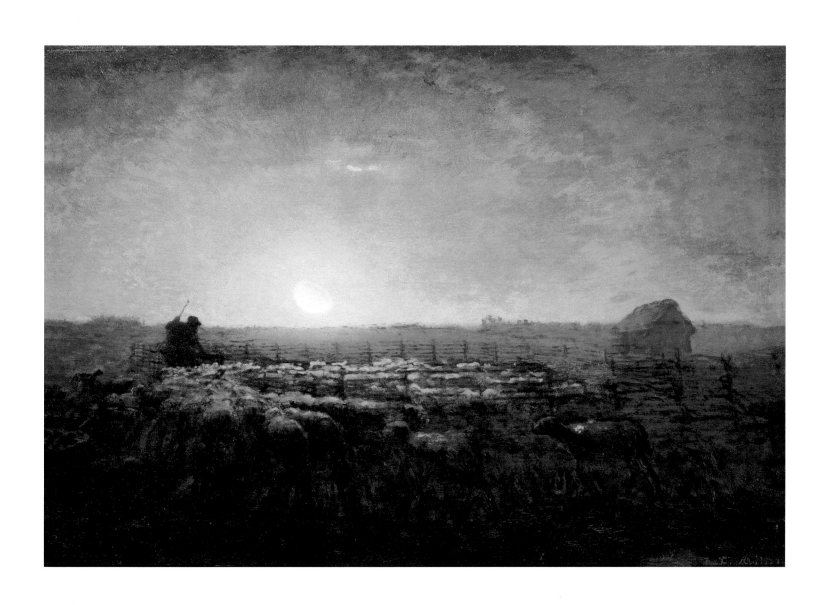

19

JEAN–FRANÇOIS MILLET

The Sheep Meadow, Moonlight (*Le parc à moutons, clair de lune*), ca. 1872

Oil on panel

15 1/2 × 22 1/2 in. (39.5 × 57 cm)

DIVERSITY AND DISCONTENT

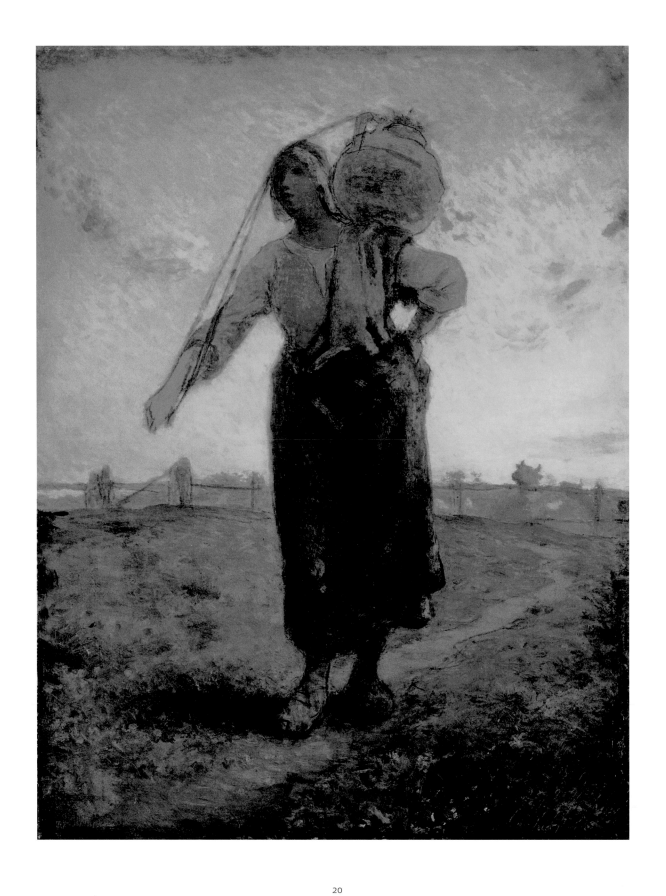

20

JEAN–FRANÇOIS MILLET
Normand Milkwoman on Her Way to Gréville (*Laitière normande à Gréville*), 1874
Oil on canvas
28 ³/₄ × 22 ¹/₂ in. (73 × 57 cm)

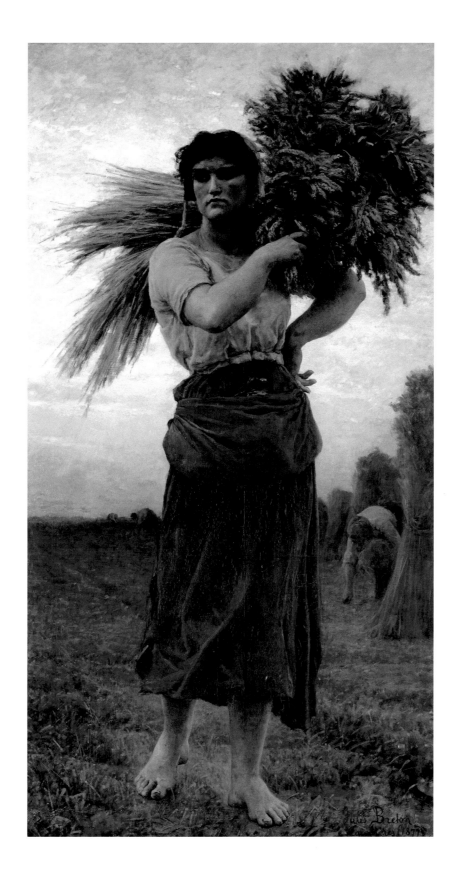

21

JULES ADOLPHE AIMÉ LOUIS BRETON
The Harvester (*La glaneuse*), 1877
Oil on canvas
90 ¾ × 49 ¼ in. (230 × 125 cm)

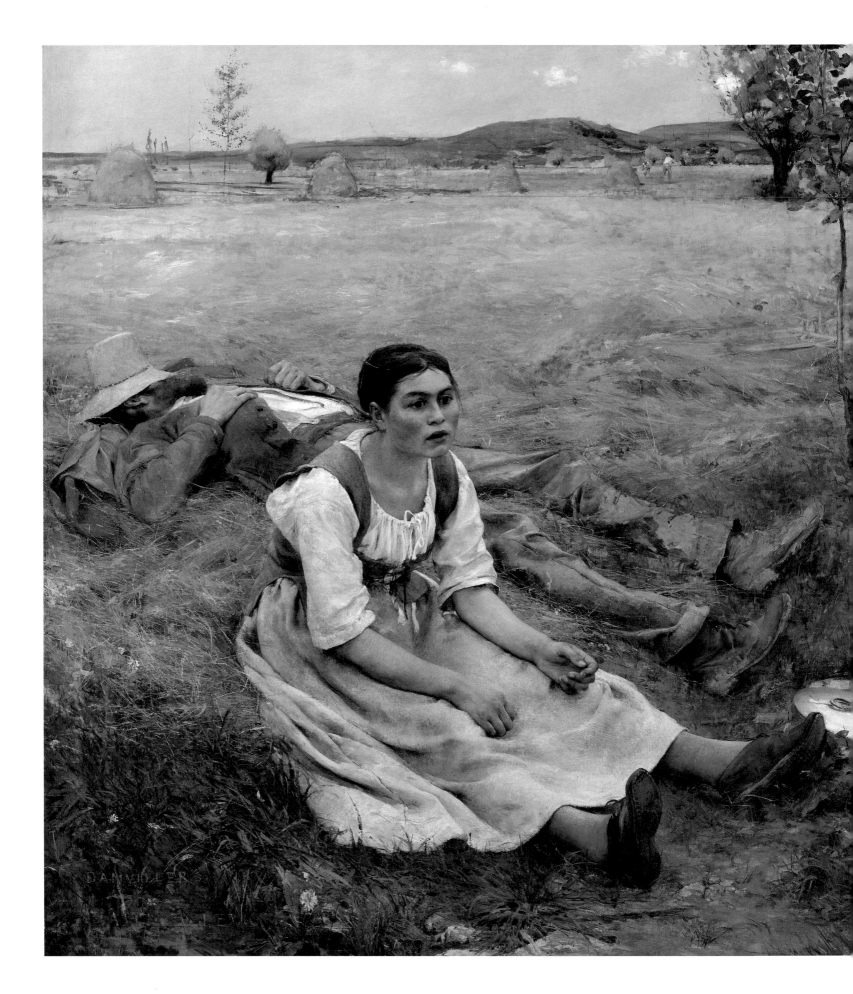

22

JULES BASTIEN–LEPAGE
Haymaking (*Les foins*), 1877
Oil on canvas
63 × 76 ¾ in. (160 × 195 cm)

The sympathy evident in Bastien-Lepage's depiction of agricultural workers reflects his childhood spent on a farm. While the young woman's features appalled some critics, this painting was popular at the 1878 Salon. The exaggerated perspective, high horizon line, and monumental size of the figures not only impart dignity to the laborers but also reveal signs of modernity within the Naturalist approach.

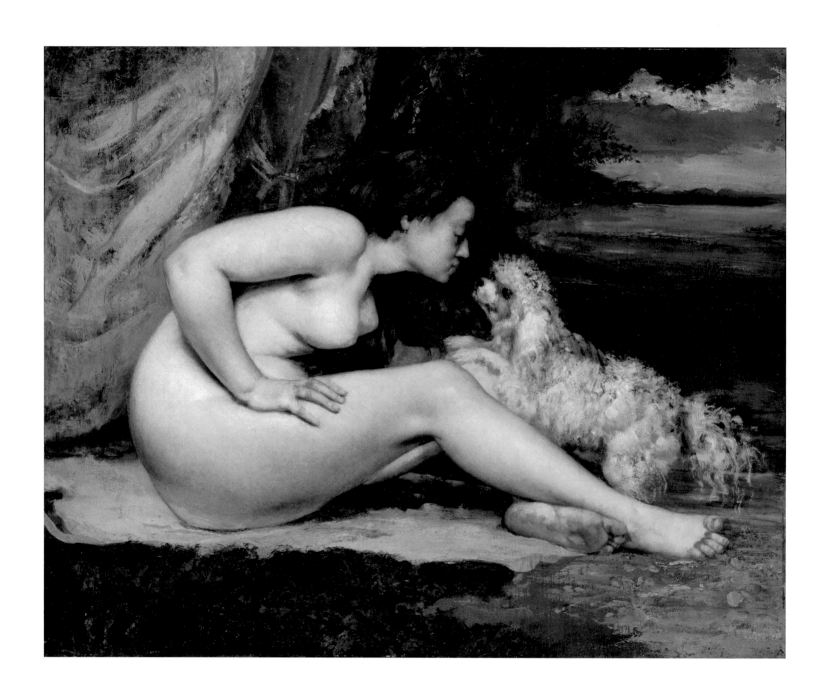

23

GUSTAVE COURBET

Nude with Dog (*Femme nue au chien*), 1861–1862
Oil on canvas
25 5/8 × 31 7/8 in. (65 × 81 cm)

While not as coarse as Manet's *Olympia* (fig. 21), this painting nonetheless presents a very modern interpretation of the classic nude. Courbet's mistress, Léontine Renaude, is depicted as a contemporary woman, not as a timeless beauty or a personification of feminine virtue. Both this picture and *The Shaded Stream* display the dark, muted palette of the Realists and present truthful yet personalized versions of their respective subjects. Courbet described the latter to his patron, Alfred Bruyas, as a "superb landscape of deep solitude produced within the valleys of my native land."

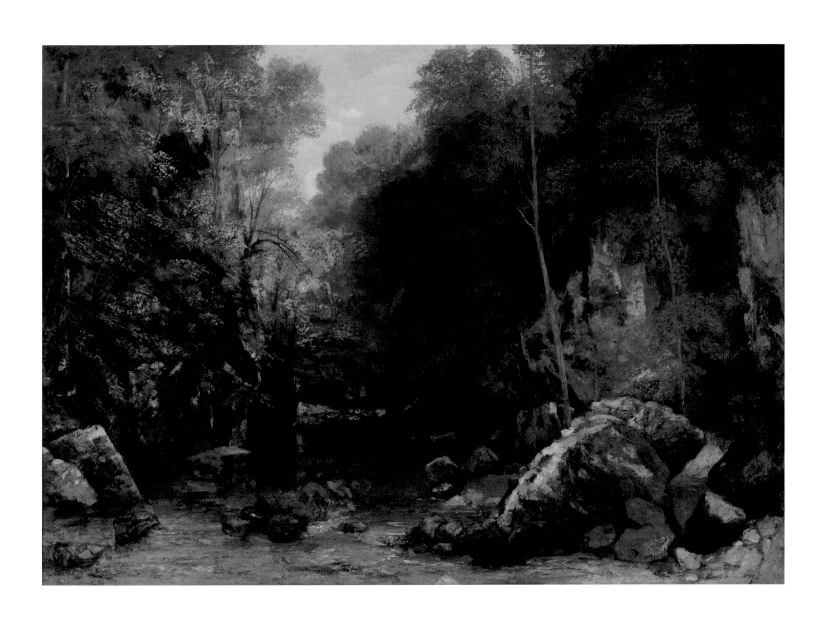

24

GUSTAVE COURBET

The Shaded Stream (*Le ruisseau noir*), 1865

Oil on canvas

37 × 52 ⅛ in. (94 × 135 cm)

DIVERSITY AND DISCONTENT

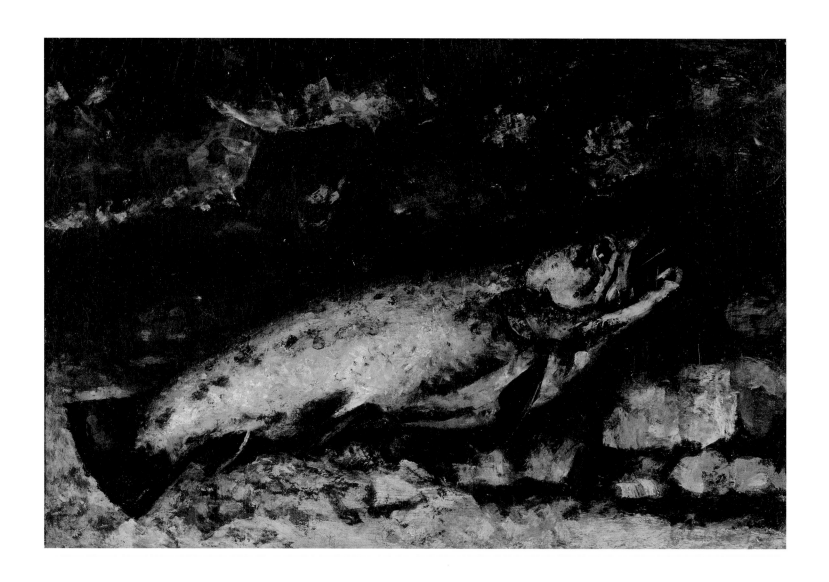

25

GUSTAVE COURBET

The Trout (*La truite*), 1873

Oil on canvas

25 ³/₄ × 38 ³/₄ in. (65.5 × 98.5 cm)

This work's limited color palette and rough handling of paint, applied in a sponta-
neous and abstract manner, powerfully suggest the forms and textures of fish and
rocks. Snared by a fisherman's hook and hovering between life and death, Courbet's
monumental trout evokes an epic struggle. The painting has been interpreted vari-
ously, most notably as an allegorical self-portrait of the imprisoned, suffering, and
ultimately exiled artist in limbo.

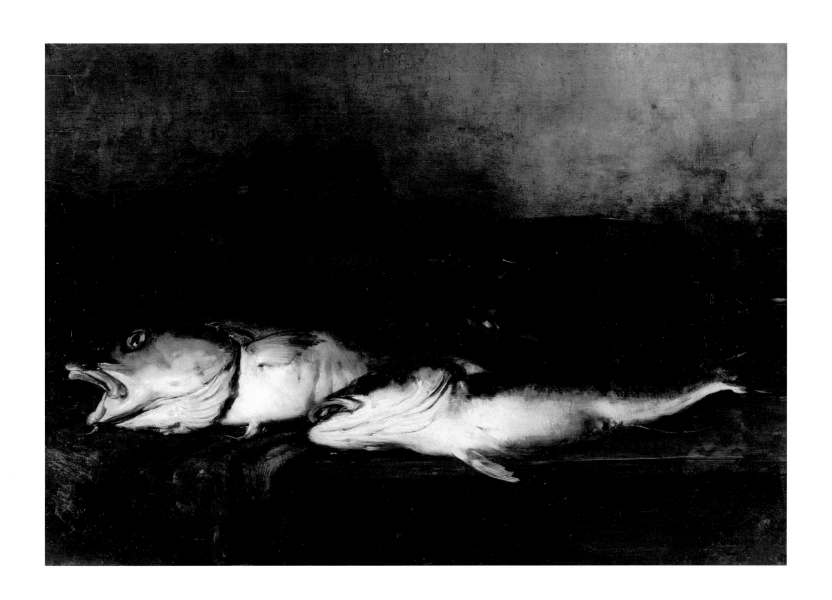

26
ANTOINE VOLLON
Saltwater Fish (*Poissons de mer*), ca. 1870
Oil on panel
32 ⁵/₈ × 47 in. (83 × 119.5 cm)

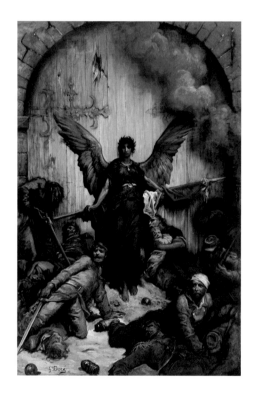

FIG. 17 **GUSTAVE DORÉ**
The Defense of Paris (*La défense de Paris*), 1871
Oil on canvas
76½ × 51 in. (194.3 × 129.5 cm)
Frances Lehman Loeb Art Center, Vassar College,
Poughkeepsie, New York, purchase, Suzette Morton
Davidson, Class of 1934, Fund, 1972.2

L'année terrible was the title Victor Hugo gave to a book of poetry in which he describes, month by month, the dramatic period that encompassed two successive conflicts, one of them a civil war. The French army suffered terrible losses during the Franco-Prussian War, having been ill prepared for the invasion and siege of the capital. This military defeat led in September 1870 to the fall of the Second Empire, which was replaced by a conservative provisional government. The subsequent revolt of the Garde Nationale and Parisian workers led to the establishment in March of the insurrectional government of the Paris Commune. The extremely violent repression of the Parisian rebellion during the "bloody week" of May 1871, and the devastating fires the Communards lit in self-defense, left the French populace utterly traumatized. The failure of the Commune, which proved that a democratic government could ensure that order was maintained, ultimately led to the establishment of the Republic in 1875, as the country was in thrall to a rise of nationalist sentiment.

The war affected artists directly. Félix Bracquemond, Émile-Auguste Carolus-Duran, Édouard Manet, Jean Louis Ernest Meissonier, Pierre Puvis de Chavannes, and James Tissot all joined the Garde Nationale. Some, like Frédéric Bazille and Henri Regnault, went off to fight and never came back. Others, like Claude Monet and Camille Pissarro, fled the capital for England or Belgium. The Commune, to which Gustave Courbet pledged his support, forced a political divide in the artistic community. In 1872 the *Gazette des Beaux-Arts* devoted nearly all of its articles to the war, while at the Salon more than thirty artists showed works that were directly related to recent events.

"M. Puvis de Chavannes brought back a superb drawing from the barricades."[1] This was how Théophile Gautier, in his *Tableaux de siège*, introduced *The Balloon* and *The Pigeon* (cats. 30–31), two famous canvases related to the siege of the capital. Puvis had already experimented with the theme of modern allegory, particularly in his murals for the Musée des Beaux-Arts in Marseille depicting the opening of the Suez Canal. Painted in the fall of 1870, *The Balloon* represents Paris, symbolized by a woman seen from behind (the model was almost certainly the Romanian princess Marie Cantacuzène, who later became the artist's wife). With her hand she points to a hot-air balloon drifting over Mont Valérien. The Parisians used balloons to send news

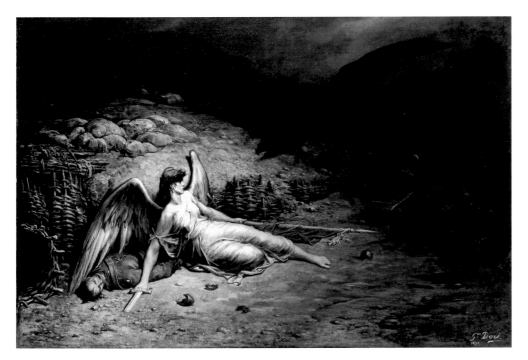

FIG. 18 **GUSTAVE DORÉ**
The Black Eagle of Prussia (*L'aigle noir de Prusse*),
1871
Oil on canvas
51 × 76 ¾ in. (129.5 × 194.9 cm)
Dahesh Museum of Art, New York, 2002.60

outside the besieged city; the balloon in Puvis's painting possibly refers to the one in which the politician Léon Gambetta escaped to Bordeaux in October 1870 in order to organize the country's defense. Leaning on a rifle with a bayonet, while cannons line the city's fortifications at her feet, the figure embodies the city's resistance and endurance, a sentiment enhanced by the artist's nearly monochrome palette of blacks and browns. *The Balloon* was reproduced as a lithograph in an edition of fifty thousand and was a great popular success. This response spurred Puvis at the beginning of the following year to create a matching picture, *The Pigeon*. Here the painter represented the city of Paris as a young woman, viewed from the front, receiving news from outside by means of a carrier pigeon. The presence of an eagle suggests the threatening advance of the enemy army, and the snow covering the ground recalls the harsh winter in the besieged city.

Gautier also noted the impact of the siege on the painter and illustrator Gustave Doré. Doré was already well-known, particularly for his magical representations: "He resides at the hostelry of fairies, in the midst of the land of dreams," wrote Émile Zola in 1865.[2] The artist had close ties to the imperial regime; he joined the army and lived through the capture of the city in helpless distress. When Gautier went to the artist's studio—Doré had fled to England—he observed: "We indeed suspected that in the intervals, from one guard to the next, he might well be creating enough to fill an entire exhibition on his own. . . . We then saw that we were not mistaken."[3] Three major paintings testify to the impact of events on Doré: *The Enigma* (cat. 29), *The Defense of Paris* (fig. 17), and *The Black Eagle of Prussia* (fig. 18). They were painted in 1871 and grouped under the title *Memories of 1870* at the time of the sale of Doré's studio in 1885.[4] Devastated by the loss of Alsace-Lorraine, the artist, who was originally from Strasbourg, juxtaposed realistic elements with allegory. *The Enigma* depicts Paris, still burning from the fires lit by the Communards. In the foreground are bodies, weapons, and a crowned, winged woman personifying France. She is consulting the Sphinx that keeps watch over Paris. Was this an allusion to the breach that had opened up between the country and the insurgent capital

during the Commune? As in the myth, France had to find the answer to an enigma that would enable her to regain possession of the burning, rebellious city.

Georges Jules Victor Clairin also had a dramatic experience of the events. A young painter, he had gone to Italy to complete his training and was touring Spain and Morocco when the war broke out. He enlisted along with his traveling companion, the painter Henri Regnault, who was killed at Buzenval. Disconsolate, Clairin stayed on in Paris throughout the unrest; at the end of the Commune he painted a moving canvas, *Fire at the Tuileries* (cat. 27), which he dedicated to Regnault's fiancée and gave to her. This painting, with its Romantic nod to Eugène Delacroix's *Liberty Leading the People* (1830, Musée du Louvre, Paris), is also profoundly Realistic. It depicts one of the barricades set up during the Commune and, in the background, the still-smoking ruins of the Tuileries. The fire, which occurred May 23–24, 1871, was one of the most dramatic incidents of the "bloody week." Of all the public buildings torched by the Communards, the château and its gardens—the stately hub of the Second Empire—symbolized the regime better than almost any other place in Paris.

Meissonier, a military artist who was very famous at the time as a painter of historical Realism, also depicted the Tuileries (fig. 19). He opted for a restrained dramatization, conveying the immense sadness that emanated from the ruins, where the irony of fate left intact text celebrating the First Empire's two most important victories, Marengo and Austerlitz. Moving away from Realism, his *Siege of Paris (1870-1871)* (ca. 1884, cat. 28), a painting that was finished many years after the event, combined historical details with numerous allegorical elements, an approach quite exceptional in the painter's work. The central figure is once again the city of Paris, a monumental female figure in mourning (a close friend of the artist's, Lisa Bezanson, posed for the picture; she became his second wife). At her feet are fictitious characters symbolizing the misfortunes of the inhabitants of Paris—a father looking for his dead son, two brothers carrying a wounded man—as well as real figures from history, all heroes who died defending the capital. The most touching of all is without doubt the figure of Regnault, whose tragic death had devastated the art world. Meissonier is said to have borrowed Regnault's clothing from his friend Clairin, and he depicts him here on the threshold of death, still clinging to his rifle and leaning against the figure of Paris. Resorting to a device that was unusual for him, Meissonier felt the need to use symbolism to represent contemporary history, no doubt because these events, still so recent and vivid, touched him personally. Aligned politically with the empire, he initially enlisted in the French army, only to withdraw upon the defeat of Napoléon III. During the siege of Paris he joined the Garde Nationale. He was present at the battle of Buzenval and told the story of how he was ordered to search for Regnault's body; he had been conversing with him only the night before. Meissonier considered this painting to be a vital statement and qualified it as "revenge" against the Prussians.[5] The painter was deeply upset by the Commune and greatly disapproved of the insurrection. His reputation later ensured official positions, from which he vented his anger against Courbet by refusing to accept his canvases at the Salon of 1872, charging that they were unpatriotic.

The dramatic events of the "terrible year" occurred at a pivotal moment in the development of the Impressionist movement, just as its key members were turning thirty and reaching the threshold of professional maturity. Their de facto leader, Manet, illustrated the events in works such as *The Barricade* (1871, Szépművészeti Múzeum, Budapest); none of his

young protégés chose to do so, though without a doubt the memory did mark a number of their paintings. When in 1875 Monet omitted the impressive ruins of the château from *The Tuileries* (cat. 51), in stark contrast to Meissonier's handling of the same subject, it was certainly a way to avoid passing judgment on the Communards; indeed, it could even be seen as a gesture of forgiveness toward them—a sign of support for the amnesty that Georges Clemenceau, portrayed in 1879–1880 by Manet (cat. 36), was struggling to obtain for them.[6] Recent historians have questioned the chronological simultaneity in France that caused the artistic revolution initiated by the Impressionist painters and the events that led to the establishment of the Third Republic to coincide, in order to show that the artists' crusade against academic institutions and traditions was part of a broader context of political and social transformation.[7]

Translated from the French by Alison Anderson

NOTES

1 Théophile Gautier, *Tableaux de siège, Paris 1870–1871* (Paris: Charpentier, 1871), 114. Translated by Frederick C. de Sumichrast as *Paris Besieged* (New York: Dumont, 1902).

2 Émile Zola, *Écrits sur l'art*, ed. Jean-Pierre Leduc-Adine (Paris: Gallimard, 1991), 56.

3 Gautier, *Tableaux*, 212.

4 Eric Zafran, ed., *Fantasy and Faith: The Art of Gustave Doré* (New York: Dahesh Museum of Art; New Haven, Conn.: Yale University Press, 2007).

5 Octave Gréard, *Jean Louis Ernest Meissonier: Ses souvenirs, ses entretiens précédés d'une étude sur sa vie et ses oeuvres* (Paris: Hachette, 1897), 242, quoted in Constance Cain Hungerford, "'Les choses importantes': Meissonier et la peinture d'histoire," in *Ernest Meissonier: Rétrospective* (Lyon: Musée des Beaux-Arts de Lyon; Paris: Réunion des Musées Nationaux, 1993), 172. On Meissonier, see also Constance Cain Hungerford, *Ernest Meissonier: Master in His Genre* (New York: Cambridge University Press, 1999).

6 See the analysis relative to Monet's 1876 painting *The Tuileries* (Musée Marmottan, Paris) in Albert Boime, *Art and the French Commune: Imagining Paris after War and Revolution* (Princeton, N.J.: Princeton University Press, 1995), 68ff.

7 In addition to Albert Boime's work cited in note 6, see Philip G. Nord, *Impressionists and Politics: Art and Democracy in the Nineteenth Century* (London: Routledge, 2000).

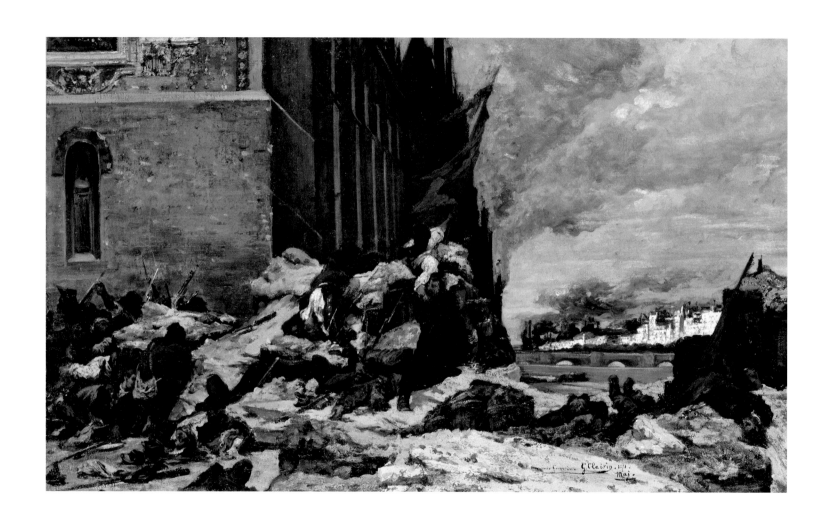

27

GEORGES JULES VICTOR CLAIRIN

Fire at the Tuileries (*L'incendie des Tuileries*), 1871

Oil on canvas

18 ⁷/₈ × 31 ¹/₈ in. (48 × 79 cm)

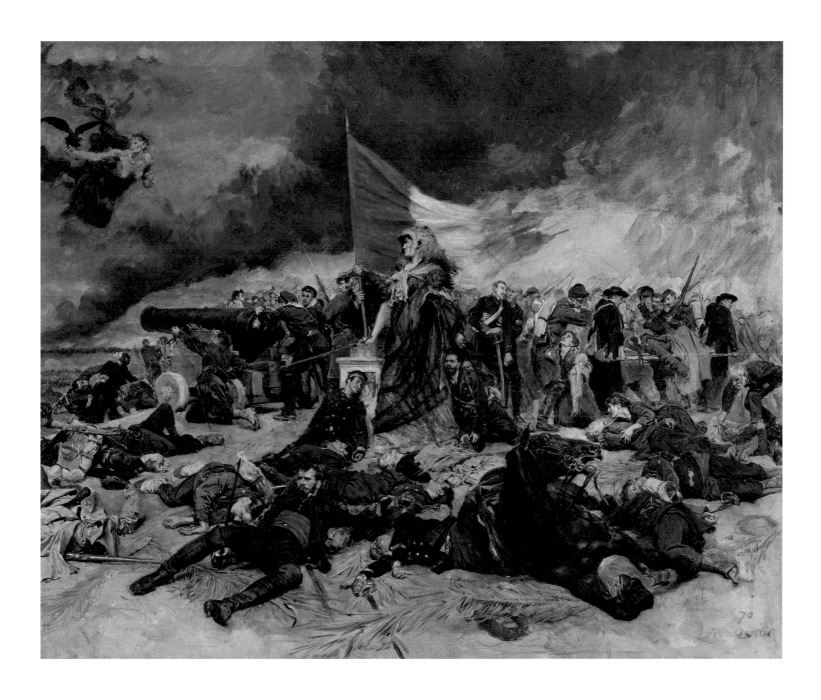

28

JEAN LOUIS ERNEST MEISSONIER

The Siege of Paris (1870–1871) (*Le siège de Paris [1870–1871]*), ca. 1884

Oil on canvas

21 × 27¾ in. (53.5 × 70.5 cm)

With precise, almost photographic accuracy, Meissonier combines the brutal realities of a contemporary, urban battle with traditional allegories of war in this small study, painted during the Franco-Prussian War. This dramatic evocation of France's defeat features a Prussian eagle and a personification of famine hovering overhead like vultures. Scattered among the fallen are laurel branches, the classical symbol of heroism. A woman wearing a lion's-head helmet symbolizes the city of Paris. Nearby lies Meissonier's fellow artist Henri Regnault, who died of his wounds.

29
GUSTAVE DORÉ
The Enigma (*L'énigme*), 1871
Oil on canvas
51 1/8 × 77 in. (130 × 195.5 cm)

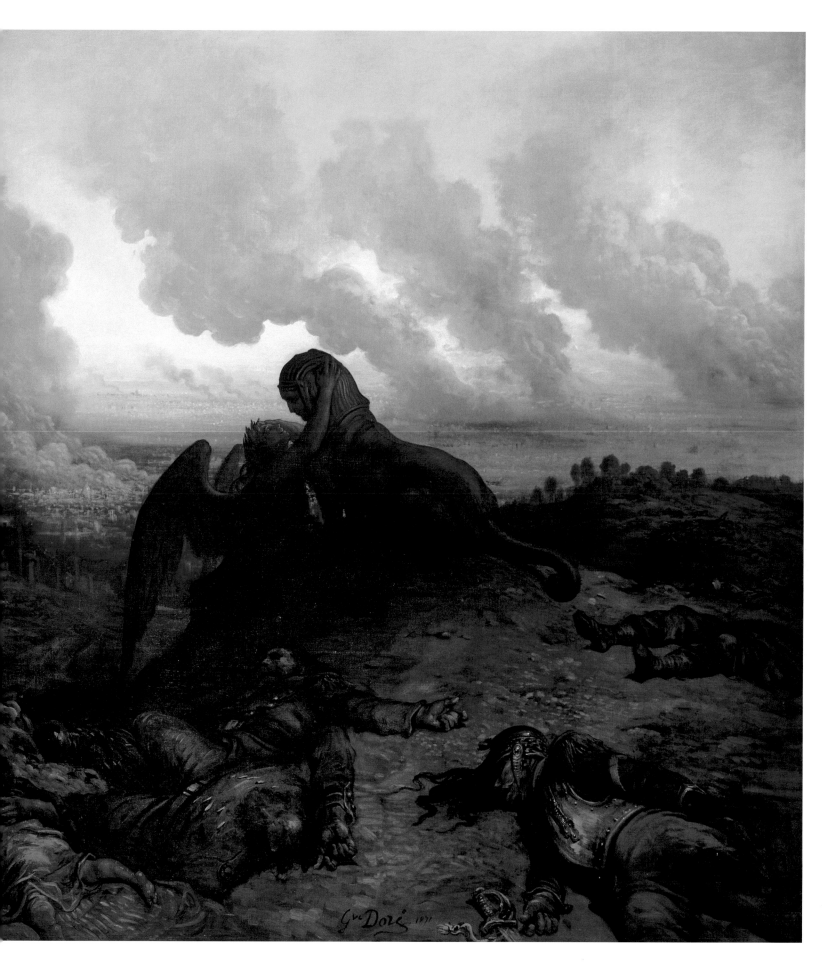

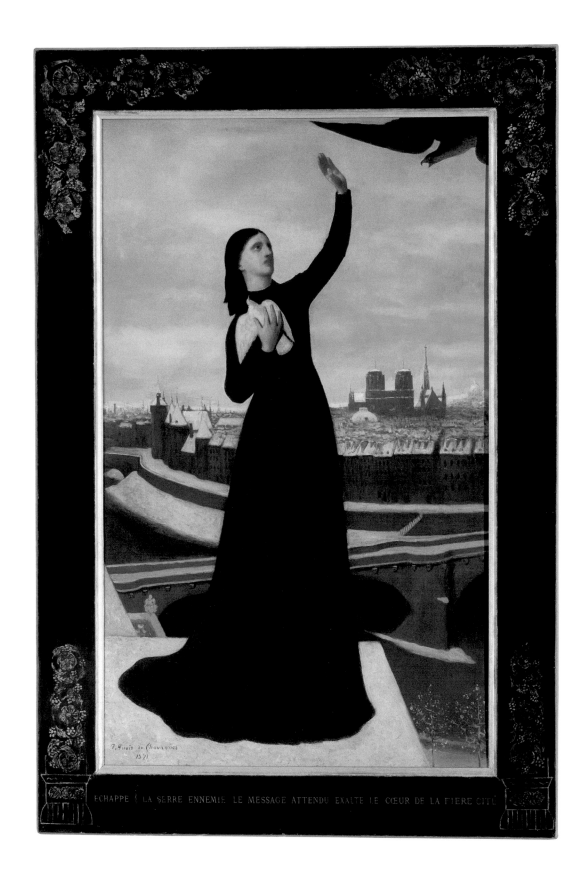

30

PIERRE PUVIS DE CHAVANNES

The Pigeon (*Le pigeon*), 1871

Oil on canvas

53 7/8 × 34 in. (136.7 × 86.5 cm)

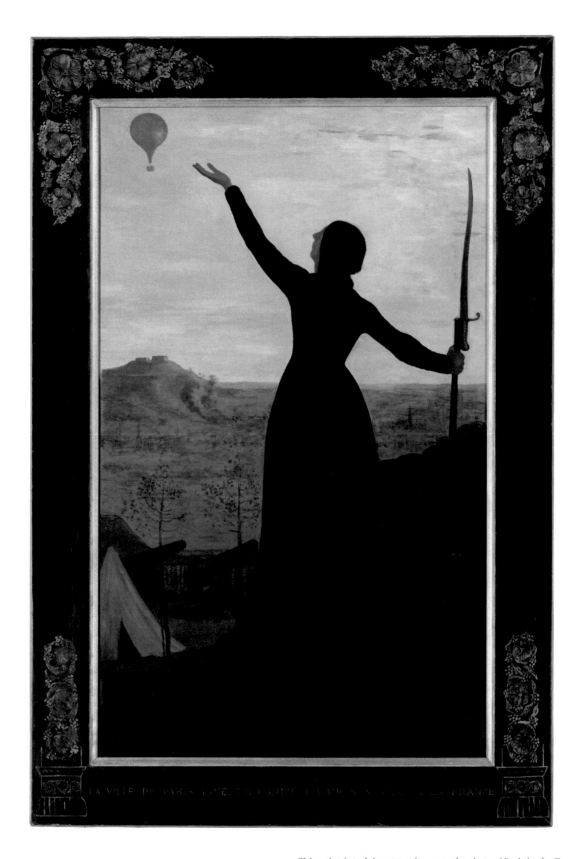

31

PIERRE PUVIS DE CHAVANNES

The Balloon (*Le ballon*), 1870
Oil on canvas
53 ⁷⁄₈ × 34 in. (136.7 × 86.5 cm)

This pair of stark images references the siege of Paris in the Franco-Prussian War of 1870–1871. *The Balloon* offers a symbol of hope, while *The Pigeon* depicts a predatory eagle, the symbol of Prussia, menacing a carrier pigeon—at one point the only means of communication between Paris and the rest of the country. The paintings' simplified forms, flattened compositions, and somber palette, which are typical of the artist's distinctive style, capture the dire nature of the events that inspired them.

PART 2

MANET ON VIEW

STÉPHANE GUÉGAN

·

Anything can happen.

ÉDOUARD MANET[1]

Beginning in 1859, the year the jury rejected *The Absinthe Drinker* (Ny Carlsberg Glypothek, Copenhagen), Édouard Manet's career was determined by his annual anticipation of the Salon. His willful attitude toward Salon acceptance persisted until his death, complicating what he had assumed would be his vocation as a history painter. By 1864, a year after the Salon des Refusés and the strategic exhibition of *Luncheon on the Grass* (fig. 20), Manet had benefited from the liberalism that accompanied the end of the Salon's imperial administration, thus enabling him to make a forceful comeback on the art scene. In 1865 *Olympia* (fig. 21) captured the attention of critics and the public alike. It was an extreme work, little understood or accepted at the time, and the incomprehension surrounding it affected Manet more than is ordinarily believed.

In the aftermath of this scandal, he made a stimulating visit to Spain and then prepared for the Salon of 1866. One of his submissions that year, *The Fifer* (cat. 32), serves as a reminder that the artist was anything but indifferent to the art world and its rules. The previous year's firestorm compelled him to return to less aggressive subjects and modes of expression than seen in his *Olympia* and the accompanying *Jesus Mocked by the Soldiers* (1865, fig. 26), whose treatment was judged too plebeian and shocking for such a religious theme. Though Manet was not prepared to give up everything the critics had found unacceptable in his work—the reduced rendering of space, the sharp contrasts, and the mysterious content—he sought, by means of moderation, to charm both the crowds and the jury (the latter largely dominated by representatives of a style of painting totally unlike his own). *The Fifer* bears only a passing resemblance to the famous two-dimensional "playing card" to which certain recent critics compared it; the painting deliberately combined the Spanish and Japanese influences that scholars and critics continued to praise for their abstract freshness and visual purity. Manet was not so much aiming for a type—the alliance of legible form and immediate significance—as he was attempting to misappropriate its codes. Despite the allegorical simplification of his painting, he knew how to render instantaneously an awareness of the child soldier's destiny, the paradox of his situation, and even the danger he faced at a time when the military ambitions of Napoléon III were still a reality experienced by all.

A connection may also be made between Manet's image of stolen childhood—the boy's absent gaze, his oversize uniform—and the painter's political views, as well as his interest in the unfathomable mysteries of adolescence. His model, far from being a studio professional, was, in fact, a soldier in a troop of the Garde Impériale. It was Commandant Lejosne, a close friend of the artist's and Charles Baudelaire's and a great partisan of liberalization within the ruling regime, who had introduced Manet to this fife player of the light infantry.[2] Though clearly a work in homage to Diego Velázquez, who set his figures against monochromatic backgrounds, the painting also refers to the portrait of Napoléon III by Hippolyte Jean Flandrin (Musée National du Château de Versailles) that was exhibited in 1863 and admired by the young Frédéric Bazille.[3] There are also echoes of Thomas Couture's *Drummer Boy* (1857, Detroit Institute of Arts) and *The Enrollment of the Volunteers of 1792* (1848–1852, Musée départemental de l'Oise, Beauvais, France).[4] Couture—Manet's first master and the bard of republican heroism—was known primarily, with the exception of his fine portraits, for the somewhat sugary lyricism of his depictions of children and gypsies.[5]

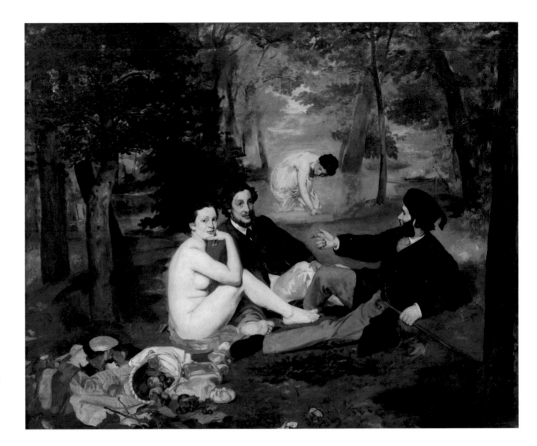

FIG. 20 **ÉDOUARD MANET**
Luncheon on the Grass (*Le déjeuner sur l'herbe*), 1863
Oil on canvas
81 ⅞ × 104 ⅛ in. (208 × 264.5 cm)
Musée d'Orsay, RF 1668

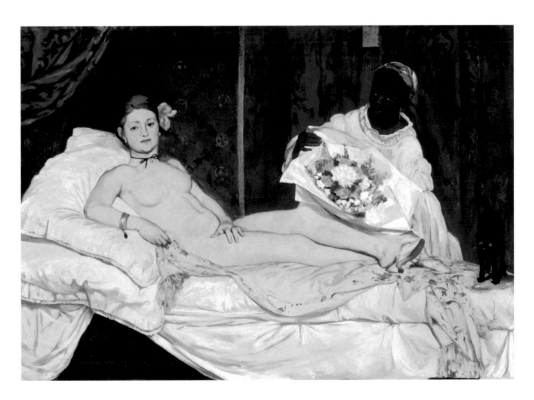

FIG. 21 **ÉDOUARD MANET**
Olympia, 1863
Oil on canvas
51 ⅜ × 74 ¾ in. (130.5 × 190 cm)
Musée d'Orsay, RF 4507

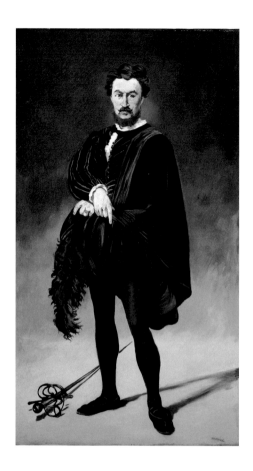

THE BAUDELAIRE MOMENT

Manet thus walked in Couture's footsteps in order to win the good graces of the guardians of the Salon and its public. Only up to a point, however. Less provocative and more virtuosic than *Olympia*, *The Fifer* contains none of the overdone sentimentality potentially inherent in the subject. On the contrary, it is a fine example of the contradictory form of address of which Manet was so fond—something between a blow from the fist and a subtle retreat.[6] On March 27, 1866, in order to facilitate the painting's exhibition at the Salon, along with *The Tragic Actor (Rouvière as Hamlet)* (fig. 22), Manet wrote to Baudelaire, as he had done successfully in the past. What Manet did not yet know was that the author of *Les fleurs du mal* (*The Flowers of Evil*) no longer had much influence with his Parisian connections. He was laid low in Belgium, where his syphilis had just taken a turn for the worse. "My dear friend," wrote Manet, "I've sent two paintings to the exhibition; I plan to have some photographs taken and to send you some. A portrait of Rouvière in the role of Hamlet, whom I call the tragic actor to avoid criticism from anyone who might think it does not resemble him—and a fife player in the light infantry of the Garde, but you have to see the paintings to get a proper idea."[7]

The closing words of the letter reveal a certain scrupulousness or fear of reproach. Manet was well aware that his technique went against the mimetic requirements of portrait painting, particularly as upheld by the Salon. He also knew that his latest contributions, however significant they might be, were neither as complex nor as inspired as the works he had exhibited in 1865. One therefore "had to see" the paintings to measure their true nature in light of the strategic toning-down he had given them.

Like *The Fifer*, the great portrait of Philibert Rouvière, reminiscent of lithographs by Eugène Delacroix, was intended to win over the more liberal members of the jury, particularly Paul de Saint-Victor and Théophile Gautier.[8] In September 1854, a few months before publishing a review of Rouvière in the role of Hamlet that was accompanied by a portrait by Henry Jules Jean Geoffroy, Baudelaire had warmly praised the actor to Saint-Victor, flattering the latter as "you who understand Romanticism."[9] Twenty years after his opening performance in Shakespeare's drama, the eccentric actor was still considered the definitive incarnation of the Danish prince. Gautier, meanwhile, had supported Rouvière throughout his career, from the moment Rouvière exchanged his paintbrushes for the stage, and he would reaffirm his support in 1865. When the actor was very ill and organizing a sale before he died, Gautier wrote an announcement for the *Moniteur Universel*: "He brought the Prince of Denmark to life, made him breathe and walk. . . . No one has conveyed better than Rouvière that hesitation of thought before action, that mixture of contrived and involuntary madness, that visionary eye where ghosts invisible to others are reflected, that profound reverie interrupted by convulsive awakenings in the presence of reality."[10]

But Manet's efforts were in vain. A jury dominated by Alexandre Cabanel, Jean-Léon Gérôme, and the aging Joseph Nicolas Robert-Fleury rejected his two paintings from the 1866 Salon. The artist's success had not lasted long. In the wake of his triumph with *The Spanish Singer* (fig. 23), which had won an honorable mention at the Salon of 1861, Manet had turned thirty full of confidence. Bolstered by the trend in Paris for Spanish-inflected art, Couture's disciple, long an unknown factor, had suddenly seen his career blossom. On March 1, 1863, his first retrospective opened at the Galeries Martinet—an opportunity for him to display the distance

he had traveled from Gustave Courbet's influence. Manet both assumed and surpassed the heritage of 1850s Realism, incorporating references that included not only the Spanish artists Francisco de Goya and Velázquez but also Jean-Antoine Watteau and the Romantic foundation that Baudelaire observed had "marked [him] since his childhood."[11] Manet's wife, Suzanne Leenhoff, had brought him closer to the Dutch tradition; now, on an equal basis, the Italian Renaissance became part of his search for a strictly French art.[12] His portrait of his parents (1860, fig. 24), for example, which was also exhibited at the 1861 Salon, combines the influences of Jean-Auguste-Dominique Ingres and Couture with Raphael's famous sixteenth-century *Self-Portrait with a Friend* (Musée du Louvre, Paris).[13] Despite such allusions to tradition, the Martinet exhibition was held to be stranger than strange. Commenting on *Music in the Tuileries Gardens* (1862, National Gallery, London)—in which Manet portrayed, among others, Gautier, Baudelaire, and Baron Taylor—Paul Mantz wrote of a "medley of red, blue, yellow and black,"[14] and Saint-Victor described a canvas that would grate on one's eyes and ears. In *La Presse* of April 27, 1863, the latter settled his score with the "eleventh-hour realist":

> His paintings at the exhibition on boulevard des Italiens are a dreadful mishmash of colors. Never before has anyone caused lines to wince or colors to shriek more horribly. His *Toreros* would frighten a Spanish cow; his *Smugglers* need only show their faces to put to flight the most intrepid customs officers.[15]

The critics' lack of understanding merely grew during the Salon des Refusés, less than two months later. In light of the ever-increasing number of submissions to the Salon, the imperial administration reinstated a quota, as they had done in 1852: three works per artist, no more.[16] This entailed greater severity on the part of the academic jury. Nearly two thousand entries were rejected. Petitions among the artists flourished, and Napoléon decided to see for himself the works that had been considered unworthy. Clearly, wrongs had been committed, and the jury's actions were not a viable solution to the problem of overcrowding at the Salon. The emperor demanded an additional exhibition. For Alfred Emilien Nieuwerkerke, this was a snub; for Manet, a blessing. His *Luncheon on the Grass*, then titled *The Bath*, benefited to a dubious degree. The best informed among the critics, such as Théophile Thoré, considered the painting to be "of very risqué taste. . . . I cannot understand what can have induced an intelligent, distinguished artist to create such an absurd composition."[17] Among Manet's rare partisans, Zacharie Astruc associated him with the "brilliance, the fiery spice, the astonishment" of the Salon des Refusés.[18] But Baudelaire, a few months before, decided to support the newcomer in the Spanish manner: "M. Manet is the author of the *Guitarist*, which caused a lively sensation at the most recent Salon. At the next Salon, several of his paintings will be instilled with the strongest Spanish flavor, and this might lead us to believe that the spirit of Spain has sought refuge in France."[19]

Despite the modest liberal turn of the Salon over the course of the 1860s, it remained a prisoner of its own contradictions. But it would be wrong to infer, as some have done, that the innovators did not see an improvement in their lot. Manet reentered the official arena in 1864. In March, to his friend Philippe de Chennevières, a key figure in the organization, Baudelaire urgently recommended "two friends, one of whom has already benefited from your kindness: M. Manet and M. Fantin. . . . You will see what marvelous faculties are revealed in these

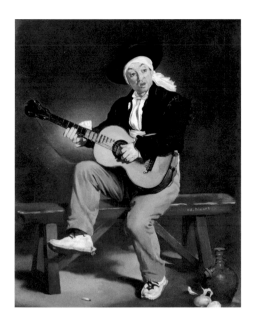

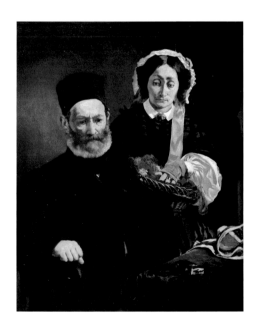

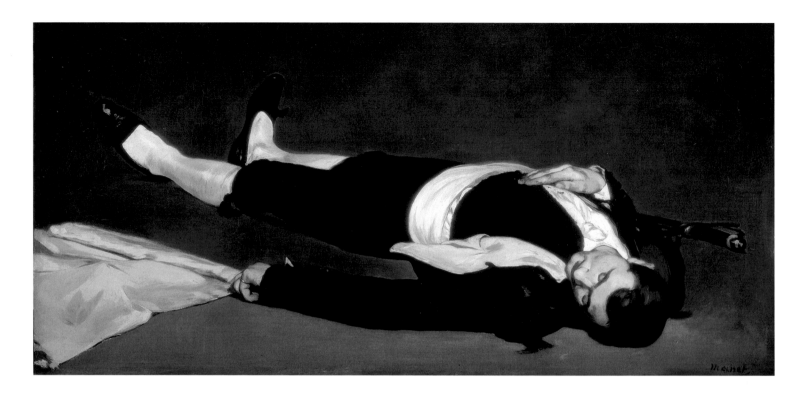

paintings."[20] On June 25, 1864, Gautier dealt with all their contributions in a weighty column. Of the two paintings by Manet—one religious, the other showing a bullfight, and both treating the subject of sacrifice—only the latter seemed to find favor with the critics. In *The Dead Christ with Angels* (Metropolitan Museum of Art, New York), a hastily washed cadaver, angels that were too colorful and hardly celestial, and a loose technique desecrated his otherwise very respectable iconographic sources. Despite its odd perspective, *Incident in the Bull Ring* appeared to be more in keeping with the artist's style; moreover, the figure of the dead toreador was in itself a detail worthy of standing alone (after the exhibition, Manet followed Gautier's advice and cut up the painting; see fig. 25).[21] Manet, concluded the ever-doubting critic, was exerting "a certain influence upon contemporary painting, while representing its most outrageous tendencies."[22]

It is hardly surprising that the same Gautier smiled upon Henri Fantin-Latour's *Homage to Delacroix* (fig. 39), in which members of the new École des Batignolles kneel before the portrait of the recently departed lion (Manet had accompanied Baudelaire to Delacroix's funeral). Fantin-Latour's apotheosis was shocking for its provocative mundaneness, its bourgeois black clothing, and, above all, its message, confused by "such a profession of faith."[23] How could these descendants of Courbet lay claim to the legacy of the great Romantic? What was Baudelaire doing among those champions of Realism? There was ample cause for consternation among those who could not or would not understand how Manet, Fantin-Latour, James Abbott McNeill Whistler, and Alphonse Legros were actually continuing Delacroix's work through their approach to color, their free borrowing from the work of the Old Masters, and some of their chosen themes. Beyond merely claiming his lineage, Fantin-Latour was presenting the baptismal certificate of a Realist new wave. Although these artists had been connected through their activities within the Société des Aquafortistes, their intention was less to form a group than to endorse, as individuals, the cause of the "New Painting."

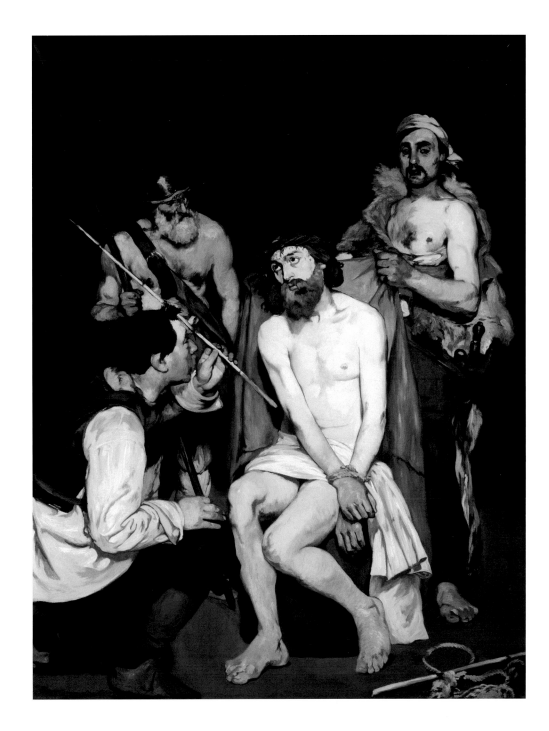

MONSIEUR MANET

In the space of a few years Manet had risen in rank and acquired a leading place among the most heretical of the up-and-coming generation. Above all he portrayed himself as the successor to Romanticism and the gravedigger for its more outdated forms—a delicate alchemy, one that would be neither noticed nor accepted for some time. The 1865 jury did, however, remain faithful to its new liberalism and accepted two paintings that were much more provocative than his previous entries. Apparently the artist was more anxious about the jury's response to his new religious work than its reaction to *Olympia*, which today seems far bolder. Manet's correspondence with Baudelaire, who had offered to mobilize his usual network, is telling:

You are wise, I was wrong to be sorry, and while I was writing to you my painting was accepted. I even think, according to the rumors, that this year will not be too bad; the painting is a *Mocking of Christ* and I think this is the last time I'll undertake a subject like this; but didn't you know that T. Gautier is a member of the jury. I did not send him your letter, it's useless now, there is no point using people's good recommendations for no good reason.[24]

The letter suggests that Manet had not given up all hope of being understood by Gautier. Yet, like his fellow critics, Gautier tore *Olympia* to shreds for its outrageous realism, extravagant technique, and enigmatic references to the Old Masters. As for *Jesus Mocked by the Soldiers* (fig. 26), a first version of which Manet had abandoned, the crime was worse: an almost farcical lack of decorum that could easily pass for blasphemy. Branded an adept of unremitting ugliness, a sort of Goya perverted by Courbet, the repeat offender now also had his own following: "M. Manet has the honor of being a danger," Gautier asserted. But the greatest surprise would be for him to "return next year with two good paintings. He is not incapable of producing them."[25] In hindsight, we know that Manet was not given that chance in 1866, when the unforeseen hardening of the Salon jury led to the rejection of *The Tragic Actor* and *The Fifer* from the exhibition. At this point Émile Zola took the lead in a veritable crusade in favor of the jury's victims, his friend Paul Cézanne in particular. Excluded from the exhibition of 1863, the painter from Aix-en-Provence would not exhibit at the Salon again until 1870. Things turned out differently for a quartet of younger painters, all born around 1840, who had met in the studio of the Néo-Grec artist Charles Gleyre. Pierre Auguste Renoir was accepted at the official exhibition in 1864, Claude Monet in 1865, and Bazille and Alfred Sisley in 1866. Manet's "school," an informal clan, recruited its new contenders in Gleyre's studio.[26]

A young novelist of twenty-six, Zola had just left the Hachette publishing house, where he had revolutionized the press office. His first books, particularly *La confession de Claude* (*Claude's Confession*), garnered much attention for their dark portrayal of the underprivileged classes and prostitution. Henry Murger's *Scènes de la vie de bohème*, all smiles in the midst of poverty, was no longer in fashion. Sure of his pen, Zola turned to journalism of the most Parisian, and therefore most caustic, variety after winning over one of its tutelary geniuses, Hippolyte de Villemessant. In November 1865 Villemessant, the man who had renovated *Le Figaro*, created *L'Événement*, a liberal newspaper that was shut down after only one year. As of April 27, 1866, Zola began to come down hard on the Salon and its censors. He did not so much attack the jury as denounce it for "bestowing an ideal" that dared to mutilate the living art of all who sought the "strong, harsh reality of nature." Instead of an injection of new blood, the Salon offered "long rooms, cold and dreary, where all the timid, mediocre works and all the unearned reputations are displayed in a harsh light."[27] As for the jury, it was nothing more than a caricature drawn by nepotism. The clique even went so far as to refuse artists they had previously accepted—Manet, for a start.

On May 4 Zola raised the tone, lambasting the Salon's sentimental elegies, naughty nudes, and the other "adorable trivialities we are all swooning over." Zola knew perfectly well that struggle tempers the true artist: "Our fathers made fun of Courbet, and now we wax ecstatic over him; we make fun of Manet, and our sons will wax ecstatic over his canvases." On May 7

the critic devoted an entire column to Manet and his "strong, convincing canvases," to the great delight of the artist himself: "What a fine article! Thank you a thousand times."[28] Between the lines, Zola was addressing Gautier, who was surprised by the advent of painting made of *taches* (stains or blots). Zola was taken with *The Fifer*: "I don't believe it is possible to obtain a more piquant effect with simpler means." His defense of Manet was accompanied by cutting words for the Realists of the previous generation. While Jean-François Millet was going soft, Courbet was doing pretty pictures such as *Woman with a Parrot* (1866, Metropolitan Museum of Art, New York). Courbet's response to Manet's *Olympia*, and to the journalists who had buried it too soon, was this nude and its "laudable return to healthy doctrines."[29]

Aesthetic and generational tensions soon caused the Realist clan to fracture. *The Toast!*, a painting Fantin-Latour had exhibited at the previous Salon, had already foreshadowed the break. Around a female allegory of Truth, as naked as the model Victorine Meurent in Manet's *Olympia*, Fantin-Latour reunited the group from *Homage to Delacroix*.[30] There was one major change, however: Baudelaire had been replaced by the critic Astruc (Manet would paint Astruc's portrait in 1866).[31] Astruc is joined by Whistler, Félix Bracquemond, Louis Cordier, and the writer and critic Louis-Émile-Edmond Duranty, as well as two young painters, Jean Charles Cazin and Antoine Vollon. It is Vollon's face that appears in one of the rare surviving fragments of the canvas (cat. 67), which Fantin-Latour cut into pieces soon after its display at the Salon. The destruction of his second "manifesto," which failed to reconcile allegorical apparition and realistic appearance, speaks volumes about the pending revision of the rules of composition in painting, a crucial issue for Manet at that time. Does it not go some way toward explaining Manet's own iconoclastic decisions to reframe the *Gypsies* in three pieces (one at the Art Institute of Chicago, the other two at the Louvre Abu Dhabi), to isolate the above-mentioned *Dead Toreador*, and to manipulate, for still-mysterious reasons, *The Races at Longchamp* (1866)? Ultimately, however, the failure of *The Toast!* conveys the dissidence within a group whose unity the painting was supposed to exalt.[32]

The moment the prospect of the Exposition Universelle of 1867 became real, Manet saw it as an opportunity to speak in the first person at the top of his voice. However, when the official commission refused him a space, he had to find another way to get his work shown. He decided to do what Courbet had done at the 1855 Exposition Universelle (something, in fact, that Courbet did again that very year): he built his own personal pavilion right next to those of the fair. The cost of admission to see fifty paintings, three copies, and three etchings was fifty centimes. Baudelaire, for whom Manet's wife played the piano during his final months (see cat. 33), was no longer well enough to write an introduction for the exhibition's catalogue. Instead the publication reprinted an article, titled "A New Manner in Painting: Édouard Manet," that Zola had published on January 1, 1867. Manet added a foreword to the catalogue (another echo of Courbet in 1855). Writing in the third person, he declared, "M. Manet ... has never claimed to overthrow the art of the past, or to create a new art. He simply sought to be himself, and no one else."[33] Moreover, his exhibition offered proof that he was the only artist at the time who scrutinized modern life in all of its aspects, from the boudoir to the racetrack, from religion to politics. The introduction to the 1867 catalogue sought first and foremost to untangle the relationship, instituted and perverted by the Salon, between modern artists and their potential viewers—another theme dear to Baudelaire: "It is the effect of sincerity to give artworks a character that causes

them to resemble a protest, when the painter was thinking only of rendering his impression." Clearly, showing his output in an appropriate public space remained vital to Manet.

Though it attracted the attention of the young artists from the studios, the personal exhibition of the "painter with the cat"—to quote the caricaturists who made fun of *Olympia*—failed to create a public stir.[34] What was needed for true scandal or revenge was the context of the Salon and the barriers it imposed. The venue was deserted that year, due to competition with the Exposition Universelle, but that did not temper complaints about the Salon barring all or part of the submissions by Bazille, Cézanne, Renoir, Monet, Sisley, and Camille Pissarro. Whistler and Fantin-Latour, however—the latter with a portrait of Manet (fig. 27)—did manage to land a corner of a gallery. The victims launched a petition against this "odious lynching" (in the words of the critic Jules-Antoine Castagnary), which Manet and Charles François Daubigny also signed. And the dissidents were beginning to draw up plans for an alternative Salon: the Impressionist schism that would occur in 1874 was already under way. No sooner had the Exposition Universelle closed its doors than Nieuwerkerke published the rules for the following Salon. The most important change concerned the electorate of the jury. Any artist who had previously exhibited was now allowed to vote on the selection of the jurors, resulting in a list that looked very different indeed. Cabanel and Gérôme were still present, but Daubigny now occupied the top spot. Gleyre, the Néo-Grec master of Bazille and his friends, was ranked in sixth place. As a consequence, the 1868 Salon was a historical turning point, bringing together for the first time the vibrant forces of young painters alongside the likes of Courbet and Manet. Another fact worthy of note, relative to the geography of the artistic landscape: the center of the Realist coterie had just moved for good to the Batignolles neighborhood, where Bazille had settled in December 1867. Rue de la Condamine was now in a position to cast a cool eye upon rue de Saint-Pétersbourg, where Manet lived and would open his studio in 1872.

THE ÉCOLE DES BATIGNOLLES

Manet would make the most of this turn for the better. Still cautious, he returned to the Salon with two paintings that might find favor, or at least less disfavor: his portrait of Zola (1868, cat. 34) and *Young Lady in 1866* (fig. 28). Most viewers failed to see the erotic innuendo of the latter painting. Victorine Meurent, still wearing Olympia's black ribbon, posed as a thoughtful Parisienne. She appears in a loose pink dressing gown, holding a bouquet of violets in one hand and toying with a man's monocle in the other. The parrot adds another erotic allusion to the picture, as does an orange half-stripped of its peel.

Gautier, like others, was impervious to the muted charms of the lady in pink. The bouquet was gritty, her hair dull, her dress dubious, her body absent, the parrot wobbly—the list of grievances was long. He far preferred the portrait of Zola, "the author of *Thérèse Raquin*, an admirable realist study of remorse, and an oh-so-specious apology for the doctrines and talent of M. Manet." He noted the composition's references to *Olympia*, Velázquez, and Japanese prints, "the phenomenal threefold nature of Realism." Moreover, "despite contrasts between black and white that are too violent, [the canvas] has been painted in a fairly ample manner, and belongs to a sphere whence the artist's other works have violently diverged."[35] In *Le Charivari*, one of the Impressionists' future detractors, the caustic Louis Leroy, explained "how the apostle of the *tache* himself became a stain."[36] The same refrain came from Gautier: "The *tache* and the

impression—big words that are often used nowadays, and they ought make critics shut up, they're not enough for us."[37] The young Odilon Redon, taking his first hesitant steps in art criticism, denigrated the portrait of Zola for its lack of psychological expressivity and even human presence. It was "more like a still life than the representation of a human being."[38]

Manet's contemporaries were not ready to accept the way the artist created an ambiguous spatial relationship between individuals and inanimate objects. And yet he continued to insist that he was a painter of figures, even of history. For more than a year, with the Salon in mind, he had been working fervently on his *Execution of Emperor Maximilian* (1868–1869, Kunsthalle Mannheim, Germany), a modern drama handled evenly but without a supposed detachment.[39] The canvas, one of the largest he ever signed, has elements of both an anti-imperialist charge and a modern crucifixion; it depicts Emperor Maximilian of Mexico being brutally shot by the firing squad of the republican forces, who are dressed in French uniforms.

The painting was as much an accusation against the error of Benito Juárez's men as it was a condemnation of the inconsistencies of Napoléon III's Mexican policy. Despite this nuance, in January 1869 the government informed the artist that he would not be allowed to show his incendiary work at that year's Salon. Zola immediately disgraced the censorship of a regime that was supposed to be more liberal. Manet instead exhibited his *Luncheon in the Studio* (Bayerische Staatsgemäldesammlungen, Munich), full of youthful male gallantry, and the famous *Balcony* (Musée d'Orsay), which marked the first public appearance of his friend Berthe Morisot in his work. The canvas renders audible the embarrassed silences of an amorous conversation, and the acid green of the modern dwellings seems to squeak.

Although *The Balcony* was widely misunderstood because of its ambiguous social and psychological content, Bazille wrote to his father that Manet, "whom they no longer dare refuse,"[40] was even beginning "to find more favor with the public."[41] Gautier would qualify his success enigmatically: "Very few viewers can remain indifferent to this strange painting, which seems to be a negation of art, yet is related to it all the same. M. Manet's influence is greater than is believed, and many people who may not realize it are subject to it."[42] The slow unraveling of the old Salon regime, which Manet, his brothers, and his closest relations were all working toward, brought with it a new reform in 1870, ridding the institution of the previous administration and endowing it with a jury elected entirely by artists.[43] Exit Gautier and Saint-Victor. There was also a revolution among the artists: Gérôme and Cabanel lost rank to Jean-Baptiste-Camille Corot, Daubigny, and Millet, the liberal threesome. Manet's submissions, *Music Lesson* (Museum of Fine Arts, Boston) and the portrait *Eva Gonzalès* (National Gallery, London), were less inspired than usual but were nonetheless torn to pieces.

It was at this Salon that Fantin-Latour exhibited his *Studio in the Batignolles* (cat. 47), the definitive manifesto of the New Painting represented by those who were part of Manet's circle. Gesturing majestically, his face bathed in light, Manet reigns at the center of a studio where Greek art lives side by side with work from Japan. Fantin-Latour also included Zola and Astruc, two of the critics who had come to the defense of his friend. It is Astruc whose portrait Manet is painting, a canvas within a canvas. The younger artists, Bazille, Monet, and Renoir, all regulars at the Café Guerbois, appear the most fervent. No previous rendering of an artistic circle had so strongly evoked its distant origins in images of Christ and his disciples. And yet the figures' attitudes and gazes seem astonishingly scattered, as if they are already preoccupied

with the dark future that looms before them. The portrait failed to represent them as a united group of individuals sharing the same aesthetic and strategic goals.

Immediately after the Salon of 1869, Duranty launched the idea of an "École des Batignolles" incorporating, in particular, Manet, Renoir, Bazille, and the German artist Otto Scholderer. Fantin-Latour was already working on his group composition. However, the Franco-Prussian War, declared in the summer of 1870, put a brutal end to the community. After France's crushing military defeat, September 4 saw the reestablishment of the Republic, a political victory that clearly pleased Manet and his brothers. Around September 15, however, fearing the worst in light of the Prussian advance, the painter entrusted Théodore Duret with several paintings, including *Olympia, The Balcony*, and *Moonlight over the Port of Boulogne* (cat. 39), which he had produced in 1869 with the Dutch masters and Goya's etchings in mind. The siege of the capital by Bismarck's armies created a terrible void. While his family took refuge in the southwest, Manet stayed behind in Paris. He wrote to his student Eva Gonzalès:

> A lot of the cowards have left, alas, among them our friends Zola and Fantin, etc. . . . I think they'll be entitled to a few sour faces when they return. We are beginning to suffer, here, eating horsemeat for a treat, donkey meat is far too expensive, there are butchers' shops selling rats and dogs. Paris is mortally dreary, when will it all end, we're utterly fed up.[44]

Bazille went to fight and died in uniform; Renoir was based elsewhere; Monet, Pissarro, and Sisley fled. Manet enlisted in the Garde Nationale, as did Edgar Degas, Henri Regnault, Jean Baptiste Édouard Detaille, and a host of other artists who decided to defend Paris and, if it came to pass, the promise of political change. Manet's correspondence is a living testament to the besieged population's everyday life, and it suggests that he continued, as an artist, to observe the unfolding of history. Bitter when released from military service on January 24, 1871, he left Paris after a regrettable surrender and did not return until June, at the end of the Commune but still in time to witness the final moments of its suppression. By awakening the patriotism and brotherhood of those who had fought in 1848, the uprising had unleashed terrible violence, the imperfect expression and resolution of all the failures of the Second Empire and the military defeat. Every form of hatred was set free. Manet was hostile toward the Commune because he saw it as a threat to the Third Republic, but he had equal scorn for the iniquitous trials and executions. His famous *Barricade* of 1871 (Szépművészeti Múzeum, Budapest) transformed the double message of *The Execution of Emperor Maximilian*, denouncing the blindness of the victors and the vagaries of an interminable civil war.

At the Salon of 1872 (which was the first to display the rigor of the new government, excluding Courbet for his role as a Communard), Manet exhibited an 1864 painting titled *The Battle of the* Kearsarge *and the* Alabama (Philadelphia Museum of Art); the work's republican significance had been revived by contemporary events.[45] In an 1864 battle of the American Civil War, the Union *Kearsarge* destroyed the Confederate *Alabama* in Channel waters nine miles off the coast of Cherbourg. At the time, France and England acted openly against the Union government of the North. Manet, however, supported Union politics. In displaying this painting at the Salon of 1872, he meant to underline his democratic commitment under Napoléon III and his intention to oppose the new rulers of his country.

FIG. 29 **ÉDOUARD MANET**
Repose (*Le repos*), ca. 1870–1871
Oil on canvas
59 ¹⁄₈ × 44 ⁷⁄₈ in. (150.2 × 114 cm)
Museum of Art, Rhode Island School of Design, bequest
of Mrs. Edith Stuyvesant Vanderbilt Gerry

Manet's studio, formerly on rue Guyot, was now on rue de Saint-Pétersbourg, a few minutes from his apartment and from the Gare Saint-Lazare. The Quartier de l'Europe, vibrating with the sound of locomotives, was the somewhat aggressive face of the new Paris, which had been transformed in only a few years. Manet and his art were receptive to this urban environment, where iron footbridges offered vistas of straight streets lined with imposing stone buildings and trains were an inspiring presence.

It was indeed a new era built on the smoking ruins of "the terrible year," a phrase taken from the title of Victor Hugo's book of poetry describing the war and its aftermath. Paul Durand-Ruel's mass purchase of twenty-five Manet canvases marked the transition in a spectacular way. The press could not believe it: "It is downright miraculous, yet I will not hesitate to confirm it: one of our greatest art dealers has just bought 50,000 francs worth of canvases from M. Manet."[46] Another source of astonishment: Manet was accepted at the 1873 Salon, though the jury was particularly tough that year, excluding many worthy artists. Manet condemned the jury's actions as roundly as he did the politics of Louis-Adolphe Thiers after the Commune.[47] Charles Blanc, the new director of the Direction des Beaux-Arts, was so stringent in his dealings with the official exhibition as to make one regret the final years of the Second Empire. There was again a profusion of petitions, and once again Manet signed them. Another circumstantial response was his painting *Le bon bock* (Philadelphia Museum of Art), an allusion to the loss of Alsace imbued with the plebeian good nature of a painting by Frans Hals or Courbet, both implicitly present in the work.[48] The press remained blind to the political message and praised the artist only for at last amending his style: "This year, M. Manet put some water in his bock."[49] Manet's other entry at the 1873 Salon was *Repose* (fig. 29), which garnered fewer admirers. *Repose* introduced a note of extreme and unseemly freedom to his portraits of Berthe Morisot, which would increase in number until her marriage. Théodore de Banville, for one, prized the canvas as the highlight of the Salon, writing that it worked

> upon the mind with its intense spirit of *modernity*; allow me this barbaric notion, it has become indispensable! . . . Baudelaire was right to appreciate M. Manet's art, for this patient and delicate artist is perhaps the only one who offers us this refined feeling of modern life, bitter joy, and delightfully savored pain that made for the exquisite originality of *The Flowers of Evil.*[50]

AT THE EDGES OF IMPRESSIONISM

Without breaking with Zola and the milieu of artists concerned with Naturalism, Manet fostered his ties with the Parnassian literary circle, the heirs to Baudelaire and Gautier, who espoused the concepts of "art for art's sake" and modernity. The art critic Banville, still very active, was viewed as one of the first writers to have supported the Parnassians. He and Manet struck up a friendship, envisaging a collaboration that would prove fruitful only up to a point. At the end of 1873 Manet met Stéphane Mallarmé, with whom the artist would have a richer and more productive relationship.[51] Literary camaraderie was vital to both Manet's creativity and his career, particularly when he was partly ostracized once again, this time from the Salon of 1874. Unable to stem the tide of works submitted for approval, the jury that year rejected two paintings out of three, but it did accept *The Railway* (1872–1873, fig. 36) and the hand-colored lithograph

Polichinelle (National Gallery of Art, Washington, D.C.), a subtle dig against the president of the Republic, Patrice de Mac-Mahon. With the exception of Mallarmé, who stood up for his new friend in a Parnassian journal, the critics ripped *The Railway* to pieces. This was the last of Manet's paintings to feature his favorite model, Victorine Meurent, who had graced *Luncheon on the Grass* and *Olympia* with her serene immodesty. She turns to us with her head bent, as if we had surprised her and interrupted her reading. Beside her is a young girl, turned out nicely in a silvery dress cinched with a large blue sash. She has her back to us, absorbed by the spectacle of a passing train we cannot see, though it leaves billowing smoke in its wake. An iron fence crosses the entire space of the painting, injecting the composition with the element of black that is peculiar to Manet. The luminous image gives an impression of pleinairism that disconcerted Manet's contemporaries, above and beyond the freedom of his style. Situated between concrete presence and subtle suggestion, *The Railway* refuses to yield all of its secrets.

Rendered with clarity and sharpness, this scene of modern urban life would have been at home among the 165 works on view in the Impressionist exhibition, which the Société Anonyme des Artistes, Peintres, Sculpteurs, et Graveurs inaugurated on May 15, 1874, at 35 boulevard des Capucines. Many members of the École des Batignolles responded to the invitation that Manet declined. Among them were Astruc, Bracquemond, Renoir, Sisley, and Degas, who did not appreciate Manet's defection:

> The realist movement no longer needs to fight with the others. It already is, it *exists*, it must show itself as *something distinct*, there must be a *salon of realists*. Manet does not understand that. I definitely think he is more vain than intelligent.[52]

Degas' assessment is hardly convincing. Manet did not continue to defy the official Salon out of simple narcissism. His strategy, like that of his political friends, was an inherent part of the system he sought to work to his advantage. Take the words written by Castagnary at the time of the 1876 Salon: "The French Republic is united; we want the unity of our artistic life."[53] The only truly democratic space for an artist's consecration, the official exhibition remained absolutely decisive where the economy of the art world was concerned. No doubt Manet would have seconded Renoir's words to Durand-Ruel in March 1881: "There are scarcely fifteen art lovers in Paris capable of liking a painter outside the Salon."[54] It mattered little that the Salon had taken a definitive turn toward becoming a consumerist bazaar, and that the great tradition lingered on in only the most illusory fashion. That the Salon had become an aesthetic shipwreck was confirmed by various appraisals of the art that triumphed under the "moral order" of President Mac-Mahon's administration.[55] In 1874 the Salon's medal of honor rewarded Gérôme's second-rate *Eminence grise* instead of paintings that were more worthy of the mantle of great art, such as Henri Léopold Lévy's *Sarpedon* (cat. 8), Léon Bonnat's *Christ*, or *Don Juan* by Alfred Roll. Moreover, the presence of titillating nudes, sheltered behind their stylistic cleanliness, was ample proof that the ostentatious morality of the regime was merely a pretense.

Aware of the arbitrary nature of the situation, Manet did not even attempt to exhibit *Woman with Fans*, his 1873 portrait of the poet and socialite Nina de Callias (cat. 35), indisputably one of his most important works. With its bold tonality and deliberately unfinished air, typical

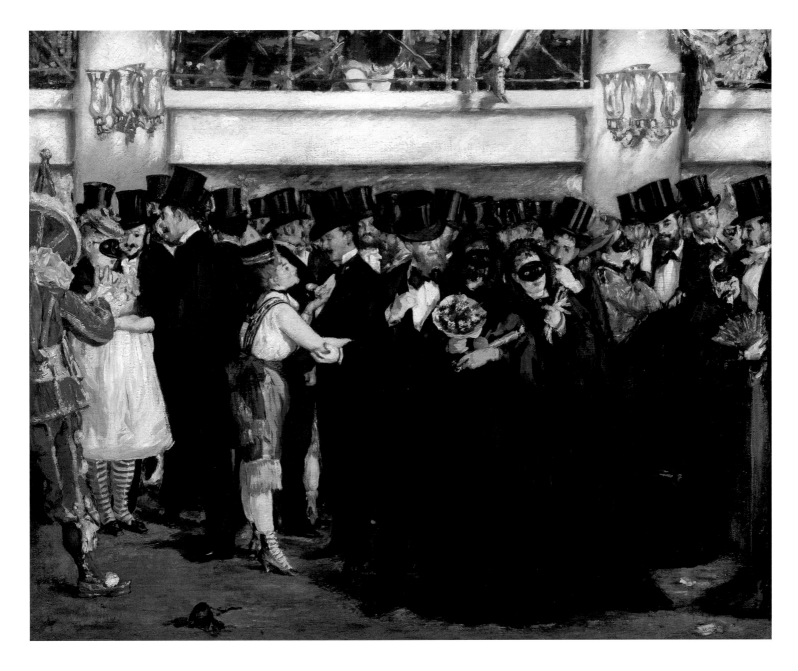

FIG. 30 **ÉDOUARD MANET**
Masked Ball at the Opera (*Bal masqué à l'opéra*), 1873
Oil on canvas
23 ¼ × 28 ⁹/₁₆ in. (59.1 × 72.5 cm)
National Gallery of Art, Washington, D.C., gift of Mrs.
Horace Havemeyer in memory of her mother-in-law,
Louisine W. Havemeyer, 1982.75.1

of the last paintings Manet produced, the large canvas would have held its own against all the highly finished images of goddesses and ladies in crinolines at the Salon. The artist was familiar with the brilliant artifice and sense of controlled indecency seen in the work of his friend Émile-Auguste Carolus-Duran. Manet's painting, by comparison, is striking for its prodigious use of black, again showing the Spanish influence in his work, and the seductive pose adopted by the sitter, one of the reigning divas of artistic Paris. She is surrounded by a Japanese-inspired decor that vibrates with ocher, blue-gray, and silver-blue tones. While Manet's wish may have been, as he wrote, to produce a "fantasy figure" in the spirit of Jean-Honoré Fragonard, he clearly also sought to portray an exceptional personage of his own era.[56] He captured fully the image of a liberated woman who collected lovers; filled her salon with poets such as Paul Verlaine, Germain Nouveau, and Charles Cros; and had no time for political caution. Her entourage, which had been republican from the start of the Second Empire, remained in opposition to Mac-Mahon. Mallarmé was among the dissidents who frequented her circle. And when Manet saw the doors

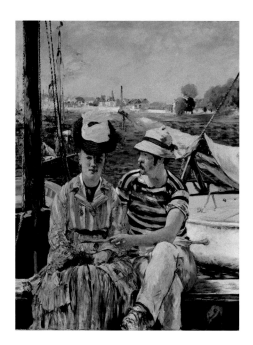

FIG. 31 **ÉDOUARD MANET**
Argenteuil, 1874
Oil on canvas
58 ⅝ × 45 ¼ in. (149 × 115 cm)
Musée des Beaux-Arts, Tournai, Belgium

of the Salon slam in his face yet again in 1876, Mallarmé took up his pen and published an authoritative, redeeming essay in the British press.[57]

But the French version, now lost, also made the rounds, and Manet read it shortly before painting his portrait of Mallarmé (cat. 37), in which the subject sits pensively in a cloud of cigar smoke, considering the arabesques of his refined poetry. For two years the writer had clashed swords for Manet's sake. In 1874 he had called upon the Salon jury to acknowledge its ridiculous behavior and upon the audience to face its responsibilities. Of the paintings that were censored in 1874, Mallarmé particularly liked Manet's *Masked Ball at the Opera* (fig. 30), which was devoid of affectation and very modern in appearance. Like Baudelaire, Mallarmé challenged the reproach that Manet did not finish his paintings enough. Was it not the harmony among all of a painting's elements that mattered most, "a harmony that brings the entire composition together, conferring a charm that is easily broken with an added brushstroke?"[58] For nearly a year, from late 1875 to late 1876, Mallarmé inundated *The Athenaeum*, a British newspaper, with gossip about Manet and his milieu, both literary and political. His purpose was most certainly to hasten the triumph of plein-air painting and "modernity," as incarnated by the artist.

Mallarmé also lent his support to *Argenteuil* (1874, fig. 31), the painting vilified at the 1875 Salon. Other critics, inspired by the recent Impressionist exhibition, confused the issues on the basis of superficial analogies between Manet's work and that of the Impressionists, such as the modern subject matter and the apparent effects of natural light. Jules Claretie's reaction at least had the virtue of expanding his references to the poet of *The Flowers of Evil*, who remained, it was obvious, inseparable from the painter: "The Impressionists start from Baudelaire. . . . M. Édouard Manet . . . sets the tone. . . . The painter of *Le bon bock* this year showed a canvas that he calls *Argenteuil*, and the plein-air school loudly proclaims it a masterpiece."[59] The following year, when Manet's submissions to the Salon were rejected, Mallarmé again took up his pen to pay tribute to Baudelaire's foresight with regard to the artist who had become the "Master of the Impressionists."[60] This epithet introduced a hierarchy and a paradox. Despite sharing the Impressionists' practice of plein-air painting and offering his support to Monet, Degas, and Renoir, Manet in the end was careful not to join the group. His aloofness reflected another, more essential distance, one that had to do with aesthetic ambition and the content of images. Furthermore, in comparison to the Impressionists, Manet embraced to a greater extent the spectacle of the contemporary demimonde, from the boudoirs of prostitutes to café concerts. His April 1880 exhibition in the salons of the Galerie de la Vie Moderne was ample proof of this. A certain iconography of Parisian pleasures, socially mixed, went along with the painter's political convictions.[61]

For they never varied, never softened. The victory of the Left in 1878, a shift that Manet welcomed enthusiastically, inaugurated the final period of the artist's career—anxious, uneven, and characterized contradictorily by the republican awakening and his syphilitic crises. His projects for decorative painting and some of his portraits were inseparable from the new political context, which was very favorable to him.[62] He began the portrait of Georges Clemenceau (cat. 36) in 1879. His portrait of Antonin Proust (Toledo Museum of Art, Ohio), minister of the arts in the government of Léon Gambetta, received some critical praise at the 1880 Salon. Manet's depiction of the famous publisher and Communard Henri Rochefort (Hamburger Kunsthalle, Germany) earned a second-class medal in 1881—a paltry reward, which the rosette of the Légion

d'Honneur, bestowed in December of that year, hardly made up for. Can one erase twenty years of proscription and incomprehension with a touch of red on the lapel of one's jacket?

Regardless, it was out of the question to abandon the battlefield. The Salon called for more than simple figures isolated against neutral backgrounds, and Manet, despite his illness, remained obsessed with producing a new major painting, even a "sensational" one, as Monet would describe *The Escape of Rochefort* (cat. 45) in 1881. With a nod to the Salon, the work conveyed the energetic impression of elemental forces that had symbolized political protest ever since Romanticism.[63] Here Manet, who had copied Delacroix's *Barque of Dante* (1822, Musée du Louvre, Paris) when he was young, painted the polemical journalist's escape from a South Seas prison in a small boat, surrounded by the vast ocean. Manet's last painting for the Salon, in 1882, took as its heroine a barmaid at the Folies-Bergère (fig. 34) who joined the sullen yet endearing denizens of Manet's world. But she was not just an anonymous courtesan working at a famous dance hall; her pose, attitude, and especially her sad glance transformed her into a figure of sacrifice. Far from being a simple genre picture, *A Bar at the Folies-Bergère* elevated a scene of modern, everyday life to the high accomplishment of a history painting.

Right to the end, the Salon meant, for Manet, the imperative of the *grand genre*—great in size, significance, and formal ambition. When the artist passed away, in 1883, the Salon was no longer under state control and had not been for two years.[64] But to a considerable degree, the history of Manet's modernity had been written there, by virtue of his unrelenting pugnacity.

Translated from the French by Alison Anderson

NOTES

1 Manet's motto, *Tout arrive*, appeared on his stationery about 1873.

2 Françoise Cachin and Charles S. Moffett, *Manet, 1832–1883* (New York: Metropolitan Museum of Art, 1983), 243.

3 Aleth Jourdan, *Frédéric Bazille* (Montpellier, France: Musée Fabre, 1992), 154.

4 After Manet's death, a critic had mistakenly sensed this filiation, though the formal reading still prevailed over the semantic. See Nestor, "Édouard Manet," *Gil Blas*, January 9, 1884.

5 Thomas Couture's impact on Manet's oeuvre, as far as form and subject matter are concerned, remains to be established. The problem is eloquently discussed by Michael Fried in *Manet's Modernism: Or, the Face of Painting in the 1860s* (Chicago: University of Chicago Press, 1996), 157–160. To take just one example, Couture became very popular with his gypsy figures at the time when Manet began to study under him. It is interesting to review the welcome reserved by critics for his submission to the 1852 Salon. See Stéphane Guégan, "Note sur les Goncourt au Salon de 1852: *Notre réalisme à nous*," *48/14: La Revue du Musée d'Orsay*, no. 26 (Spring 2008): 6–15.

6 The most brilliant analysis is provided by Fried in *Manet's Modernism*.

7 Claude Pichois, ed., *Lettres à Baudelaire*, Études baudelairiennes 4–5 (Neuchâtel, France: À la baconnière, 1973): 238–239.

8 One can never underestimate Manet's debt to Delacroix, an admiration that also had the virtue of bringing him closer to Baudelaire and the Romantic critics. The portrait of Rouvière, in this respect, condenses Velázquez's and Delacroix's lithographs on the Shakespearean theme. At the time of the posthumous sale of Delacroix's works in early 1864, Paul Meurice, the playwright who collaborated with Alexandre Dumas on *Hamlet* at the end of 1846, bought the lithographic stones for the series and reprinted them. Manet's painting, as well as Henri Fantin-Latour's *Homage to Delacroix* (1864, fig. 39), should be read in this memorial context.

9 Letter from Baudelaire to Saint-Victor, September 26, 1854, in Charles Baudelaire, *Correspondance*, vol. 1, ed. Claude Pichois and Jean Ziegler (Paris: Gallimard, Bibliothèque de La Pléiade, 1973), 291–292. See also the entry on Rouvière in Claude Pichois and Jean-Paul Avice, *Dictionnaire Baudelaire* (Tusson, France: Du Lérot éditeur, 2002), 416–417.

10 Théophile Gautier, "Feuilleton dramatique," *Le Moniteur Universel*, February 13, 1865, quoted in Eric Darragon, *Manet* (Paris: Fayard, 1989), 129.

11 Letter from Baudelaire to Paul de Théophile Thoré, about June 20, 1864, in Charles Baudelaire, *Correspondance*, vol. 2, ed. Claude Pichois (Paris: Gallimard, Bibliothèque de La Pléiade, 1973), 386.

12 This is in line with the thesis of *Francité* put forward in Fried, *Manet's Modernism*.

13 Manuela B. Mena Marquès, *Manet en el Prado* (Madrid: Museo Nacional del Prado, 2003), 152–156. Antonin Proust drew a comparison between the portrait of Manet's parents and the work of Frans Hals without explaining why. See Antonin Proust, "L'art d'Édouard Manet," *Le Studio*, no. 21 (January 15, 1901). No doubt such a comparison may be justified because of the impressive power of the composition and the possible echo of Hals's portrait of a couple in a garden (Rijksmuseum, Amsterdam), which Théophile Thoré had praised in 1857 for its exceptional liveliness. Subsequently, Hals's influence over Manet became decisive. See Nancy Locke, "New Documentary Information on Manet's Portrait of the Artist's Parents," *The Burlington Magazine*, no. 1057 (April 1991): 249–252.

14 Paul Mantz, "Exposition du boulevard des Italiens," *Gazette des Beaux-Arts*, April 1, 1863. See also Jérôme Poggi, "Les galeries du boulevard des Italiens, antichambre de la modernité, *48/14: La Revue du Musée d'Orsay*, no. 27 (Autumn 2008): 22–33.

15 Paul de Saint-Victor, *La Presse*, April 17, 1863, quoted in Darragon, *Manet*, 80.

16 For more on the history of the Salon process, see Eric Zafran's and Dominique Lobstein's contributions to this volume and Guégan, "Note sur les Goncourt."

17 W. Bürger [Théophile Thoré], "Le Salon de 1863 à Paris," *L'Indépendance Belge*, June 11, 1863, quoted in Darragon, *Manet*, 88.

18 Zacharie Astruc, "Feuilleton quotidien," *Le Salon*, May 20, 1863. See Alan Krell, "Manet's *Déjeuner sur l'herbe* in the Salon des Refusés: A Reappraisal," *The Art Bulletin*, no. 65 (June 1983): 316–320.

19 Charles Baudelaire, "Peintres et aquafortistes," *Le Boulevard*, September 14, 1862.

20 Baudelaire, *Correspondance*, vol. 2, 350–351.

21 When he decided to cut up his painting, Manet may have recalled what Gautier wrote in 1859 about the two versions of Gérôme's *The Death of Caesar* (the larger of the two showed only the emperor's body): "In the large canvas, an impression; in the small one, the truth." Théophile Gautier, "Salon de 1859," *Le Moniteur Universel*, April 23, 1859.

22 Théophile Gautier, "Salon de 1864: 8ᵉ art," *Le Moniteur Universel*, June 25, 1864.

23 Ibid. Gautier: "One cannot imagine an apotheosis reduced to more bourgeois and modest proportions. . . . One immediately recognizes Champfleury, the father and apostle of Realism in literature; Charles Baudelaire, Manet, de Balleroy, Whistler, the artist of the remarkable *White Girl*, which made such an impact last year at the Salon des Refusés; Fantin-Latour in person, Duranty, and two or three others whose faces are not familiar enough for me to put names on them with certainty." Gautier did not mention the painters Louis Cordier and Alphonse Legros or the engraver Félix Bracquemond.

24 Quoted in Juliet Wilson-Bareau, ed., *Manet par lui-même: Correspondance et conversations, peintures, pastels, dessins et estampes* (Paris: Éditions Atlas, 1991), 32.

25 Théophile Gautier, "Salon de 1865: VI," *Le Moniteur Universel*, June 24, 1865.

26 On the New Painting of the 1860s and Manet's role, see Gary Tinterow and Henri Loyrette, *Origins of Impressionism* (New York: Metropolitan Museum of Art, 1994).

27 Émile Zola, "Salon de 1866," *L'Événement*, April 27, 1866.

28 Quoted in Wilson-Bareau, *Manet par lui-même*, 38.

29 Théophile Gautier, "Salon de 1866," *Le Moniteur Universel*, July 4, 1866.

30 On the very complicated elaboration of the painting, see Douglas Druick's precise investigation in *Fantin-Latour*, by Douglas Druick and Michel Hoog (Ottawa: National Gallery of Canada, 1983), 179–190. However, Jules Lefebvre's *Truth* (cat. 3) could not have inspired Fantin-Latour, as Druick suggests. The painting was exhibited at the 1870 Salon, not at the one in 1859, which means it could not possibly have been a source for Fantin-Latour.

31 On Manet and Astruc, see Fried, *Manet's Modernism*.

32 Fantin-Latour, while painting *The Toast!*, had in mind the meetings of the Société des Aquafortistes, for lack of another group inspired by a more unifying aesthetic ideal. On November 12, 1864, he attended the Société's annual banquet and disapproved of the anti-imperial political bent expressed at the meeting. Manet, Ribot, and Astruc were present. See Druick and Hoog, *Fantin-Latour*, 182.

33 Quoted in Wilson-Bareau, *Manet par lui-même*, 43.

34 See, for example, Bazille's reaction in a letter to his parents: "The Salon is the most mediocre one I've seen yet, at the Exposition Universelle there are twenty or so fine canvases by Millet and Corot. Courbet and Manet's private exhibitions will be opening soon, and I'm eager to see them." Quoted in Michel Schulman, *Frédéric Bazille: Catalogue raisonné* (Paris: Éditions de l'Amateur, 1995), 356.

35 Théophile Gautier, "Salon de 1868," *Le Moniteur Universel*, May 11, 1868.

36 See Darragon, *Manet*, 152.

37 Gautier, "Salon de 1868."

38 Quoted in Cachin and Moffett, *Manet*, 285.

39 See, finally, regarding this key painting, the summary by John Elderfield in *Manet and the Execution of Maximilian* (New York: Museum of Modern Art, 2006).

40 Bazille to his father, April 9, 1869, quoted in Schulman, *Frédéric Bazille*, 372.

41 Bazille to his father, May 2, 1868, quoted in ibid., 373.

42 Théophile Gautier, "Salon de 1869: II," *L'Illustration*, reprinted in Théophile Gautier, *Tableaux à la plume* (Paris: Charpentier, 1880), 284–285.

43 See Philip Nord, *Impressionists and Politics: Art and Democracy in the Nineteenth Century* (London: Routledge, 2000).

44 Manet to Eva Gonzalès, November 19, 1870, quoted in Wilson-Bareau, *Manet par lui-même*, 60.

45 See Juliet Wilson-Bareau and David Degener, *Manet and the Sea* (New Haven, Conn.: Yale University Press, 2004).

46 Hans, "La semaine fantaisiste," *L'Opinion Nationale*, quoted in Darragon, *Manet*, 203.

47 On Manet's political stance after the Commune, his ties with Léon Gambetta's circle, and his attitude regarding the Salon's latest crackdown, see John Hutton, "The Clown at the Ball: Manet's *Masked Ball of the Opera* and the Collapse of Monarchism in the Early Third Republic," *Oxford Art Journal* 10, no. 2 (1987): 76–94.

48 See Samuel Rodary, "Courbet Manebit," *Ironie*, no. 135 (December 2008–January 2009), http://ironie.free.fr/iro_135.html.

49 Albert Wolff, "Le terrible Manet," *Le Figaro*, May 13, 1873, quoted in Darragon, *Manet*, 217.

50 Théodore de Banville, "Feuilleton du *National*: Salon de 1873; Deuxième article," *Le National*, May 15, 1873.

51 See Juliet Wilson-Bareau, *Manet, Monet, and the Gare Saint-Lazare* (Washington, D.C.: National Gallery of Art; New Haven, Conn.: Yale University Press, 1998), particularly 150–165.

52 Degas to James Tissot, February–March 1874 (Paris: Bibliothèque Nationale de France), quoted in Charles S. Moffett, "Manet and Impressionism," in Cachin and Moffett, *Manet*, 29. See also Ina Conzen et al., *Édouard Manet und die Impressionisten* (Ostfildern-Ruit, Germany: Hatje Cantz, 2002).

53 Quoted in Pierre Vaisse, *La Troisième République et les peintres* (Paris: Flammarion, 1995), 114.

54 Quoted in Anne Distel, *Renoir: "Il faut embellir"* (Paris: Découvertes Gallimard, 1993), 78.

55 See in particular Geneviève Lacambre, *Le Musée du Luxembourg en 1874* (Paris: Grand Palais, 1974).

56 See the letter from Manet to Hector de Callias, about 1873–1874, reproduced in Luce Abélès, *La dame aux éventails: Nina de Callias, modèle de Manet* (Paris, Musée d'Orsay, 2000), 82.

57 Stéphane Mallarmé, "The Impressionists and Édouard Manet," *The Art Monthly Review*, September 30, 1876.

58 Stéphane Mallarmé, "Le jury de peinture pour 1874 et M. Manet," *La Renaissance Littéraire et Artistique*, April 12, 1874.

59 Quoted in Cachin and Moffett, *Manet*, 355.

60 Mallarmé, "The Impressionists and Édouard Manet."

61 Juliet Wilson-Bareau and Malcolm Park, *Division and Revision: Manet's* Reichshoffen *Revealed* (London: Paul Holberton, 2008).

62 From the moment Jules Grévy came to power and Jules Ferry was nominated minister of education and culture, Manet would make his presence known to the Republic's new authorities. In May 1879 he met Edmond Turquet, undersecretary of state for fine arts, and tried to convince him to buy, for the Musée du Luxembourg, a painting that "had the sanction of the Salon" (as quoted in Cachin and Moffett, *Manet*, 437). Why not buy *Le bon bock*, a painting with clear patriotic resonance, which had been successfully presented at the Salon in 1873 and which the artist had bought back at the Faure sale on April 23, 1878? But Manet had no success with the ministry until Turquet was replaced by Antonin Proust in November 1881. A month later he was appointed chevalier of the Légion d'Honneur. It still meant a great deal to Manet and to his ambition as an artist to succeed at the Salon.

63 On the larger version of *The Escape of Rochefort* (Kunsthaus Zürich) as a potential painting for the Salon, see John House's review of the exhibition *Manet and the Sea* in *The Burlington Magazine* 146 (April 2004): 286–288.

64 See Patricia Mainardi, *The End of the Salon: Art and the State in the Early Third Republic* (New York: Cambridge University Press, 1993).

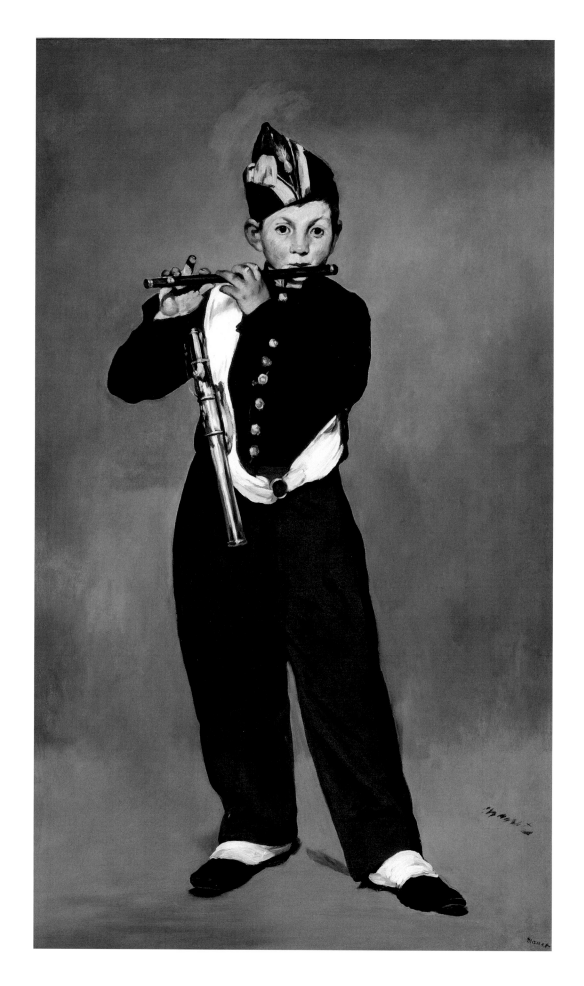

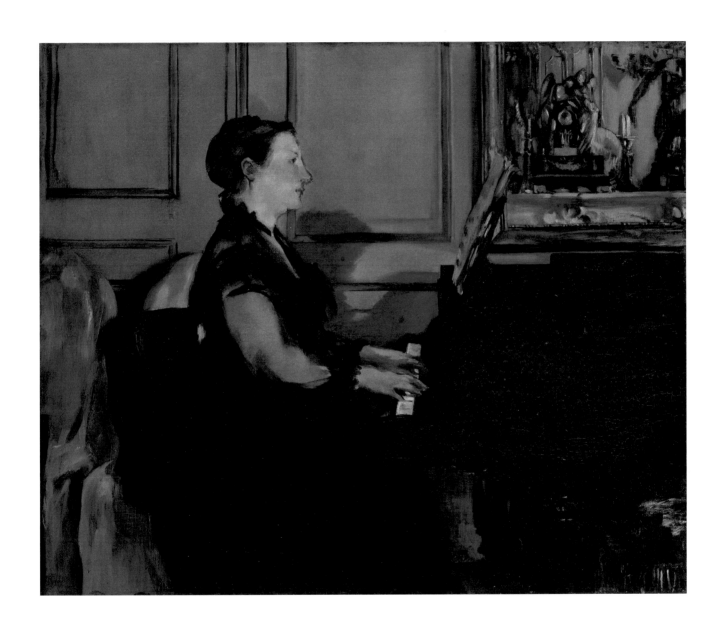

32
ÉDOUARD MANET
The Fifer (*Le fifre*), 1866
Oil on canvas
63 × 38 1/4 in. (161 × 97 cm)

33
ÉDOUARD MANET
Madame Manet at the Piano (*Madame Manet au piano*), 1868
Oil on canvas
15 × 18 1/4 in. (38 × 46.5 cm)

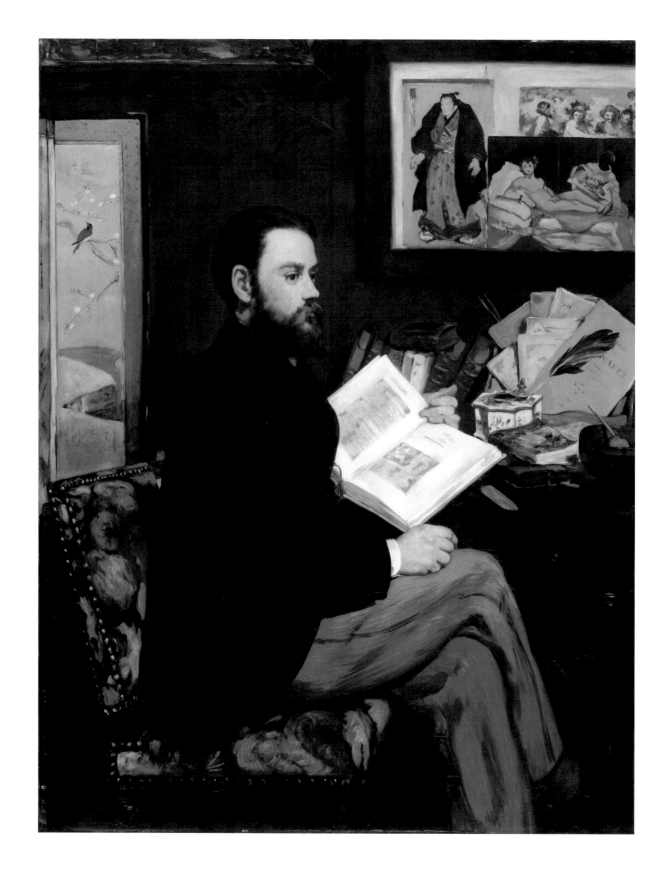

34

ÉDOUARD MANET

Émile Zola, 1868

Oil on canvas

57 5/8 × 44 7/8 in. (146.5 × 114 cm)

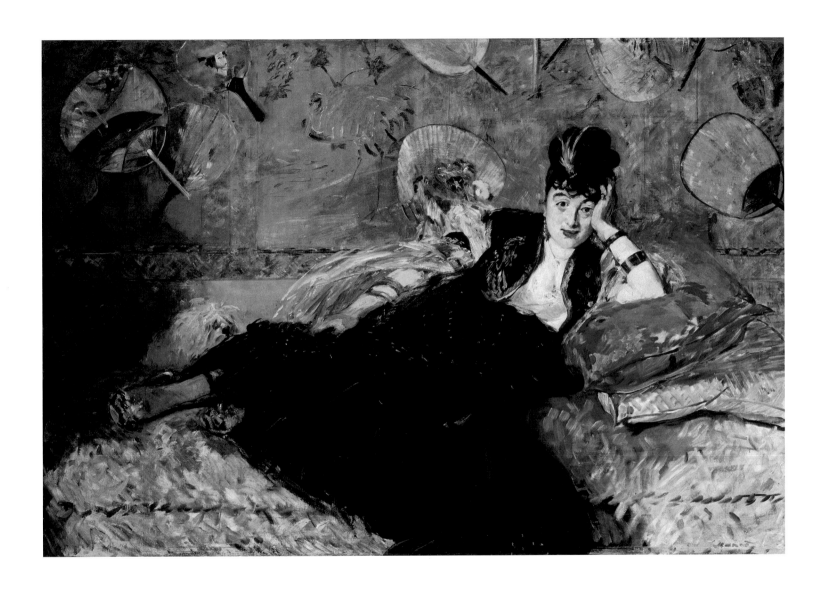

35

ÉDOUARD MANET

Woman with Fans (*La dame aux éventails*), 1873
Oil on canvas
44⅝ × 65½ in. (113.5 × 166.5 cm)

Exhibited at the Salon in 1868, Manet's portrait of Zola, his great advocate, illuminates the aesthetic interests of their progressive circle. The influential critic is surrounded by symbols of his (and Manet's) avant-garde tastes, including an engraving by Diego Velázquez, a reproduction of *Olympia* (fig. 21)—one of Manet's most controversial paintings—and a Japanese print and screen. Similar Oriental details animate *Woman with Fans*, a portrait of Nina de Callias. A writer and poet, she hosted salons for the Parisian cultural set.

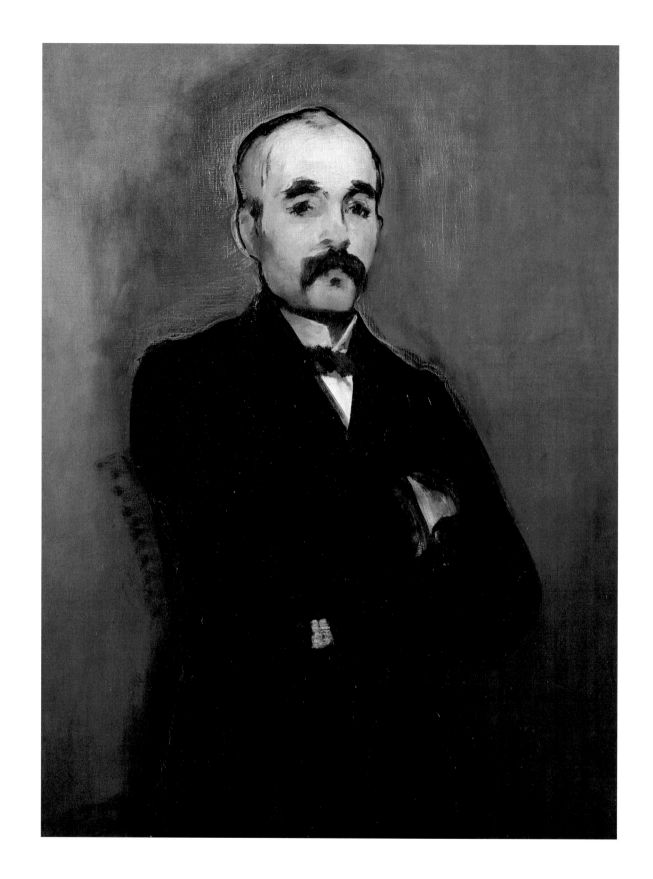

36

ÉDOUARD MANET

Georges Clemenceau, 1879–1880

Oil on canvas

37 1/4 × 29 1/8 in. (94.5 × 74 cm)

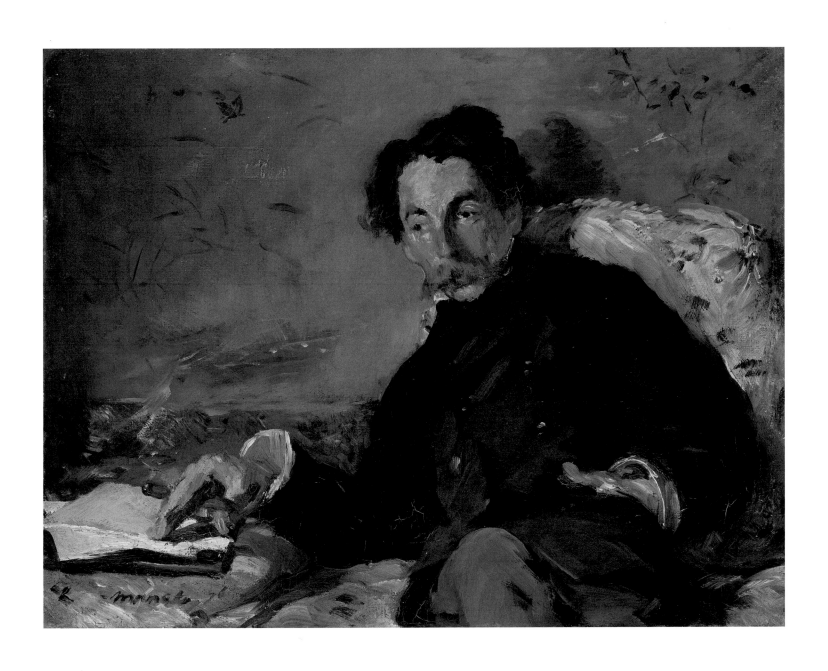

37

ÉDOUARD MANET

Stéphane Mallarmé, 1876
Oil on canvas
10 7/8 × 14 1/8 in. (27.5 × 36 cm)

Manet painted this portrait of Mallarmé, which the poet and critic described as a "curious wee painting," to commemorate their friendship. The men met nearly every day for ten years to share ideas and discuss topics ranging from art to literature to women's fashion. Their close companionship is suggested by Mallarmé's candid, informal pose and nonchalant gesture. This freely brushed portrait remained in the collection of the poet's family for more than fifty years.

MANET: BETWEEN TRADITION AND INNOVATION

ALICE THOMINE-BERRADA

•

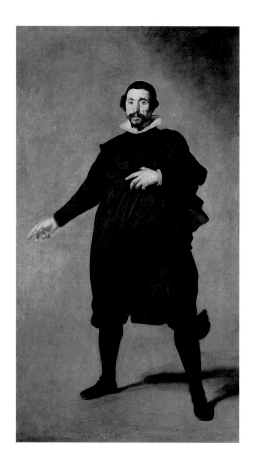

FIG. 32 **DIEGO VELÁZQUEZ**
Pablo de Valladolid, ca. 1635
Oil on canvas
82 ¼ × 48 ⅜ in. (209 × 123 cm)
Museo Nacional del Prado, Madrid, P01198

Now recognized as the pivotal figure between the Salon establishment and the young French avant-garde, Édouard Manet dealt with the Impressionists with some ambivalence, simultaneously embracing them and holding them at arm's length. While the critics were frequently offended by Manet's abuse of traditional narrative and aesthetic conventions, younger artists were drawn to him admiringly, establishing an informal group with Manet at its center. "M. Manet is not just anyone: he has a school, admirers, even fanatics; his influence extends much farther than you would think. M. Manet has the honor of being a danger," Théophile Gautier wrote, presciently, in his review of the Salon of 1865.[1] Similarly, Manet's relationship with the art of the past was complex and nuanced. The perceived innovations of his subjects, compositions, and technique were frequently responses to canonical artworks that he studied in the museums of Paris and abroad. Indeed, Manet demonstrated an ability to translate French, Dutch, and Spanish Old Masters into a modern vocabulary meaningful to his contemporary audiences.

References to works of the past play an essential role in Manet's oeuvre. The artist regularly copied canvases at the Louvre, where he was particularly drawn to Spanish painting. Manet's friend Charles Baudelaire no doubt had something to do with his fascination with Spain, already as of 1830 very fashionable with the generation of the Romantics. Manet would discover the country itself during a visit in August 1865. Before and after his trip, he produced a number of works clearly influenced by Diego Velázquez and Francisco de Goya. The Spanish quality of *Angélina* (1865, cat. 12) is rendered not simply by the presence of the figure's traditional mantilla but also stylistically, through the preponderance of black and brown tones and the strong side lighting. Historians have encountered considerable difficulty in establishing the exact source for this painting—proof of the virtuosity with which Manet transformed his influences in order to make them his own. Angélina's harsh, almost caricatured, features found little favor with the critics when the painting was exhibited for the first time, in 1867, at Manet's place de l'Alma pavilion.

Also shown in the pavilion was *The Fifer* (cat. 32), one of the paintings rejected by the 1866 Salon jury. This portrait of a young musician in the Garde Impériale, painted when Manet had just returned from Spain, is also marked by memories of Velázquez. It should be compared

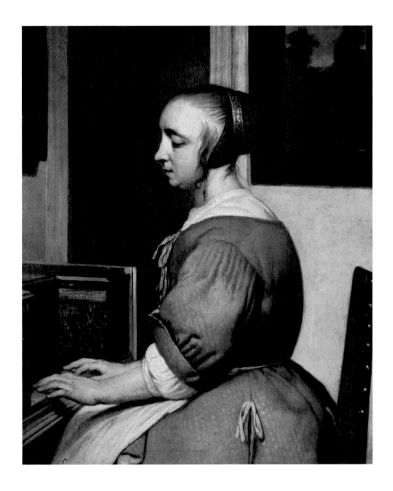

with Velázquez's portrait *Pablo de Valladolid* (ca. 1635, fig. 32), which Manet had admired in a letter to Henri Fantin-Latour: "The background disappears, it is air that surrounds the fellow all dressed in black and alive."[2] In *The Fifer*, Manet, like Velázquez, used a monochromatic background, accentuating the contrast between red, gray, and black in the young boy's clothing. Critics denounced the painting's simplicity, comparing it to the flat, schematic figures found in the popular prints known as *images d'Epinal*.[3] Émile Zola was one of the few to defend the work, recognizing in it the influence of Japanese prints.[4] He had noticed it in Manet's studio in 1866 and sang its praises in his review of that year's Salon. Manet, very upset by the jury's rejection, was greatly moved by Zola's words and consequently wrote a letter to the critic that signaled the beginning of their friendship.

Executed soon afterward, *Madame Manet at the Piano* (1868, cat. 33) depicts the Dutch pianist Suzanne Leenhoff, whom the artist had met in 1849 when she was giving lessons to his brothers. He married her in 1863. Painted in Manet's mother's apartment on rue de Saint-Pétersbourg, the scene includes the clock that the king of Sweden had given Manet's mother as a wedding present (she belonged to a family of diplomats).[5] Here the painter makes a virtuosic display of the light gray tones he favored, which are ideal for the intimacy of the scene. Manet certainly took inspiration from *A Woman at the Clavichord* (17th century, fig. 33) by the Dutch artist Gabriel Metsu, reproduced in the first volume of Charles Blanc's *L'histoire des peintres* (1861), one of the most important books in Manet's studio.[6] While the reference to the Dutch school was naturally part of an overall rediscovery of seventeenth-century Realist painting, it also allowed Manet to give an affectionate nod to his wife's nationality.

The artist painted another canvas rooted in the Dutch tradition, *Moonlight over the Port of Boulogne* (cat. 39), in the summer of 1869. It was inspired by his memories of the nocturnal seascapes by Claude-Joseph Vernet in the Louvre but also brings to mind a seventeenth-century seascape by Aert van der Neer in Manet's own collection. Personal experiences also came into play; the painting depicts Boulogne-sur-Mer, where Manet had taken his family the previous summer. The window of his hotel room overlooked the port, busy with fishing boats and passenger ships embarking for England. In the painting he portrayed the bustle of the harbor at night and women awaiting the return of the fishing fleet. Manet's friend the Belgian artist Alfred Stevens, who particularly appreciated this canvas, insisted that Manet send it to the 1869 Salon in Brussels. There, for the first time, Manet was well received by the critics.

Ten years after he painted *Olympia* (1863, fig. 21), Manet revived the theme of the reclining woman in *Woman with Fans* (1873, cat. 35), his second reinterpretation of Titian's *Venus of Urbino* (1538, Uffizi Gallery, Florence). The Venus represented was a very modern woman, Nina de Callias, who had briefly been the wife of Hector de Callias, a capricious yet generous journalist who welcomed writers and artists to his table. Manet was introduced to his subject by his friend Charles Cros, a poet, inventor, and Nina's lover of ten years. Painted in Manet's studio—the screen in the background is the same one used in the portrait of Stéphane Mallarmé (1876, cat. 37) and *Nana* (1877, Hamburger Kunsthalle, Germany)—the canvas conveys the unconventional atmosphere that reigned in Nina's private residence. The model, dressed in the Oriental style, lies back against the cushions in a pose that is both nonchalant and lively. Behind her is an arrangement of fans, a decorative device that had previously been used by James Abbott McNeill Whistler, James Tissot, and Pierre Auguste Renoir; here it serves to accentuate the subject's exotic personality. The extreme expressiveness of her face corresponds with the poetic portrait drawn by Paul Verlaine, a habitué of Nina's salon: "a hellish spirit / with the laughter of a lark."[7] Although he possibly intended it for the 1874 Salon, Manet was never able to exhibit this painting; Hector de Callias refused to allow his ex-wife, and his name, to be put on display.

It was no doubt through Nina that Manet made the acquaintance of Mallarmé in 1873.[8] They became close friends over daily conversations in Manet's studio. The two men had a great deal in common, including a particular sensibility toward feminine elegance. Manet completed Mallarmé's portrait in October 1876 and went on to collaborate with him on illustrations for Edgar Allan Poe's "The Raven" (1875) and Mallarmé's own "Afternoon of a Faun" (1876). Importantly, Mallarmé had written two forceful articles in Manet's defense, in 1874 and 1876; the latter was published in English shortly before the portrait was finished.[9] The portrait's small format, along with the poet's relaxed and dreamy pose and the evanescent nature of his cigar smoke, give the painting an intimate feel. The emphasis on Mallarmé's hand, laid delicately upon a few sheets of paper, suggests his activity as a poet as well as the articles he wrote about Manet.

During the same era, Manet, loyal to his bourgeois origins, continued to cultivate more conventional friendships, as shown by his portrait of Marguerite de Conflans (ca. 1876, cat. 42). He had long been a close friend of her parents, art lovers who frequented the salons of Manet's mother and wife. According to Étienne Moreau-Nélaton, it was through them that Manet first discovered Goya.[10] Having portrayed the young Marguerite on four other occasions, Manet was at his most original with this composition. It is distinguished by the use of a mirror, a device Manet borrowed from Jean-Auguste-Dominique Ingres that would assume a very important role in

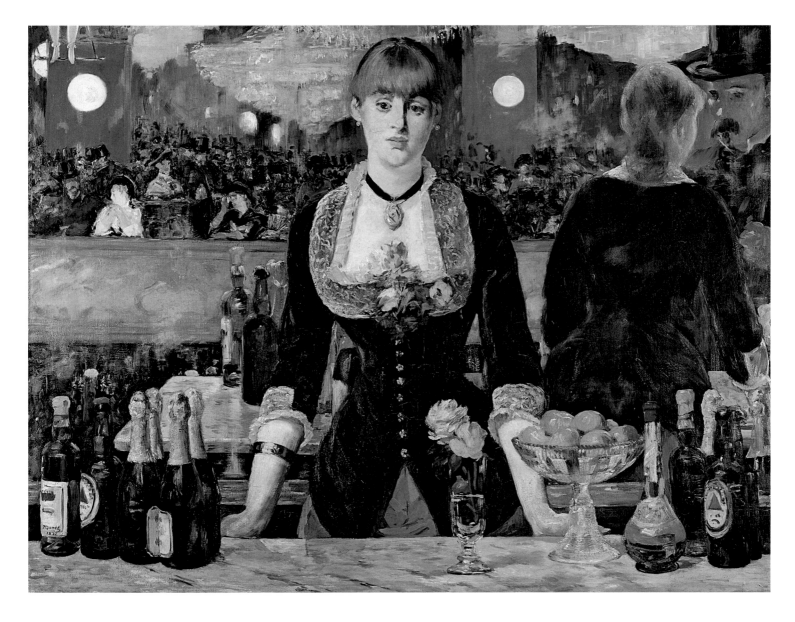

A Bar at the Folies-Bergère (1882, fig. 34). With its clear tonalities and play of transparent effects, the portrait demonstrates the influence of the light palette favored by Manet's Impressionist friends. Both its intimate subject matter and its technique are particularly reminiscent of the work of Berthe Morisot; indeed, the likeness of Marguerite is a luminous counterpart to *Berthe Morisot with a Bouquet of Violets* (1872, cat. 38), a brilliant display of Manet's mastery of the dark tones of Dutch and Spanish painting.

In addition to portraiture, Manet continued to paint contemporary history, a subject of lesser interest to his Impressionist colleagues. For Manet, the desire to give new life to historical painting had an ideological dimension, particularly during the early 1870s. Though he disapproved of the excesses of the Commune, he was a confirmed supporter of the Republic. He shared the convictions of his brothers: Eugène, who under the Second Empire had close ties with the famous Republican lawyer Emile Ollivier, and Gustave, elected a member of the notoriously left-wing municipal council of Paris in 1874. In 1879, as the Republican left was becoming established, Manet began work on a portrait of the movement's leading figure, Georges Clemenceau (cat. 36), whom Manet probably met through his brothers.[11] With great economy of means—few

brushstrokes and a limited color range—the painter managed to convey the determination and energy of the politician. Clemenceau's intransigent pose reflects his uncompromising political resolve. Elected to the Paris Chamber of Deputies in 1876, Clemenceau began to wage the battles that would make him famous, including a campaign for amnesty on behalf of the Communards—an effort that informed Manet's canvas *The Escape of Rochefort* (ca. 1881, cat. 45).

A journalist and politician who strongly opposed the Second Empire, Henri Rochefort was deported to the French colony of New Caledonia in 1873 for his participation in the Commune. He managed to escape the following year but returned to France in 1880 only by way of Clemenceau's amnesty. Manet met Rochefort in 1880, probably at Nina de Callias' salon or through his friend the engraver Marcellin Desboutin, a relative of Rochefort's. According to Claude Monet, Manet set to work on his painting of the escape in December 1880 with a view to making "a sensational painting for the Salon."[12] Manet's aim was to create a composition that combined contemporary history and seascape, not unlike his 1864 painting *The Battle of the* Kearsarge *and the* Alabama (Philadelphia Museum of Art), which depicts a sea engagement of the American Civil War. Eager to ensure historical accuracy, Manet interviewed Rochefort several times and even had a boat set up in his garden. Uncertain of the painting's accuracy as reportage, Manet ultimately decided against exhibiting the painting at the 1881 Salon.

The Escape of Rochefort was, with *A Bar at the Folies-Bergère*, one of Manet's last great compositions. In the early 1880s, the painter began to suffer from the late stages of syphilis and devoted himself primarily to small still-life paintings, often given to friends. Thus he returned to a practice developed fifteen years earlier under the influence of Dutch painting. The tiny masterpiece *Asparagus* (1880, cat. 43) was sent to Charles Ephrussi, the director of the *Gazette des Beaux-Arts*, to thank him for paying a thousand francs for a still life that Manet had priced at eight hundred. With the painting Manet sent a little note: "There was an asparagus missing from your bunch."[13] Another still life, *Flowers in a Crystal Vase* (1882, cat. 44), was purchased in 1882 by Dr. Thomas W. Evans, companion to the actress Méry Laurent, who had been Manet's model on several occasions. The little picture, dedicated to Evans, is a visual reminder of the flowers that the loyal Laurent often brought the artist, who was by then housebound due to illness.

The diversity of Manet's artistic production is ample proof of the ambivalence of his relationship to the Impressionist movement.[14] From 1884, the date of Manet's retrospective exhibition at the École des Beaux-Arts, his painting was considered the harbinger of the Impressionist revolution. "He was one of the most energetic instigators of light painting, studied in nature, found in the broad daylight of contemporary surroundings and which gradually drew our salons from their dark and gloomy atmosphere to cheer them with a veritable ray of sunshine," wrote his valiant herald Zola.[15] Paul Mantz expressed the same idea, though with a note of criticism: "What light colors might lead to, Manet only suspected; others will proclaim it. We see in him nothing more than a beginning. Manet is like one of those poorly awoken dawns, where night still lingers."[16] Though never sparing of support for his young friends, Manet pursued techniques that remained distinct from Impressionism. The subjects he chose, and the structured, compressed treatment he gave them, are evidence of an aesthetic ambition that was very much his own.

Translated from the French by Alison Anderson

NOTES

1 *Le Moniteur Universel*, June 24, 1865, quoted in
 Pascal Bonafoux, *Correspondances impression-
 nistes* (Paris: Selliers, 2008), 59.

2 Letter from Manet to Fantin-Latour, postmarked
 Madrid, 1865, in Pierre Courthion, ed., *Manet
 raconté par lui-même et par ses amis: Ses contem-
 porains, sa postérité, documents* (Geneva: Pierre
 Cailler, 1953), vol. 1, 44–46.

3 During the retrospective exhibition of Manet's
 work in 1884, Paul Mantz was still referring to a
 "jack of diamonds stuck on a door." "Les oeuvres
 de Manet," *Le Temps*, January 16, 1884, quoted in
 Courthion, *Manet raconté par lui-même et par ses
 amis*, vol. 2, 134.

4 Émile Zola, "Une nouvelle manière en peinture:
 Édouard Manet," *Revue du XIXe Siècle*, January 1,
 1867, quoted in Françoise Cachin and Charles S.
 Moffett, *Manet, 1832–1883* (New York: Metropoli-
 tan Museum of Art, 1983), 247.

5 Adolphe Tabarant, *Manet et ses oeuvres* (Paris:
 Gallimard, 1947), 155.

6 Theodore Reff, "Manet and Blanc's 'Histoire des
 peintres,'" *The Burlington Magazine* 112 (1970):
 456–458.

7 Quoted in Tabarant, *Manet et ses oeuvres*,
 229–230.

8 Cachin and Moffett, *Manet*, 377.

9 Stéphane Mallarmé, "The Jury for Painting in
 1874 and M. Manet," *La Renaissance Littéraire
 et Artistique*, April 12, 1874, 155–157; and "The
 Impressionists and Édouard Manet," *The Art
 Monthly Review and Photographic Portfolio* 1,
 no. 9 (September 30, 1876): 117–122.

10 Étienne Moreau-Nélaton, *Manet raconté par lui-
 même* (Paris: Henri Laurens, 1926), vol. 2, 33.

11 Philip Nord, *Les impressionnistes et la politique*
 (Paris: Tallandier, 2009), 88.

12 Letter from Monet to Théodore Duret,
 December 9, 1880, quoted in Tabarant, *Manet
 et ses oeuvres*, 403.

13 Tabarant, *Manet et ses oeuvres*, 381.

14 See Charles S. Moffett, "Manet and Impression-
 ism," in Cachin and Moffett, *Manet*, 29–35.

15 Quoted in Moreau-Nélaton, *Manet raconté par
 lui-même*, vol. 2, 108.

16 "Les oeuvres de Manet," *Le Temps*, January 16,
 1884, quoted in Moreau-Nélaton, *Manet raconté
 par lui-même*, vol. 2, 141.

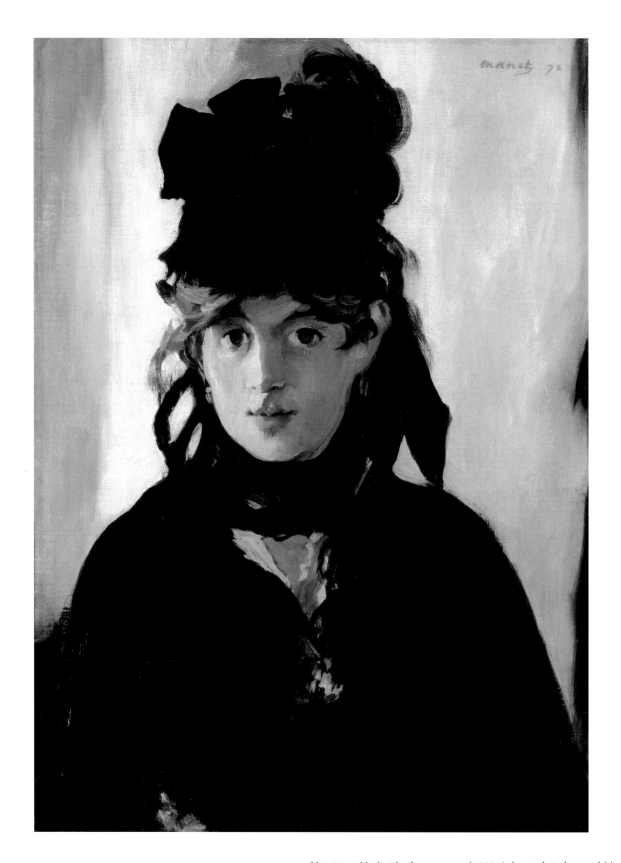

38

ÉDOUARD MANET

Berthe Morisot with a Bouquet of Violets
(*Berthe Morisot au bouquet de violettes*), 1872
Oil on canvas
21 5/8 × 15 in. (55 × 38 cm)

Manet met Morisot in the summer of 1868. A devoted student and friend of Manet's, she married his brother Eugène in 1874. Morisot became an ardent supporter of the Impressionists, participating in seven of their group shows as an organizer and exhibitor. Her bold ambition is suggested by Manet's forthright portrait. The work's striking tonal contrast reflects the artist's affinity for the approach of the Spaniards Diego Velázquez and Francisco de Goya.

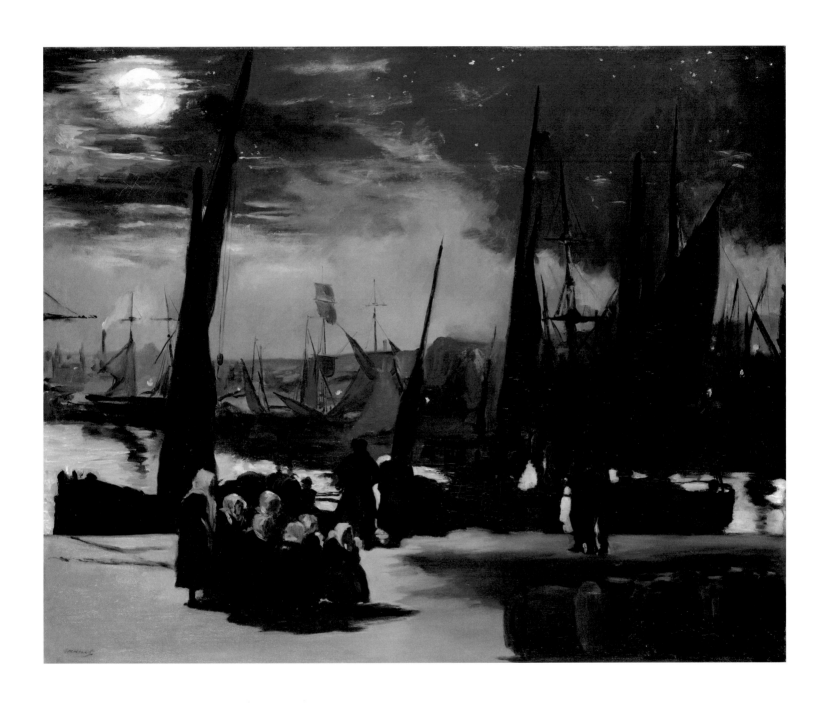

39

ÉDOUARD MANET

Moonlight over the Port of Boulogne (*Clair de lune sur le port de Boulogne*), 1869

Oil on canvas

32¼ × 39¾ in. (82 × 101 cm)

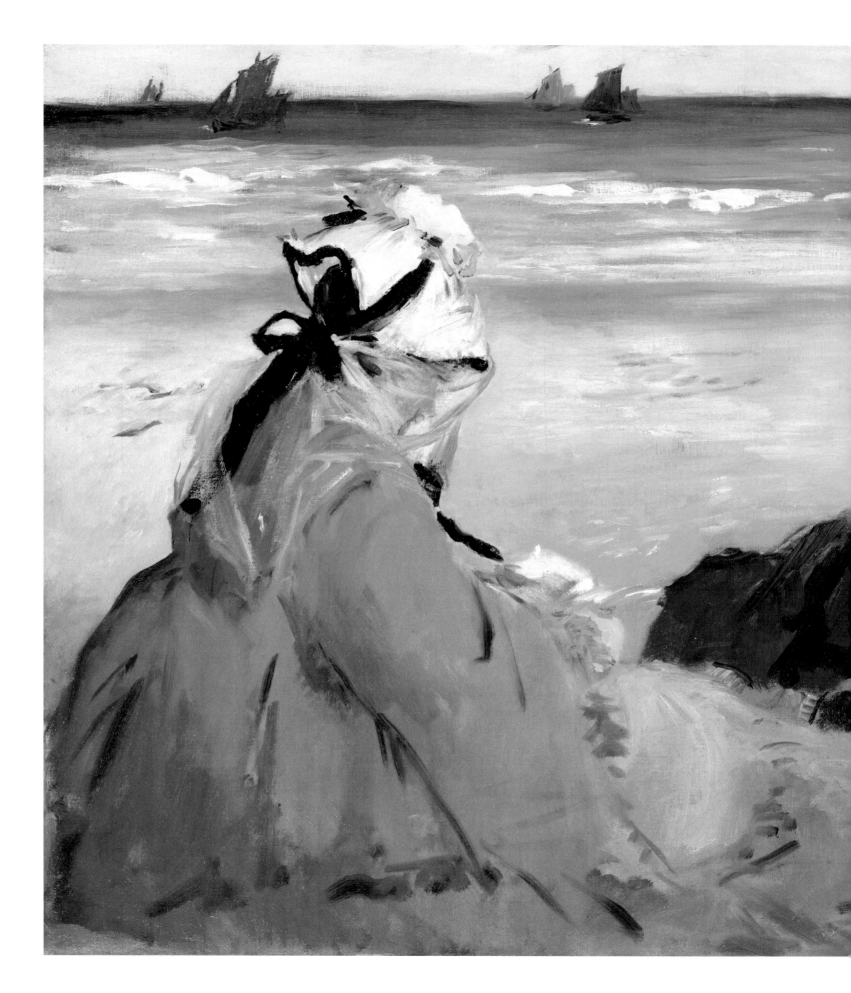

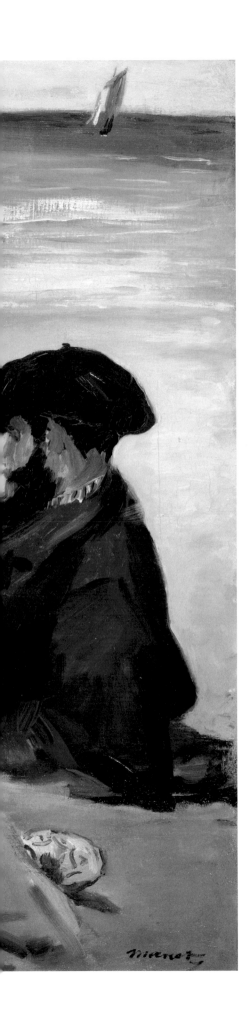

40
ÉDOUARD MANET
On the Beach (Sur la plage), 1873
Oil on canvas
23 ¼ × 28 ¾ in. (59 × 73 cm)

Manet and his family often vacationed along the French coast. Here, he sketched his wife, Suzanne, and his brother on the beach at Berck-sur-Mer. The grains of sand embedded in the paint surface are evidence that the artist worked *en plein air*. Progressive pictorial elements include the flat, simplified forms, which reflect Manet's interest in Japanese prints. The picture subsequently belonged to the couturier Jacques Doucet and is presented in an Art Deco frame that dates from his ownership.

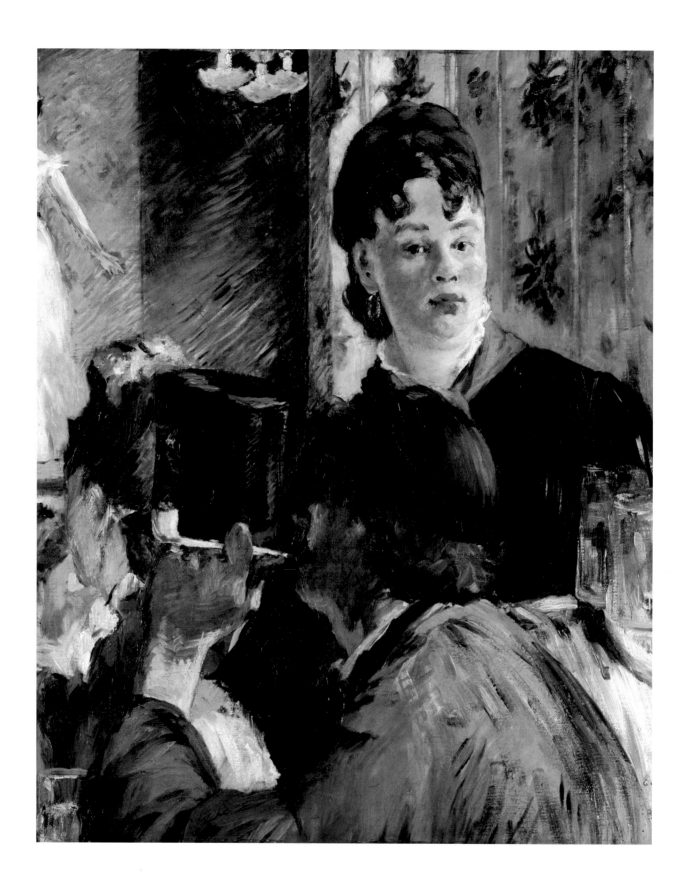

41

ÉDOUARD MANET

The Beer Waitress (*La serveuse de bocks*), 1878–1879
Oil on canvas
30 ½ × 25 ⅝ in. (77.5 × 65 cm)

This animated café scene presents a sliver of contemporary Parisian life. The woman's direct gaze, the handling of the paint, and the tight cropping of the composition mark the canvas as a bold and modern departure from the hierarchy of academic history painting.

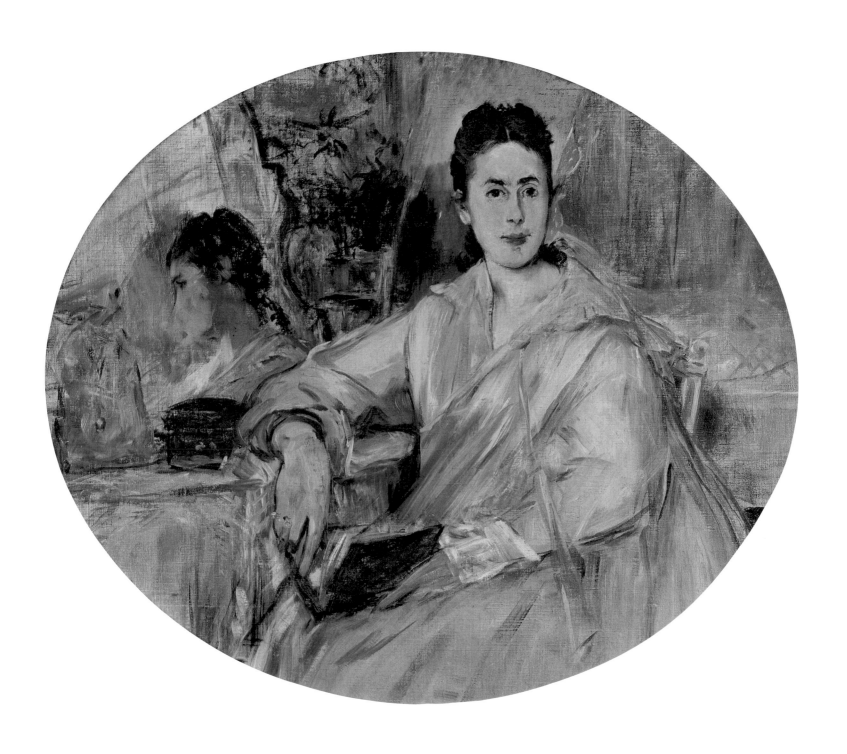

42

ÉDOUARD MANET

Marguerite de Conflans, ca. 1876

Oil on canvas

20 7/8 × 25 1/4 in. (53 × 64 cm)

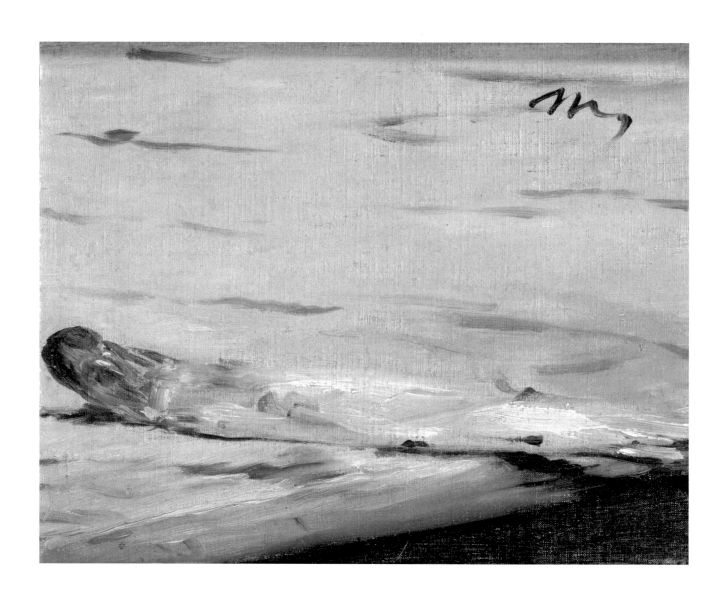

43
ÉDOUARD MANET
Asparagus (L'asperge), 1880
Oil on canvas
6 ½ × 8 ½ in. (16.5 × 21.5 cm)

44
ÉDOUARD MANET
Flowers in a Crystal Vase (Fleurs dans un vase de cristal), 1882
Oil on canvas
21 ½ × 13 ⅞ in. (54.6 × 35.2 cm)

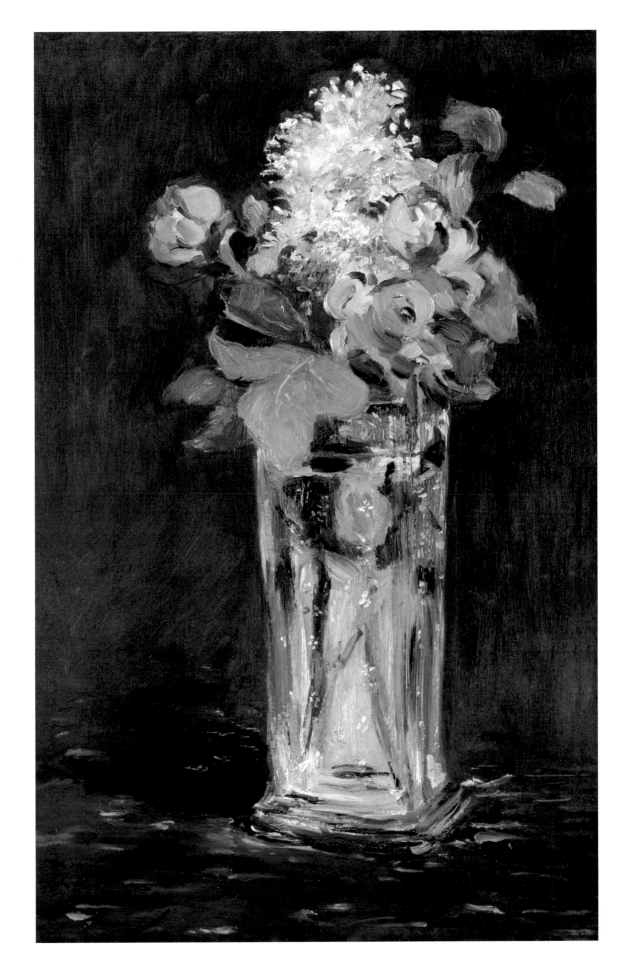

MANET ON VIEW

45
ÉDOUARD MANET
The Escape of Rochefort (*L'évasion de Rochefort*), ca. 1881
Oil on canvas
31 1/2 × 28 3/4 in. (80 × 73 cm)

Henri Rochefort founded the controversial political
journal *La Lanterne* and was actively opposed to the im-
perial regime of Napoléon III; this led to his involvement
in the Paris Commune, for which he was imprisoned.
Manet depicts Rochefort's daring escape from a French
prison colony in New Caledonia. Intended for the Salon
of 1881, Manet's political commentary transforms the
recent past into modern history.

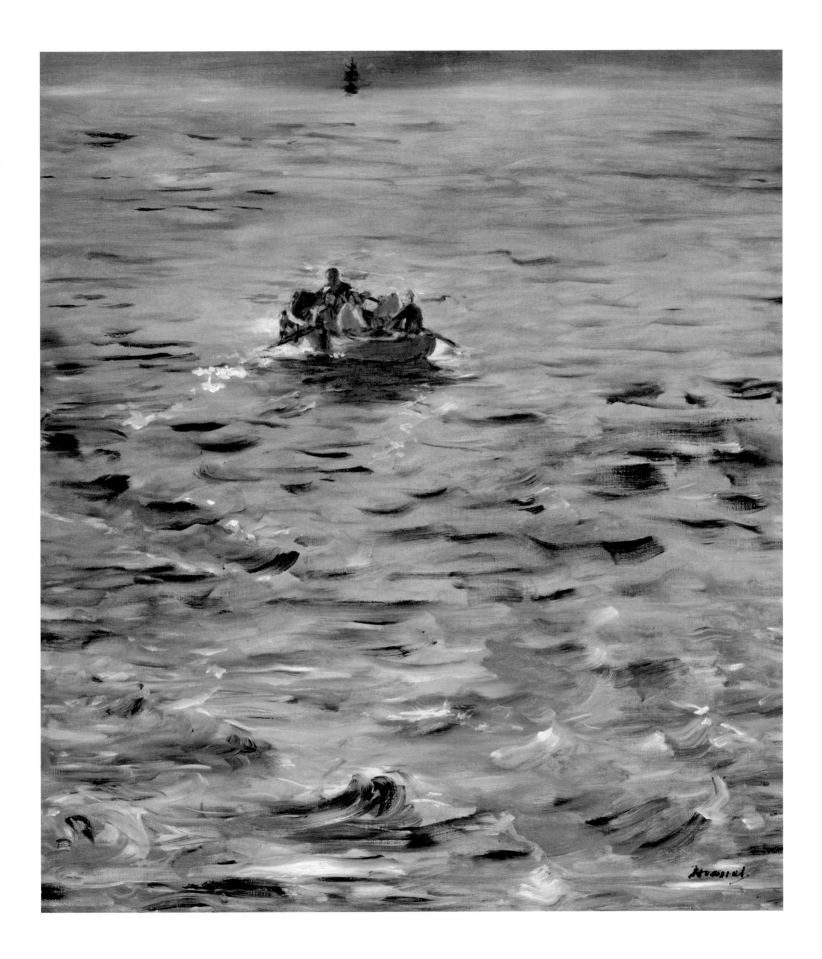

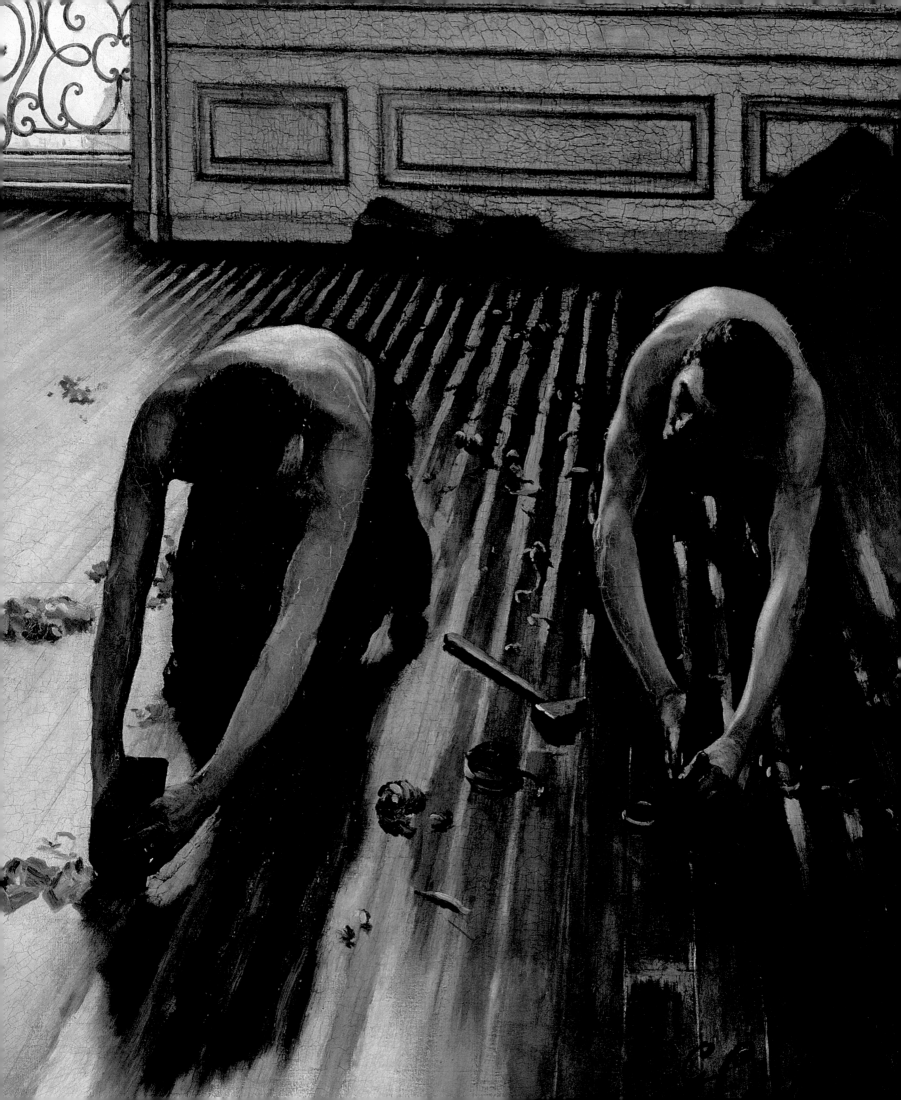

IMPRESSIONISM AND THE NEW PAINTING

CHARLES S. MOFFETT

.

I believe I have already spoken about the small group of painters who call themselves Impressionists. To me, this term seems unfortunate; but it is nonetheless undeniable that these Impressionists—since they insist upon the name—are at the head of the modern movement.

ÉMILE ZOLA, 1879

The emergence of an avant-garde movement is clear only in retrospect. With the benefit of decades of hindsight, we are better able to understand what happened, but even then there are differing interpretations and points of view. For example, the Marxist perspective that was so popular and prevalent in the 1980s had a particular lens through which to analyze developments in French painting during the second half of the nineteenth century. The history of art began to take on a kaleidoscopic character, inflected by economic, social, literary, political, and intellectual history. In many ways the variety of viewpoints enriched our understanding of how and why Impressionism and the New Painting emerged. In contradistinction, the essay that follows is an attempt to focus principally on the fundamentals of what occurred. To borrow the words of Wallace Stevens, it is concerned with "the thing itself" rather than "ideas about the thing."[1]

Many authors have noted that it is impossible to write history because they are inevitably influenced by the tenor of their times. The view in the rearview mirror is never complete and is compromised experientially with the passage of time. As certain new ideas and points of view become fashionable, our thinking is shaped at any given moment by schools, universities, journalists, critics, teachers, professors, books, articles, documentaries, press releases, advertisements, and a wide range of media (newspapers, magazines, television, the Internet). As Lionel Trilling once wrote, we are all "of this time, of that place."[2] John Fowles offers a brilliant variation on this theme in his novella *The Ebony Tower* (1975), with specific reference to art history, criticism, and the gravitational pull of major artists.

Today, how do we answer when someone asks who the greatest young artists are? Which writers, painters, sculptors, graphic artists, draftsmen/women, photographers, filmmakers, video artists, architects, and musicians will make meaningful contributions and perhaps change the history of their disciplines? In Paris during the 1860s and 1870s, how would one have answered? As is the case today, very few people had a good response. Sorting out an emerging avant-garde is always difficult, and only a few prescient and well-informed individuals are ever able to see over the horizon. The artists categorized today as Impressionists were mocked and derided when they first began to show their work. People left their early exhibitions muttering the same sort of invective that one is likely to hear today as visitors leave the Whitney Biennial. The problem, of course, is not dissimilar. The good, the mediocre, and the bad are mixed together. One must work to distinguish between the meritorious and the meretricious.

The narrative—the *history,* or more simply, the *story*—of Impressionism or the New Painting is perhaps the best means to understand its nature and its goals. The mise-en-scène is familiar: in Paris during the early 1860s a group of artists came to know one another at art schools and through conversations in gathering places such as the Café Guerbois and later the Café de la Nouvelle-Athènes. In an 1867 letter to his family, Frédéric Bazille described the frustrated plans of "a group of young people" to arrange exhibitions of their own work independent of the officially sanctioned, juried exhibitions known as the Salons.[3] The members of the group, whom Bazille did not name, were most probably Claude Monet, Pierre Auguste Renoir, Alfred

PAGE 126
GUSTAVE CAILLEBOTTE
The Floor Scrapers (*Raboteurs de parquet*), 1875
Detail of cat. 50

Sisley, Camille Pissarro, Paul Cézanne, Henri Fantin-Latour, Édouard Manet, Antoine Guillemet, Edgar Degas, Berthe Morisot, Félix Bracquemond, Armand Guillaumin, and, of course, Bazille himself. The project collapsed shortly thereafter because of a lack of money.

But money was only one issue. The art establishment—including the Ministry of Culture, the Salon jury, professors at the École des Beaux-Arts, the Académie des Beaux-Arts, and all of those with a vested interest in maintaining the status quo—militated against the rise of the group of artists whose work offered an alternative to traditional ideas about style and subject matter and challenged the thinking of those empowered to distinguish between "good" and "bad" art. Stéphane Mallarmé described the situation bluntly:

> In 1867 a special exhibition of the works of Manet and some few of his followers gave the semblance of a party to the then nameless school of recent painting which thus grew up, and party strife grew high. The struggle with this resolute intruder was preached as a crusade from the rostrum of each school. For several years a firm and implacable front was formed against its advance.[4]

The power and influence of long-established and deeply entrenched institutions notwithstanding, the "resolute intruder" persevered. In 1869 Bazille reported to his parents that "a dozen talented people" had decided to rent a space in order to hold nonjuried exhibitions of their own work as well as that of others by invitation.[5] It is very likely that the revitalized project had resulted from the efforts of, among others, the group portrayed in Fantin-Latour's *A Studio in the Batignolles* (1870, cat. 47): Otto Scholderer, Manet, Renoir, Zacharie Astruc, Émile Zola, Edmond Maître, Bazille, and Monet. The central figure in the painting is Manet, who sits before an easel as if offering instruction to the others. Ironically, the painting was shown in the Salon of 1870. Key members of the avant-garde had found their way into the Salon but not in the guise they had hoped for.

In the late 1860s Manet emerged as the key figure among the avant-garde painters in their Monday-evening gatherings at the Café Guerbois. Older artists such as Constantin Guys and the photographer Nadar were included, as were the writers Zola, Armand Silvestre, Théodore Duret, and Louis-Émile-Edmond Duranty, who later defined the modern movement in the brilliant essay *La nouvelle peinture* (*The New Painting*), published as a pamphlet after the second Impressionist group show in 1876. The principal painters who participated in the *causeries* were Fantin-Latour, Marcellin Desboutin, Degas, Renoir, Cézanne, Sisley, Monet, Bazille, and Pissarro. It was an extraordinary assemblage of intellectual, artistic, and literary talent. By about 1870, the informal confederation of the most advanced painters and authors in Paris was more or less complete. As a group, they constituted a force that would not be stopped, even by the intervention of the Franco-Prussian War (1870–1871) and the subsequent violent civil upheaval known as the Commune (1871).

Ideas were exchanged, advanced, argued, and defended at the Café Guerbois, which served as the crucible of the Impressionist movement. In the midst of conversations fueled by beer, wine, and café food, we find the refiner's fire of Impressionism and the New Painting. One can imagine Zola and Duranty crafting the language and articulating the ideas that would define the movement. In a conversation with the journalist François Thiébault-Sisson that took

place in 1900, Monet described the discussions at the Café Guerbois as a formative influence and a continuous source of inspiration:

> In 1869 . . . Manet invited me to join him every evening in a café in the Batignolles quarter, where he and his friends would gather and talk after leaving their ateliers. There I met Fantin-Latour, Cézanne, and Degas, who joined the group shortly after his return from Italy, the art critic Duranty, Émile Zola, who was then embarking on his literary career, as well as some others. I myself brought along Sisley, Bazille, and Renoir. Nothing was more interesting than our discussions, with their perpetual clash of opinion. They sharpened one's wits, encouraged frank and impartial inquiry, and provided enthusiasm that kept us going for weeks and weeks until our ideas took final shape. One always came away feeling more involved, more determined, and thinking more clearly and distinctly.[6]

Although Manet (cat. 46) declined to exhibit with the Impressionists in any of the eight group exhibitions that they organized between 1874 and 1886, his role was of paramount importance. In 1887 Silvestre, who had been a regular at the Café Guerbois, remembered him as a "revolutionary," a driving force in the group, whose ideas, observations, and opinions were listened to and respected: "Manet was not a *chef d'école*—no one was less suited for that by temperament, for I have never known a person less solemn by nature; but, without exaggeration, his influence was certainly considerable. Although less magisterial, less intense, and much less sure in matters of taste than Baudelaire, he nonetheless asserted in painting, as Baudelaire did in poetry, a sense of modernity which has been widely aspired to but which had not yet seen the light of day."[7]

Despite Silvestre's claim that Manet was not a *chef d'école*, he had described him as such eleven years earlier when referring to "the little group of intransigents of which [Manet] is considered the leader."[8] Indeed, references to Manet as the leader of the artists later known as the Impressionists began to appear regularly in the early 1870s. In June 1873 the politician and critic Ernest Duvergier de Hauranne reported that Manet had founded a new school.[9] Writing in May 1875, Jules Castagnary described him as the head of a school and acknowledged his influence on a certain group of painters.[10] In 1876 Mallarmé described Manet as a key figure in an article titled "The Impressionists and Édouard Manet."[11] The same year, in *La nouvelle peinture*, Duranty referred to Manet, without actually naming him, as the "head of the movement."[12]

When Bazille wrote to his parents in 1869 announcing that "a dozen talented people" planned to launch their own program of exhibitions, the Franco-Prussian War was beyond the horizon. Moreover, he probably could not have imagined the subsequent catastrophic civil strife of the Paris Commune. Nearly three years passed, but the interest in holding independent exhibitions remained alive. Organizing the shows may have lagged in part because Bazille, the enthusiastic young artist from Montepellier who had been a driving force in the preparations, did not survive the war. In addition, the French economy was in shambles. Nevertheless, in an article published in the May 5, 1873, issue of *L'Avenir National*, the critic Paul Alexis encouraged the formation of an "artistic corporation" to counter the iniquitous shortcomings of the Salon system.[13] He also alluded to earlier plans for such a "syndicate" and recalled discussions at the Café Guerbois of "projects of annual or monthly contributions put forward in certain groups, of

CAT. 46 **ÉMILE-AUGUSTE CAROLUS-DURAN**
Édouard Manet, ca. 1880
Oil on canvas
25 ⅝ × 21 ¼ in. (65 × 54 cm)

FIG. 35 A view of Nadar's studio at 35 boulevard des Capucines, Paris, site of the first Impressionist group show in 1874

statutes outlined, of societies for exhibitions and sales ready to be founded."[14] He specifically mentioned plans for an arrangement whereby "each member would have contributed five francs every month and been entitled to show two of his works for permanent exhibition and sale; no preliminary inspection, no exclusions."[15]

At about that time Monet began to play a stronger role in the group. A week after Alexis's article, a letter in response by Monet was published in the same newspaper. The thirty-year-old artist announced the imminent formation of an association similar to that described by Alexis: "A group of painters assembled in my home has read with pleasure the article you have published in *L'Avenir National.* We are happy to see that you defend ideas which are ours, too, and we hope that, as you say, *L'Avenir National* will kindly give us assistance when the society that we are about to form will be completely constituted."[16]

In a note following Monet's letter, Alexis provided additional information that is crucial to understanding the nature of the group. From the beginning, it embraced a variety of styles and a broad focus. It was never intended to represent a specific style, such as the loose brushwork and the emphasis on color that we associate with the term *Impressionism.* Alexis pointed out the diversity of the organization and noted, "These painters, most of whom have previously exhibited, belong to that group of naturalists which has the right ambition of painting nature and life in their large reality. Their association, however, will not be just a small clique. They intend to represent interests, not tendencies, and hope for the adhesion of all serious artists."[17] Alexis made clear that the group encompassed a wide range of "interests." As a result, the movement eludes a simple definition.

The association held the first of eight jointly organized exhibitions in the spring of 1874, taking over the studio of the photographer Nadar (fig. 35). The last one would occur exactly twelve years later.[18] Manet did not join the group at any time. Instead, he continued to seek recognition at the official Salons to which he had been submitting work since 1859. He challenged the art establishment on its own ground and battled in the most public way possible.

Between 1874 and 1886 the critics used many labels to describe the group that participated in the so-called Impressionist exhibitions. The artists were known variously as Independents, Impressionists, Intransigents, phalangists, and radicals. They were occasionally characterized as lunatics, maniacs, or worse (one caricaturist suggested that pregnant women risked miscarriage at the sight of the new art[19]).

In retrospect, it is evident that few individuals, including some of the most astute artists and critics, had a thorough understanding of the movement. Zola, for example, championed Manet's work in the 1860s but later lost confidence in his innovations and those of most other members of the avant-garde. However, when Duranty published *La nouvelle peinture* in 1876, it became evident that at least one critic understood and appreciated the modern movement in nearly all of its forms and variations. But it should be noted that he never once used the word *Impressionist* in the essay.

The group's identity and philosophy were unclear in part because the participants themselves wished to avoid a name for the association that denoted a specific style. During the course of the planning for the first exhibition, Degas proposed that they call themselves La Capucine (The Nasturtium). Renoir later referred to his own fear of a title signifying a "new school."[20] Evidently, most members recognized the need for a neutral title because in 1874

they chose "société anonyme des artistes, peintres, sculpteurs, graveurs, etc." In today's vernacular, they might have called themselves Artists, Painters, Sculptors, Printmakers, Inc. (*Société Anonyme* is the French term that is the equivalent of Incorporated). The band of renegades recognized its own diversity, but the name initially adopted belied the extraordinary richness and complexity of the fledgling movement.

The title page of the catalogue for the second group show (1876) refers only to "la 2ᵉ exposition de peinture" and omits the name Société Anonyme. According to at least one critic, the artists had already begun to call themselves Impressionists.[21] Furthermore, by the time Mallarmé's essay "The Impressionists and Édouard Manet" appeared in 1876 the word was widely used and bore none of the pejorative implications intended by Louis Leroy, the critic who had coined the term two years earlier in a scathing review of the first exhibition. Although the title page of the catalogue for the third exhibition (1877) also identifies the show only by number and fails to credit a sponsoring organization, during the planning for the show the participants agreed to bill it as an "Exposition des Impressionnistes."[22] Degas, who opposed the move, proposed in 1879 that the fourth group show be held under the auspices of "un groupe d'artistes indépendants, réalistes, et impressionnistes."[23] However, only the phrase "Groupe d'Indépendants" proved acceptable to the general membership. It is clear that the artists themselves insisted upon the recognition of Impressionism as only one thread in the increasingly complex fabric of the modern movement.

For the fifth (1880), sixth (1881), and seventh (1882) shows, the artists apparently continued to bill themselves as independents. But in 1886 they dropped the word *Indépendants* because of possible confusion with the recently formed Société des Artistes Indépendants, which included, among others, Georges Seurat, Paul Signac, Odilon Redon, Albert Dubois-Pillet,

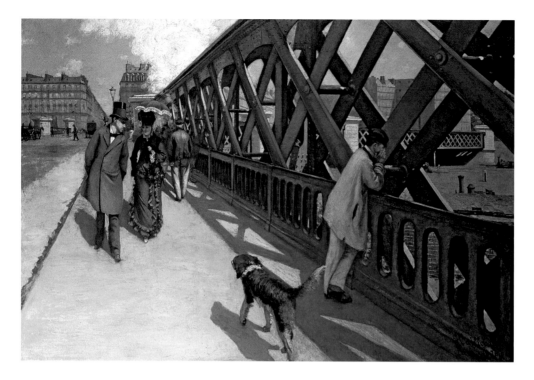

Charles Angrand, and Guillaumin. Both the exhibition poster and the catalogue cover for the last group show tell us only that it was the eighth exhibition. In short, the loose confederation that began as a Société Anonyme ended its series of exhibitions with no name at all. The eight group shows were in fact umbrella exhibitions for an association of disparate avant-garde artists whose constantly changing membership obviated the ongoing usefulness of a term such as *Impressionism*.

Degas' proposal that the artists call themselves "indépendants, réalistes, et impressionistes" seems, in retrospect, quite reasonable, but the strong factionalism within the group prevented it. In addition, the membership was very fluid. Only Pissarro exhibited in all eight exhibitions. Even patently Impressionist artists such as Monet and Renoir defected to the Salon in certain years, only to return to the fold later. Had the group exhibitions been organized under ideal circumstances, contemporary audiences might have seen works such as Manet's *The Railway* (1872–1873, fig. 36) in one of the exhibitions. However, instead of appearing in the first show in 1874, it was exhibited in the Salon at about the same time. As a view of a scene near the Gare Saint-Lazare, it would have been especially interesting in the context of the third exhibition, which included several views by Monet of the interior and exterior of the Gare Saint-Lazare (see cat. 57) as well as Gustave Caillebotte's view of the nearby Pont de l'Europe (fig. 37).

Choosing terminology that accurately describes the complex phenomenon reflected by the eight shows remains a problem, but Duranty's *La nouvelle peinture* offers a solution that seems less distorting than other rubrics, labels, titles, and "isms." In his discussion of the emerging movement, Duranty carefully avoided the use of any term that implied stylistic exclusivity. Although the essay reflects his bias for Realist and Naturalist painting and reveals his strong interest in the work of his friend Degas, it is the first cogent attempt to deal comprehensively with the new art and to describe the main characteristics of the movement without insisting that it adhere to any one formula. Like Mallarmé, Duranty recognized that art was undergoing fundamental changes and would never be the same again, and that the innovative styles and wide-ranging

FIG. 38 A nineteenth-century view of the Café de la Nouvelle-Athènes, Paris, a favorite meeting place of the Impressionists

subject matter signaled the arrival of a new aesthetic order. However, he resisted the use of an "ism" to describe it. The word *Impressionism*, as noted above, does not appear in his essay.

"The New Painting" accurately describes not only the main thrust of the eight famous exhibitions but also the work of Manet and others who did not participate in them. The modern movement encompassed far more than the introduction of plein-air painting, feathery brushwork, and a novel understanding of color and light. During the 1870s and 1880s artists turned to unprecedented subjects and developed styles appropriate to them. Modern life provided a contemporary iconography that demanded fresh approaches and originality of expression. Although the new French painting of the last quarter of the nineteenth century evolved as a logical outgrowth of Realism and Naturalism, it soon led toward an art that exhausted the possibilities of imagery concerned principally with the appearance of things as they are. Moreover, as Richard Shiff shows, this avant-garde painting was directly and indirectly influenced by cutting-edge theories of perception that affected both the understanding and the experience of art:

> In 1860, [Émile] Littré published a general statement on the problem of perception and knowledge of the external world. For Littré an external object cannot be known; only the individual's impression of it is known as real or true; one can never have absolute knowledge of the external world in the manner that one does have absolute knowledge (or experience) of an impression; our view of the world is induced from our experience of impressions and is necessarily relative. The significance of Littré's argument for the questions we are discussing lies in the implication that a personal impression, if somehow presented publicly (say, by means of a painting), would reveal as much "truth" about the world as could any other genuine impression. Thus the rendering of an impression would be an "accurate" expression of both the artist and his natural environment.[24]

And what of the work of Manet, the artist who was regarded as the de facto leader of the avant-garde? Beginning with his first Salon submission in 1859, Manet's experiments with subject matter, deliberate spatial ambiguities, innovative compositions, bold brushwork, emphasis on the two-dimensional nature of paintings, and delight in controversy placed him at the center of the maelstrom that accompanied the rise of modern art. Nevertheless, his independence within the ranks of the avant-garde makes him difficult to classify. He could perhaps be described most appropriately as a painter of advanced tendencies who was a key figure in the informal confederation of writers, intellectuals, and artists whose common interests brought them together as a group, first at the Café Guerbois and later at the Café de la Nouvelle-Athènes (fig. 38). We can identify him as an Impressionist only insofar as the term is used as a synonym for the avant-garde in French painting from the 1860s to the 1880s. As Zola observed in 1879, the word was a misnomer from its inception: "I believe I have already spoken about the small group of painters who call themselves Impressionists. To me, this term seems unfortunate; but it is nonetheless undeniable that these Impressionists—since they insist upon the name—are at the head of the modern movement."[25]

With regard to style, George Heard Hamilton observes that there are both important parallels and fundamental differences between Manet's paintings and those of the artists we

would consider mainstream Impressionists: "At Boulogne in 1868 and 1869, at Arcachon and Bordeaux in the spring of 1871, and at Berck-sur-Mer in 1873, [Manet] pursued his research in the transcription of light and movement in a manner, if not entirely a technique, analogous to the experiments of Monet and Renoir at Bougival and Argenteuil during the same period. With them he helped to make explicit the primary Impressionist concern with the moment in time and the position in space, seen instantly and revealed through light."[26]

During the course of events that changed the perception of art and created the foundations of modernism—a process that began in the 1860s and continued into the 1890s—Manet is unquestionably a seminal figure. That he did not participate in any of the so-called Impressionist exhibitions indicates that, for a variety of reasons, he chose not to become identified with a fragmented, compromised view of the modern movement. Even if the exhibitions had not taken place, it is unlikely that Manet, and probably most other avant-garde artists, would have developed very differently. The modern movement had established itself, had gathered momentum, and would have emerged, in one form or another, whether or not Manet exhibited with the group. Furthermore, Manet apparently believed that more was to be gained personally and professionally by continuing to challenge the artistic establishment openly through submitting work to the Salon. The sporadic Impressionist exhibitions were important as visible evidence of the viability and achievements of the avant-garde, and they provided a rallying point for the artists, but equally significant were Manet's regular skirmishes and confrontations with the Salon juries and the critics. With the exception of 1878, not a single season passed during the 1870s and early 1880s without controversy generated by Manet's submissions to the Salon. The notoriety of his work made him a public figure, and as a result he became, willingly or not, the standard bearer of the avant-garde.

The accounts of Duranty, Albert Moore, Monet, and others reveal that the younger generation paid close attention to the charismatic Manet. Furthermore, the artists who showed their work in the Impressionist exhibitions seem not to have resented Manet's decision not to join them. Both he and they continued to frequent the Café de la Nouvelle-Athènes, which served as a gathering place that transcended factionalism. As heretical as it may seem to art historians, perhaps the artists who participated in the Impressionist exhibitions should be seen as merely a series of fractious splinter groups that originated in the broader circle in which the dapper and cosmopolitan Manet was visibly and indisputably a primary figure. Throughout the 1870s the Nouvelle-Athènes remained a consistent element in the life of virtually every important avant-garde artist in Paris. It is of great significance that the makeup of the avant-garde that gathered there was wider and far more diverse in its attitudes, opinions, and stylistic tendencies than the term *Impressionism* would lead us to believe. Because this multifaceted group never presented itself as an organized entity or issued any sort of manifesto, we tend to underestimate its collective importance (albeit Duranty's *La nouvelle peinture* could serve as a de facto treatise for the group as a whole). The broader group is a more accurate and complete reflection of the revolution that took place in French painting and thinking about art during the 1870s than that of the ever-changing collection of artists who participated in the landmark group shows between 1874 and 1886. Historical accuracy and truth to circumstances notwithstanding, no one should expect to see a reference to Café Guerboisisme or Café de la Nouvelle-Athènesisme anytime soon.

NOTES

1 This essay depends heavily on research and writing that appear in essays that I published in 1983 and 1986: "Manet and Impressionism," in *Manet, 1832–1883*, by Françoise Cachin and Charles S. Moffett (New York: Metropolitan Museum of Art, 1983), 29–35; and "Introduction," in *The New Painting: Impressionism 1874–1886*, by Charles S. Moffett et al. (San Francisco: Fine Arts Museums of San Francisco, 1986), 17–23. Each essay tells half of the story of the rise of the Impressionist movement, but here they have been merged, with the kind permission of the Metropolitan Museum of Art and the Fine Arts Museums of San Francisco, in order to tell a fuller story.

2 Lionel Trilling, "Of This Time, of That Place," originally published in *The Menorah Journal* (1929).

3 Paul Tucker, "The First Impressionist Exhibition in Context," in Moffett et al., *The New Painting*, 93–117; and John Rewald, *The History of Impressionism*, 4th rev. ed. (New York: Museum of Modern Art, 1980), 172.

4 Stéphane Mallarmé, "The Impressionists and Édouard Manet," *The Art Monthly Review and Photographic Portfolio* 1, no. 9 (September 30, 1876): 117; and Moffett et al., *The New Painting*, 28–34.

5 Tucker, "First Impressionist Exhibition," 93; and Rewald, *History of Impressionism*, 173.

6 François Thiébault-Sisson, "Claude Monet: Les années d'épreuves," *Le Temps*, November 26, 1900, 3.

7 Armand Silvestre, *Au pays des souvenirs* (Paris, 1887), 160–161.

8 Armand Silvestre, "Les deux tableaux de Monsieur Monet," *L'Opinion Nationale*, April 23, 1876, as quoted in Adolphe Tabarant, *Manet et ses oeuvres* (Paris: Gallimard, 1947), 285.

9 E. Duvergier de Hauranne, "Le Salon de 1873," *La Revue des Deux Mondes*, June 1, 1873.

10 Jules Castagnary, "Le Salon de 1875," *Le Siècle*, May 29, 1875; see also George Heard Hamilton, *Manet and His Critics* (New Haven, Conn.: Yale University Press, 1954; repr. New York: Norton, 1969), 191.

11 Stéphane Mallarmé, "The Impressionists and Édouard Manet," 117–122. The article has also been reprinted in Carl Paul Barbier, *Documents Stéphane Mallarmé*, vol. 1 (Paris: Nizet, 1968), 66–86; as well as in Charles S. Moffett et al., *The New Painting*, 27–34.

12 Louis-Émile-Edmond Duranty, *La nouvelle peinture: À propos du groupe d'artistes qui expose dans les galeries Durand-Ruel* (Paris: E. Dentu, 1876), 17: "Another, finally, has redoubled the boldest claims, has fought the most stubbornly, has not merely opened the windows a crack but has flung them wide—has breached the walls—to the *open-air* and *real sunlight*; he has assumed the leadership of the movement, and time and time again has given the public, with a candor and courage akin to genius, works that are the most innovative, the most flawed, most rife with excellence; works full of breadth and intensity, a voice distinct from all others; works in which the most powerful expression is bound to clash with the uncertainties of an almost entirely new approach that lacks, as yet, its full means of embodiment and realization" (as quoted in Cachin and Moffett, *Manet*, 32).

13 P[aul] Alexis, "Paris qui travaille, 3: Aux peintres et sculpteurs," *L'Avenir National*, May 5, 1873, as cited and translated in Rewald, *History of Impressionism*, 309.

14 Rewald, *History of Impressionism*, 309.

15 Ibid., 213.

16 Monet to Alexis, May 7, 1873. The original text, as it appeared in the May 12, 1873, edition of *L'Avenir National*, is reprinted in Daniel Wildenstein, *Claude Monet: Biographie et catalogue raisonné*, 4 vols. (Lausanne and Paris: Bibliothèque des arts, 1974–1985), vol. 1, 428, letter 65. This translation is from Rewald, *History of Impressionism*, 309.

17 See ibid.

18 See Moffett et al., *The New Painting*, for a wide-ranging discussion of the eight group exhibitions.

19 Caricature by Cham [Amédée-Charles-Henry de Noé], *Le Charivari*, April 16, 1877, 3.

20 Charles S. Moffett, introduction to Moffett et al., *The New Painting*, 18.

21 Bernadille [François-Victor Fournel], review in *Le Français*, April 21, 1876, as cited in Tabarant, *Manet et ses oeuvres*, 285. See also Rewald, *History of Impressionism*, 366.

22 Rewald, *History of Impressionism*, 390.

23 Ibid., 421.

24 Richard Shiff, "The End of Impressionism: A Study in Theories of Artistic Expression," *The Art Quarterly* (New Series) 1, no. 4 (Autumn 1978): 348.

25 Émile Zola, "Deux expositions d'art au mois de mai," *Le Messager de l'Europe* (St. Petersburg, in Russian, June 1876), reprinted in Émile Zola, *Le bon combat de Courbet aux impressionnistes: Anthologie d'écrits sur l'art*, ed. Gaëton Picon (Paris: Collection Savoir/Hermann, 1974), 182–186. The article describes Manet as the *former* leader of the avant-garde. Joris-Karl Huysmans adopted a similar point of view the following year (see Cachin and Moffett, *Manet*, 33).

26 Hamilton, *Manet and His Critics*, 177.

47

HENRI FANTIN-LATOUR

A Studio in the Batignolles
(*Un atelier aux Batignolles*), 1870
Oil on canvas
80 ³/₈ × 107 ⁵/₈ in. (204 × 273.5 cm)

Fantin-Latour's painting, which was exhibited at the
Salon of 1870, is like a member's roster of the Parisian
avant-garde. Paying deference to Gustave Courbet's
monumental canvas *The Painter's Studio: A Real Allegory
Determining a Period of Seven Years of My Artistic and
Moral Life* (fig. 11), it heralds the arrival of a small
group of bold innovators led by Édouard Manet (sitting
at the easel). Around him are gathered (standing, from
left) the painters Otto Scholderer and Pierre Auguste
Renoir, the writers Émile Zola and Edmond Maître,
and the artists Frédéric Bazille and Claude Monet;
seated next to Manet is the writer, painter, and sculp-
tor Zacharie Astruc.

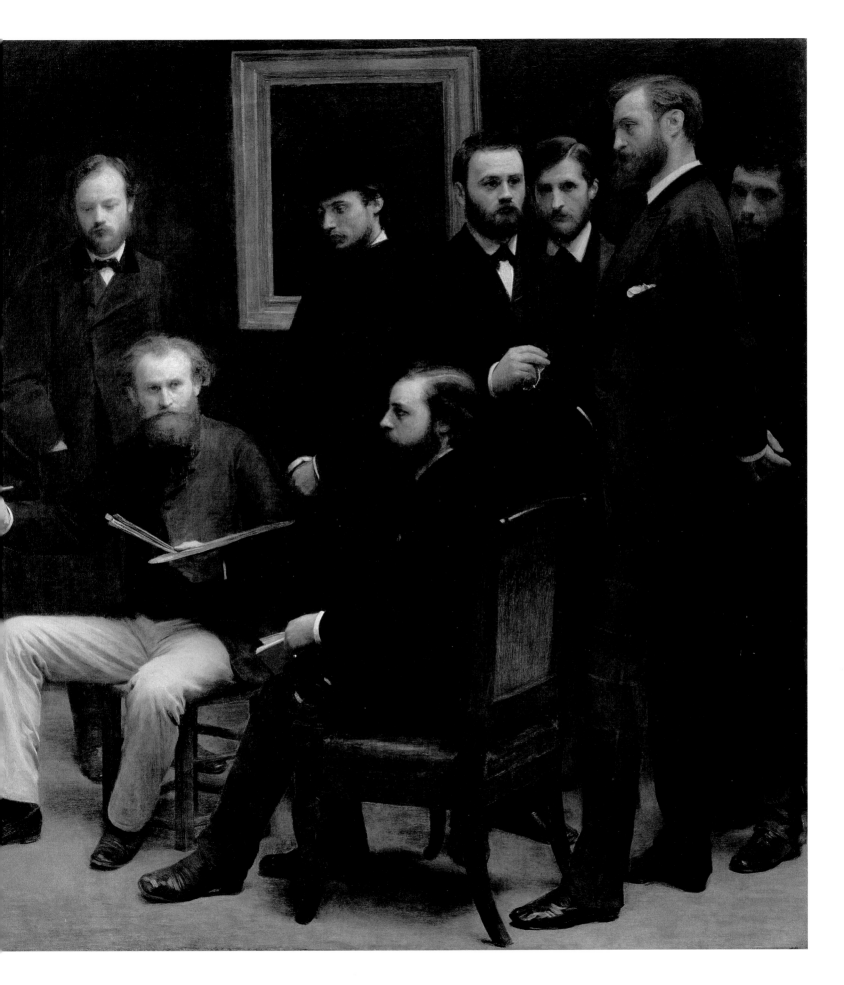

IMPRESSIONISM AND THE NEW PAINTING

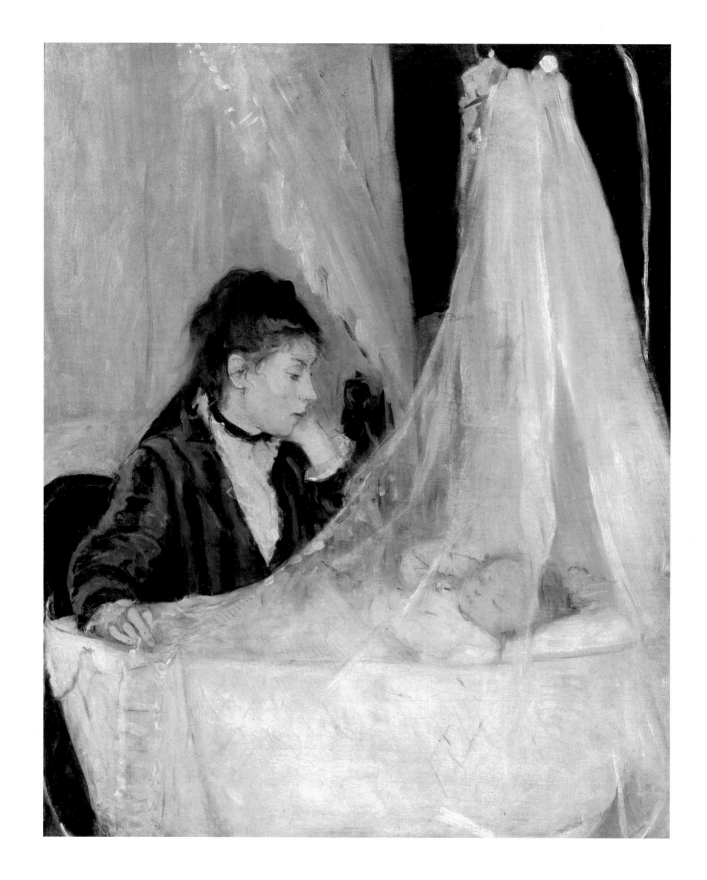

48

BERTHE MORISOT

The Cradle (*Le berceau*), 1872

Oil on canvas

22 × 18 1/8 in. (56 × 46 cm)

49
ALFRED STEVENS
The Bath (*Le bain*), ca. 1867
Oil on canvas
29 ⅞ × 36 ⅝ in. (76 × 93 cm)

Stevens found celebrity in Brussels, London, and Paris, where he moved in 1849. He became recognized for his sophisticated depictions of bourgeois Parisian women in luxurious domestic interiors. In this scene of a woman lost in thought, a book at her side, Stevens captures the sensuality of an intimate moment. Until 1875 *The Bath* was in the Hoschedé collection (Madame Hoschedé married Claude Monet in 1892). It belonged subsequently to the painter Léon-Augustin Lhermitte, who gave it to the Musée du Jeu de Paume.

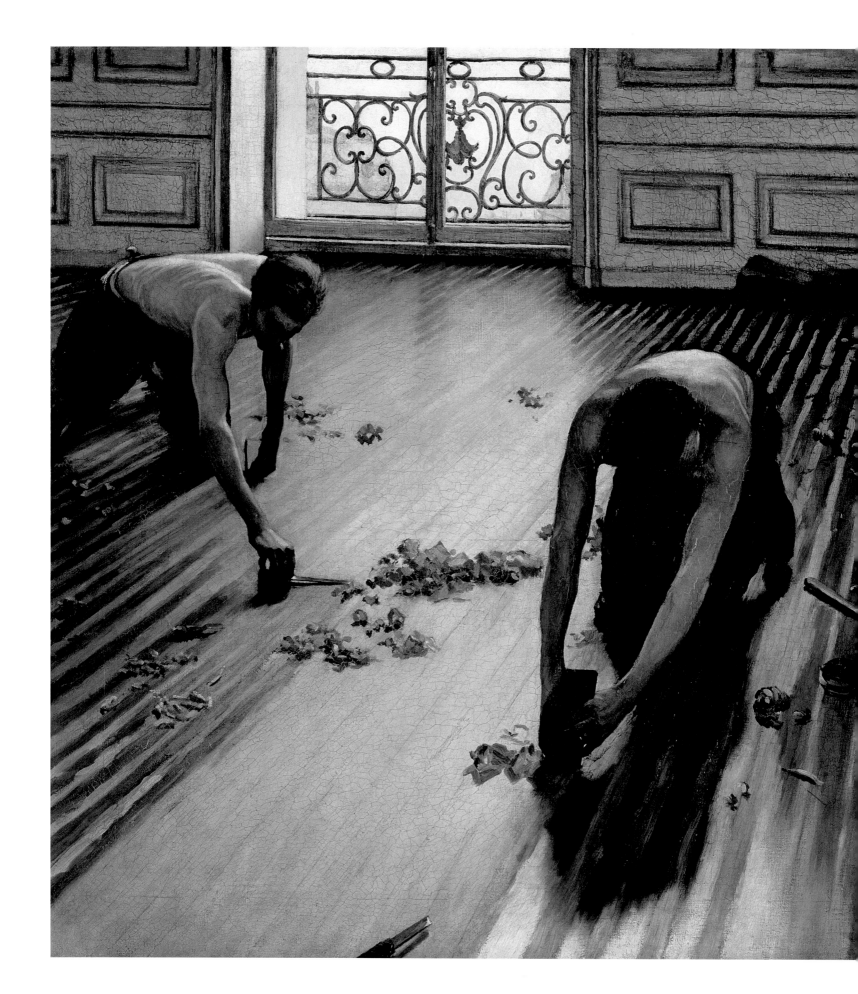

50

GUSTAVE CAILLEBOTTE
The Floor Scrapers (*Raboteurs de parquet*), 1875
Oil on canvas
40 ⅛ × 57 ⅝ in. (102 × 146.5 cm)

Caillebotte initially studied painting in the academic
tradition with Léon Bonnat. After *The Floor Scrapers* was
rejected by the Salon in 1875, Renoir invited Caillebotte
to join the Impressionist group, and the work was
exhibited in 1876 at the second Impressionist exhibi-
tion. Likely inspired by laborers renovating his home,
Caillebotte approached the proletarian subject in an
academic fashion, completing numerous preparatory
drawings. However, his focus on the working class and
his accurate treatment of the anonymous figures' bare
torsos distinguish Caillebotte as a true Realist.

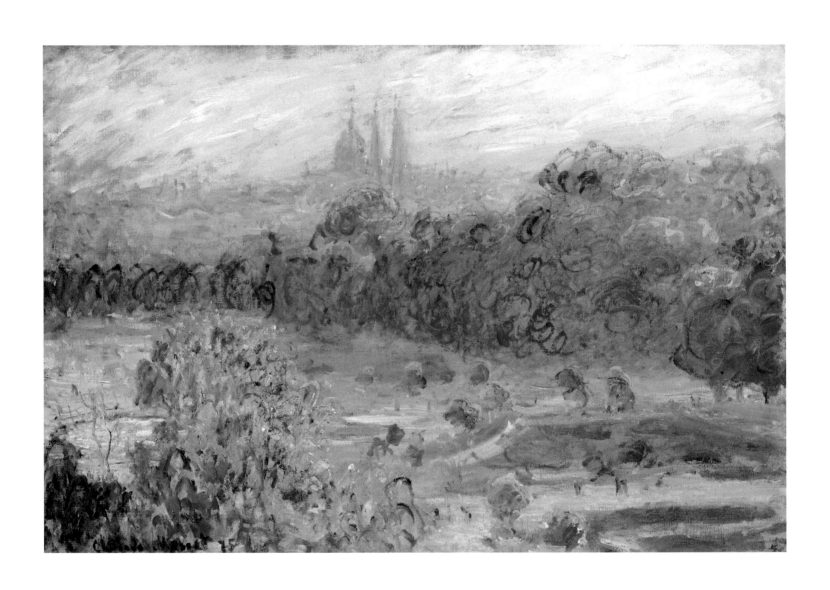

51

CLAUDE MONET

The Tuileries (*Les Tuileries*), 1875

Oil on panel

19 5/8 × 29 5/8 in. (50 × 75 cm)

144

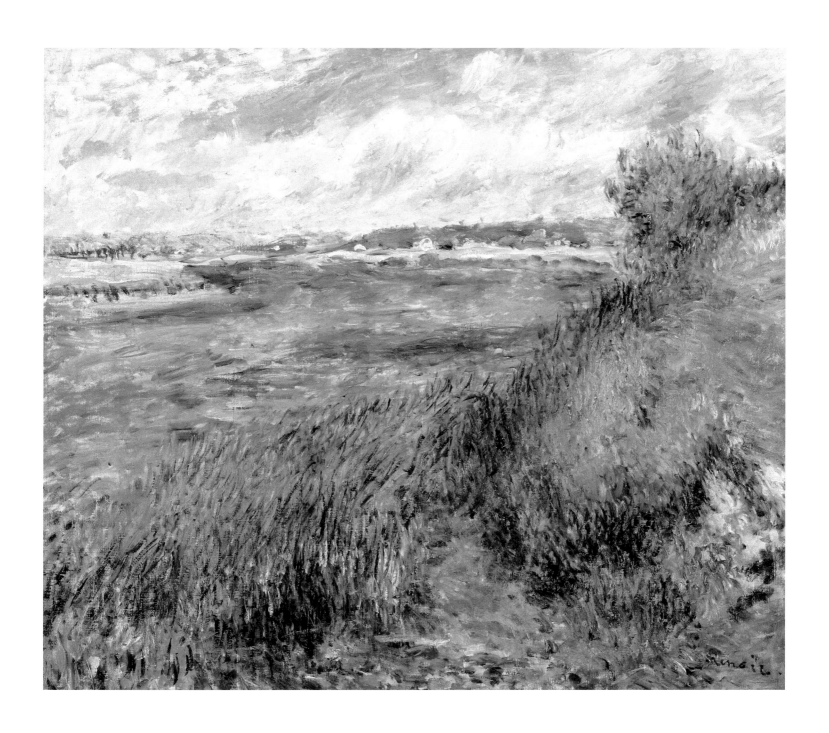

52

PIERRE AUGUSTE RENOIR

The Seine at Champrosay (*La Seine à Champrosay*), 1876
Oil on canvas
21 5/8 × 26 in. (55 × 66 cm)

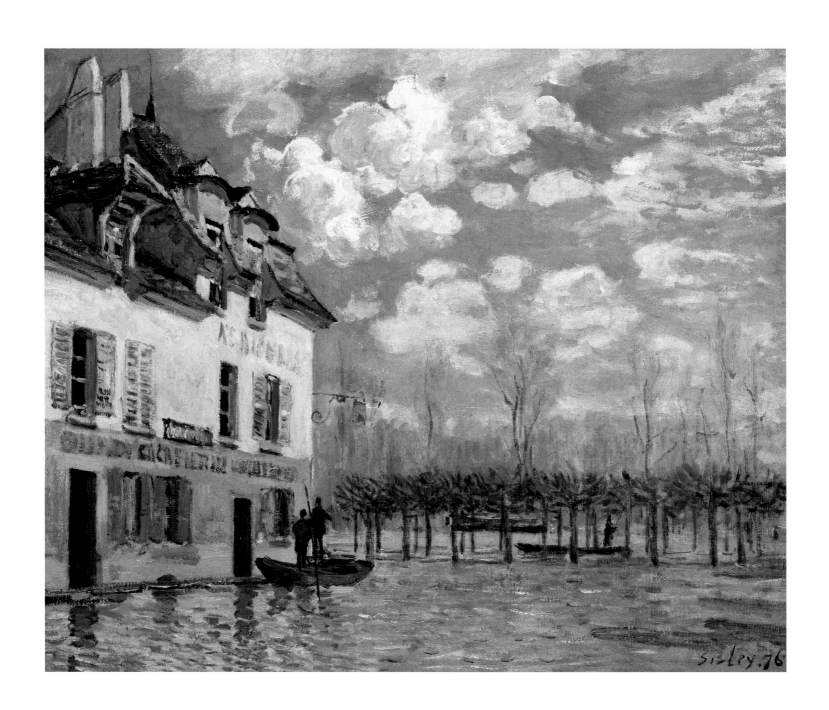

53
ALFRED SISLEY
The Barge during the Flood, Port-Marly
(*La barque pendant l'inondation, Port-Marly*), 1876
Oil on canvas
19 7/8 × 24 in. (50.5 × 61 cm)

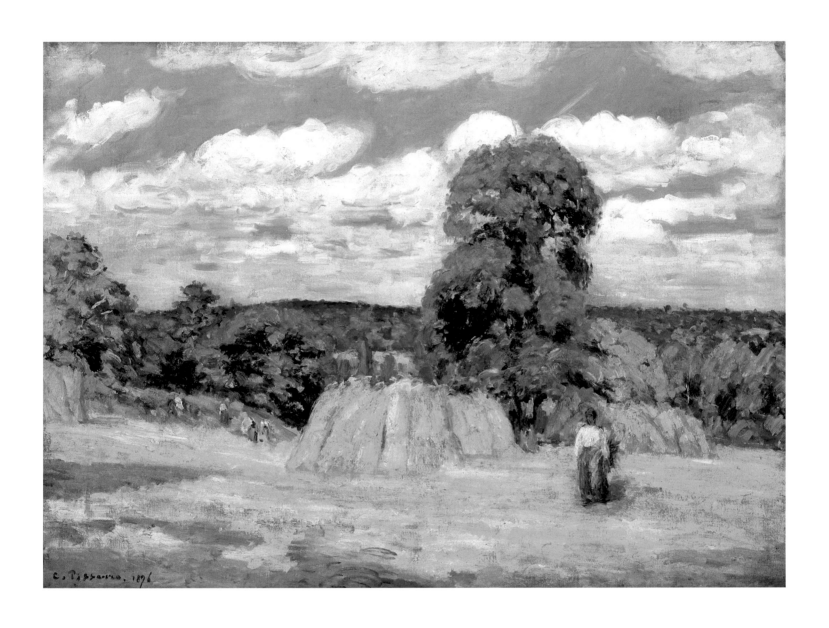

54

CAMILLE PISSARRO

Harvest at Montfoucault (*La moisson à Montfoucault*), 1876

Oil on canvas

25 5/8 × 36 3/8 in. (65 × 92.5 cm)

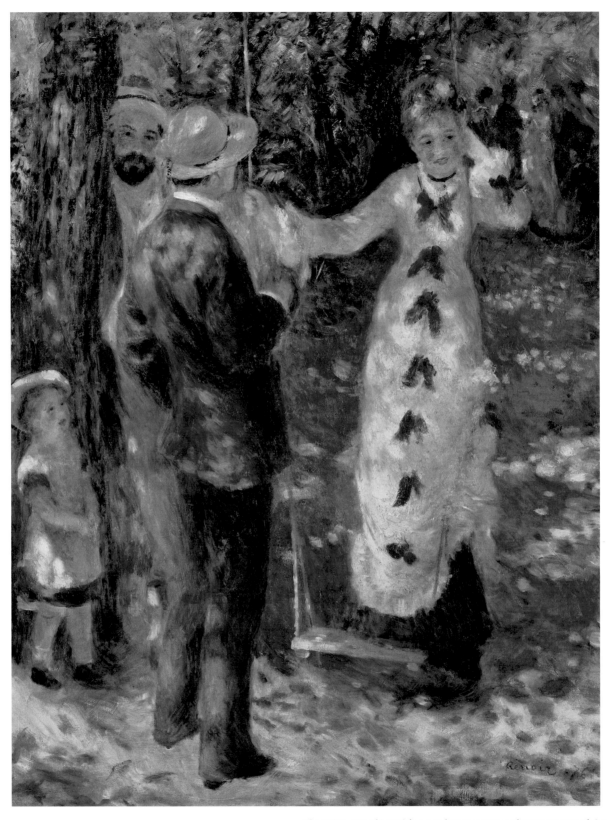

55

PIERRE AUGUSTE RENOIR

The Swing (*La balançoire*), 1876
Oil on canvas
36 ¼ × 28 ¾ in. (92 × 73 cm)

The Swing, one of Renoir's most famous scenes of contemporary leisure, is believed to feature his brother Edmond, the painter Robert Goeneutte, and Jeanne, a model from Montmartre. The most notable element of the composition is the rendering of dappled sunlight filtered through the trees. When this painting debuted in 1877 at the third Impressionist exhibition, critics found these spots of light particularly offensive. However, artist and exhibition organizer Gustave Caillebotte understood the picture's poetry and acquired it for his own collection.

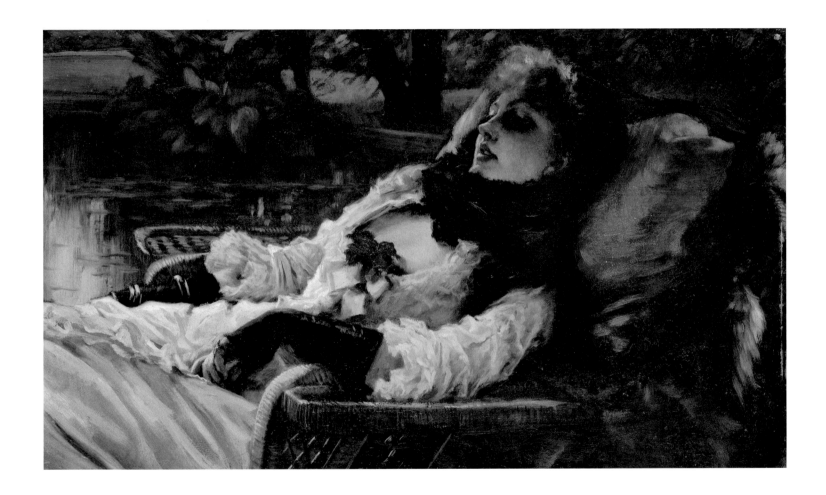

56

JAMES TISSOT

The Dreamer or *Summer Evening* (*La rêveuse* ou *Soirée d'été*), ca. 1876
Oil on panel
13 ³⁄₄ × 23 ³⁄₄ in. (34.9 × 60.3 cm)

Tissot left France in 1871, after the Commune, and spent about a decade in London. Along with Whistler, he belonged to a clique of artists who found success in both London and Paris. He is best known for paintings of women that document and subtly critique high society's conventions. The muted colors and tight cropping in this intimate, casual portrait of Mrs. Newton, Tissot's companion and frequent model, reveal an affinity with the developing art of photography.

57

CLAUDE MONET

The Gare Saint-Lazare (*La gare Saint-Lazare*), 1877
Oil on canvas
29 ¾ × 41 in. (75.5 × 104 cm)

Here Monet plays with the illusory power of colored vapor to dissolve the material world. This work appeared in 1877 at the third Impressionist exhibition, showcased with several other depictions of Monet's radically modern motif: the atmospheric conditions of steam and smoke within the expansive train shed of the Gare Saint-Lazare. In this group of paintings Monet first experimented with the visual and expressive potential of the repetition of a single motif. Among the last of Monet's paintings of Parisian subjects, the Gare Saint-Lazare pictures are some of his most innovative.

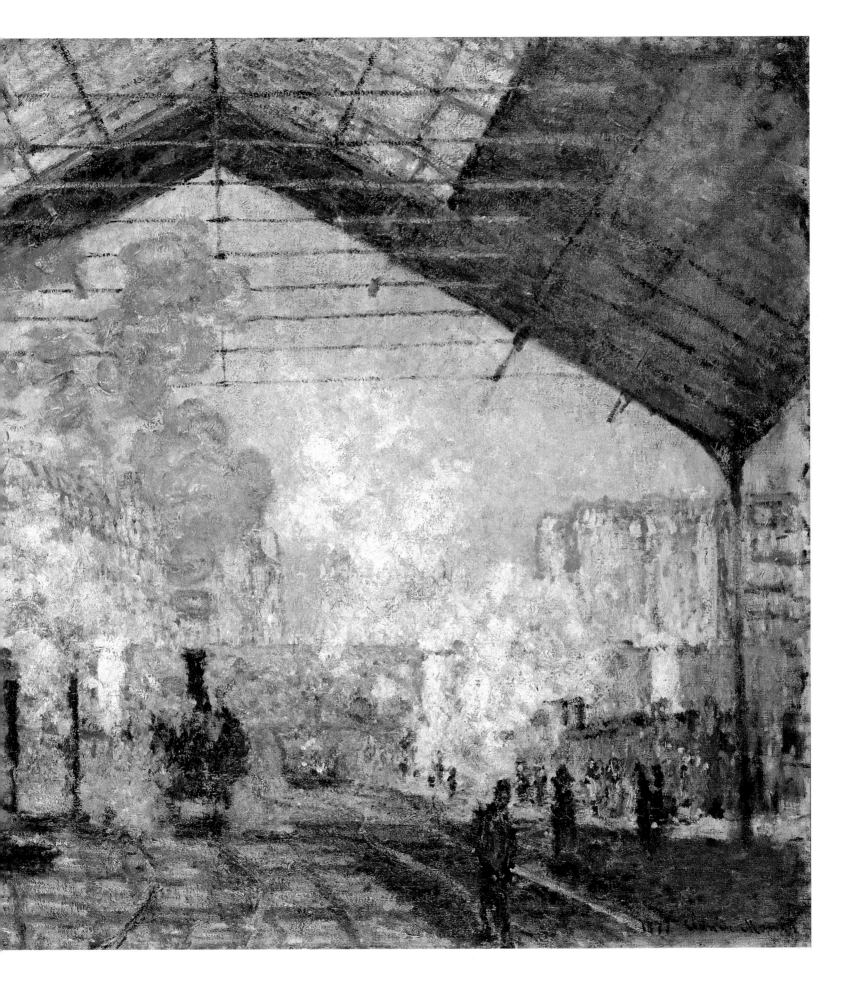

IMPRESSIONISM AND THE NEW PAINTING

ALICE THOMINE-BERRADA

Henri Fantin-Latour's *A Studio in the Batignolles* (1870, cat. 47), the companion piece to *Homage to Delacroix* (fig. 39) painted six years earlier, illustrates the aesthetic upheaval that character- ized the final years of the Second Empire. The central figure of the painting is no longer the late father of Romanticism but the leader of the pictorial avant-garde, Édouard Manet, who was still very much alive. Since the scandal surrounding *Olympia* (1863, fig. 21), Manet had been widely talked about in artistic circles. The scene unfolding in Manet's studio shows the artist in the process of painting Zacharie Astruc's likeness, his pose recalling a portrait that had been painted in 1866 (Kunsthalle Bremen, Germany). Astruc was an artist, sculptor, and critic; a longtime friend of Manet's, he was one of the first to come to his defense during the contro- versy over *Olympia*.[1] Standing around them are (from left) Otto Scholderer, a German painter very close to Fantin-Latour; Pierre Auguste Renoir; Émile Zola, who had been a champion of Manet's art since 1866; a friend they all had in common, Edmond Maître, a lover of art and music; Frédéric Bazille; and Claude Monet. *Bazille's Studio* (cat. 60), painted by Bazille the same year as *A Studio in the Batignolles*, reunites almost all the same protagonists: Bazille by his easel, conversing with Manet; Maître at the piano; and three individuals whose identities have not yet been firmly established (from left to right, they are either Alfred Sisley, Monet, and Astruc or Renoir, Zola, and Monet).

The two paintings are a testament to the bonds of friendship among these young artists. They all gathered around Manet at the Café Guerbois on rue des Batignolles, where the painter was a habitué. Fantin-Latour met Manet in 1857 at the Louvre, and from 1862 on he got together regularly with Renoir, Monet, and Bazille.[2] They had all become acquainted in the studio of Charles Gleyre, where Renoir had been the first to enroll in 1861. The friendship between these artists was founded on mutual material assistance and shared work. From July 1866, the more affluent Bazille began sharing his studio with Renoir, and soon Monet joined them. In *Bazille's Studio*, which depicts the atelier Bazille took over in early 1870, one can identify not only works by Bazille but also those by Renoir and Monet, who were still sharing his studio. This painting-within-a-painting device is further evidence of the ties that bound the artists. Moreover, apparently it was Manet who painted Bazille's portrait.

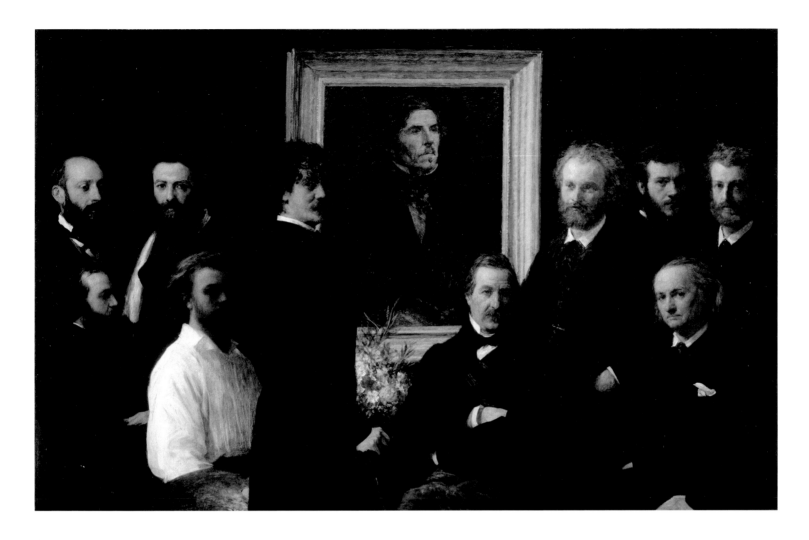

FIG. 39 **HENRI FANTIN-LATOUR**
Homage to Delacroix (*Hommage à Delacroix*), 1864
Oil on canvas
63 × 98 ³⁄₈ in. (160 × 250 cm)
Musée d'Orsay, RF 1664

Produced a few years earlier, in 1867, the interconnected portraits of Bazille by Renoir (cat. 63) and Renoir by Bazille (cat. 62) round out one's impression of the camaraderie in Bazille's studio. Renoir represented his friend at his easel in a totally spontaneous pose, like a craftsman entirely absorbed by a manual task—an image quite different from that of the typical marginalized artist, whether dandy or bohemian, that critics tended to convey.[3] The portrait was also influenced by Manet, who greatly appreciated the canvas and eventually bought it; it was not unlike his own art for its economy of means, the originality of its framing, and its tonalities. Renoir's portrait by Bazille, a bookend of sorts to Bazille's portrait by Renoir, shows Renoir in an utterly incongruous pose. Seated, his legs folded up in front of him, the artist was clearly painted from life, captured in a familiar posture between bouts of work, when he felt he could relax. Bazille made the most of this strange position in order to accentuate the lines of the composition. The famous portrait of Monet by Renoir (cat. 66), painted in 1875, illustrates the continuity of friendship between the artists.

Not only studios but also subjects were shared. The heron that Bazille was in the process of painting as Renoir was working on Bazille's portrait was the same one represented by Sisley, who was also in the habit of painting at Bazille's studio (see cat. 64). Bazille's still life (1867, Musée Fabre, Montpellier, France) enables us to put a date on Sisley's work. The young artists shared their pictorial ambitions in other ways, too. Bazille's *Family Reunion* (1867, cat. 59) had the same aim of bringing together figures in a landscape as did Monet's *Women in*

IMPRESSIONISM AND THE NEW PAINTING

the Garden (1867, fig. 14), a canvas rejected by the Salon jury of 1867 but purchased that same year by Bazille, who wanted to help his friend financially. Rather than depicting its subjects as part of a landscape, as did Monet's painting, *Family Reunion* brings together eleven people—the artist's parents, brother and sister-in-law, uncle and aunt, and cousins—and displays them as a gallery of individual portraits (indeed, the composition's original title was *Portraits of the Family X*). The striking stiffness of the figures is perhaps a reflection of the Protestant beliefs of Bazille's family. The artist began the painting in the summer of 1867 in Méric, his ancestral home near Montpellier, and finished it that winter in his Paris studio. His work had been accepted at the Salon of 1866, and it would be again in 1868. *Family Reunion* was poorly displayed at the Salon and received little attention, but it did obtain the support of Zola, who saw in it the trace of an "intense love of truth."[4]

In 1868 the Salon jury was more sympathetic to this circle of artists than it had been in previous years. It selected one painting by Monet, who had exhibited in the Salons of 1865 and 1866, where his *Camille* (Kunsthalle Bremen), also known as *Woman in the Green Dress*, had met with some success. Renoir also had his first canvas accepted, *Lise with Umbrella* (Museum Folkwang, Essen). The following year, however, Monet's submissions were not as successful. *The Magpie* (1868–1869, cat. 73), probably conceived for the Salon of 1869, was refused. The painting seems to have been produced during the winter that Monet spent in Étretat, where journalists were surprised to find the young artist working in the cold and snow.[5] Following in the footsteps of Courbet, who had also tried to represent the qualities of snow, Monet set about studying the changing effects of nature. He abandoned the sort of monumental compositions typical of Courbet, choosing instead a light palette and applying a delicate touch to the colored rendering of shadows. With this signature technique, Monet created one of the first masterpieces of Impressionism.

A Studio in the Batignolles was a monumental work, the solemn manifesto of a new way of painting. Manet's central position and the respectful attitude of the figures around him led people to believe that Fantin-Latour intended it as a portrait of the École des Batignolles, a name Louis-Émile-Edmond Duranty coined at the time of the 1869 Salon to designate, very broadly, the artists who were Manet's regular companions at the Café Guerbois. But the painting was a far cry from the innovative work undertaken by those who would later become known as the Impressionists, with their orientation toward pleinairism and light. The composition and dark tonalities of Fantin-Latour's canvas place it firmly within the traditions of both Flemish group portraits and seventeenth-century French Realism, which was being rediscovered at that time. The comparison with *Bazille's Studio* may shed some light in this respect. Fantin-Latour's painting is just as striking for the solemn arrangement of its figures as Bazille's luminous scene is charming for the artists' informal attitudes, depicted from life.

Though Fantin-Latour remained close to the artists he had depicted, he refused to take part in their first group exhibition in 1874.[6] Painted the previous year, his portrait of Victoria Dubourg (cat. 58), a young artist he had met at the Louvre in 1866 and who became his wife ten years later, exemplifies his lasting interest in dark tonalities, which were quite opposite the light palette favored by Manet's friends. Only the intimacy of the scene and its tight framing made this painting in any way comparable to those of his Impressionist colleagues. Like Manet, to whom he remained a close and loyal friend (he was a pallbearer at Manet's funeral),

CAT. 58 **HENRI FANTIN-LATOUR**
Victoria Dubourg, 1873
Oil on canvas
36 3/8 × 29 7/8 in. (92.5 × 76 cm)

Fantin-Latour liked above all to paint still lifes of flowers, a subject that would become one of his particular strengths (see cat. 68).

Neither the painting of Fantin-Latour's studio nor that of Bazille's could be said to portray the members of a coherent aesthetic movement, all the more so in that the number of artists missing from both group portraits—Paul Cézanne, Edgar Degas, Camille Pissarro, and even Sisley—is considerable. If we look closely at these canvases, the fragile cohesion of the new school gathered around Manet becomes apparent. For example, Monet is located at the far right of Fantin-Latour's painting, in the background, and seems strangely removed from the glorification of *Olympia*'s creator. In Bazille's studio, on the other hand, Manet's role is undetermined. The central figure of the composition, Bazille at his easel, turns to Manet for advice, but the other figures seem completely oblivious to their discussion. Might these be indications of the detachment Duranty noticed in his review of the Salon of 1870, in which he wrote that the painters of the École des Batignolles had "each the most intense desire to head off down a separate path around the *Via Manetia*"?[7]

These emerging aesthetic differences did not stop the group from organizing the first collective exhibition of their work in 1874 at the studio of the photographer Nadar. The project was first conceived in the late 1860s, born of the young painters' exasperation in the face of repeated rejections by the Salon. Bazille wrote about it in a letter to his mother in April 1867: "We have . . . decided that each year we will rent a large studio where we will exhibit our works in as large a number as we wish. . . . We are certain of success."[8] Though Manet supported their project, he did not exhibit at Nadar's studio, preferring to continue his struggle in the official arena of the Salon. The École des Batignolles, a group that in the late 1860s gathered around a painter who withdrew from it the moment it had its first public exposure, eventually chose a different name: following an ironic witticism published in a report on the 1874 exhibition in *Le Charivari*, the artists adopted the designation *Impressionists*. They went on to organize eight joint exhibitions of work that broke with academic aesthetics. In 1886 the adventure came to an end, the result of artistic differences; defections on the part of those who, like Manet, preferred the Salon; and the organization of a rival exhibition, the Salon des Indépendants, by Georges Seurat and Paul Signac, representatives of the new generation.

Translated from the French by Alison Anderson

NOTES

1 Françoise Cachin and Charles S. Moffett, *Manet: 1832–1883* (New York: Metropolitan Museum of Art, 1983), 249.

2 Friedrich Florence, ed., *Fantin-Latour: De la réalité au rêve* (Lausanne: Fondation de l'Hermitage, 2007), 175.

3 Behind Bazille appears a snowscape that is presumably by Monet—a nod to the third inhabitant of Bazille's studio.

4 Émile Zola, *Écrits sur l'art*, ed. Jean-Pierre Leduc-Adine (Paris: Gallimard, 1991), 210.

5 Reyburn Scott, *Monet* (London: Medici Society, 1992), 12.

6 Florence, *Fantin-Latour*, 176.

7 *Paris-Journal*, May 19, 1870, quoted in Marcel Crouzet, *Un méconnu du réalisme: Duranty (1833–1880); L'homme—le critique—le romancier* (Paris: Nizet, 1964), 297.

8 Guy Barral and Didier Vatuone, *Frédéric Bazille: Correspondance* (Montpellier, France: Les Presses du Languedoc, 1992), 137.

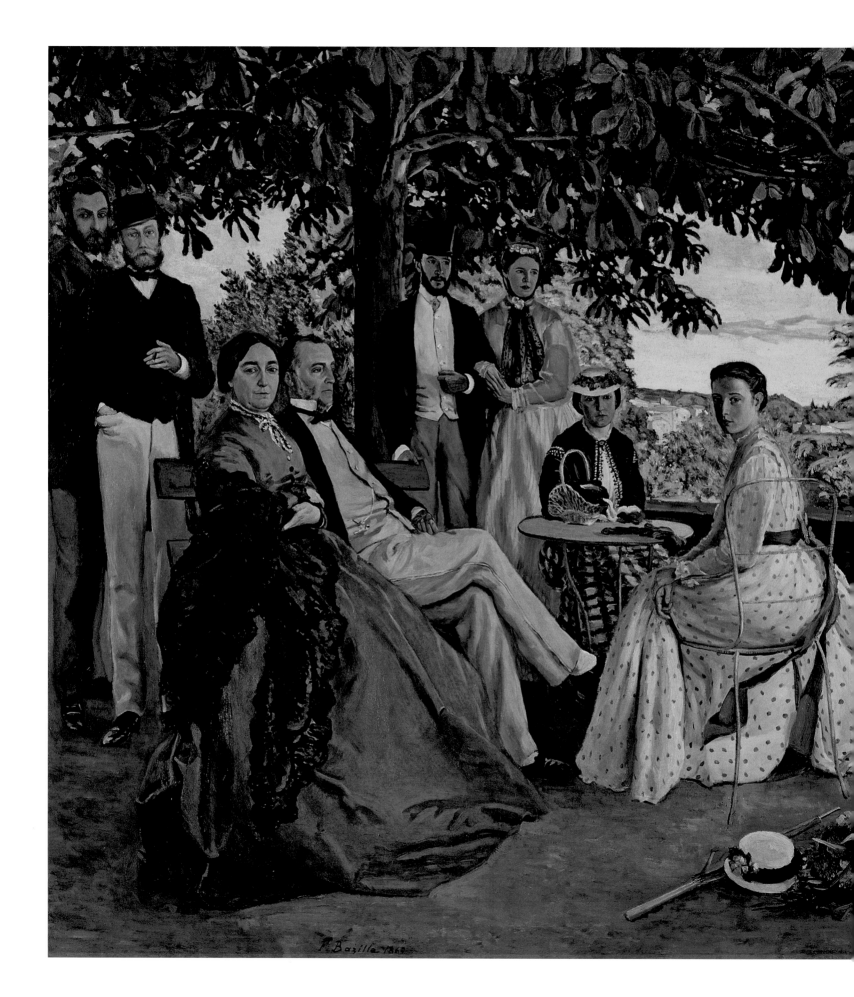

59

FRÉDÉRIC BAZILLE

Family Reunion (*Réunion de famille*), 1867
Oil on canvas
59 7/8 × 90 1/2 in. (152 × 230 cm)

Bazille, a prime mover in the École des Batignolles,
exhibited at the Salon of 1868 this portrait of his fam-
ily gathered on the terrace of their property outside
Montpellier. The painting's grand scale and bold treat-
ment of a conventional subject suggest that Bazille
wished to make sure the work would be accepted by
the conservative jury. Nonetheless, his provocative
experimentation with the strong effects of light and
shadow, characteristic of the south of France, reveals
a fascination with motifs and techniques that became
hallmarks of Impressionism.

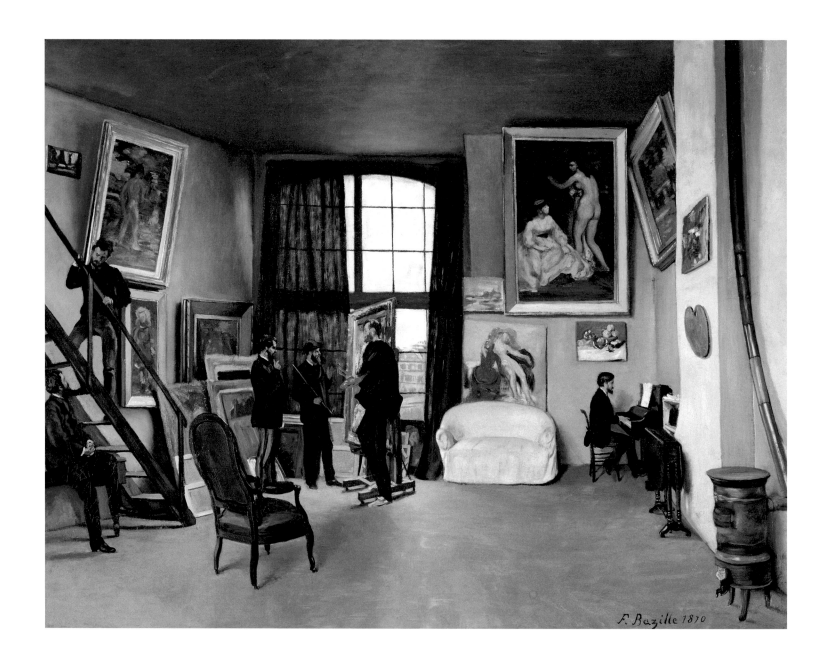

60
FRÉDÉRIC BAZILLE
Bazille's Studio (*L'atelier de Bazille*), 1870
Oil on canvas
38 ⁵/₈ × 50 ⁵/₈ in. (98 × 128.5 cm)

The towering figure of Bazille in the center of this canvas, which depicts visitors to the artist's studio, was actually painted by Manet. Several pictures on the studio's walls are recognizable as Bazille's—particularly *The Toilette*, which is displayed prominently behind the pink couch. Reinforcing the dynamic and evolving relationship between the avant-garde and the Salon, these painted depictions of traditional subjects represent the younger generation, which would eventually supplant the entrenched academic hierarchy.

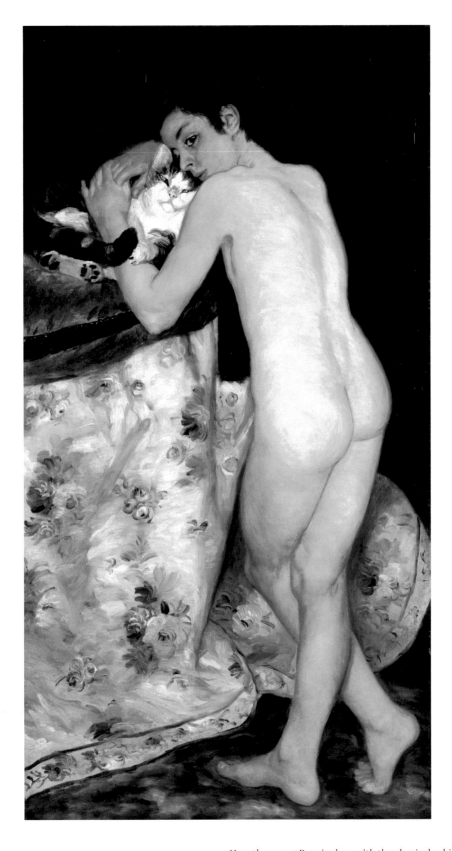

61

PIERRE AUGUSTE RENOIR

Boy with a Cat (*Le garçon au chat*), 1868
Oil on canvas
48 ³/₈ × 26 in. (123 × 66 cm)

Here the young Renoir plays with the classical subject of the male nude, divorcing it from its conventional context within the realm of academic mythological painting. Lacking any overt narrative, the enigmatic painting's principal subject is the masterful juxtaposition of pale skin and pale fabric. In its frank representation, bold contours, and color contrasts, the painting typifies the moment when Renoir is stylistically closest to Manet.

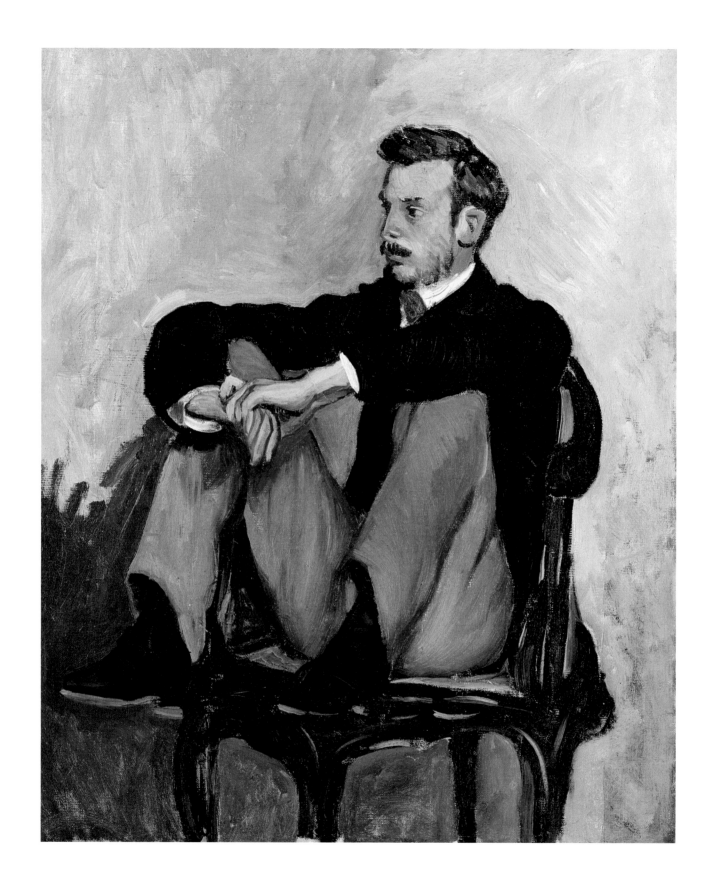

62

FRÉDÉRIC BAZILLE

Pierre Auguste Renoir, 1867

Oil on canvas

24 3/8 × 20 1/8 in. (62 × 51 cm)

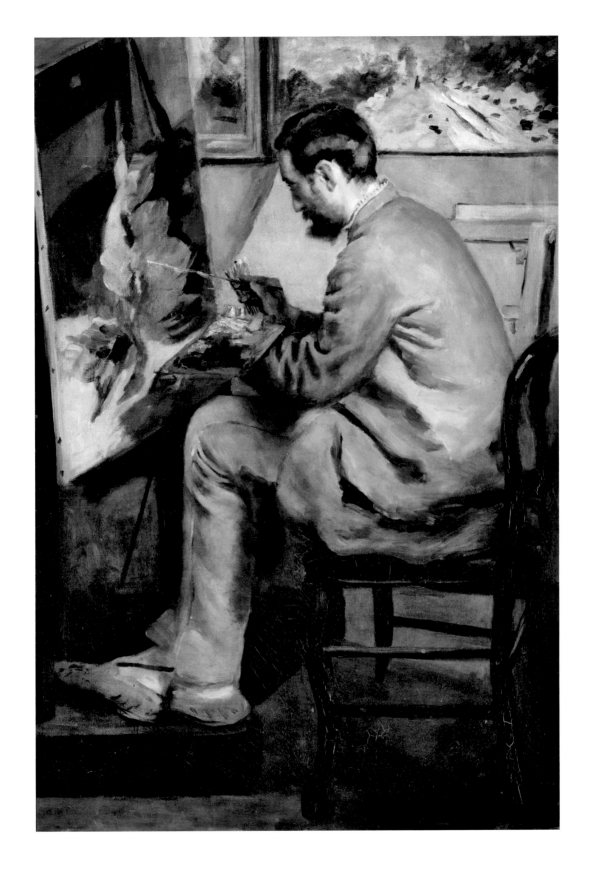

63

PIERRE AUGUSTE RENOIR

Frédéric Bazille, 1867

Oil on canvas

41 ³/₈ × 29 in. (105 × 73.5 cm)

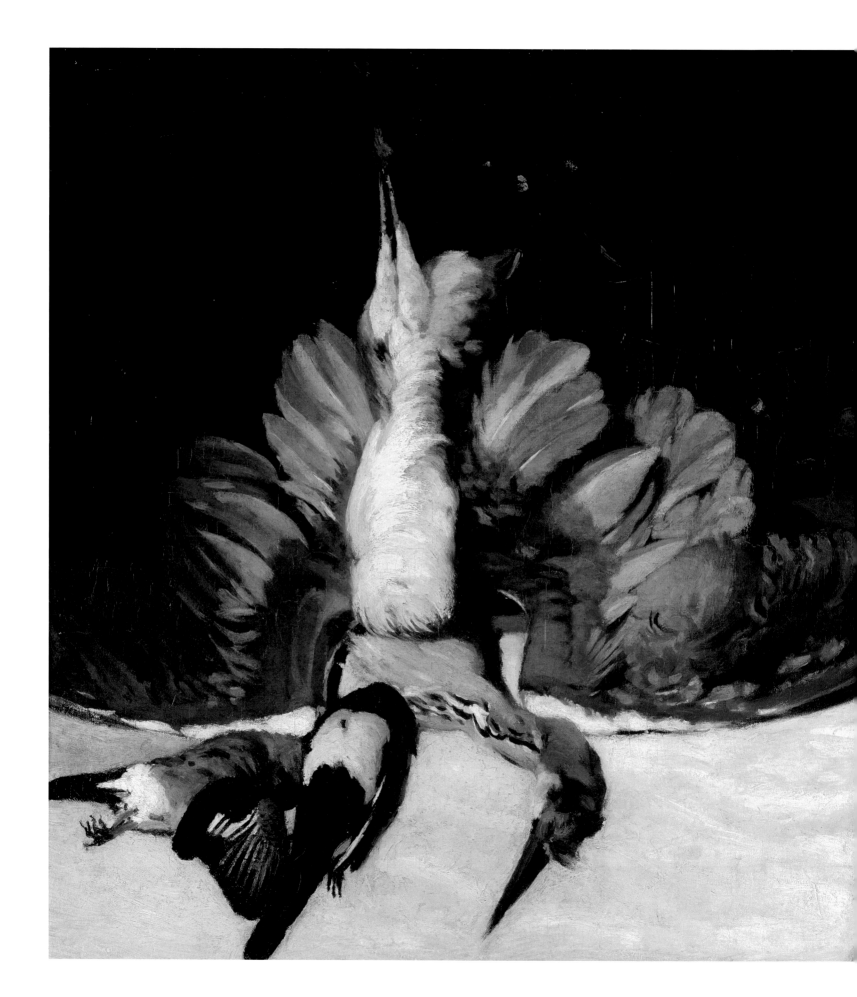

64

ALFRED SISLEY

Dead Heron with Spread Wings
(*Le héron mort aux ailes déployées*), 1865
Oil on canvas
31 ⅛ × 39 ⅜ in. (80 × 100 cm)

Sisley's bird still life was staged in Bazille's studio,
where Renoir recorded Bazille painting the same subject
(cat. 63). The striking range of grays, blacks, and whites
in Sisley's canvas was dictated by the birds' plumage.
Renoir followed this color scheme throughout his own
composition, which includes a winter landscape by
Monet hanging on the wall behind the intently working
artist. Sisley's magnificent game piece is a rarity in his
landscape-dominated output. Representative of a genre
developed by seventeenth-century Dutch artists, this
composition employs several traditional devices, in-
cluding Baroque diagonals and rich chiaroscuro effects.
Through careful observation and staging, Sisley's dead
creatures are imbued with a calm dignity.

65

PIERRE AUGUSTE RENOIR

William Sisley, 1864

Oil on canvas

32 ⅛ × 25 ¾ in. (81.5 × 65.5 cm)

66

PIERRE AUGUSTE RENOIR

Claude Monet, 1875

Oil on canvas

33 1/2 × 23 7/8 in. (85 × 60.5 cm)

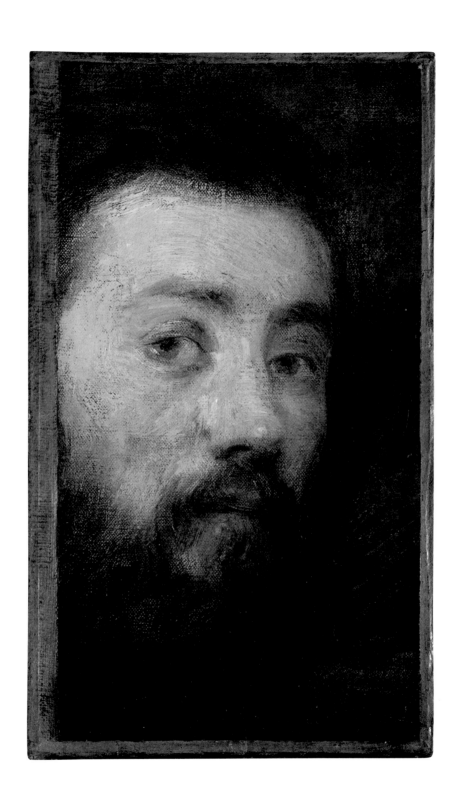

67

HENRI FANTIN-LATOUR
Antoine Vollon, 1865
Oil on canvas
11 7/8 × 7 1/8 in. (30 × 18 cm)

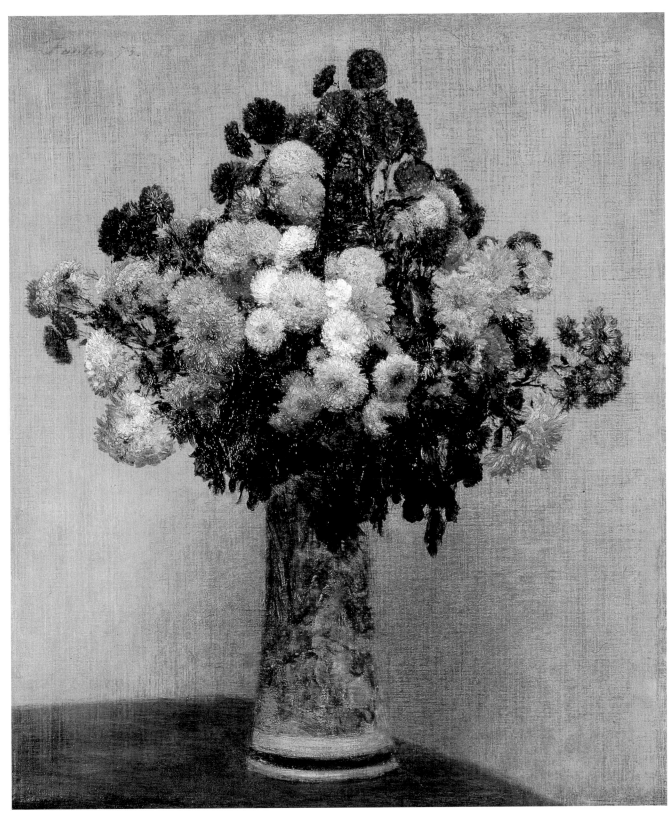

68

HENRI FANTIN-LATOUR

Chrysanthemums in a Vase (*Chrysanthèmes dans un vase*), 1873

Oil on canvas

24 ⁵/₈ × 21 ¼ in. (62.7 × 54 cm)

Fantin-Latour's *Chrysanthemums* exhibits the artist's accomplished handling of a traditional floral still life—a genre in which he was prolific and commercially successful. Opposite (cat. 67) is a small section of a larger painting initially titled *The Toast!*, which appeared at the Salon of 1865. The original canvas depicted a group of artists gathered around a nude female—a personification of truth. Dissatisfied with the picture, the artist cut it up; only the portraits of Fantin-Latour, Whistler, and Vollon survive.

69

JAMES ABBOTT MCNEILL WHISTLER

*Arrangement in Gray and Black, No. 1: Portrait of the
Painter's Mother* (*Arrangement en gris et noir, no. 1*), 1871
Oil on canvas
56 3/4 × 64 in. (144.3 × 162.5 cm)

Dividing his time between Paris and London, Whistler
moved in the avant-garde circles of both artistic capi-
tals. *Arrangement in Gray and Black* by the expatriate
artist endures as the most famous American painting
outside the United States. The starkly stylized pictorial
composition and musical allusion in the title hint at
the increasingly abstract and decorative sensibility of
the artist's later work. This painting, popularly known
as "Whistler's Mother," was nearly rejected by the
British Royal Academy in 1872; this marked the end of
Whistler's relationship with that body. And it was not
until 1891 that the painting was purchased for the col-
lection of the Musée du Luxembourg.

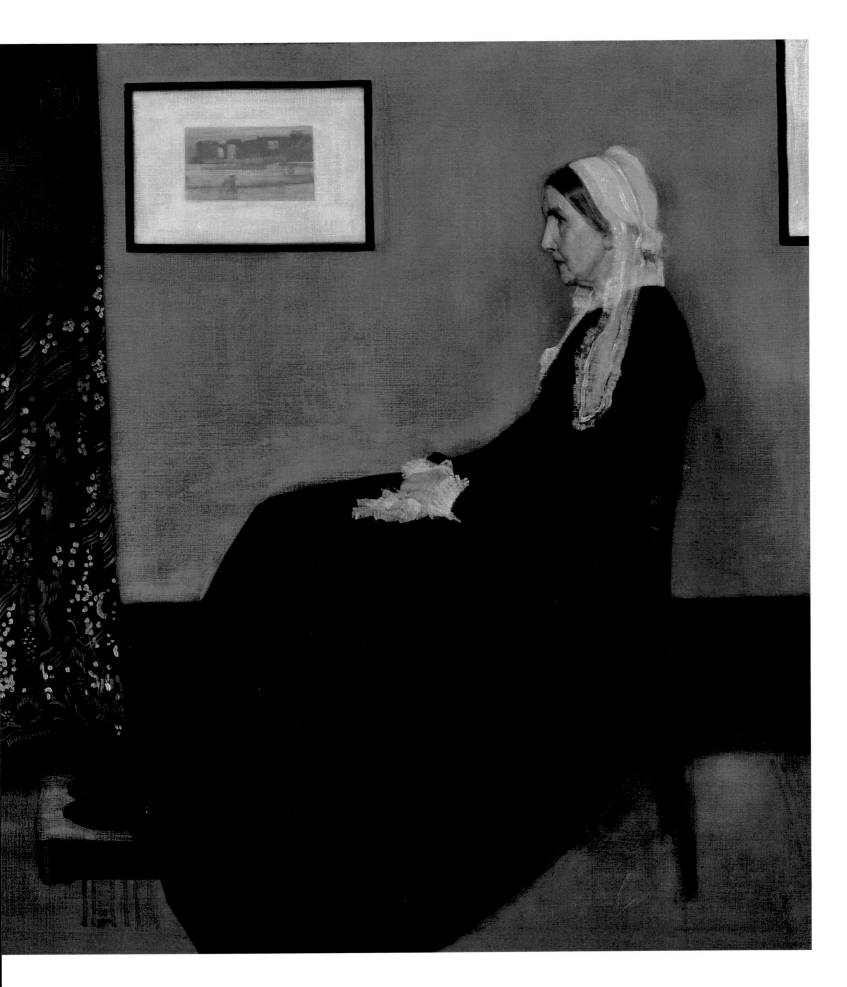

IMPRESSIONISM AND THE NEW PAINTING

CLASSIC IMPRESSIONISTS: MONET, RENOIR, AND SISLEY

LYNN FEDERLE ORR

•

Today the classic Impressionist paintings of Claude Monet, Pierre Auguste Renoir, and Alfred Sisley provide museum audiences with immense pleasure, but to many nineteenth-century viewers these vivacious works represented unsanctioned and unsuccessful experimentations. In a deliberate departure from convention, the representation of convincing three-dimensional form and spatial depth—the central goals of Western painting since late medieval times—was not the Impressionists' overriding formal concern. Indeed, in his essay on the "New Painting," Louis-Émile-Edmond Duranty specifically requested that these artists "invite form to the banquet."[1] Rather, the Impressionists sought to approximate the visual perception of temporal and atmospheric sensations. The means they employed to convey the transitory effects of shifting light and movement inherent in the world around us—whether in the rural, suburban, or urban landscape—were their assertive brushwork and orchestration of color. The implications of this novel focus and technique are evident in the luscious canvases by Monet, Renoir, and Sisley included in this exhibition, works that illustrate both the artists' individual voices and their collective evolution. Featuring lovely views of the French countryside, its waterways and quiet villages, as well as bustling scenes of urban Paris, these paintings embody the first maturity of Impressionism.

Monet, Renoir, and Sisley initially expanded on Realist concerns by focusing on the contemporary actualities of French scenery and the commonplaces of daily life. In his early *Farm Courtyard in Normandy* (ca. 1863, cat. 70), for example, Monet adopted the naturalistic color scheme of variegated browns and greens typically seen in the paintings of his Barbizon contemporaries. He also adapted their gestural approach for the application of his pigments. These formal choices of color range and painting technique underscore the earthiness of his rural subject.

At the heart of the Impressionists' devotion to momentary visual effects was plein-air painting. During the nineteenth century, first sketching and then painting outdoors gradually became acceptable practices for landscape painters. Proto-Impressionists such as Eugène Louis Boudin and Johan Barthold Jongkind (cats. 71–72) encouraged the approach—advice the young Impressionists took to heart. However, painting outdoors presented logistical challenges,

particularly in inclement weather. The icy poetry of Monet's snowscapes, nowhere more breath-taking than in *The Magpie* (1868–1869, cat. 73), often resulted from great physical discomfort. This much-cited contemporary description of Monet working *en plein air* appeared in 1868 and suggests the unpleasant realities of working "before the motif":

> It was during winter, after several snowy days, when communications had almost been interrupted. The desire to see the countryside beneath its white shroud had led us across the fields. It was cold enough to split rocks. We glimpsed a little heater, then an easel, then a gentleman swathed in three overcoats, with gloved hands, his face half-frozen. It was M. Monet studying an aspect of the snow.[2]

Unfortunately, Monet's virtuoso choreography of brushwork and color, unlike anything taught in the conservative curriculum of the École des Beaux-Arts, left the jury of the 1869 Salon unconvinced: they rejected *The Magpie*.

The novelty of snowscapes, including Sisley's *Snow at Louveciennes* (1878, cat. 78), is their seasonal subject matter; to create art from winter's austerity tests the artist's imagination and skill as a colorist. The Impressionists often capitalized on unusual weather occurrences. For example, in 1876 Sisley recorded the extensive spring flooding at Port-Marly in several pictures, including *The Barge during the Flood, Port-Marly* (cat. 53). As an artistic subject, water provided an ideal vehicle for investigating the fluctuating interpenetration of light and color trapped in and reflected across its surface. Here Sisley's characteristic geometric structuring of his compositions is evident. Distinct areas of color and variation in the brushwork reinforce and balance the pictorial elements. For example, the line of bare brown trees establishes a pronounced horizontality that counterbalances the visual animation created by rippling water and cotton-puff clouds in the blue sky.

The Impressionists occasionally tackled more traditional subjects, particularly portraiture. They brought to the task of representing physiognomy and personality the broken brushwork utilized in their landscape paintings. Renoir's 1874 portrait of Charles Le Coeur (cat. 87) demonstrates how the Impressionists' approach to paint application—well suited to depicting the variegated surfaces of vegetation or choppy water—served also to animate their human subjects. Le Coeur, an architect, collector, and important patron during Renoir's early career, is represented as a dapper man of the here and now. Renoir renders Le Coeur's jaunty pose and the casual outdoor setting with his rapid strokes of isolated color, searching out the patterns of light that describe three-dimensional forms. The result is the portrayal of a confident modern professional: a lively man at ease with himself and with the world.

With the goal of making images of leisure activities into art, Renoir painted *The Swing* (cat. 55) in the summer of 1876. Today the viewer delights in this enchanting image of a pleasurable pastime enjoyed by beautiful contemporary people. When the painting was exhibited at the Impressionists' third exhibition in 1877, the critic Bertall called it out for its "sublime" qualities: "Renoir's is one of the prolific and daring ones in the place. I recommend his *Balançoire*, sublime in its grotesqueness and in its audacious impudence."[3] Others noted the work's "frighteningly intense" and "ferocious" blue.[4] Regardless, the evocation of dappled sunlight filtering into the painted scene is an obvious tour de force. Thought to have inspired

Émile Zola, the picture quickly found a buyer: Renoir's fellow artist Gustave Caillebotte, who, in fact, owned nine of the paintings in this exhibition.

Joining Caillebotte and Le Coeur as an early collector of the New Painting was the wealthy industrialist Ernest Hoschedé. His collection included the Sisley flood picture and Monet's dazzlingly decorative *Turkeys* (1877, cat. 81), the most distinctive of a suite of four large panels designed for Hoschedé's country residence in Montgeron. Given its monumental size, *Turkeys* wraps the viewer in vibrant color and bold pattern. When exhibited at the third Impressionist group show in 1877, it incited numerous jibes:

> I come now to the *Dindons blancs* [white turkeys], no. 101. I am not afraid to announce that this is the last word in Impressionist art. These fowl have exquisitely irresolute form. Do not look at them from close up! One breath might send them floating away like feathers. Those fools who convulse with laughter at the sight of them obviously are unaware of the amount of courage it took for the artist to throw to the wolves these creatures so completely outside the order of gallinaceous birds![5]

However, other critics discerned in the originality of Monet's subject matter a broadening of his artistic interests. The dictates of Hoschedé's commission may have determined the decorative nature of these paintings, but the years 1877 and 1878 saw other new motifs in Monet's output.

Monet's most famous essay on industrialization took shape in early 1877. This concerted campaign focuses on the recently expanded Gare Saint-Lazare, Paris's busiest railroad station. Monet must have known the location well; while living in Le Havre and Argenteuil, he had finished each journey into Paris at this station. More than a dozen paintings and related sketches depict different aspects of the railway complex. One particularly elaborate drawing (fig. 40) reads like a preparatory sketch for *The Gare Saint-Lazare* (1877, cat. 57).[6] The Orsay's marvelous canvas is the epitome of the New Painting. The subject is very contemporary, literally and figuratively commemorating the arrival of the locomotive into the urban landscape. The technique is broad and suggestive, not descriptive, of forms and space. The colors—decorative complementary pastels—evoke the atmosphere of steam and smoke trapped beneath the vast iron-and-glass roof. The Gare Saint-Lazare campaign, Monet's first experiment with the visual and expressive potential of repetition, anticipates his subsequent practice of constructing series of related canvases that scrutinize a single motif under different affects or from different angles.

Building on his repertoire of radically modern subjects, the following year Monet created the exhilarating painting *Rue Montorgueil, Paris* (cat. 82). The composition records the June 30 festivities celebrating the end of the Exposition Universelle, the 1878 world's fair marking France's economic recovery. Awash in the hues of the Republic's tricolor, the canvas vibrates with the energy of crowds milling in the street, fluttering banners, light-splashed buildings, and shifting shadows. This urban energy is replicated in Monet's brushwork; his hand moved quickly across the canvas, creating a haze of small notations of color. The Gare Saint-Lazare and rue Montorgueil pictures are among Monet's most innovative works. He subsequently deserted Paris as a subject; increasingly, the modernity of his art was based less on what was represented than on the artist's method of execution.

By 1880 Monet, Sisley, and Renoir had moved in different directions. Sisley left the suburban communities west of Paris to live in the picturesque environs east of Fontainebleau, where he had first painted with Monet, Renoir, and Frédéric Bazille in the 1860s. Throughout the rest of his career, Sisley remained true to the motifs and techniques of classic Impressionism. Meanwhile, Monet ventured into new territory. He traveled extensively during the 1880s, seeking inspiration from a broader range of locales throughout Normandy, Brittany, and the Creuse Valley of France's Massif Central region. Monet's artistic focus and vocabulary also evolved. He devoted more studio time to each canvas, exchanging the impression of spontaneity for a poetic vision that was his new interpretation of Impressionist naturalism. Renoir also redefined his art, with a sensuous figural idiom predicated on Old Master prototypes and reflecting his experiences in Italy and Algeria in 1881.

Collectively, Monet, Renoir, and Sisley played crucial roles as Impressionism took shape in the 1860s and 1870s, their lives and careers intersecting first as students in Charles Gleyre's studio and then as painting companions, rivals, and participants in the Impressionist group shows. Their experimental enterprises introduced new artistic and business practices as well as a fresh approach to viewing the temporal world. And the eventual acceptance of their paintings brought with it the liberating recognition that skilled choreography of color, pattern, and brushwork, as a record of the kinetic process of artistic creation, was indeed art.

NOTES

1 Louis-Émile-Edmond Duranty, *La nouvelle peinture: À propos du groupe d'artistes qui expose dans les galeries Durand-Ruel* (Paris: E. Dentu, 1876), quoted in Daniel Wildenstein, *Monet or the Triumph of Impressionism*, 4 vols. (Cologne: Taschen; Paris: Wildenstein Institute, 1996), vol. 1, 119.

2 Léon Billet, "Exposition des Beaux-Arts," *Journal du Havre*, October 9, 1868, quoted in Charles Stuckey, *Monet: A Retrospective* (New York: Park Lane, 1985), 40.

3 Charles-Albert d'Arnoux, writing under the pseudonym Bertall, "Exposition des impressionnistes," *Paris-Journal*, April 9, 1877, quoted in Nicholas Wadley, *Renoir: A Retrospective* (New York: Park Lane, 1989), 111.

4 Louis Leroy, "Exposition des impressionnistes," *Le Charivari*, April 11, 1877, quoted in Wadley, *Renoir*, 111.

5 Leroy, "Exposition des impressionnistes," quoted in Charles S. Moffett et al., *The New Painting: Impressionism 1874–1886* (San Francisco: Fine Arts Museums of San Francisco, 1986), 226.

6 Juliet Wilson-Bareau, *Manet, Monet, and the Gare Saint-Lazare* (Washington, D.C.: National Gallery of Art; New Haven, Conn.: Yale University Press, 1998), 199, cat. 43, 109, fig. 97.

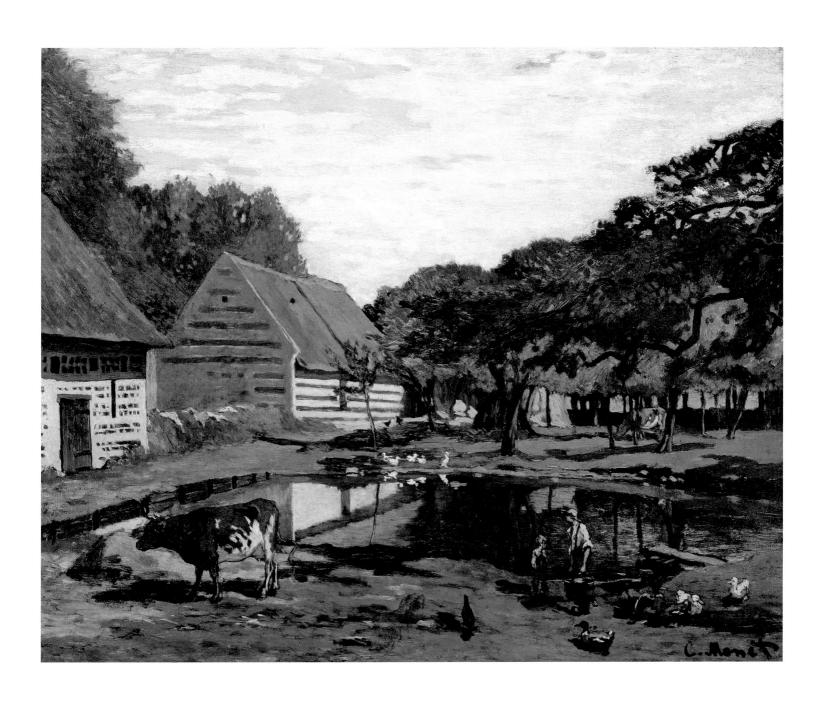

70

CLAUDE MONET

Farm Courtyard in Normandy (*Cour de ferme en Normandie*), ca. 1863
Oil on canvas
25 ⅝ × 32 ⅛ in. (65 × 81.5 cm)

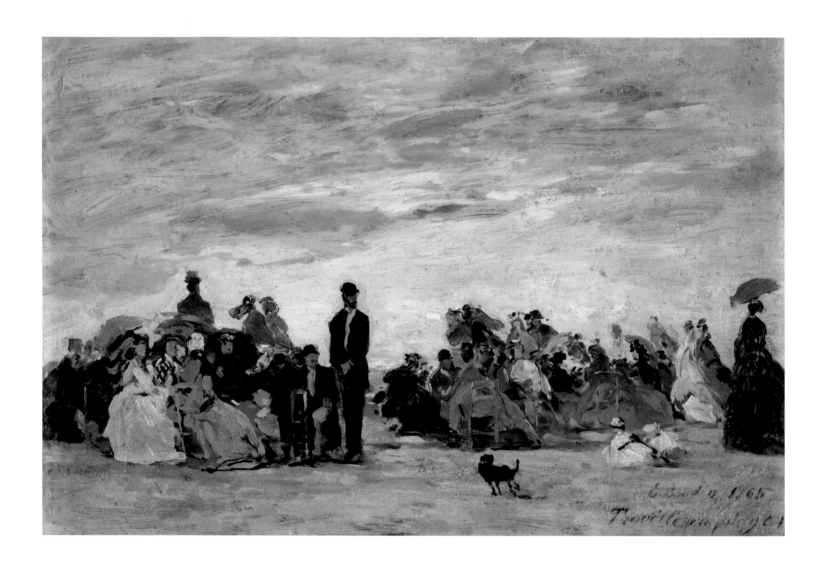

71

EUGÈNE LOUIS BOUDIN

The Beach at Trouville (*La plage de Trouville*), 1865
Oil on paperboard
10 ³/₈ × 16 in. (26.5 × 40.5 cm)

A direct precursor of the Impressionists, Boudin specialized in seascapes and harbor and beach scenes. As the new railway system made travel throughout France easier and cheaper, resorts developed along the coasts. In Normandy, Trouville and neighboring Deauville were the most glamorous holiday spots, providing accommodations to suit tourists of every pocketbook. Here, with quick, economical brushstrokes, Boudin captures the essential forms and outlines of figures engaged in social interaction on the fashionable beach. The informality of his technique complements the lighthearted mood of his subject.

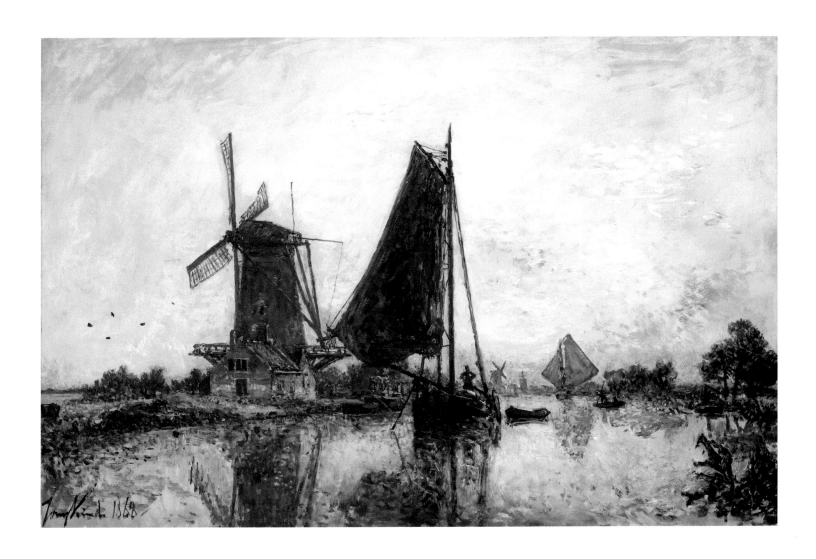

72

JOHAN BARTHOLD JONGKIND

In Holland, Boats near the Mill
(*En Hollande, les barques près du moulin*), 1868
Oil on canvas
21 × 32 in. (53.5 × 81.3 cm)

One among several foreign artists working in Paris during the 1860s whose approach to landscape prepared the way for Impressionism, the Dutchman Jongkind sketched watercolor seascapes along the northern French coast, often in the company of Boudin, Courbet, and Monet. This is a typically Dutch river scene with a compositional formula perfected in the seventeenth century, characterized by a low horizon line that provides a great expanse of canvas for the painting of sky and clouds. The sophisticated observation and portrayal of the nuances of natural light, atmosphere, and weather conditions were the basis of both the seventeenth-century Dutch school and the nascent Impressionism.

73
CLAUDE MONET

The Magpie (*La pie*), 1868–1869
Oil on canvas
35 × 51 1/8 in. (89 × 130 cm)

The Magpie is one of Monet's early masterpieces.
Celebrating the austerity of the winter landscape, this
painting is an essay in white and purple that replicates
the effects of radiant light and glowing shadows playing
across the snow. A tiny magpie, perched on the gate
like a note on a music staff, punctuates the stillness of
the snow-blanketed landscape. Despite its calm and
luminous beauty, *The Magpie* was rejected by the Salon
in 1869.

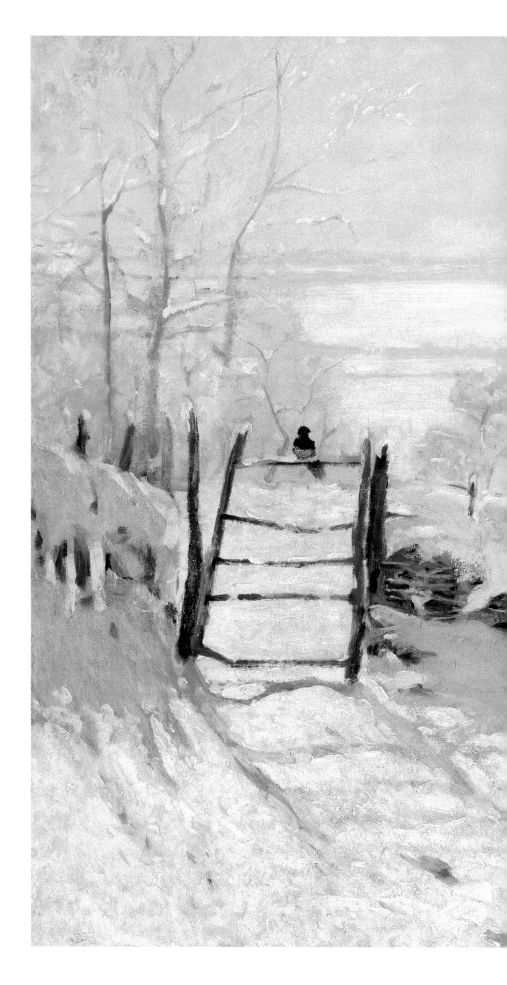

IMPRESSIONISM AND THE NEW PAINTING

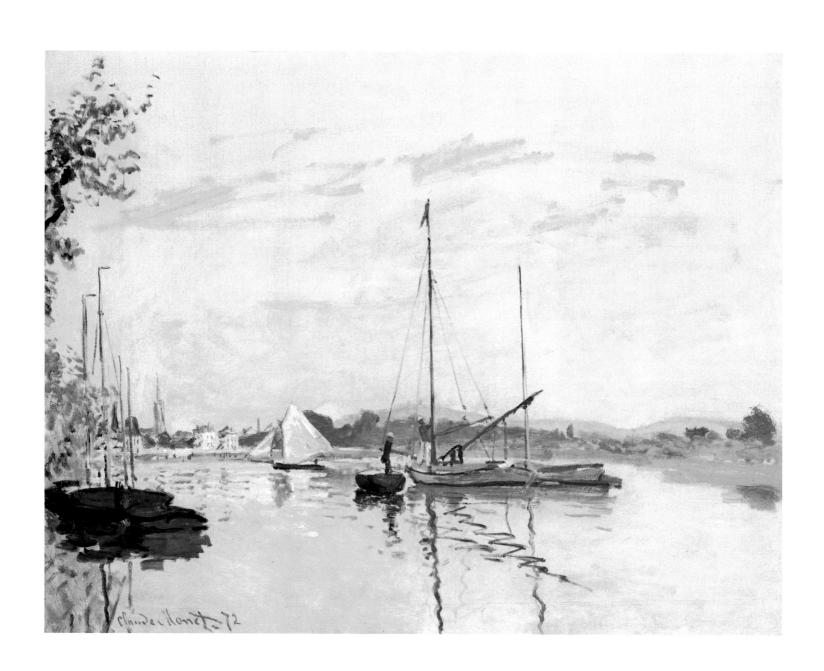

74
CLAUDE MONET
Argenteuil, 1872
Oil on canvas
19 5/8 × 25 5/8 in. (50 × 65 cm)

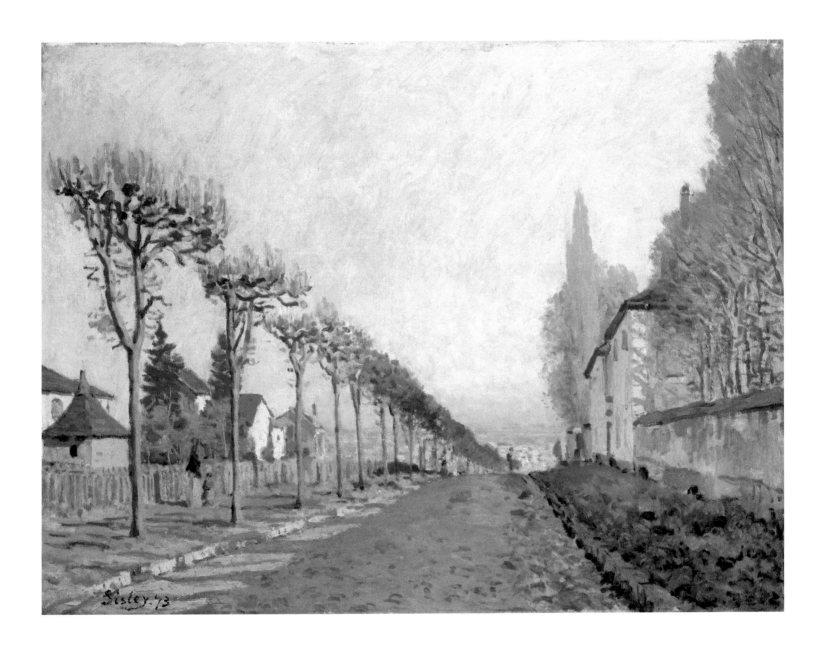

75

ALFRED SISLEY

Chemin de la Machine, Louveciennes, 1873
Oil on canvas
21 1/2 × 28 3/4 in. (54.5 × 73 cm)

Among the initial members of the Impressionist group, Sisley remained the most committed to the exploration of shifting light and weather effects, celebrating the power and visual pleasure of pure color applied with broken brushstrokes. Represented here is rue de la Machine, which leads from Voisins-Louveciennes toward Bougival and the Seine. The road is named for the Machine de Marly. This still-functioning waterworks, commissioned in 1681 by Louis XIV to provide water to the gardens of the châteaux at Marly and Versailles, was one of Sisley's favorite motifs.

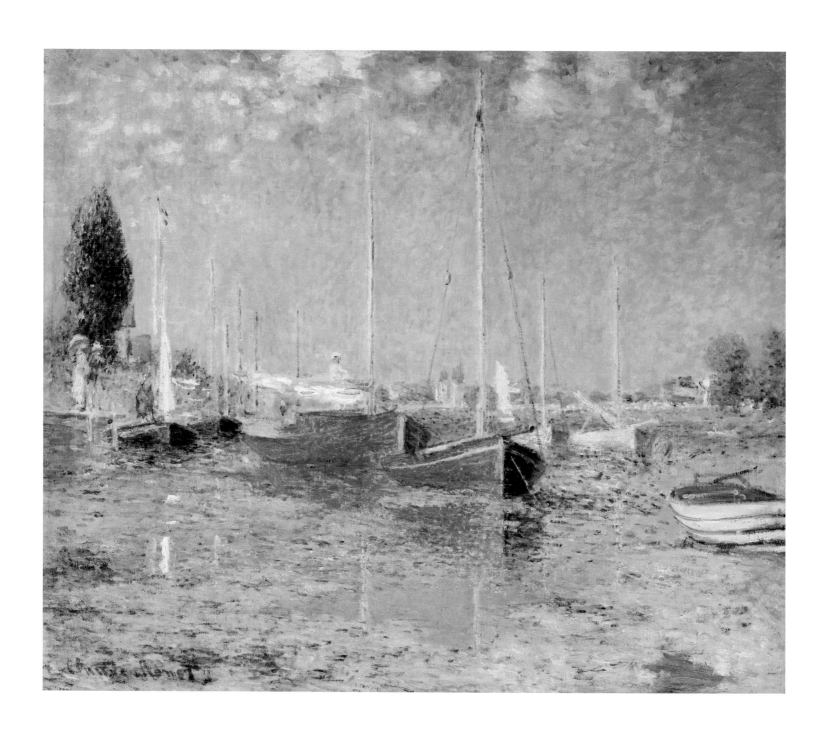

76

CLAUDE MONET

Argenteuil, 1875
Oil on canvas
22 × 26 ³/₈ in. (56 × 67 cm)

The extension of the suburban train lines allowed middle-class Parisians to live beyond the city's borders in growing communities such as Argenteuil, less than thirty minutes from the Gare Saint-Lazare. This location afforded Monet a varied repertoire of motifs, many centered on the river. With the commercial gains of the Industrial Revolution, the middle class enjoyed increased disposable income and leisure time. Activities such as yachting gained popularity, and boating clubs organized races to attract tourists. The Impressionists made these novel activities subjects for their modern histories.

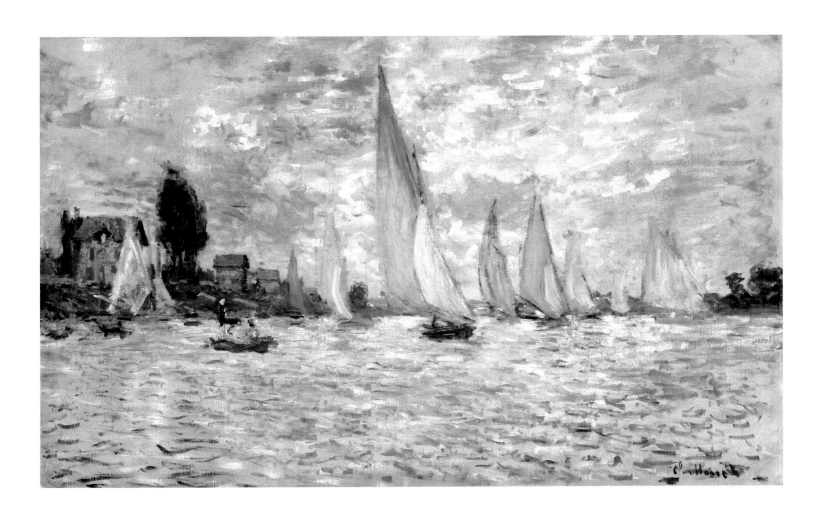

77

CLAUDE MONET

Boats: The Regatta at Argenteuil (*Les barques: Régates à Argenteuil*), ca. 1874

Oil on canvas

25 $\frac{5}{8}$ × 39 $\frac{3}{8}$ in. (60 × 100 cm)

78

ALFRED SISLEY

Snow at Louveciennes (*La neige à Louveciennes*), 1878
Oil on canvas
24 × 19⅞ in. (61 × 50.5 cm)

79

ALFRED SISLEY

Under the Snow: Farm Courtyard in Marly-le-Roi
(*Sous la neige: Cour de ferme à Marly-le-Roi*), 1876
Oil on canvas
15 ⅛ × 21 ⅞ in. (38.5 × 55.5 cm)

Having studied the works of John Constable and Joseph Mallord William Turner in London, Sisley brought to Impressionist painting an understanding of the English achievements in portraying luminous atmospheric conditions. These snowscapes also demonstrate Sisley's insistence on the geometry of his compositions. *Under the Snow* is characterized by a pronounced horizontality that is reinforced by architectural elements and calm brushwork. In *Snow at Louveciennes*, the composition's underlying structure is beautifully countered by bold, undulating brushwork and delicately choreographed color.

80

CLAUDE MONET

The Church at Vétheuil (L'église de Vétheuil), 1879
Oil on canvas
25 ¾ × 19 ⅞ in. (65.5 × 50.5 cm)

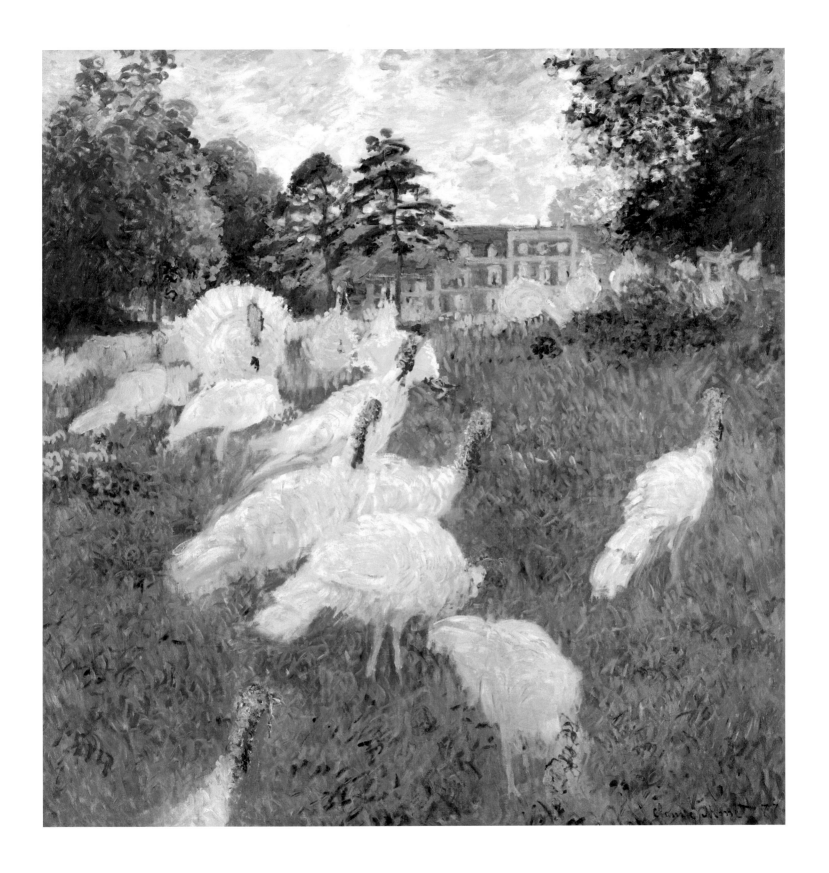

81

CLAUDE MONET

Turkeys (*Les dindons*), 1877

Oil on canvas

68 7/8 × 68 1/8 in. (175 × 173 cm)

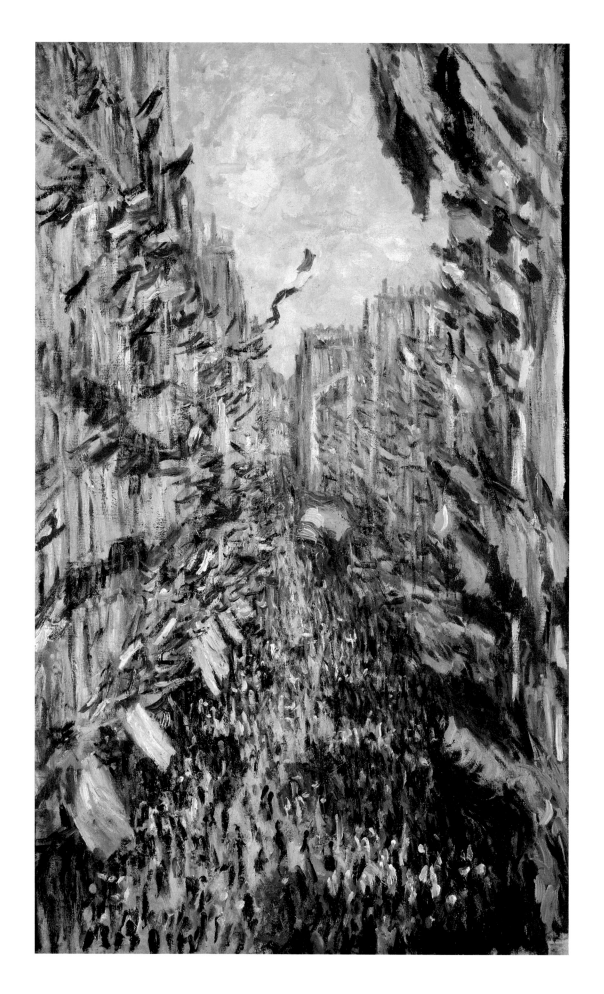

82

CLAUDE MONET
Rue Montorgueil, Paris (*La rue Montorgueil*), 1878
Oil on canvas
31 7/8 × 19 7/8 in. (81 × 50.5 cm)

This joyous painting vibrates with the pure red, blue,
and white of hundreds of French flags waving over
rue Montorgueil in Paris. Marking the triumphant
conclusion of the 1878 Exposition Universelle, the
street celebration attested to the revitalized spirits of
Parisians and Frenchmen alike only seven years after
the devastations of 1870–1871. This image also glorifies
Baron Haussmann's remaking of Paris into a modern
metropolis, with wide, straight boulevards lined by
handsome and harmonious buildings—the center of
commerce and civic vitality.

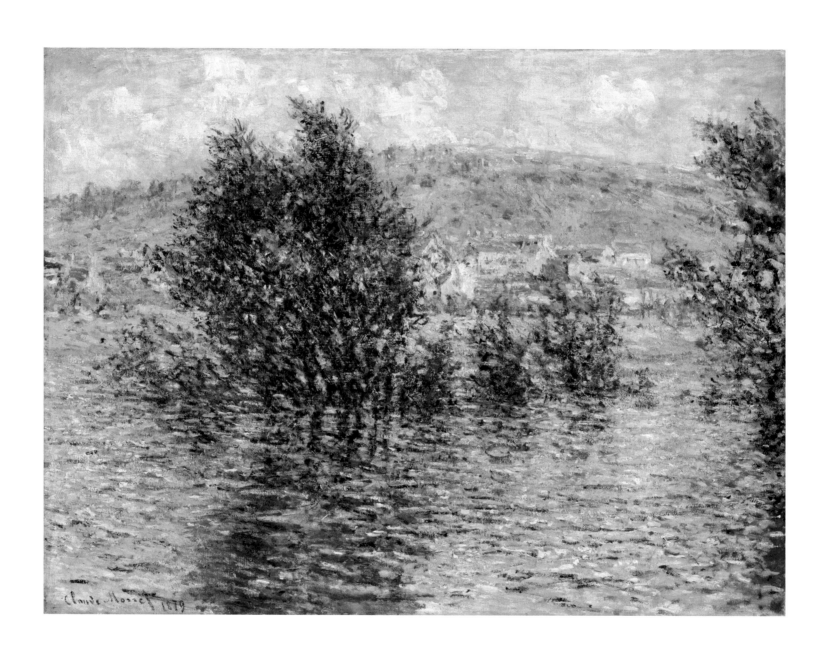

83

CLAUDE MONET

The Seine at Vétheuil (*La Seine à Vétheuil*), 1879

Oil on canvas

23 ⅝ × 31 ⅞ in. (60 × 81 cm)

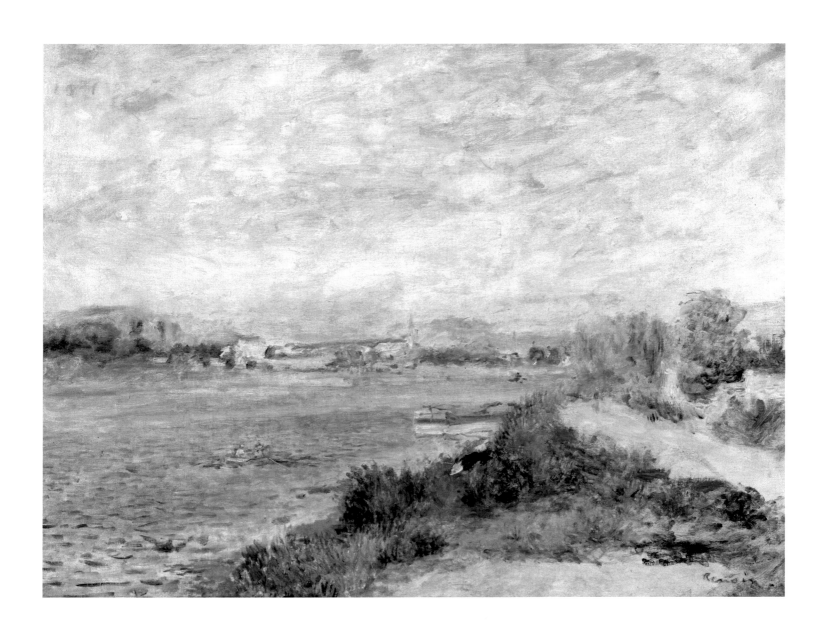

84

PIERRE AUGUSTE RENOIR

The Seine at Argenteuil (*La Seine à Argenteuil*), ca. 1873

Oil on canvas

18 1/4 × 25 5/8 in. (46.5 × 65 cm)

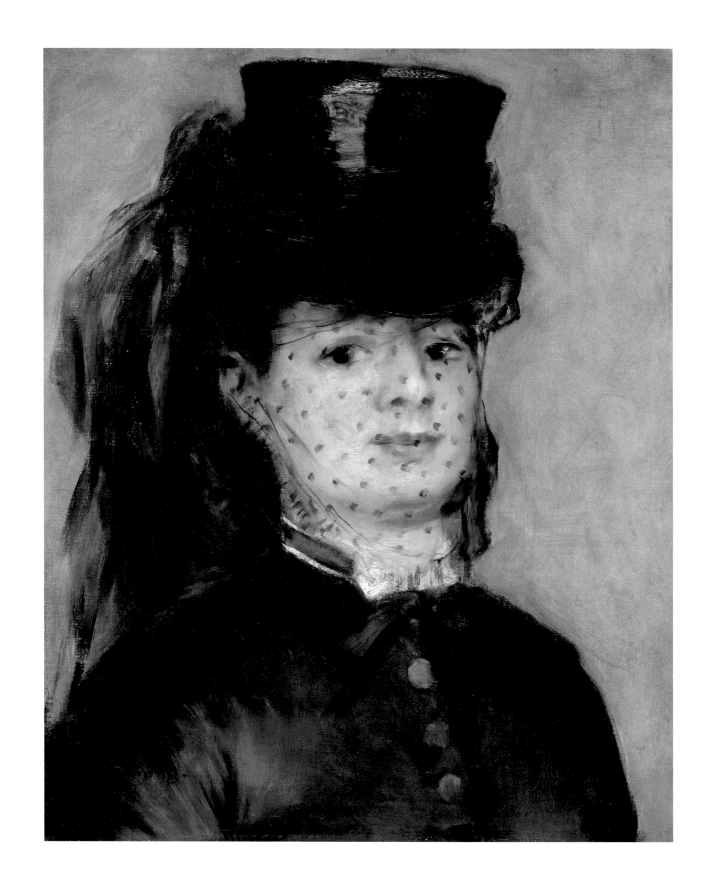

85

PIERRE AUGUSTE RENOIR

Madame Darras, ca. 1868

Oil on canvas

18 ³/₄ × 15 ³/₈ in. (47.5 × 39 cm)

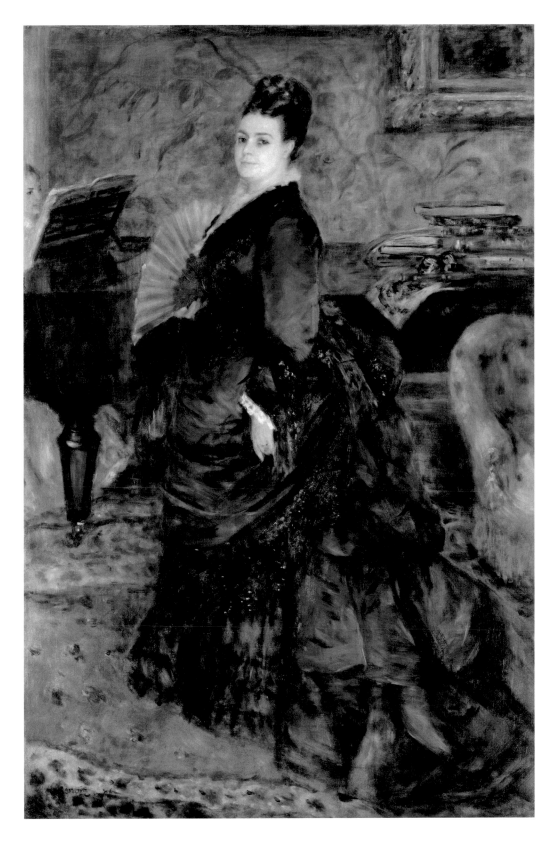

86

PIERRE AUGUSTE RENOIR

Portrait of a Woman, Thought to Be Madame George Hartmann
(*Portrait de femme, dit de Madame George Hartmann*), 1874
Oil on canvas
72 × 48 ³⁄₈ in. (183 × 123 cm)

IMPRESSIONISM AND THE NEW PAINTING

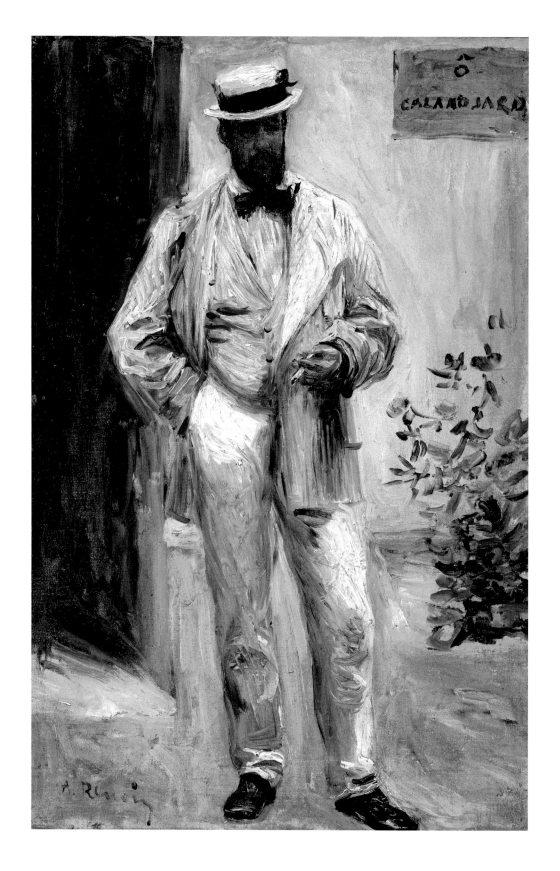

87

PIERRE AUGUSTE RENOIR

Charles Le Coeur, 1874

Oil on canvas

16 ½ × 11 ¾ in. (42 × 29 cm)

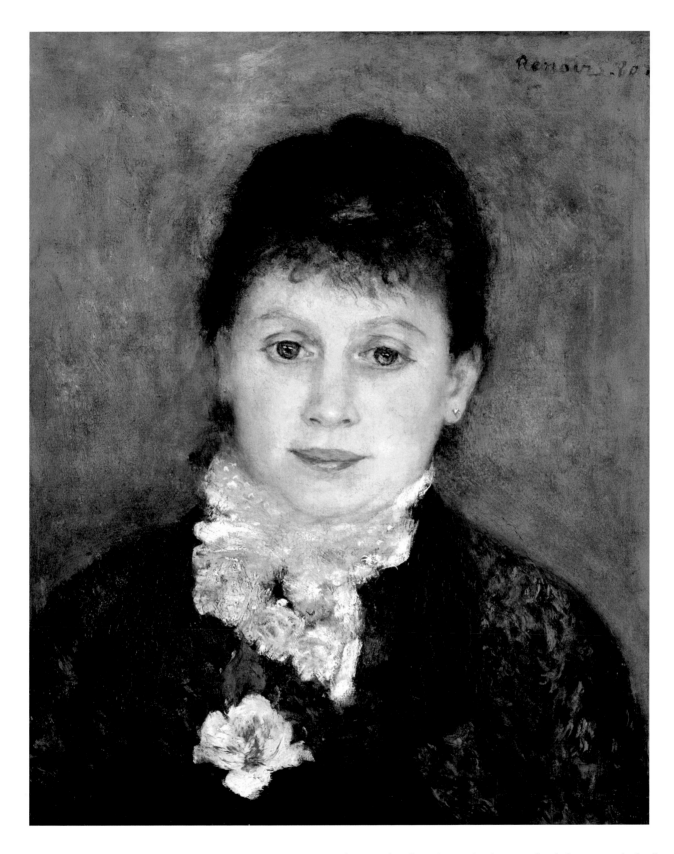

88

PIERRE AUGUSTE RENOIR
The Woman with a White Jabot (*La femme au jabot blanc*), 1880
Oil on canvas
18¼ × 15 in. (46.5 × 38 cm)

The 1880s found Renoir experiencing a new level of success, as he finally gathered around him a circle of wealthy patrons and collectors. At this time he produced a number of his best portraits, including this canvas. The delicate paint handling effortlessly describes the sitter's facial features, coiffure, and costume details. Renoir presents the woman with such direct, yet decorous, intimacy that the portrait is like his introduction of a special friend.

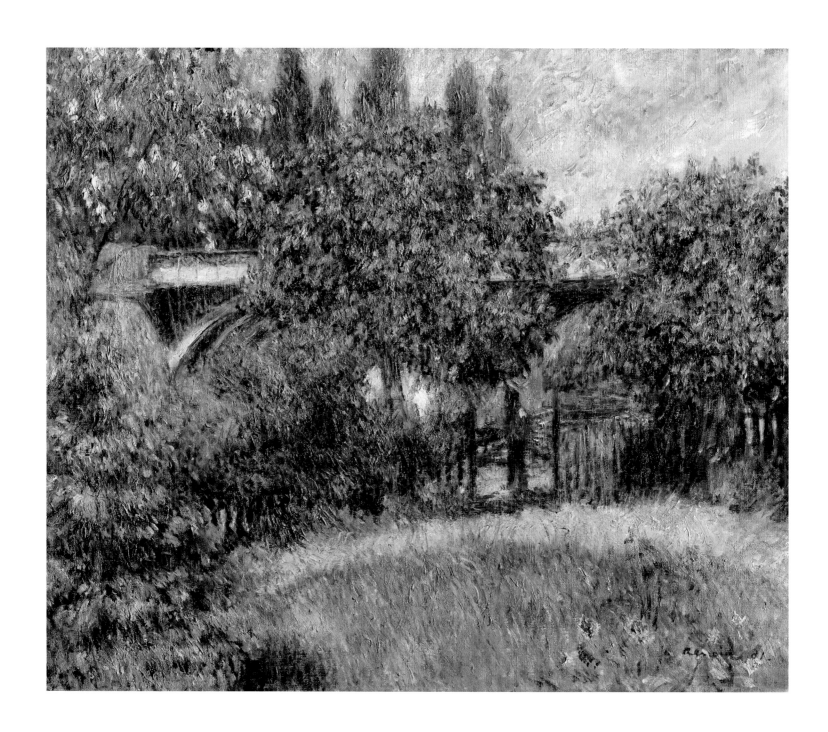

89

PIERRE AUGUSTE RENOIR

Railway Bridge at Chatou (*Pont de chemin de fer à Chatou*), 1881

Oil on canvas

21 1/4 × 25 3/4 in. (54 × 65.5 cm)

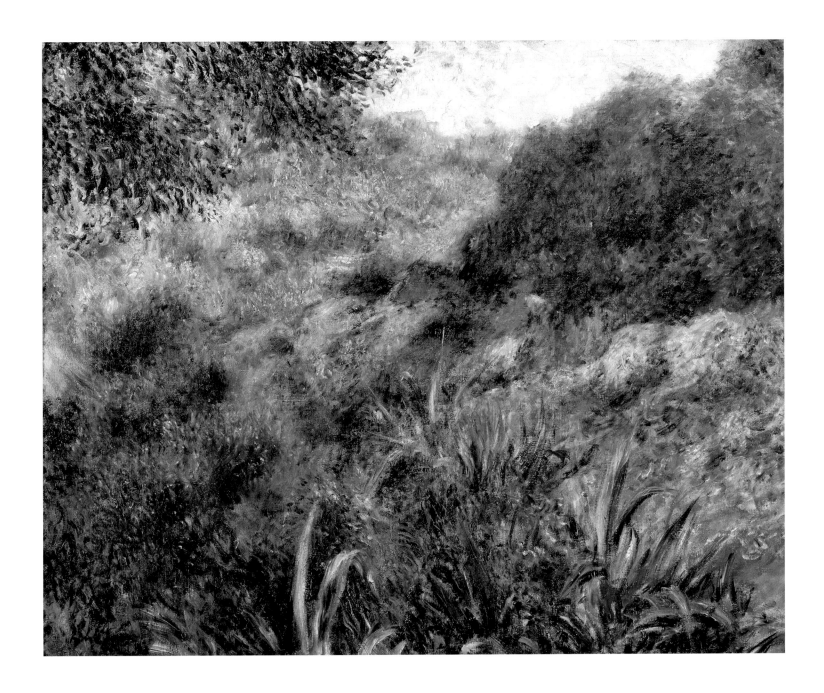

90

PIERRE AUGUSTE RENOIR
Algerian Landscape, the Ravine of the "Femme Sauvage"
(*Paysage algérien, le ravin de la femme sauvage*), 1881
Oil on canvas
25 ³/₄ × 31 ⁷/₈ in. (65.5 × 81 cm)

After his 1881 trip to Algiers, Renoir infused his landscapes with the effects of the dazzling light of North Africa. In this brilliant oil he captured the warmth of the Algerian landscape in blue, green, and sienna hues. Nineteenth-century travel accounts describe the beauty of this ravine, thickly covered with lush and exotic vegetation, including pomegranate, aloe, and prickly pear. The source of the site's intriguing name has a variety of explanations, including the story of a young woman who served drinks to laborers constructing a nearby road.

PISSARRO AND CÉZANNE: AN EARLY MODERN FRIENDSHIP

KRISTA BRUGNARA

Camille Pissarro and Paul Cézanne met about 1860 at art school in Paris, each having fled his bourgeois roots to pursue his passion. The two artists immediately bonded over their mutual disdain for the art establishment. Over the next decade, Pissarro's work was often accepted by the Salon while Cézanne's was consistently rejected; in 1863 both participated, alongside Édouard Manet, in the Salon des Refusés, an exhibition that bucked the traditional and en-trenched academic system represented by the Salon. Beginning in 1866 Pissarro and Cézanne began taking part in group gatherings led by Manet and Émile Zola that would open informal discussions of a new way of painting. However, social and political turmoil over the next few years squelched rebellious artistic trends, and in the early 1870s both Pissarro and Cézanne found themselves drawn to the French countryside. As they painted in nature their pictorial curiosity flourished, often in direct response to each other's work.

Collectively, their paintings from this period represent a form of intense artistic dia-logue. Though Pissarro was the elder of the two, they did not have a traditional master-student relationship; Pissarro clearly saw Cézanne as an artist from whom he could learn. Their efforts were collaborative and they interacted as equals. While reveling in their distinct approaches, they often grappled with the same subject matter. Indeed, through mutual influence they paved the way toward a modern mode of painterly experimentation.[1]

Both artists participated in the first Impressionist exhibition in 1874. Pissarro, the only painter to show his work in all eight group exhibitions, struck a balance between the style of the masters he admired from the previous generation, such as Jean-Baptiste-Camille Corot and Jean-François Millet, and the avant-garde approach of his contemporaries, most importantly Cézanne. As much as Pissarro revered nature, as is evidenced by his prolific landscape paintings, his purposeful inclusion of the human figure in much of his work should not be ignored. This tendency reflects his strong humanist leanings, for which he was known. He was also among the most politically radical of his artistic contemporaries. Pissarro was equally progressive in his approach to art, experimenting with one strategy after another. Cézanne famously referred to him as "humble and colossal,"[2] perhaps because, though not a strident self-promoter like many of their associates, Pissarro had a major impact on their work.

A native of Aix-en-Provence, Cézanne was a friend from childhood of the influential thinker, writer, and critic Zola. Both felt strongly that art should be marked by the temperament of the artist; this sentiment clearly informed Cézanne's expressive style, through which he asserted the unrestrained nature of his personality. Cézanne took part in the first and third Impressionist exhibitions, contributing paintings that were stylistically close to those of Pissarro. Both worked outdoors and chose to build up their canvases with an ardent layering of brushstrokes. In retrospect, Cézanne has eluded categorization as an Impressionist in part because he constantly reinvented and reoriented his approach to art with great success, and, as a result, he thoroughly influenced the next generation of artists. However, he consistently balanced the imaginary and the abstract with what he observed in nature; he did so in a novel way, taking liberties with color and form but always relying on a conscious study of nature. Cézanne's enigmatic work did not conform to the conventions of his era but rather transcended them.

Pissarro kept a studio in Paris but preferred to live in the country with his family, first in Louveciennes and then, from 1872 to 1882, in Pontoise. *Road to Ennery* (1874, cat. 92), with its expanse of gray sky, captures the slow pace of the countryside that Pissarro so enjoyed. Cézanne also moved his family to Pontoise in 1872 and then to nearby Auvers-sur-Oise, where he and Pissarro often worked together. At times they approached the same subjects with regularized brushstrokes and a restricted color range, creating a new sense of pictorial space in the process. The comparison of canvases by the two masters affords a number of insights into their work.

Pissarro's *Hoarfrost* (1873, cat. 93), which captured the essence of a completely still winter day, was one of five pictures the artist showed in the first group exhibition. It received mixed reviews from the critics. Philippe Burty offered that it reminded him of one of Millet's best themes, while noticing a lack of precise definition.[3] Jules-Antoine Castagnary praised the artist for his sobriety yet noted the "grave error" of painting shadows cast by trees outside the frame.[4] Louis Leroy complained of the "palette-scrapings placed uniformly on a dirty canvas. It has neither head nor tail, top nor bottom, front nor back."[5] Clearly the critics did not fully appreciate the purpose of Pissarro's bold use of the brush and palette knife.

Cézanne's *The Hanged Man's House* (1873, cat. 96) was also shown in the first Impressionist exhibition. The critics did not spare it any more than they did his painting *A Modern Olympia* (1873–1874, Musée d'Orsay), which hung nearby. Nonetheless, it sold to Comte Armand Doria and, at the artist's request, was exhibited on a regular basis throughout his life. This portrait of an austere village, devoid of human presence, exudes a strong sense of melancholy. The complex composition distracts the viewer's eye from the titular house with its conflicting angles of closely laid planes: at the left a steep path climbing up, at the center another leading down, at the right stones curving away, the bare tree branches swooping upward. Pissarro had encouraged Cézanne to abandon his earlier, coarser approach and instead capture the vibrating light. His influence is evident in Cézanne's use of thick brushstrokes and a restrained color palette to describe the density of the architecture, vegetation, and pavement.

Several years later, in *Red Roofs, Village Corner, Winter Effect* (1877, cat. 97), Pissarro conveyed a similar sense of space and solitude by borrowing Cézanne's juxtaposition of diagonal and vertical planes. The trees, barren of leaves in the winter cold, define the foreground and set the tone for the composition. In the middle ground houses recede behind a curtain of trees, their strong vertical lines echoed in the background. Varying from deep red to brown,

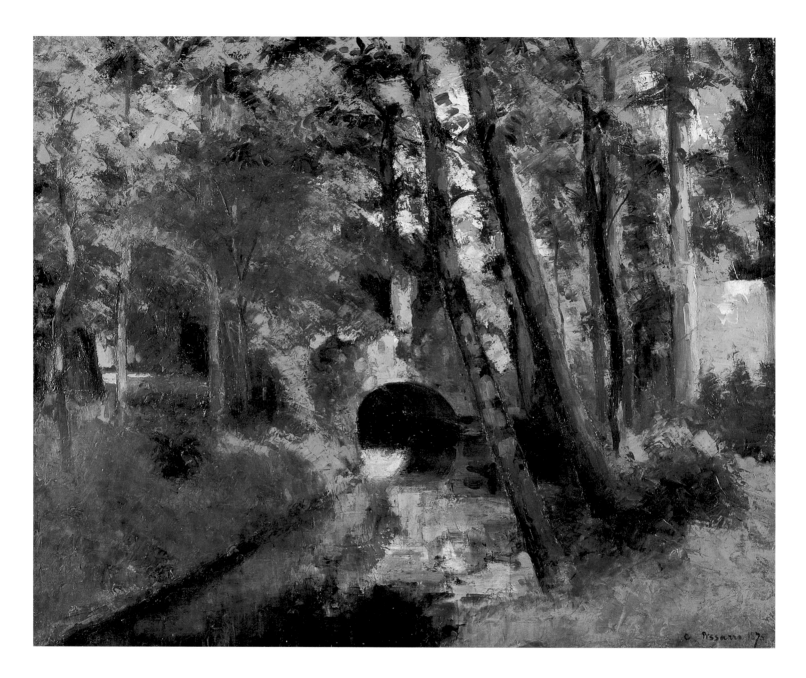

the diagonal rooftops repeat the lines and tones of the foreground foliage and background hills. Pissarro's thickly applied paint further emphasizes the silhouettes of the trees, catching the light and intensifying the vitality of the scene. This vibrant painting was exhibited at the third Impressionist show in 1877.

Throughout his career Cézanne painted dazzling still-life arrangements, such as *Still Life with a Soup Tureen* (ca. 1873–1874, cat. 99), which belonged to Pissarro.[6] He structured these compositions with everyday objects, bold prints, cluttered backgrounds, and abundant fruit. Alongside a soup tureen and a bottle, apples spill out of their basket, the yellow fruit dancing against the red patterned tablecloth. The haphazard array of pictures hanging on the wall, which has lost some of its plaster, suggests the simple home of an artist.

Cézanne's *The Maincy Bridge* (cat. 101), painted about 1879, portrays an actual place, a bridge spanning the Almont River at Maincy near Melun. However, it also represents a figurative bridge to Cézanne's style from the 1880s onward, during which time he developed a wholly

original approach to composition. The close hatching of richly colored, parallel brushstrokes gives an enticing depth to the canvas, which is full of inventive shapes created by the arched bridge and trees and their myriad reflections. It recalls and expands upon the bridge motif in Pissarro's *Small Bridge, Pontoise* (1875, fig. 41), which also focuses on an arched span in a dense forest. Pissarro created a densely textured surface by interchanging his palette knife and brush in the application of the paint, a technique often employed by Cézanne. No longer painting to imitate what he saw, Cézanne re-created his visual experience through a deliberate structuring of color, light, and shadow that produced a patterned, woven effect. Unlike artists whose exploration of a modern pictorial approach emphasized flat shapes over three-dimensional forms, Cézanne never abandoned the rigorous modeling of volume through tonal gradation. However, he relied on juxtaposed patches of color instead of subtle transitions to describe form and pictorial space.

At this crucial point in their careers, both Pissarro and Cézanne developed intense work habits. Individually, but often in response to each other, they executed sequences of closely related compositions while immersed fully in the landscape. All the while they learned from and challenged each other as colleagues, forging, through strong friendship and mutual admiration, a thoroughly modern approach to art.

NOTES

1 My understanding of the relationship between these two artists is heavily indebted to the scholarship of Joachim Pissarro in *Cézanne and Pissarro: Pioneering Modern Painting* (New York: Museum of Modern Art, 2005).

2 Émile Zola, *Écrits sur l'art*, ed. Jean-Pierre Leduc-Adine (Paris: Gallimard, 1991), 112.

3 Philippe Burty, "Exposition de la société anonyme des artistes," *La Republique Française*, April 25, 1874, quoted in Charles S. Moffett et al., *The New Painting: Impressionism 1874–1886* (San Francisco: Fine Arts Museums of San Francisco, 1986), 138.

4 Jules-Antoine Castagnary, "Exposition du boulevard des Capucines: Les impressionnistes," *Le Siècle*, April 29, 1874, quoted in Moffett et al., *The New Painting*, 138.

5 Louis Leroy, "L'exposition des impressionnistes," *Le Charivari*, April 25, 1874, quoted in Moffett et al., *The New Painting*, 138.

6 The painting has been dated previously as early as 1873 and as late as 1885.

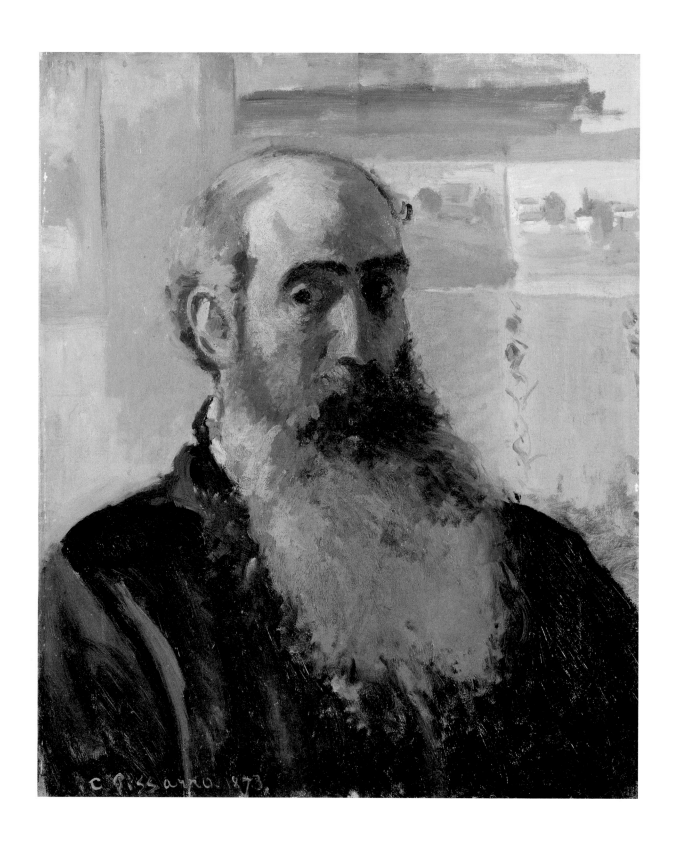

91

CAMILLE PISSARRO

Self-Portrait (*Portrait de l'artiste*), 1873

Oil on canvas

22 × 18¼ in. (56 × 46.5 cm)

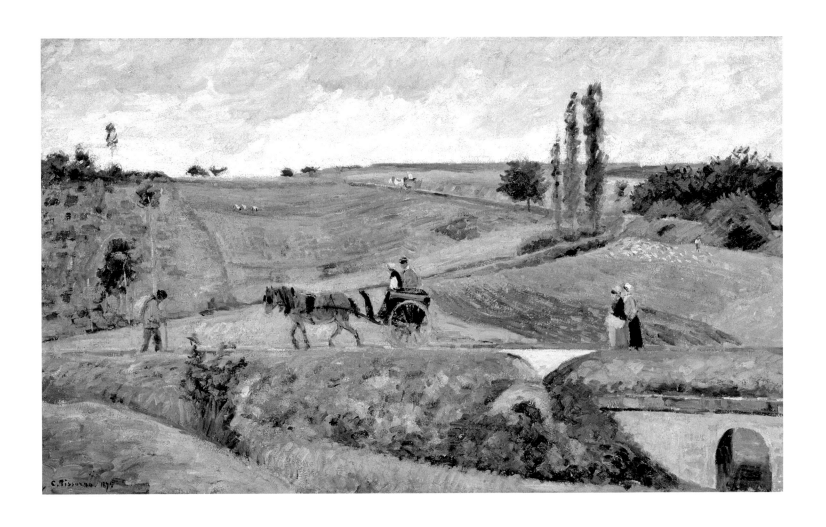

92

CAMILLE PISSARRO

Road to Ennery (Route d'Ennery), 1874

Oil on canvas

21 ⁵/₈ × 36 ¹/₄ in. (55 × 92 cm)

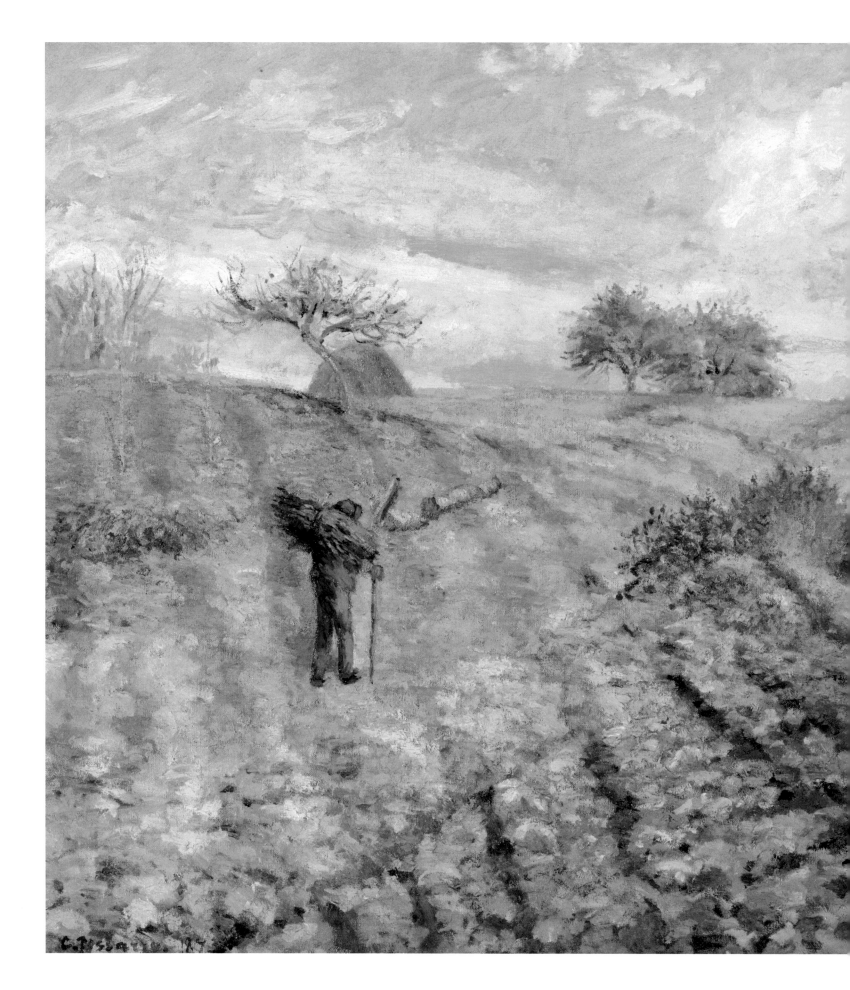

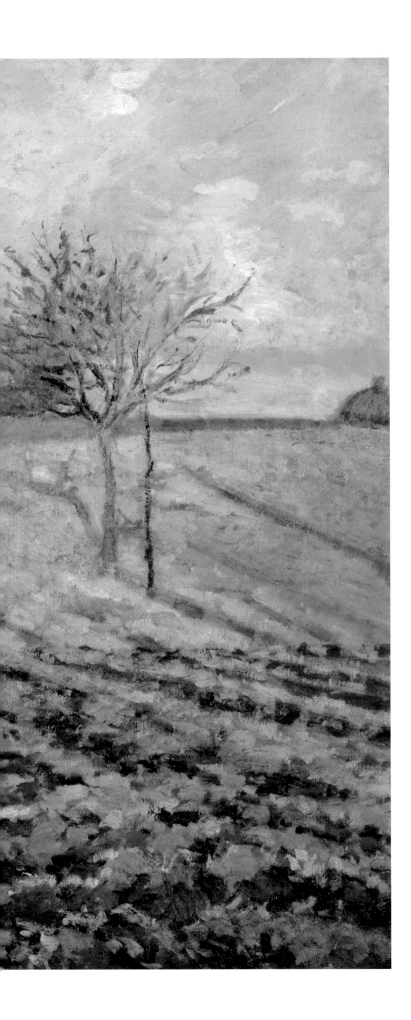

93

CAMILLE PISSARRO

Hoarfrost (*Gelée blanche*), 1873
Oil on canvas
25 5/8 × 36 5/8 in. (65 × 93 cm)

Pissarro's *Hoarfrost* is one of five paintings the artist
contributed to the first Impressionist exhibition, held
in 1874. The thick buildup of paint and the cropped
composition together give the painting an earthbound
quality, which echoes the plodding step of the peasant.
The attention paid to the effects of seasonal light and
to the decorative quality of the color is characteristic
of Impressionist landscapes.

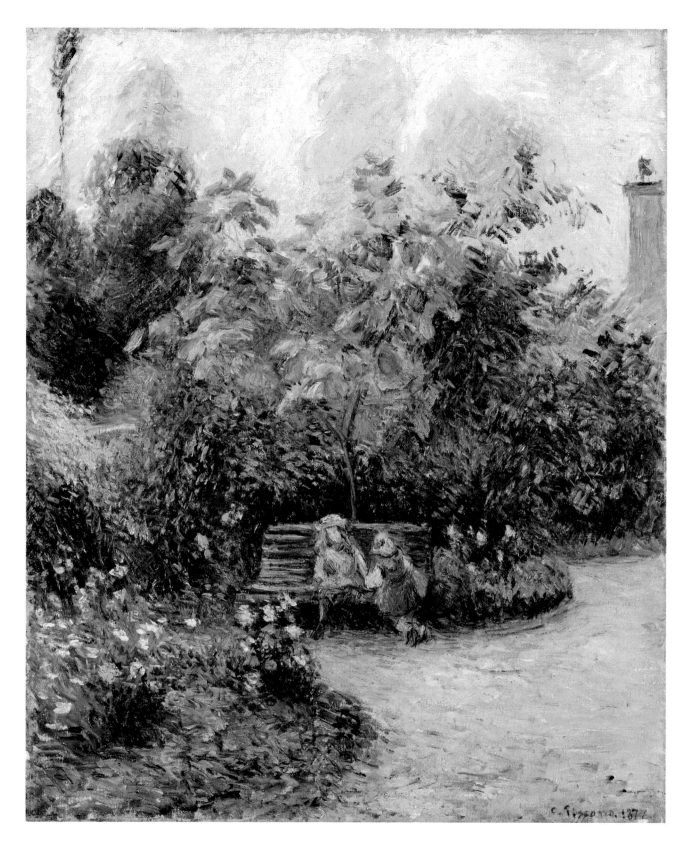

94

CAMILLE PISSARRO
Corner of the Garden at the Hermitage, Pontoise
(*Coin de jardin à l'Hermitage, Pontoise*), 1877
Oil on canvas
21 ⁵/₈ × 17 ³/₄ in. (55 × 45 cm)

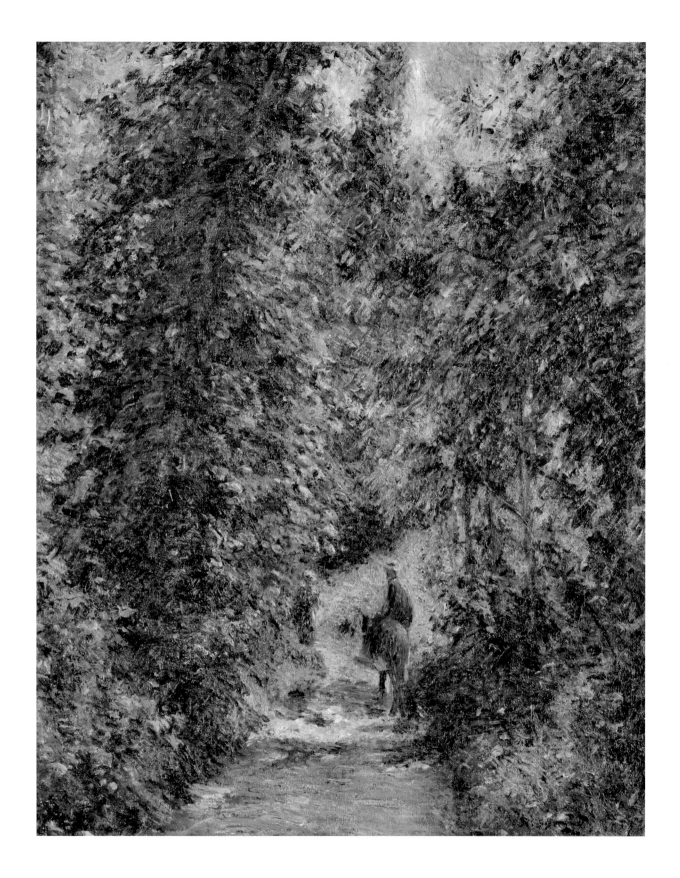

95

CAMILLE PISSARRO

Path through the Woods, Summer (Chemin sous bois, en été), 1877
Oil on canvas
31 7/8 × 25 7/8 in. (81 × 65.7 cm)

96

PAUL CÉZANNE

The Hanged Man's House (*La maison du pendu*), 1873

Oil on canvas

21 5/8 × 26 in. (55 × 66 cm)

97

CAMILLE PISSARRO

Red Roofs, Village Corner, Winter Effect
(*Les toits rouges, coin de village, effet d'hiver*), 1877
Oil on canvas
21 1/2 × 25 7/8 in. (54.5 × 65.6 cm)

98

PAUL CÉZANNE

Self-Portrait with a Pink Background (*Portrait de l'artiste au fond rose*), ca. 1875
Oil on canvas
26 × 21 5/8 in. (66 × 55 cm)

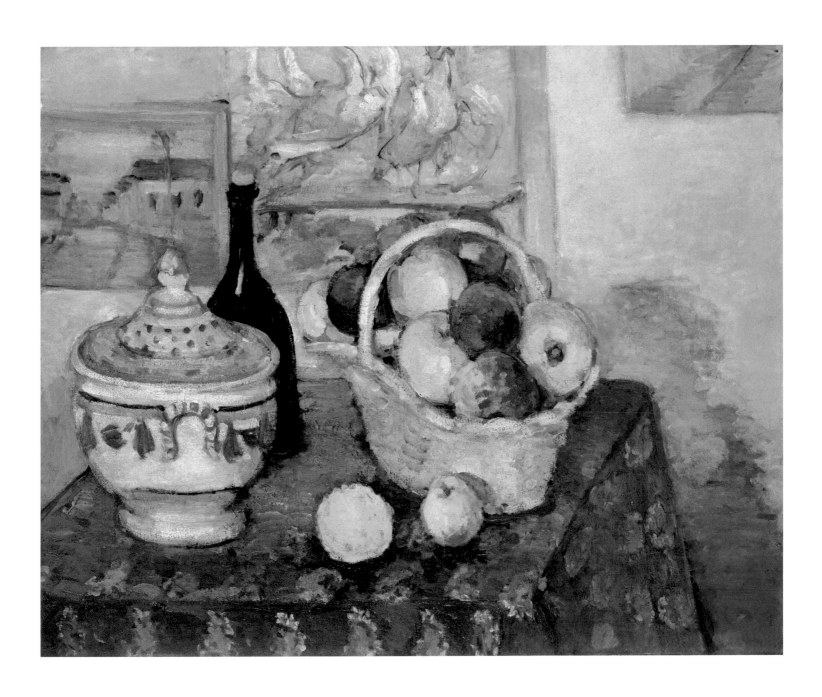

99

PAUL CÉZANNE

Still Life with a Soup Tureen (*Nature morte à la soupière*), ca. 1873–1874
Oil on canvas
25 1/4 × 32 1/8 in. (65 × 81.5 cm)

By 1873 Cézanne's stylistic divergence from the Impressionists was becoming more apparent. While Renoir and Monet were intrigued by indistinct forms dissolved by broken brushwork and atmospheric effects, Cézanne was obsessed with depicting volumes in space, which led to an increasing solidity of form in his work. Here he simplified the forms to clearly express the surfaces of the objects and favored intense, localized color. The result is a composition altogether more formally structured and substantial than those of his contemporaries.

100

PAUL CÉZANNE
The Gulf of Marseille from L'Estaque
(*Le golfe de Marseille vu de L'Estaque*), 1878–1879
Oil on canvas
22 7/8 × 28 3/4 in. (58 × 72 cm)

During the Franco-Prussian War of 1870–1871 Cézanne
sought refuge in the seaside suburbs of Marseille, where
his mother owned a small house at L'Estaque. Inspired
by the landscape, he returned to L'Estaque several times
after the war. Although Cézanne exhibited with the
Impressionists and practiced some of their techniques,
such as painting *en plein air*, his quest to render the
volume and solidity of forms—as seen in this balanced,
horizontal composition with clearly defined planes—
set him apart from his contemporaries.

101

PAUL CÉZANNE

The Maincy Bridge (*Pont de Maincy*), ca. 1879

Oil on canvas

23 × 28 ½ in. (58.5 × 72.5 cm)

The gap between Cézanne and the Impressionists continued to widen following his participation in the third Impressionist exhibition in 1877. Hurt by the scathing reaction of critics, he continued nonetheless to seek official approval by submitting his work to the annual Salons, where it was regularly rejected. In his landscapes, Cézanne continued to strive for balance with rigidly defined geometric compositions. Short, choppy brushstrokes describe planes and volumes. This work exemplifies the artist's stylistic dialogue with Pissarro, with whom he often worked at this time.

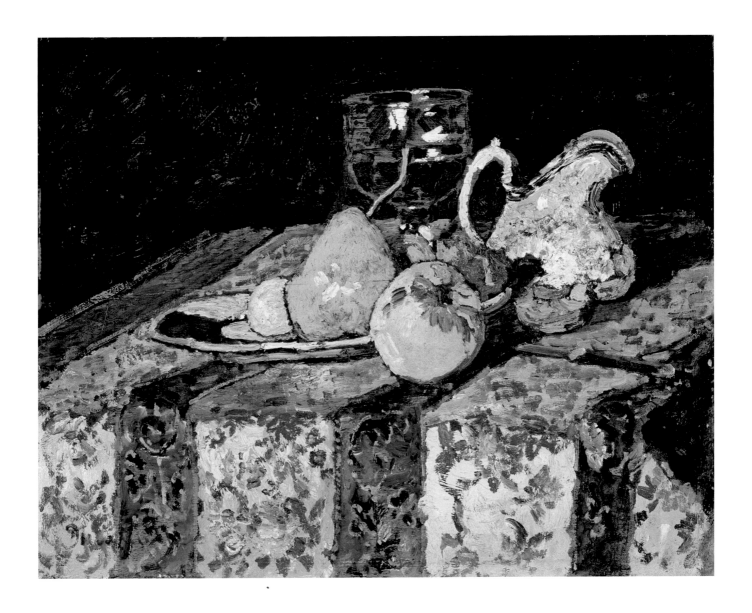

102

ADOLPHE MONTICELLI

Still Life with White Pitcher (*Nature morte au pichet blanc*), ca. 1878
Oil on panel
16 ⁷⁄₈ × 24 ³⁄₄ in. (43 × 63 cm)

Toward the end of his career, Monticelli modified his style, a shift that coincided with the advances of the emerging generation. Here, for example, he addressed the conventional still life with a modern approach not unlike Cézanne's. The thick impasto in his late works was so aggressive that some critics speculated about his sanity. Monticelli countered that it would take half a century for viewers to understand his experimentations. Van Gogh owned at least six paintings by Monticelli and acknowledged his indebtedness to him.

DEGAS: A SNAPSHOT OF MODERN LIFE

MARÍA LÓPEZ FERNÁNDEZ

"There is nothing spontaneous about my art; it is all reflection," Edgar Degas said.[1] But his works evoke a strong sense of immediacy that seems to belie this assertion, making him, in the eyes of the general public, the painter par excellence of modern life, that ever-changing world of which the artist captures only an instant.

The racetrack, the ballet, intimate views of women, and portraits of the triumphant bourgeoisie are the main subjects of his work. But Degas shows the other side of the glamour that more conventional artists exploit. His horses aren't racing; they are ambling or exercising. His dancers are almost always rehearsing, dressing, or stretching; when they perform, they are seen from the wings of the stage. His women are caught at the most delicate moment of their toilet; his men, unposed, in the frenetic pitch of their economic or amorous conquests.

All of Degas' subjects are moving, conveying what is happening and what they are experiencing at that precise, ephemeral moment. And the viewer gazes in amazement—always as a voyeur—at a scene so immediate that it becomes dynamic and real, like a snapshot of modern life. Degas knew, however, that art was not a snapshot; only photographs were supposed to be.[2] Art was a great "convention," as he told Paul Valéry, a sort of "artifice" to be constructed through elaborate compositional procedures.[3]

Degas lived at a time when the first moderns were challenging the classical values of composition and finish. The impetuous brushstrokes of Impressionist canvases definitely did not fit with the principles of Jean-Baptiste-Dominique Ingres. Louis-Émile-Edmond Duranty had noted certain differences of approach among the emergent avant-garde, explaining in *La nouvelle peinture* (*The New Painting*), "Some limit themselves to transforming tradition and strive to translate the modern world without straying far from the ancient and magnificent formulas that have served to express the preceding worlds," while others "abruptly reject the methods of times past."[4] To which group did Degas belong? It is true that in spite of stylistic differences between Degas and his contemporaries, we consider the painter as part of the Impressionist group. On the one hand, Degas pestered his friends to participate in the Impressionist exhibitions. On the other hand, he often delayed his own submissions to the exhibitions, even when the works were finished—thus purposefully undercutting his participation in them.[5]

FIG. 42 **EDGAR DEGAS**

Women on the Lawn: Study for Racehorses before the Stands (*Femmes sur la pelouse: Étude pour* Le défilé), ca. 1866–1868

Wash, oil, and gouache

18 1/8 × 12 13/16 in. (46 × 32.5 cm)

Musée d'Orsay, 5602

According to Joris-Karl Huysmans, Degas redefined the fundamental formal values of art, overturning all the conventions of painting and sculpture.[6] Among other innovations, he adopted new compositional approaches derived from Japanese woodblock prints, photography, and graphic illustration—elements on which he based the fragmentary structure of his works. Degas became acquainted with Japanese prints in 1856 through his friend Félix Bracquemond. Together they visited Madame Desoye's famous Parisian boutique La Porte Chinoise, a veritable school of Japanese art. He also acquired drawings by Andō Hiroshige, sixteen albums by Kitagawa Utamaro, and various prints by artists such as Torii Kiyonaga and Katsushika Hokusai. *Ukiyo-e* prints are characterized by high vantage points; the privileged, asymmetrical placement of some elements of the composition; and the aesthetic use of empty, or negative, space—novelties appealing to Degas. Photography also proved an important influence. Duranty had encouraged artists to explore scientific discoveries, and the photographic image offered Degas fresh ideas on how to accentuate certain perspectives and to achieve "selective framing."

These compositional approaches allowed Degas to infuse his work with a strong sense of spontaneity. *Racehorses before the Stands* (1866–1868, cat. 103), one of his first works to focus on the racetrack, is a good example: the painting is structured along two independent planes, one for the audience and one for the horses and their jockeys, juxtaposing, as in Japanese prints, two different points of view. There is no relation of scale between the two realms: the people attending the race appear dwarfed by the horses. Despite the spontaneous appearance of his paintings, Degas occasionally made numerous preparatory studies. For example, the drawing

Women on the Lawn (fig. 42), a study for *Racehorses before the Stands*, shows the same woman in more than ten different poses.

In spite of the disjuncture between the horses and the crowd, critics of the time perceived in this painting the feverish atmosphere of the racetrack. When *Racehorses before the Stands* was presented at the first Impressionist exhibition under the title *False Start*, Philippe Burty praised the work. The artist, said Burty, "knows how to see, and to show, a race, the jockeys glued to their saddles, the excited crowd."[7] Indeed, the nervous movement of the Thoroughbreds evokes the imminence of the race.

The horse was a very appropriate subject for Degas. He once said he considered horses the only pure beings of modern reality. At the same time, the subject allowed Degas to allude to the classical canon of European Old Masters, drawing inspiration from Paolo Uccello, Benozzo Gozzoli, and Anthony van Dyck. Valéry found correspondences between the horse and the dancer, two of Degas' favorite subjects.[8] Indeed, Degas used the long limbs of both to provide the structural underpinning of his works.

As they did for his fellow artists, horses and racetracks served as vehicles for Degas to develop his studies of motion. In early explorations such as *Racehorses before the Stands*, though the viewpoints are innovative, he adhered to certain conventions for depicting the horses at gallop. In this, Jean Louis Ernest Meissonier—who, to achieve greater realism in his portrayals, made studies of horses from the sidewalks of the Champs-Élysées—was still Degas' great inspiration. Years later, Degas admitted that in the late 1860s, though well versed in the anatomy of horses, he knew absolutely nothing about the mechanism of their movements.[9]

In works such as *The Racetrack: Amateur Jockeys near a Carriage* (1876–1887, cat. 104), where Degas depicts horses at rest, at an amble, and at a gallop, we see an obvious evolution. By that date, as Valéry pointed out, Degas had learned about the motion studies of the American photographer Eadweard Muybridge, who, since 1872, had been analyzing the gaits of horses through sequences of still images produced using multiple cameras. In December 1878 the magazine *La Nature*, to which Degas subscribed, published the results of these studies of animal motion and, in 1882, explained the mechanism of the zoetrope based on images taken by Muybridge.[10] Degas missed Muybridge's November 1881 lecture in Meissonier's studio, and Muybridge did not publish his *Animal Locomotion* in its entirety until 1887. Thus, Degas probably used the images from *La Nature* as his source for several small wax horse sculptures.[11] He was convinced, he declared years later, that "to produce an interpretation of the animal so perfect that it would give the impression of life, I had to resort to three dimensions."[12]

In one of his first depictions of a ballet rehearsal, *The Dance Foyer at the Opera on Rue Le Peletier* (1872, cat. 109), Degas produces a vivid impression of reality. But it was not until 1883 that he was given access to the opera's rehearsals. Until then, professional ballerinas posed in his studio, and Degas used the drawings made during these sessions to populate his ballet compositions. Here, the pilasters, the corners of the room, and the teacher's cane present a series of vertical accents, punctuated by the dancers themselves. Two opposing groups of ballerinas occupy the edges of the canvas while the central space remains empty, occupied only by a single chair—a classic example of Degas' idiosyncratic pictorial composition.

In *The Dancing Lesson* (1873–1876, cat. 106), the empty section of the composition—displaced to the right—is occupied by the old choreographer Jules Perrot. In stark contrast to

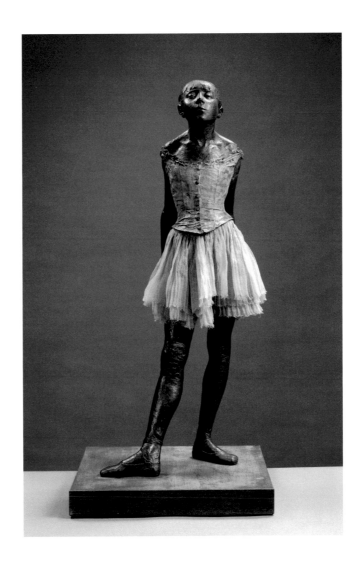

FIG. 43 **EDGAR DEGAS**

Small Dancer Aged Fourteen (*Petite danseuse de quatorze ans*), cast 1921–1931

Bronze, tulle, and satin

38 ³/₈ × 13 ⁷/₈ × 9 ⁵/₈ in. (98 × 35.2 × 24.5 cm)

Musée d'Orsay, RF 2137

Perrot's upright posture and attentive concentration, one of the dancers, positioned on the far left with a yellow sash, appears utterly bored, scratching her back in an animal-like stance. Degas reproduced the pose in several other important works, including *Ballet Rehearsal on the Set* (1874, cat. 108), presented at the first Impressionist exhibition. For his depiction of this dancer, Degas made explicit use of sources on criminal anthropology. The flatness of her skull and the protrusion of her jaw, very similar to the features seen in his *Small Dancer Aged Fourteen* (fig. 43, modeled between 1865 and 1881), identify the figure with the "dangerous" or less evolved classes, as categorized in contemporary theses on comparative anatomy. For example, the physician Bénédict Augustin Morel had put forward his theories on human degeneration, and criminal anthropologists, including Cesare Lombroso, had adopted a model to establish racial and evolutionary differences on the basis of cranial structures. Conventional wisdom associated a sharp facial angle, a protruding jaw, and prominent cheekbones with the lower classes and, essentially, with what Lombroso considered the criminal bestiality of women— that is, prostitution.[13]

Drawing on scientific sources was, at that time, a sign of modernity in the arts. The new realism had to be based in the physical, social, and racial characteristics of individuals, and above all, it had to classify those it portrayed. The motivation to construct visual signs of difference stemmed from the growing need of the European male bourgeoisie to be assured of

a separate, higher status on the scale of biological and cultural evolution, legitimating its position of patriarchal domination.

For all of these reasons, *At the Stock Exchange* (1878–1879, cat. 105) is, perhaps paradoxically, the perfect complement to *The Dancing Lesson*. Announced in the catalogues for the 1879 and 1880 shows, the painting was never actually shown at an Impressionist exhibition.[14] The catalogues indicated that the painting belonged to the art collector Ernest May, and it was, in fact, a commissioned portrait.[15] But what a modern approach to portraiture. May dominates the scene, surrounded by a crowd of people that suggests the agitation that reigns in the stock exchange. Their features are undefined, causing the viewer's attention to focus instead on the portrait's subject. The setting is one that Degas, given his family background, no doubt knew well but also partly rejected, as the somewhat grotesque features of the figures on the left may reflect. What Degas was depicting were the codes and customs of a social group that was very representative of his time, one that moved with equal ease at the stock exchange and the bordello. Degas' unconventional portraits give visual form to thoughts that Duranty had expressed in *La nouvelle peinture*: that a portrait should be "the study of moral reflections on physiognomy and dress, the observation of a man's intimacy with his dwelling, of the special character that his profession imprints on him. . . . Their postures will reveal to us that this figure is off to a business engagement, while this other one is returning from a romantic engagement."[16] Through his unconventional subject matter, compositional devices, and techniques, Degas exemplified the liberation of the avant-garde from the limiting structures of academic convention. For his modern subjects he produced a modern idiom.

Translated from the Spanish by Rose Vekony

NOTES

1 Quoted by Paul Jamot in his preface to the exhibition catalogue *Degas*, ed. Jacqueline Bouchot-Saupique and Marie Delaroche-Vernet (Paris: Musée de l'Orangerie, 1937).

2 In a letter to his friend Lorentz Frölich, a Danish painter, Degas asserted, "The snapshot is photography, and nothing more." *Lettres de Degas*, ed. Marcel Guérin (Paris: Grasset, 1945), 23.

3 Paul Valéry, *Degas, danse, dessin* (Paris: Gallimard, 1949).

4 Louis-Émile-Edmond Duranty, *La nouvelle peinture: À propos du groupe d'artistes qui expose dans les galeries Durand-Ruel* (Paris: E. Dentu, 1876), 19.

5 Gary Tinterow and Anne Norton, "Degas aux expositions impressionnistes," in *Degas inédit: Actes du Colloque Degas*, ed. Henri Loyrette (Paris: Musée d'Orsay, 1989), 289-350.

6 "The fact is that M. Degas has, from the very first, overturned the traditions of sculpture, just as he has, for quite some time, shaken the conventions of painting." J.-K. Huysmans, "L'exposition des indépendants en 1881," in *L'art moderne* (1883), 2nd ed. (Paris: Plon, 1908), 250.

7 Philippe Burty in *La République Française*, April 23, 1874. Quoted in Tinterow and Norton, "Degas aux expositions impressionnistes," 292.

8 Valéry wrote: "The horse walks on its toes, the nails of which, its four hooves, carry it. No animal is so like the prima ballerina, the star of the company, as a thoroughbred in perfect equilibrium, seemingly suspended by the rider's hand, advancing in nimble steps under the bright sun." Valéry, *Degas, danse, dessin*, 63-64.

9 In 1897, the artist confessed to Thiébault-Sisson: "You are probably unaware that, about the year 1866, I perpetrated a *Scène de steeplechase*, the first, and the only scene of mine to have been inspired by a racecourse. . . . [Although I] had no great difficulty in telling the difference between pure-bred and a half-bred, whereas I was quite familiar with the anatomy and myology of the animal, which I had studied on one of those anatomical models to be found in any plaster caster's premises, I was totally ignorant of the mechanism that regulated a horse's movements. . . . [Étienne-Jules Marey] had not yet invented the device which made it possible to decompose the movements—imperceptible to the human eye—of a bird in flight, of a galloping or trotting horse." François Thiébault-Sisson, "Degas, the Sculptor, Tells His Own Story," in *Degas Sculptures: Catalogue Raisonné of the Bronzes*, ed. Joseph S. Czestochowski and Anne Pingeot (Memphis, Tenn.: Torch Press, 2002), 277.

10 *La Nature* (1882): 72.

11 One of the sculptures appears to have been copied from volume 4 of *Animal Locomotion*; another is based on the horse Daisy in volume 9.

12 Thiébault-Sisson, "Degas, the Sculptor."

13 Anthea Callen, "Anatomie et physiognomie: La petite danseuse de quatorze ans de Degas," in *L'âme au corps: Arts et sciences, 1793-1993*, ed. Jean Clair (Paris: Réunion des Musées Nationaux / Gallimard-Electa, 1993), 360-373.

14 Tinterow and Norton, "Degas aux expositions impressionnistes," 291, 317.

15 In a letter to Bracquemond, written during the time that Degas was finishing this modern portrait, Degas mentioned that May was organizing his small collection into a gallery and comments that this "Jew . . . is entering the art world." Degas to Bracquemond, 1879, in Guérin, *Lettres*, 47.

16 Duranty, *La nouvelle peinture*, 24-25.

103

EDGAR DEGAS

Racehorses before the Stands (*Le défilé*), 1866–1868
Oil on paper mounted on canvas
18 1/8 × 24 in. (46 × 61 cm)

In this painting Degas modernized a heroic theme
popular in academic painting, that of the horse and
rider, here focusing on a quiet moment before the race
rather than on the exhilaration of the race itself. With
the technical help of photography, Degas suggested
the sequence of the horses' movement, the rendering
of which had evaded painters using strictly academic
methods. His concentration on line, flat color, and the
simplification of forms and detail is further evidence
of his straightforward, modern approach.

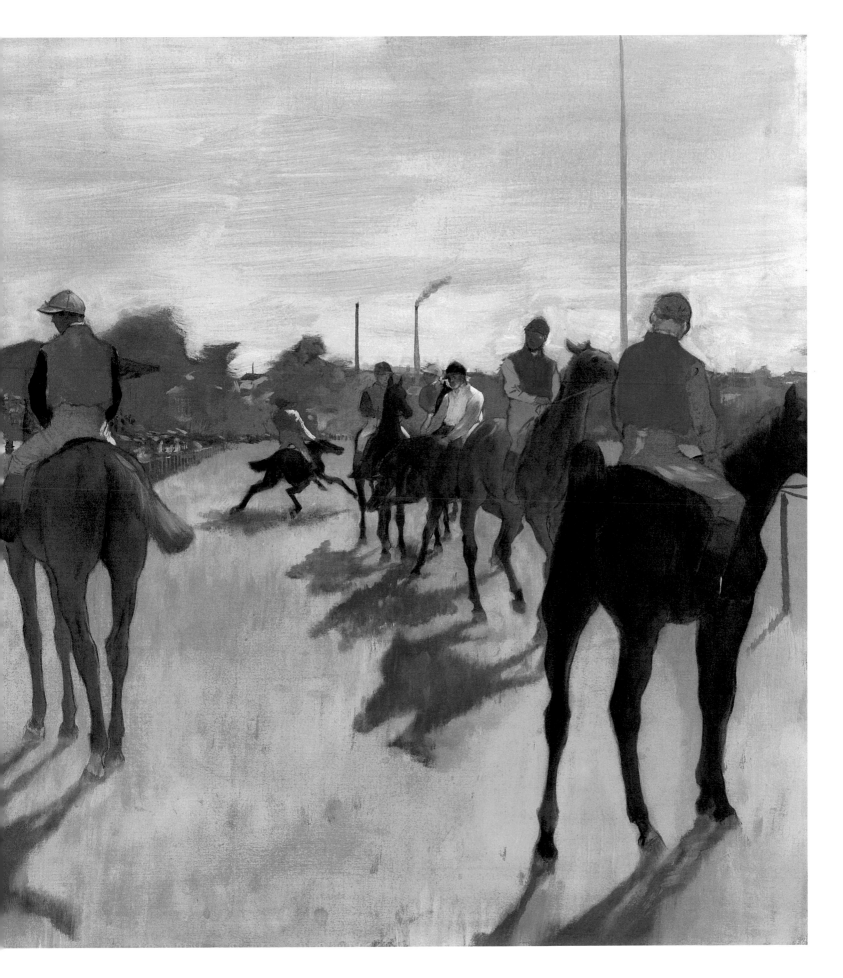

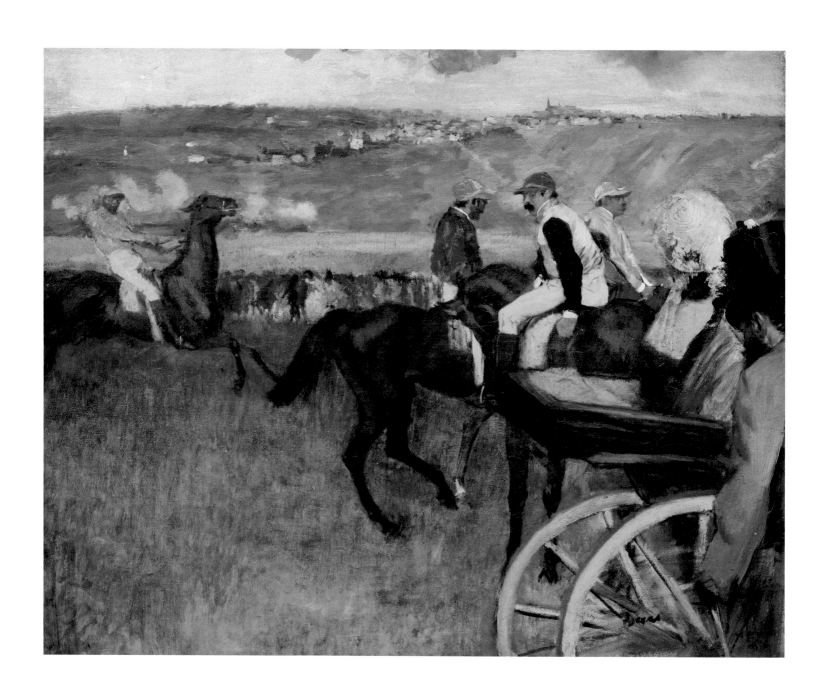

104

EDGAR DEGAS

The Racetrack: Amateur Jockeys near a Carriage

(*Le champ de courses: Jockeys amateurs près d'une voiture*), 1876–1887

Oil on canvas

26 × 31⅞ in. (66 × 81 cm)

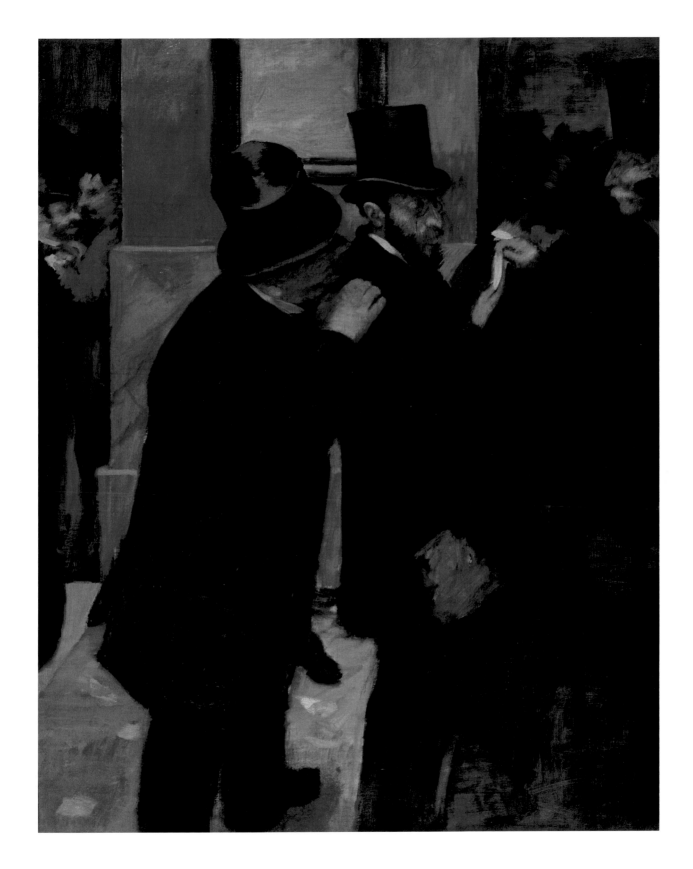

105
EDGAR DEGAS
At the Stock Exchange (*Portraits à la Bourse*), 1878–1879
Oil on canvas
39 3/8 × 32 1/4 in. (100 × 82 cm)

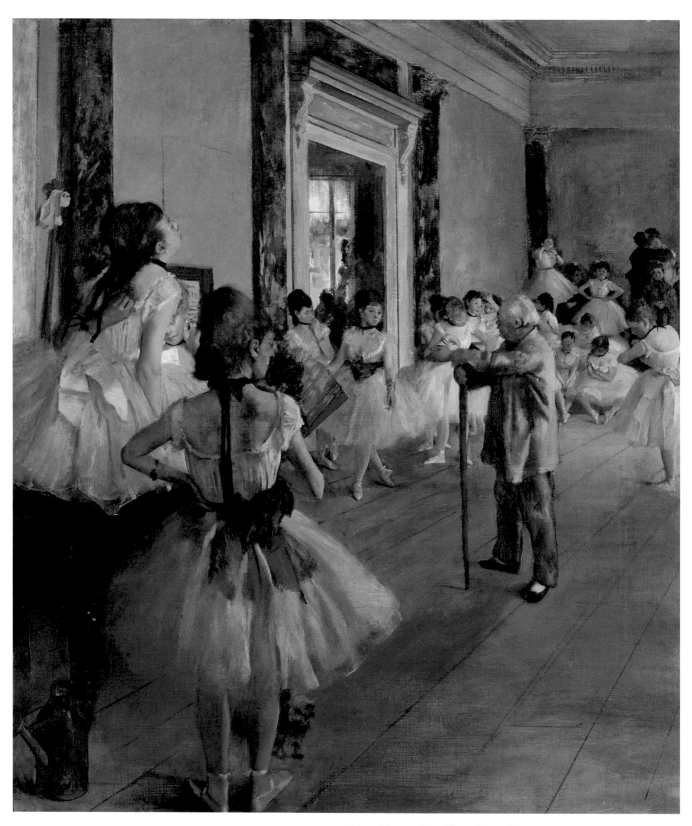

106

EDGAR DEGAS
The Dancing Lesson (*La classe de danse*), 1873–1876
Oil on canvas
33 ½ × 29 ½ in. (85 × 75 cm)

Although he considered himself a Realist, Degas participated in all but one of the Impressionist exhibitions. He sought to capture the art inherent in scenes of contemporary life, often finding novelty in images of the young women who belonged to the entertainment world—the ballets, cabarets, and brothels of Paris. From the early 1870s Degas devoted much of his later career to the portrayal of ballerinas at the opera. Here he rendered an accurate portrait of dance instructor Jules Perrot, as well as the spontaneous gestures of the dancers.

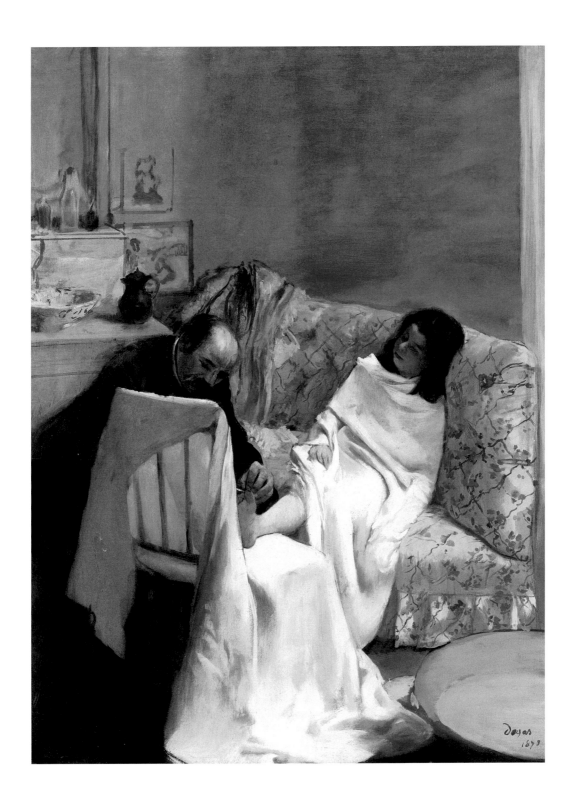

107

EDGAR DEGAS

The Pedicure (*Le pédicure*), 1873

Oil on paper on canvas

24 × 18 ¹⁄₈ in. (61 × 46 cm)

108

EDGAR DEGAS

Ballet Rehearsal on the Set (*Répétition d'un ballet sur la scène*), 1874
Oil on canvas
25 ⅝ × 31 ⅞ in. (65 × 81 cm)

109
EDGAR DEGAS
The Dance Foyer at the Opera on Rue Le Peletier
(*Le foyer de la danse à l'Opéra de la rue Le Peletier*), 1872
Oil on canvas
12 5/8 × 18 1/8 in. (32 × 46 cm)

"SECRET AFFINITIES": THE NEW PAINTING AND RATIONALIST ARCHITECTURE IN NINETEENTH-CENTURY PARIS

ALICE THOMINE-BERRADA

In 1876 the critic Louis-Émile-Edmond Duranty published *La nouvelle peinture* (*The New Painting*), an attempt to define the objectives of the avant-garde painters who had been holding group exhibitions outside the Salon context since 1874. Today, *New Painting* seems a better term for the diversity of approaches undertaken by these artists than *Impressionism*, which was made popular by the critic Louis Leroy in 1874.[1] By insisting upon the notion of a break with the old, the New Painting mirrored the emergence of "the new Paris," a phrase commonly used to describe the radical transformation of the capital that had begun in the time of the Second Empire under Georges Eugène Haussmann, the administrative head of the department of the Seine. The ambitious campaign entailed leveling medieval neighborhoods of narrow, winding streets and centuries-old buildings and erecting much of the Paris we know today, characterized by wide, straight boulevards that are lined with trees and apartment houses and offer perspectives on imposing landmarks, such as the Paris Opéra.

While Édouard Manet and the Impressionists were inventing modern painting, architects were inventing the modern city. Since John Rewald and Michel Ragon have taken this chronological convergence for granted in their writings on the history of painting and architecture, it has remained a focus of study among scholars. The resulting research has attempted to explain the connection between the redevelopment of Paris and the iconographic themes adopted by the painters associated with the Impressionist movement.[2] Theodore Reff, for example, has demonstrated how the themes Manet chose in the 1860s and 1870s were determined by the demolition of the neighborhood known as Little Poland, the disappearance of the comedy theaters in the Temple quarter, and the artist's own move to a studio on rue de Saint-Pétersbourg, which brought him closer to the new, more cosmopolitan Paris.[3] Others have sought to situate the paintings in the social, political, or economic context of "modern life." This essay takes a different approach, comparing the histories of modern art and modern architecture as they unfolded simultaneously. By examining the ties between these two creative spheres, we discover that the new concerns of architects and painters were probably founded on comparable principles.

The two spheres may seem mutually exclusive on first inspection. Architects have long been concerned with the relationship between monumental painting and architecture, yet the architectural journals of the nineteenth century—the profession's main forum for exchange—never address the question of painting, let alone the debates raging in artistic circles in the 1860s and 1870s. And none of the numerous studies devoted to the so-called Impressionists, even those who were interested in the spectacle of modern urban life, has uncovered specific links to the architectural milieu or proof of familiarity with the issues that absorbed that profession. Indeed, the rare exchanges between Impressionist painters and architects that historians have been able to locate seem purely anecdotal. On the one hand, the relationship between Pierre Auguste Renoir and the architect Charles Le Coeur, which lasted until 1874, appears to have been motivated by chance rather than by shared aesthetic convictions.[4] On the other hand, there were close ties between architects and painters educated at the École des Beaux-Arts: the final stage of the curriculum, a stay in Rome, provided an opportunity for them to share quarters for several years. Prominent friendships were founded as a result, including those of Victor Baltard and Hippolyte Jean Flandrin and of Charles Garnier and Paul Jacques Aimé Baudry.[5]

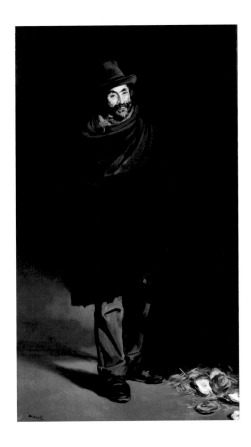

FIG. 44 **ÉDOUARD MANET**
Beggar with Oysters (Philosopher) (*Le philosophe*),
1865/1867
Oil on canvas
73 3/4 × 42 1/2 in. (187.3 × 108 cm)
Art Institute of Chicago, Arthur Jerome Eddy Memorial
Collection, 1931.504

Although sources are silent on the matter, there is nothing to rule out the hypothesis that each group was perfectly aware of the other's concerns. Frédéric Bazille's correspondence contains no mention of the commotion among students at the École des Beaux-Arts during the architect and theorist Eugène Emmanuel Viollet-le-Duc's first course on aesthetics in November 1863, but it is unlikely that Bazille, Renoir, Claude Monet, and Alfred Sisley, all students in Charles Gleyre's studio, would have been unaware of it. Similarly, although Haussmann's memoirs contain not a single mention of the ongoing debate over contemporary painting, he would doubtless have had the opportunity at some imperial celebration (as would Prosper Mérimée and Viollet-le-Duc) to discuss the incongruity of Manet's *Luncheon on the Grass* (fig. 20) or the ugliness of *Olympia* (fig. 21). Taking these suppositions somewhat further sheds light on the bonds between art and architecture at that time.

FROM MANET TO RATIONALISM

Let us begin with one of the rare mentions of Manet's opinion of modern Paris. Antonin Proust, in a book devoted to his childhood friend, refers to a stroll during which the painter stopped outside a building that was being destroyed and said, "Here it is . . . the symphony in white major that Théophile Gautier was talking about."[6] By invoking the title of a poem in Gautier's *Émaux et camées* (*Enamels and Cameos*) of 1852, Manet was surely referring to an 1854 *Moniteur Universel* article praising the urban works—a text that served as a preface for *Paris démoli*, a book by Édouard Fournier published the following year.[7] According to Proust, Manet was looking for a subject; seconds later he stopped to observe a woman coming out of a cabaret. It was she who inspired *Street Singer* (ca. 1862, Museum of Fine Arts, Boston). It is difficult to determine, on the basis of Proust's ambiguous remarks, whether Manet, like Gautier, was enthralled by Haussmann's architectural projects or whether his comment was sadly ironic.[8] Françoise Cachin has thrown some light on the matter, drawing a connection between the philosopher-beggars painted by Manet in 1865–1867 (see fig. 44) and a statement by Charles Yriarte. Yriarte, an architect who became a journalist and an art historian (an expert on Francisco de Goya), was a close friend of Manet's and Le Coeur's. In the *Paris Guide* published for the 1867 Exposition Universelle, he wrote at length about the marginal figures doomed to disappear in the wake of Haussmann's transformation of the city:

> The straight line has killed what is picturesque and unexpected. . . . No more colorful rags, no more extravagant songs or extraordinary speeches. . . . Wandering musicians, philosophizing ragmen . . . have emigrated in the early hours of the day, the very same who used to come to contemplate beneath the canopy of Les Halles the arrival of the cabbage and the entrance of the watercress, and to entertain some intrigued merchants with the finest verses of Virgil and Horace.[9]

From this association one might conclude that Manet hardly appreciated Haussmann's work. This was a painter who had greeted the advent of Napoléon III with reluctance and whose two brothers were openly pro-Republican. Haussmann, whose venture was closely associated with the imperial regime, was becoming the principal target of leftist opposition, as witnessed not long thereafter by the publication of Jules Ferry's *Les comptes fantastiques de Haussmann*,

FIG. 45 **EUGÈNE EMMANUEL VIOLLET-LE-DUC**
Iron-Frame Houses (*Maisons à pans de fer*), ca. 1872
Graphite, ink, and watercolor on paper
18 7/8 × 14 5/8 in. (48 × 37 cm)
Musée d'Orsay, ARO 2008 21

which was serialized in *Le Temps* beginning in 1867. Manet's friend and champion Émile Zola also protested Haussmann's work: "Like a desperate lover, how I miss the former horizons, my old streets, my old Bois de Boulogne, my old Luxembourg," he wrote in 1869.[10] Zola's opinion, as one might speculate about Manet's, mixed political motivation and aesthetic conviction. The writer principally reproached Haussmann for his outrageous expenditure and his lack of interest in the fate of the underprivileged social classes, who were displaced by the redevelopment.[11] As for the artistic qualities of Haussmann's accomplishments, Zola was "too reasonable not to concede that no other city has a park as grandiose as our own."[12] *La curée* (*The Kill*), a novel published in 1872—two years after Haussmann's fall—testifies to Zola's conflicted view of the modernization of Paris. Even as it criticizes the financial speculation involved in Haussmann's schemes, *La curée* reveals Zola's fascination with the emerging new Paris,[13] along with a certain anxiety about the scale of the metamorphosis. At a time when urban development was a long way from being viewed as an autonomous domain at the crossroads of art and technology,[14] it was surely difficult for Zola and his contemporaries to appreciate the modernity of Haussmann's project—which would explain, no doubt, the novelist's ambivalence. However, they did not refrain from taking sides in debates over other aspects of Second Empire politics, particularly those concerning finance, the disappearance of old Paris, and the aesthetic value of the new architecture.

With regard to the latter, Zola's opinion was anything but positive. In *La curée* he scoffed at the eclectic design of the *hôtels particuliers* of the time, particularly the one belonging to Aristide Rougon Saccard. In his character sketch of the architect Dubuche in *L'oeuvre* (*The Masterpiece*), published in 1886, the novelist wrote: "All the young architects are classical; this is where the modern movement has been felt the least." The novel, which came out at a time when Haussmannization was still in full swing and the proponents of the New Painting were beginning to receive due recognition, compares the two art forms, contrasting the innovative but isolated artist Lucien Lantier, inspired by Paul Cézanne, with Louis Dubuche, a bourgeois and academic architect. Lantier finds that "the embellishments [in Dubuche's projects] are still those of a fairly bastardized tradition." But Dubuche doesn't know what to say when confronted with the work of his artist friend: "This disordered painting disturbed him deep within his level-headed nature, within his good pupil's respect for established formulas."[15]

Zola, of course, based Dubuche's character on a survey of the architectural circles of the time. He likely relied on information provided by the architect Frantz Jourdain, whom he consulted for help describing Octave Mouret's department store—a "cathedral to modern commerce"—in 1881, while writing *Au bonheur des dames* (*The Ladies' Paradise*). Jourdain was surely one of the era's most solid links between the architectural and artistic communities. He was not only an architect, writer, and art critic but also an outspoken advocate of modern painting. Already a friend of Manet and the Impressionists, he took part in the creation of the Société Nationale des Beaux-Arts in 1890 and in 1903 created the Salon d'Automne. Moreover, it was at Manet's that Jourdain first met Zola.[16] Although he received the traditional academic training at the École des Beaux-Arts, he was an active proponent of Viollet-le-Duc's pioneering architectural theories.

Viollet-le-Duc was one of the principal forces for renewal in nineteenth-century architecture, espousing first a return to the Gothic model, which he favored for its structural functionalism, and then a principle of architectural Rationalism, based on the use of new

FIG. 46 **HENRI LABROUSTE**
Interior View of the Bibliothèque Sainte-Geneviève
(*Vue intérieur de la bibliothèque Sainte-Geneviève*),
1842
Graphite and ink on paper
17 3/4 × 23 1/4 in. (45 × 59 cm)
Musée d'Orsay, RF 4141

materials and construction techniques that met the needs of contemporary society. As of 1863 he was already, in veiled terms, denouncing Haussmann's work.[17] By 1872 he had become more outspoken, publishing a print that presented a radical, picturesque alternative to the baron's monotonous, traditional architecture. Whereas the baron demanded stylistically consistent stone facades with classical fenestration and mansard roofs, Viollet-le-Duc advocated the use of iron and other materials to create polychrome, artfully arranged facades that expressed their structure (see fig. 45). His suggestions proved visionary; a decade later, new city legislation gave architects the first tools allowing them to temper the urban uniformity. And in 1902 Paris adopted a new building code that constituted a definitive break with the monumental classical harmony so dear to Haussmann. The principal author of the 1902 code was Louis Bonnier, a friend of Renoir's;[18] it is known that he did not care for Haussmann's facades, "cold and lined up like soldiers on parade."[19] Like Renoir and Viollet-le-Duc, Jourdain, who was well acquainted with Bonnier,[20] probably cared little for the aesthetics of Haussmann's Paris. His designs for Paris's La Samaritaine department store (1903–1907) are among the first applications of principles recommended by Viollet-le-Duc in 1872. Given the ties between Jourdain, Zola, Renoir, and Manet, some members of the artistic avant-garde must have known (and shared) the ideas defended by the partisans of architectural Rationalism, at that time the main aesthetic alternative to Haussmann's classicism.[21] A comparative examination of discussions among the various artists, based on examples taken from the literature of the era, reveals a number of shared convictions.

MODERN LIFE

"The artist, the true artist, will be the one who knows how to capture the life of the present day in its epic moments, and make us see and understand how great, how poetic we are in our cravats and polished boots," wrote Charles Baudelaire in his commentary on the Salon of 1845.[22] Duranty said exactly the same thing in 1876 when, inspired by a witticism of Degas', he exhorted painters to leave behind the model of the Greek woman and adopt one more contemporary: "Perhaps someday the living French woman with her upturned nose will dislodge the marble Greek woman with her straight nose and thick chin and who is embedded in your brains, like a fragment of an old frieze in a wall made by a mason after a dig."[23] The problem of representing the modern in art—the question behind both the "cravats and polished boots" and the "woman with her upturned nose"—was not unlike the architectural controversy surrounding the use of new materials. Even as Baudelaire was encouraging artists to seek inspiration in contemporary life, a similar challenge confronted architects. Indeed, the innovation of architecture through the bold and truthful use of modern materials, principally iron and glass, was the central theme of Viollet-le-Duc's Rationalist theories. As he asserted in *Entretiens sur l'architecture* (*Lectures on Architecture*, 1862–1872), "We must be convinced, once again, that architecture can adopt new forms only if it seeks them out in a rigorous application of a new structure; that covering iron columns with brick cylinders, or stucco coating, or encasing iron supports with masonry, for example, is hardly the result of a calculated effort, or imagination, but merely the hidden use of a means."[24] This was the challenge embraced twenty-five years earlier by Henri Labrouste in his design for Paris's Bibliothèque Sainte-Geneviève (1842–1850, fig. 46), and also by Gustave Eiffel in his famous tower for the 1889 Exposition Universelle.

The controversy was expressed in comparable terms in both disciplines. In the 1850s, a complex debate over the issue of "realism" in painting—the limits of which its principal proponents, Gustave Courbet and Champfleury, had discovered—centered on what was true and real versus camouflage and misrepresentation. All of Manet's art was subsequently colored by this notion of sincerity. "Come and see sincere works," urged the painter in the foreword to his exhibition catalogue of 1867. "Sincerity has the effect of giving works a character that makes them resemble a protest, even though all the painter sought to do was to render his impression."[25] In 1884 Edmond Bazire described *Olympia* (1863, fig. 21) as a "sincere canvas, with such a sure brushstroke, such a truthful flesh tint."[26] This is, of course, a very old aesthetic debate; from time immemorial, proponents of veracity in representation have faced off against partisans of the superiority of the ideal over appearances. The problem was obviously different in architecture, since it is not an art of representation, yet it was set out in almost identical terms of sincerity, truth, and candor.[27] As witnessed by a famous statement by Viollet-le-Duc:

> In architecture, there are . . . two ways of being true. There is truth according to the program, and truth according to the construction methods. To be true according to the program means meeting the conditions imposed by need exactly and scrupulously. To be true according to construction methods means using materials according to their qualities and their properties.[28]

Twenty years later, Jourdain invoked the same arguments to defend the principles behind La Samaritaine, echoing the architect in Zola's novel: "To plaster over the joists of a ceiling is a lack of common sense, almost of loyalty. . . . There will be no cheating in favor of the absurd prejudice against iron. They will not seek to imitate either stone or wood, and will only render that which cast iron and iron itself can produce."[29] Artists and architects were thus defending their aesthetic advances in the same way, with an identical vocabulary that carried overtones of morality, philosophy, and even political engagement.

One excellent example of the way in which the debate over Realism in painting reflected the preoccupations of architects is a text by Jules-Antoine Castagnary, an art critic, politician, and friend of Courbet's who would become a supporter of Manet's art in the 1870s.[30] In his contribution to *Paris qui s'en va et Paris qui vient* of 1860 (illustrated by Léopold Flameng), he lambasted the Fontaine Saint-Michel (1858–1861, fig. 47), which was designed by Gabriel Davioud, one of Haussmann's main collaborators, to convey the majesty of the Second Empire. Castagnary transposed problems inherent in painting to architecture, beginning with ironic comments on the fountain's eclecticism:

> What sort of unknown architecture can this be . . . that mixes the most disparate elements? Assuredly, it is a new endeavor; but what is the inventor trying to say? What on earth can there be in common between flowing water and this Saint Michael striking down the demon and all the embellishments accompanying him? . . . What mysterious link can connect all these things and give them a significance equal to the purpose of the monument housing them?[31]

More than criticizing the design's eclecticism, Castagnary's attack targeted the lack of harmony between the fountain's decoration and its function. His arguments come straight from Rationalist architectural discourse on the role of ornamentation:

> A fountain is not a fountain because it provides water. . . . It is a fountain in and of itself, from head to toe; the water is an insignificant detail; the structure of the monument and the clothes it wears alone must tell us all what is its purpose. Its architecture and its embellishments must be combined in such a way that there can be no possible misunderstanding.[32]

We cannot be sure whether Castagnary knew Viollet-le-Duc personally when he wrote these lines. However, by 1874 they were both holding office on the Paris city council and working together on the commission in charge of fine arts, and their political careers were founded on shared republican convictions. It was at this time that Castagnary defended Manet's art and wrote his first (and only) text in favor of the Impressionists.[33]

One last illustration of the permeability of the debate is Zola's recourse to the principles of Realism to denounce Haussmann's "lying" oeuvre, which he likened to a theater set: "I cannot stand the false nature of these cardboard cities where you see ladies in white gloves picking roses from which the gardener has been ordered to remove the thorns."[34]

MODERN ART AND THE PAST

Over the past thirty years, research in the history of architecture and art has renewed our perception of the nineteenth and twentieth centuries, revealing that the aesthetic avant-garde did not break completely with the past but rather established a new, and very rich, relationship with its legacy. Michael Fried, for example, has unraveled the wealth of historical sources in Manet's work,[35] while Reff has shown that one of the most important books on the shelves of the painter's studio was Charles Blanc's *Histoire des peintres*.[36] In architecture, meanwhile, historians have demonstrated that the historicism of nineteenth-century architects, so adamantly denounced by the modern movement, was a means of renewing their approach. Among other things, these scholars have reiterated what the disciples of Viollet-le-Duc had always proclaimed: that the restorer of Notre-Dame paved the way for architecture using metal and reinforced concrete, as well as for Art Nouveau. Indeed, it was by studying the past, not copying it, that Viollet-le-Duc attempted to find the means to renovate contemporary architecture:

> If we study the systems adopted by builders prior to our own time, it is a sure way of learning ourselves how to build, but we must gain something more from this study than just flat copies. Thus, for example, we recognize that in the structural principles of medieval vaults there are excellent elements, insofar as they allow a great freedom of execution, a great lightness and elasticity at the same time. Does that mean that if we want to use the new materials that the industry is providing us with, such as cast iron or sheet metal, we should merely substitute iron or sheet metal arcs for stone arcs? No. . . . We must develop applications for these new materials and show how, by preserving excellent principles, accepted by builders in the past, we may be led to modify the forms of the structure.[37]

Can we compare the place of Gothic architecture in Viollet-le-Duc's philosophy with that of Diego Velázquez and Spanish painting in Manet's art? In the process of painting *The Spanish Singer* (1860, fig. 23), immediately after the failure of his *Absinthe Drinker* at the 1859 Salon, Manet summed up his objectives as follows: "What I created [in *The Absinthe Drinker*] was a fellow from Paris, observed in Paris; in the execution I have kept the professional naïveté that I found in the painting by Velázquez. No one understands. Maybe they'd understand better if I'd created a Spanish guy."[38] Just as Viollet-le-Duc did not advocate copying Gothic architecture, merely using its inherent building principles, Manet did not seek to produce a Spanish style of painting, merely to find something of Velázquez's "naïveté." Stéphane Mallarmé expressed a similar notion in his analysis of Manet's work:

> In the isolation he was seeking, two masters—masters from the past—came forward to help him in his rebellion. He was under the particular spell of Velázquez and the painters of the Flemish school. The wonderful atmosphere that envelops the compositions of the great Spanish Old Master, and the brilliant tonality that emanates from the canvases of his peers, the painters from the North, won the student's admiration by introducing him to two aspects of art that he went on to master, and which he uses as he sees fit. . . . He was striving for something more, and his originality is not immediately apparent; it frequently consists, in fact, . . . in coordinating very disparate elements.[39]

This last phrase, "coordinating very disparate elements," so perfectly apposite to Manet's work, unquestionably could also be applied to the masterpieces of nineteenth-century architecture, from Léon Vaudoyer's cathedral in Marseille (1852–1893) to Charles Garnier's Opéra (1861–1875) by way of Viollet-le-Duc's work on the basilica of Saint-Denis de l'Estrée (1864–1866), all of which are collages of architecture from the past reconstructed with modern ideas.

FROM "SECRET AFFINITIES" TO A SYNTHESIS OF THE ARTS

The controversy surrounding Manet and the Impressionists, the rejection of their works by the official Salon, and the incomprehension of the public have been the principle focus of the literature on the artistic avant-garde of the second half of the nineteenth century. Similarly, a number of sources at the time marginalized the most innovative architects, from Hector Horeau to Labrouste and Viollet-le-Duc.[40] In this respect, the story of Zola's Dubuche was perfectly representative of the lives of the great nineteenth-century architects: he ended his life in ruins, rejected by his in-laws, after going bankrupt because he wished to "introduce art"[41] into his father-in-law's business. Dubuche's fate was not unlike that of the misunderstood painter Lantier, who hanged himself in front of one of his unfinished works. This tragic end emphasized that the friendship between the two artists was not mere coincidence but rather the result of "secret affinities."[42] Could these secret affinities have led Dubuche and Lantier to any existence other than these strangely parallel experiences? Could the friendship between the Rationalist architect and the avant-garde artist have led to a common endeavor? And in the real world, during the second half of the nineteenth century, would it have been possible to bring about a convergence of the goals of the New Painting and the principles of architectural Rationalism, producing a total work of art?

In 1860 Champfleury invoked a visionary fusion of Realist painting and new architectural systems:

> [Courbet] belongs to a century preoccupied with industrial ideas; let him show industry the support that it can find in Art. Our architects are not simply restorers of ancient monuments, more interested in the debris in their ruins than in the constant replastering that is ceaselessly applied to them. The nineteenth century has not found an architectural style, outside the construction of covered markets and railroads. Why shouldn't Courbet, for the sake of a new effort, try to create great decorations for the railroad stations? If frescoes are to be applied anywhere that would be the place, where people could banish the boredom of waiting by contemplating the great industrial developments that steam has brought.[43]

Fifteen years later, when the advent of the Third Republic and the affirmation of republican ideology gave a new importance to monumental painting, Viollet-le-Duc, who had always advocated an alliance between decorative painting and architecture for aesthetic harmony in buildings, sent an impassioned reminder of what was at stake in a report to the city council. He wrote the 1875 report, exhorting Paris to decorate its town halls and schools, on behalf of the fifth municipal commission in charge of fine arts, presided over by Castagnary; Manet's youngest brother, Gustave, was also a member.[44] Was Viollet-le-Duc aware that he was paving the way for one of Manet's dreams? In 1879, when officials were once again examining the issue of decorating public edifices, Manet, who "all his life had nurtured the project of making a major, modern decorative work,"[45] wrote to the Parisian authorities to suggest a great mural for the Hôtel de Ville. Proof of his desire to be associated with a building site that symbolized the country's republican commitment, he proposed "to paint a series of compositions representing . . . 'the Belly of Paris' . . . the covered markets (Les Halles), the railroads, the port, the underground, the racetracks and gardens."[46] This program was obviously inspired by Zola, and Viollet-le-Duc would have greeted it with enthusiastic applause. Manet never received a reply, and Viollet-le-Duc passed away a few months later. But the painter and the architect had fought the same good fight. While Manet had endeavored to "give order to the new French work of art—enduring, bright, deep, sharp, or haunted with shades of black,"[47] Viollet-le-Duc, through his writings and his service on the city council, had defended a form of architecture that became the reflection of the nation, free from the constraints of the past but informed by its Gothic precedents.[48]

Translated from the French by Alison Anderson

NOTES

1 See Charles S. Moffett et al., *The New Painting: Impressionism 1874–1886* (San Francisco: Fine Arts Museums of San Francisco, 1986). The term *Impressionism* was popularized by Louis Leroy in "L'exposition des impressionnistes," *Le Charivari*, April 25, 1874.

2 See, among others, Timothy J. Clark, *The Painting of Modern Life: Paris in the Art of Manet and His Followers* (New York: Knopf, 1985); Robert Louis Herbert, *Impressionism: Art, Leisure, and Parisian Society* (New Haven, Conn.: Yale University Press, 1988); Julia Sagraves, "The Street," in *Gustave Caillebotte: Urban Impressionist*, by Anne Distel et al. (Chicago: Art Institute of Chicago, 1995); Andrea Frey, *Der Stadtraum in der französischen Malerei, 1860–1900* (Berlin: Reimer, 1999); and Barbara Palmbach, *Paris und der Impressionismus: Die Großstadt als Impuls für neue Wahrnehmungs-formen und Ausdrucksmöglichkeiten in der Malerei* (Weimar: VDG, 2001).

3 Theodore Reff, "Manet and the Paris of His Time," in *Kunst um 1800 und die Folgen: Werner Hofmann zu Ehren* (Munich: Prestel, 1988), 247–262.

4 Marc Le Coeur, *Charles Le Coeur, 1830–1906: Architecte et premier amateur de Renoir* (Paris: Réunion des Musées Nationaux, 1996).

5 Jean-François Pinchon, "L'exemple de Baudry et de Garnier," *Monuments Historiques*, no. 123 (October–November 1982): 67–71.

6 Antonin Proust, *Édouard Manet: Souvenirs* (Paris: Henri Laurens, 1913).

7 "The monuments, freed from the hideous tumbledown houses that had been hiding them, were at last visible in all their beauty; others emerged from their unfinished ruins and were at last completed, adding white courses to those that were already black. . . . What a strange sight, these gaping houses with their floors hanging over the abyss. . . . There is a certain beauty to all this upheaval; shadow and light confer pictur-esque effects upon the rubble, on the haphazard tumble of stone and beam; but now the plots are being cleared and flattened so that the new constructions can rise impatiently in all their young whiteness, and the old town puts on a tunic of palaces all trimmed in sculpture." Théo-phile Gautier, *Le Moniteur Universel*, January 21, 1854, reprinted as the preface to *Paris démoli*, by Édouard Fournier (Paris: Auguste Aubry, 1855).

8 We cannot, in fact, be certain of the dates of these events; see Françoise Cachin and Charles S. Moffett, *Manet, 1832–1883* (New York: Metropoli-tan Museum of Art, 1983), 106.

9 Ibid., 234, 236.

10 Émile Zola, "Livres d'aujourd'hui et de demain," *Le Gaulois*, March 8, 1869, reprinted in *L'atelier de Zola: Textes de journaux, 1865–1870*, ed. Martin Kanes (Geneva: Droz, 1963), 121.

11 "I dreamed of creating vast fairgrounds in all four corners of Paris. Haussmann, who is full of solicitude for the rich, has made the Bois de Boulogne and Vincennes into promenades for princes, where the happy few of this world can go and indulge their reveries to the regular trot of their thoroughbred horses; these are earthly paradises whose gates are also opened to grand ladies, and little women. Workers must flee from these well-swept lanes, these large avenues crowded with barouches, the sight of which might give them unhealthy desires; in the evening, when they go to lie upon their hard mean pallets, they might think angrily of the plush cushions inside those carriages, where fat men with beefy faces sprawl, and the next morning they might grow seriously angry and ask why they earn so little when scoundrels steal so much. Perhaps the prefect of the Seine district thinks he has done enough for the poor by sprin-kling Paris with squares. But are they not sad patches of Nature, mere dusty, stifling places to walk. . . . The people with their powerful blood, their strong hearts, need something else from the open sky: they need the real countryside, they need real trees, vast prairies where they can run free. . . . It is my ardent wish that my project might be taken into consideration. We have the Bois for the stylish ladies and the marquises, we must have a Heath for the working women and laborers." Émile Zola, "Causerie," *La Tribune*, October 18, 1868, reprinted in Kanes, *L'atelier de Zola*, 174–175.

12 Zola, "Livres d'aujourd'hui et de demain," in Kanes, *L'atelier de Zola*, 121–122.

13 "The lovers had fallen in love with the new Paris. They often rode through the city in their carriage, taking a detour to go along certain boulevards that they loved with a personal tenderness. They were delighted with the tall houses with their large sculpted doors, their heavy balconies, and the gleam of big golden letters spelling out names, signs, businesses. . . . On they rolled, and it seemed to them that the carriage was rolling over a carpet down a straight, endless causeway that had been made solely to spare them from venturing into the dark narrow streets. Every boulevard was a corridor of their hotel." Émile Zola, *La curée* (*The Kill*), quoted by Sylvie Patin, "Le paysage urbain," in *L'impressionnisme et le paysage français*, ed. Michel Laclotte (Paris: Réunion des Musées Nationaux, 1985), 182.

14 See Vincent Berdoulay and Paul Claval, *Aux débuts de l'urbanisme français: Regards croisés de scientifiques et de professionnels, fin XIXe-début XXe siècle* (Paris: L'Harmattan, 2001).

15 Émile Zola, *L'oeuvre* (Paris: G. Charpentier et Cie, 1886), 52.

16 Arlette Barré-Despond, *Jourdain: Frantz 1847-1935, Francis 1876-1958, Frantz-Philippe 1906-1990* (New York: Rizzoli, 1991), 48.

17 "They are building everywhere, profusely; millions are spent on hundreds of projects in our cities, and one can hardly detect any attempts at a true and practical application of the considerable means at our disposal." Eugène Emmanuel Viollet-le-Duc, *Entretiens sur l'architecture*, 2 vols. (Paris: A. Morel et Cie, 1863-1872), vol. 1, 450.

18 They knew each other through Jean-François Deconchy, an artist friend of Renoir's and Monet's and Bonnier's brother-in-law.

19 Pierre Auguste Renoir, "Lettre sur l'architecture," *L'Impressionniste*, April 14, 1877, quoted in Augustin de Butler, ed., *Renoir: Écrits, entretiens et lettres sur l'art* (Paris: Les Éditions de l'Amateur, 2002), 42. See also John House's conjecture that it was undoubtedly a point of view that Renoir adopted only after the fall of the Second Empire; "Renoir: Between City and Country," in *Renoir: Master Impressionist* (Sydney: Art Exhibitions Australia, 1994), 13-14.

20 Jourdain was one of the first to recognize Bonnier's talents; see Bernard Marrey, *Louis Bonnier: 1856-1946* (Liège: Mardaga, 1988), 100.

21 This tallies with Julia Sagraves's analysis of Caillebotte's oeuvre. See Sagraves, "The Street," in Distel et al., *Gustave Caillebotte*.

22 Charles Baudelaire, "Salon de 1845," reprinted in *Charles Baudelaire: Écrits sur l'art*, ed. Francis Moulinat (Paris: Le Livre de poche, 1992), 60.

23 Louis-Émile-Edmond Duranty, *La nouvelle peinture: À propos du groupe d'artistes qui expose dans les galeries Durand-Ruel* (Paris: E. Dentu, 1876), reprinted in *Les écrivains devant l'impressionnisme*, ed. Denys Riout (Paris: Macula, 1989), 115.

24 Viollet-le-Duc, *Entretiens sur l'architecture*, vol. 2, 67.

25 Pierre Courthion, ed., *Manet raconté par lui-même et par ses amis: Ses contemporains, sa postérité, documents* (Geneva: Pierre Cailler, 1953), vol. 1, 135.

26 Ibid., 117.

27 See David Watkin, *Morality and Architecture: The Development of a Theme in Architectural History and Theory from the Gothic Revival to the Modern Movement* (Oxford: Clarendon Press, 1978).

28 Viollet-le-Duc, *Entretiens sur l'architecture*, vol. 1, 451.

29 Text published by Véronique Cnockaert, *Au bonheur des dames d'Émile Zola* (Paris: Gallimard, 2007), 204-205.

30 Jean-Paul Bouillon et al., *La promenade du critique influent: Anthologie de la critique d'art en France, 1850-1990* (Paris: Hazan, 1990), 62.

31 Jules-Antoine Castagnary, "La Fontaine Saint-Michel," in Léopold Flameng et al., *Paris qui s'en va et Paris qui vient* (Paris: Delâtre, 1860), 1.

32 Ibid., 4.

33 Jules-Antoine Castagnary, "Exposition du boulevard des Capucines: Les impressionnistes," *Le Siècle*, April, 29, 1874, reprinted in Riout, *Les écrivains devant l'impressionnisme*, 52-58.

34 Émile Zola, "Causerie," *La Tribune*, June 28, 1868, quoted in Kanes, *L'atelier de Zola*, 3.

35 Michael Fried, "Manet's Sources: Aspects of His Art, 1859-1865," *Artforum*, March 7, 1969, 28-82.

36 Theodore Reff, "Manet and Blanc's 'Histoire des peintres,'" *The Burlington Magazine* 112 (July 1970): 456-458.

37 Viollet-le-Duc, *Entretiens sur l'architecture*, vol. 2, 56-57.

38 Proust, *Édouard Manet*, 72.

39 Stéphane Mallarmé, "The Impressionists and Édouard Manet," *The Art Monthly Review and Photographic Portfolio* 1, no. 9 (September 30, 1876): 119.

40 Among other examples: Ernest Bosc, "Notice nécrologique sur Hector Horeau," *Le Moniteur des Architectes* (1872), 226; César Daly, "Nécrologie de M. Labrouste," *Revue Générale de l'Architecture et des Travaux Publics* (1877), column 62; Anatole de Baudot, *L'Architecture: Le passé, le présent, le futur* (Paris: Henri Laurens, 1916), 146.

41 Émile Zola, *Carnets d'enquêtes: Une ethnographie inédite de la France*, ed. Henri Mitterrand (Paris: Plon, 1986), 263.

42 Zola, *L'oeuvre*, 34.

43 *Champfleury: Le réalisme*, ed. Jean and Geneviève Lacambre (Paris: Hermann, 1973), 184. Champfleury further developed this idea in *Le Diable*, July 30, 1870, reprinted in ibid., 189.

44 Pierre Vaisse, *La Troisième République et les peintres* (Paris: Flammarion, 1995), 52.

45 Proust, *Édouard Manet*.

46 Letter from Manet to the prefect and president of the municipal council, in Edmond Bazire, *Manet* (Paris: A. Quantin, 1884), 142.

47 On the French character of Manet's work, see Fried, "Manet's Sources"; and Michael Fried, *Manet's Modernism: Or, the Face of Painting in the 1860s* (Chicago: University of Chicago Press, 1996).

48 On the relationship between the municipal and national scale in the writings of Viollet-le-Duc, see Alice Thomine, "La cité, la nation, l'Europe: Politique et architecture chez Viollet-le-Duc," in *Idée nationale et architecture en Europe, 1860-1919: Finlande, Hongrie, Roumanie, Catalogne*, by Jean-Yves Andrieux, Fabienne Chevallier, and Anja Kervanto Nevanlinna (Rennes: Presses Universitaires de Rennes; Paris: Institut National d'Histoire de l'Art, 2006), 87-95.

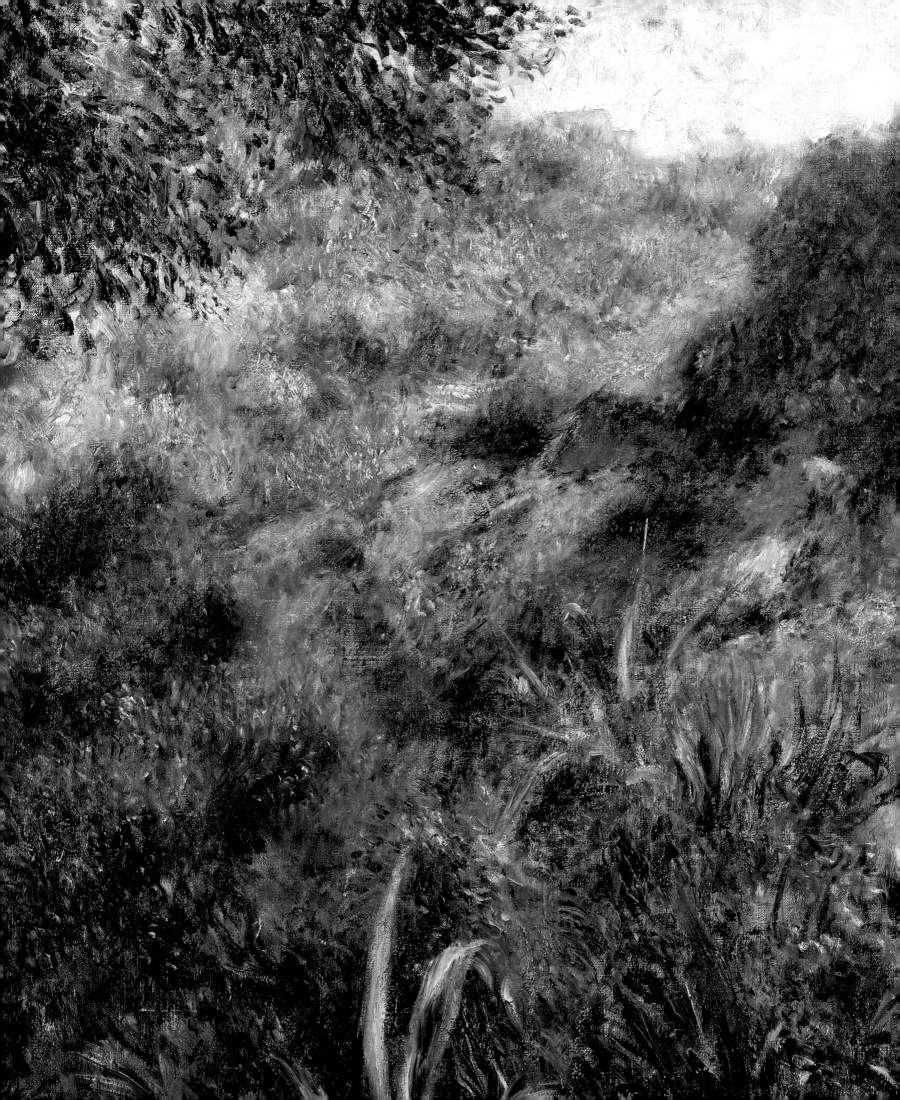

SUGGESTED FURTHER READING

·

CATALOGUE OF THE EXHIBITION

·

INDEX OF NAMES AND ARTWORKS

·

SUGGESTED FURTHER READING

Compiled by Melissa Buron

The following bibliography presents English-language books and exhibition catalogues that offer additional context on nineteenth-century French painting and the development of Impressionism. Readers interested in perusing French reviews and criticism published at the time of the Impressionists will find them collected in the first item on the list, Ruth Berson's *Documentation* volumes for *The New Painting*.

Berson, Ruth, ed. *The New Painting: Impressionism 1874–1886: Documentation*. 2 vols.: vol. 1 reviews, vol. 2 exhibited works. San Francisco: Fine Arts Museums of San Francisco, 1996.

Bomford, David, et al. *Art in the Making: Impressionism*. London: National Gallery, 1990.

Brettell, Richard R. *Impression: Painting Quickly in France, 1860–1890*. New Haven, Conn.: Yale University Press; Williamstown, Mass.: Sterling and Francine Clark Art Institute, 2000.

Cachin, Françoise, and Charles S. Moffett. *Manet, 1832–1883*. New York: Metropolitan Museum of Art, 1983.

Callen, Anthea. *The Art of Impressionism: Painting Technique and the Making of Modernity*. New Haven, Conn.: Yale University Press, 2000.

Clark, T. J. *The Painting of Modern Life: Paris in the Age of Manet and His Followers*. Princeton, N.J.: Princeton University Press, 1984.

Denvir, Bernard. *The Chronicle of Impressionism: An Intimate Diary of the Lives and World of the Great Artists*. London: Thames and Hudson, 2000. First published 1993.

Frascina, Francis, et al. *Modernity and Modernism: French Painting in the Nineteenth Century*. New Haven, Conn.: Yale University Press, 1993.

Herbert, Robert L. *Impressionism: Art, Leisure, and Parisian Society*. New Haven, Conn.: Yale University Press, 1988.

House, John. *Impressionism: Paint and Politics*. New Haven, Conn.: Yale University Press, 2004.

King, Ross. *The Judgment of Paris: The Revolutionary Decade That Gave the World Impressionism*. New York: Walker and Co., 2006.

Lemoine, Serge, ed. *Paintings in the Musée d'Orsay*. New York: Harry N. Abrams, 2004.

Lewis, Mary Tompkins, ed. *Critical Readings in Impressionism and Post-Impressionism: An Anthology*. Berkeley: University of California Press, 2007.

Mainardi, Patricia. *The End of the Salon: Art and the State in the Early Third Republic*. New York: Cambridge University Press, 1993.

Milner, John. *The Studios of Paris: The Capital of Art in the Late Nineteenth Century*. New Haven, Conn.: Yale University Press, 1990.

Moffett, Charles S., et al. *The New Painting: Impressionism 1874–1886*. San Francisco: Fine Arts Museums of San Francisco, 1986.

Nord, Philip. *Impressionists and Politics: Art and Democracy in the Nineteenth Century*. London: Routledge, 2000.

Roe, Sue. *The Private Lives of the Impressionists*. New York: HarperCollins, 2006.

Roos, Jane Mayo. *Early Impressionism and the French State (1866–1874)*. New York: Cambridge University Press, 1996.

Rubin, James H. *Impressionism*. London: Phaidon, 1999.

Thomson, Belinda. *Impressionism: Origins, Practice, Reception*. London: Thames and Hudson, 2000.

Tinterow, Gary, and Henri Loyrette. *Origins of Impressionism*. New York: Metropolitan Museum of Art, 1994.

CATALOGUE OF THE EXHIBITION

All works in this exhibition are from the collection of the Musée d'Orsay, Paris. Unless otherwise indicated below, all paintings will be presented at both the de Young Museum, San Francisco, and the Frist Center for the Visual Arts, Nashville.

JULES BASTIEN-LEPAGE

French, 1848–1884
Haymaking (*Les foins*), 1877 [cat. 22]
Oil on canvas
Inscribed with date and signature lower left: *Damvillers 1877 J. Bastien-Lepage*
63 × 76 ³⁄₄ in. (160 × 195 cm)
Salon, Paris, 1878
RF 2748

FRÉDÉRIC BAZILLE

French, 1841–1870
Family Reunion (*Réunion de famille*), 1867 [cat. 59]
Oil on canvas
Signed and dated lower left: *F. Bazille, 1867*
59 ⁷⁄₈ × 90 ¹⁄₂ in. (152 × 230 cm)
Salon, Paris, 1868
RF 2749

Pierre Auguste Renoir, 1867 [cat. 62]
Oil on canvas
24 ³⁄₈ × 20 ¹⁄₈ in. (62 × 51 cm)
DL 1970 3

Bazille's Studio (*L'atelier de Bazille*), 1870 [cat. 60]
Oil on canvas
Signed and dated lower right: *F. Bazille 1870*
38 ⁵⁄₈ × 50 ⁵⁄₈ in. (98 × 128.5 cm)
RF 2449

EUGÈNE LOUIS BOUDIN

French, 1824–1898
The Beach at Trouville (*La plage de Trouville*), 1865 [cat. 71]
Oil on paperboard
Signed and dated lower right: *E. Boudin, 1865*
Inscribed lower right: *Troville* [sic] *(la plage)*
10 ³⁄₈ × 16 in. (26.5 × 40.5 cm)
RF 3663

ADOLPHE-WILLIAM BOUGUEREAU

French, 1825–1905
Virgin of Consolation (*Vierge consolatrice*), ca. 1877 [cat. 2]
Oil on canvas
Signed and dated lower left: *W. Bouguereau, 1877*
80 ³⁄₄ × 57 ⁷⁄₈ in. (205 × 147 cm)
Salon, Paris, 1877
RF 190

Birth of Venus (*Naissance de Vénus*), 1879 [cat. 1]
Oil on canvas
Signed and dated lower left: *W. Bouguereau—1879*
118 ¹⁄₈ × 84 ⁵⁄₈ in. (300 × 215 cm)
RF 253

JULES ADOLPHE AIMÉ LOUIS BRETON

French, 1827–1906
The Harvester (*La glaneuse*), 1877 [cat. 21]
Oil on canvas
Signed and dated lower right: *Jules Breton Courrières 1877*
90 ³⁄₄ × 49 ¹⁄₄ in. (230 × 125 cm)
Salon, Paris, 1877
RF 191

ALEXANDRE CABANEL

French, 1823–1889
Countess Keller (*La comtesse de Keller*), 1873 [cat. 11]
Oil on canvas
Signed and dated upper right: *Alex. Cabanel, 1873*
39 × 29 ⁷⁄₈ in. (99.2 × 76 cm)
Panama Pacific International Exposition, San Francisco, 1915
RF 2048

GUSTAVE CAILLEBOTTE

French, 1848–1894
The Floor Scrapers (*Raboteurs de parquet*), 1875 [cat. 50]
Oil on canvas
Signed and dated lower right: *G. Caillebotte 1875*
40 ¹⁄₈ × 57 ⁵⁄₈ in. (102 × 146.5 cm)
Second Impressionist Exhibition, Paris, 1876
RF 2718

ÉMILE-AUGUSTE CAROLUS-DURAN

French, 1837–1917
Lady with a Glove (*La dame au gant*), 1869 [cat. 13]
Oil on canvas
Signed and dated lower left: *Carolus Duran, 1869*
89 ³⁄₄ × 64 ¹⁄₂ in. (228 × 164 cm)
Salon, Paris, 1869
RF 152

Édouard Manet, ca. 1880 [cat. 46]
Oil on canvas
Signed lower right: *CD*
25 ⁵⁄₈ × 21 ¹⁄₄ in. (65 × 54 cm)
RF 1987 30
Nashville only

PAUL CÉZANNE

French, 1839–1906
The Hanged Man's House (*La maison du pendu*), 1873 [cat. 96]
Oil on canvas
Signed lower left: *P. Cézanne*
21 ⁵⁄₈ × 26 in. (55 × 66 cm)
RF 1970

Still Life with a Soup Tureen (*Nature morte à la soupière*), ca. 1873–1874 [cat. 99]
Oil on canvas
25 ¹⁄₄ × 32 ¹⁄₈ in. (65 × 81.5 cm)
RF 2818

Self-Portrait with a Pink Background (*Portrait de l'artiste au fond rose*), ca. 1875 [cat. 98]
Oil on canvas
26 × 21 ⁵⁄₈ in. (66 × 55 cm)
RF 2000 14

The Gulf of Marseille from L'Estaque (*Le golfe de Marseille vu de L'Estaque*), 1878–1879 [cat. 100]
Oil on canvas
Signed lower right: *P. Cézanne*
22 ⁷⁄₈ × 28 ³⁄₄ in. (58 × 72 cm)
Panama Pacific International Exposition, San Francisco, 1915
RF 2761

The Maincy Bridge (*Pont de Maincy*), ca. 1879 [cat. 101]
Oil on canvas
23 × 28 ¹⁄₂ in. (58.5 × 72.5 cm)
RF 1955 20

GEORGES JULES VICTOR CLAIRIN

French, 1843–1919
Fire at the Tuileries (*L'incendie des Tuileries*), 1871 [cat. 27]
Oil on canvas
Signed and dated lower right: *à mon amie Geneviève G. Clairin, Mai 1871*
18 ⁷⁄₈ × 31 ¹⁄₈ in. (48 × 79 cm)
RF 1981 31

GUSTAVE COURBET

French, 1819–1877
Nude with Dog (*Femme nue au chien*), 1861–1862 [cat. 23]
Oil on canvas
Signed and dated lower left: *68. G. Courbet*
25 ⁵⁄₈ × 31 ⁷⁄₈ in. (65 × 81 cm)
RF 1979 56

The Shaded Stream (*Le ruisseau noir*), 1865 [cat. 24]
Oil on canvas
Signed and dated lower right: *G. Courbet. 65*
37 × 52 ¹⁄₈ in. (94 × 135 cm)
Salon, Paris, 1865
RF 275
Nashville only

The Trout (*La truite*), 1873 [cat. 25]
Oil on canvas
Signed and dated lower right: *G. Courbet 73*
25 ³⁄₄ × 38 ³⁄₈ in. (65.5 × 98.5 cm)
RF 1978 15
San Francisco only

247

EDGAR DEGAS
French, 1834–1917
Racehorses before the Stands (*Le défilé*), 1866–1868
[cat. 103]
Oil on paper mounted on canvas
Signed lower left: *Degas*
18 1/8 × 24 in. (46 × 61 cm)
RF 1981

The Dance Foyer at the Opera on Rue Le Peletier
(*Le foyer de la danse à l'Opéra de la rue Le Peletier*), 1872
[cat. 109]
Oil on canvas
Signed lower left: *Degas*
12 5/8 × 18 1/8 in. (32 × 46 cm)
Fifth Exhibition of the Society of French Artists,
London, 1872
RF 1977
Nashville only

The Pedicure (*Le pédicure*), 1873 [cat. 107]
Oil on paper on canvas
Signed and dated lower right: *Degas 1873*
24 × 18 1/8 in. (61 × 46 cm)
RF 1986

The Dancing Lesson (*La classe de danse*), 1873–1876
[cat. 106]
Oil on canvas
Signed lower left: *Degas*
33 1/2 × 29 1/2 in. (85 × 75 cm)
First Impressionist Exhibition, Paris, 1874
RF 1976
San Francisco only

Ballet Rehearsal on the Set (*Répétition d'un ballet sur la
scène*), 1874 [cat. 108]
Oil on canvas
Signed lower right: *Degas*
25 5/8 × 31 7/8 in. (65 × 81 cm)
First Impressionist Exhibition, Paris, 1874
RF 1978
Nashville only

The Racetrack: Amateur Jockeys near a Carriage (*Le
champ de courses: Jockeys amateurs près d'une voiture*),
1876–1887 [cat. 104]
Oil on canvas
Signed lower right: *Degas*
26 × 31 7/8 in. (66 × 81 cm)
RF 1980

At the Stock Exchange (*Portraits à la Bourse*), 1878–1879
[cat. 105]
Oil on canvas
39 3/8 × 32 1/4 in. (100 × 82 cm)
Fourth Impressionist Exhibition, Paris, 1879
RF 2444

ELIE DELAUNAY
French, 1828–1891
Diana (*Diane*), 1872 [cat. 4]
Oil on canvas
Signed and dated lower left: *JElie Delaunay 1872*
57 7/8 × 37 in. (147 × 94 cm)
Salon, Paris, 1872
RF 2712

GUSTAVE DORÉ
French, 1832–1883
The Enigma (*L'énigme*), 1871 [cat. 29]
Oil on canvas
Signed and dated lower right: *Gve Doré 1871*
51 1/8 × 77 in. (130 × 195.5 cm)
RF 1982 68

JEAN ALEXANDRE JOSEPH FALGUIÈRE
French, 1831–1900
Wrestlers (*Lutteurs*), 1875 [cat.15]
Oil on canvas
Signed and dated lower right: *A. Falguière, 1875*
94 1/2 × 75 1/4 in. (240 × 191 cm)
Salon, Paris, 1875
RF 1995 19

HENRI FANTIN–LATOUR
French, 1836–1904
Antoine Vollon, 1865 [cat. 67]
Oil on canvas
Signed and dated upper right: *Fantin 1865*
11 7/8 × 7 1/8 in. (30 × 18 cm)
Salon, Paris, 1865
RF 1974 17
Nashville only

A Studio in the Batignolles (*Un atelier aux Batignolles*),
1870 [cat. 47]
Oil on canvas
Signed and dated lower left: *Fantin, 70*
80 3/8 × 107 5/8 in. (204 × 273.5 cm)
Salon, Paris, 1870
RF 729

Chrysanthemums in a Vase (*Chrysanthèmes dans un
vase*), 1873 [cat. 68]
Oil on canvas
Signed and dated upper left: *Fantin 73*
24 5/8 × 21 1/4 in. (62.7 × 54 cm)
RF 2000 16

Victoria Dubourg, 1873 [cat. 58]
Oil on canvas
Signed and dated upper right: *Fantin, 73*
36 3/8 × 29 7/8 in. (92.5 × 76 cm)
Salon, Paris, 1873; Panama Pacific International
Exhibition, San Francisco, 1915
RF 3629

JOHAN BARTHOLD JONGKIND
Dutch, 1819–1891
In Holland, Boats near the Mill (*En Hollande, les barques
près du moulin*), 1868 [cat. 72]
Oil on canvas
21 × 32 in. (53.5 × 81.3 cm)
RF 1990
Nashville only

JULES JOSEPH LEFEBVRE
French, 1834–1912
Truth (*La Vérité*), 1870 [cat. 3]
Oil on canvas
Signed and dated lower left: *Jules Lefebvre 1870*
104 1/4 × 44 in. (264.7 × 111.8 cm)
Salon, Paris, 1870
RF 1981 29

HENRI LÉOPOLD LÉVY
French, 1840–1904
Sarpedon (*Sarpédon*), 1874 [cat. 8]
Oil on canvas
Signed and dated lower left: *Henry Lévy 1874*
120 1/4 × 92 7/8 in. (305 × 236 cm)
Salon, Paris, 1874
RF 1984 117

ÉDOUARD MANET
French, 1832–1883
Angélina, 1865 [cat. 12]
Oil on canvas
Signed lower right: *Manet*
36 1/4 × 28 3/4 in. (92 × 73 cm)
Manet's Pavilion, Paris, 1867
RF 3664

The Fifer (*Le fifre*), 1866 [cat. 32]
Oil on canvas
Signed lower right: *Manet*
63 × 38 1/4 in. (161 × 97 cm)
Manet's Pavilion, Paris, 1867
RF 1992

Émile Zola, 1868 [cat. 34]
Oil on canvas
Inscription on book, center right: *Manet*
57 5/8 × 44 7/8 in. (146.5 × 114 cm)
Salon, Paris, 1868
RF 2205
Nashville only

Madame Manet at the Piano (*Madame Manet au piano*),
1868 [cat. 33]
Oil on canvas
15 × 18 1/4 in. (38 × 46.5 cm)
RF 1994

Moonlight over the Port of Boulogne (*Clair de lune sur le port de Boulogne*), 1869 [cat. 39]
Oil on canvas
Signed lower left: *Manet*
32 ¼ × 39 ¾ in. (82 × 101 cm)
RF 1993

Berthe Morisot with a Bouquet of Violets (*Berthe Morisot au bouquet de violettes*), 1872 [cat. 38]
Oil on canvas
Signed and dated upper right: *Manet 72*
21 ⅝ × 15 in. (55 × 38 cm)
RF 1998 30
Nashville only

On the Beach (*Sur la plage*), 1873 [cat. 40]
Oil on canvas
Signed lower right: *Manet*
23 ¼ × 28 ¾ in. (59 × 73 cm)
RF 1953 24
Nashville only

Woman with Fans (*La dame aux éventails*), 1873 [cat. 35]
Oil on canvas
Signed lower right: *Manet*
44 ⅝ × 65 ½ in. (113.5 × 166.5 cm)
RF 2850

Stéphane Mallarmé, 1876 [cat. 37]
Oil on canvas
Signed and dated lower left: *Manet, 76* [date added subsequently by Manet]
10 ⅞ × 14 ⅛ in. (27.5 × 36 cm)
RF 2661

Marguerite de Conflans, ca. 1876 [cat. 42]
Oil on canvas
20 ⅞ × 25 ¼ in. (53 × 64 cm)
RF 1945 4

The Beer Waitress (*La serveuse de bocks*), 1878–1879 [cat. 41]
Oil on canvas
Signed lower right: *E. Manet* [in the hand of Mme. Manet]
30 ½ × 25 ⅝ in. (77.5 × 65 cm)
RF 1959 4
Nashville only

Georges Clemenceau, 1879–1880 [cat. 36]
Oil on canvas
37 ¼ × 29 ⅛ in. (94.5 × 74 cm)
RF 2641

Asparagus (*L'asperge*), 1880 [cat. 43]
Oil on canvas
Signed upper right: *M*
6 ½ × 8 ½ in. (16.5 × 21.5 cm)
RF 1959 18

The Escape of Rochefort (*L'évasion de Rochefort*), ca. 1881 [cat. 45]
Oil on canvas
Signed lower right: *Manet*
31 ½ × 28 ¾ in. (80 × 73 cm)
RF 1984 158

Flowers in a Crystal Vase (*Fleurs dans un vase de cristal*), 1882 [cat. 44]
Oil on canvas
Signed and dedicated lower left: *A mon ami / le Dr Evans / Manet*
21 ½ × 13 ⅞ in. (54.6 × 35.2 cm)
RF 2000 19

JEAN LOUIS ERNEST MEISSONIER
French, 1815–1891
The Siege of Paris (1870-1871) (*Le siège de Paris [1870-1871]*), ca. 1884 [cat. 28]
Oil on canvas
Signed lower right: *EMeissonier*; inscribed lower right: *70*
21 × 27 ¾ in. (53.5 × 70.5 cm)
RF 1249

JEAN-FRANÇOIS MILLET
French, 1814–1875
Spring (*Le printemps*), 1868–1873 [cat. 17]
Oil on canvas
Signed lower right: *J. F. Millet*
33 ⅞ × 43 ¾ in. (86 × 111 cm)
RF 509

The Church at Gréville (*L'église de Gréville*), 1871–1874 [cat. 18]
Oil on canvas
Signed lower left: *J. F. Millet*
23 ⅝ × 28 ⅞ in. (60 × 73.4 cm)
RF 140
Nashville only

The Sheep Meadow, Moonlight (*Le parc à moutons, clair de lune*), ca. 1872 [cat. 19]
Oil on panel
Signed lower right: *J. F. Millet*
15 ½ × 22 ½ in. (39.5 × 57 cm)
RF 1881
Nashville only

Normand Milkwoman on Her Way to Gréville (*Laitière normande à Gréville*), 1874 [cat. 20]
Oil on canvas
Signed lower left: *J. F. Millet*
28 ¾ × 22 ½ in. (73 × 57 cm)
RF 1978 18

CLAUDE MONET
French, 1840–1926
Farm Courtyard in Normandy (*Cour de ferme en Normandie*), ca. 1863 [cat. 70]
Oil on canvas
Signed lower right: *C. Monet*
25 ⅝ × 32 ⅛ in. (65 × 81.5 cm)
RF 3703

The Magpie (*La pie*), 1868–1869 [cat. 73]
Oil on canvas
Signed lower right: *Claude Monet*
35 × 51 ⅛ in. (89 × 130 cm)
RF 1984 164
San Francisco only

Argenteuil, 1872 [cat. 74]
Oil on canvas
Signed and dated lower left: *Claude Monet. 72*
19 ⅝ × 25 ⅝ in. (50 × 65 cm)
RF 1961 4

Boats: The Regatta at Argenteuil (*Les barques: Régates à Argenteuil*), ca. 1874 [cat. 77]
Oil on canvas
Signed lower right: *Cl. Monet*
25 ⅝ × 39 ⅜ in. (60 × 100 cm)
RF 2008

Argenteuil, 1875 [cat. 76]
Oil on canvas
22 × 26 ⅜ in. (56 × 67 cm)
RF 1963 106
Nashville only

The Tuileries (*Les Tuileries*), 1875 [cat. 51]
Oil on panel
Signed and dated lower left: *Claude Monet 75*
19 ⅝ × 29 ⅝ in. (50 × 75 cm)
Third Impressionist Exhibition, Paris, 1877
RF 2705
San Francisco only

The Gare Saint-Lazare (*La gare Saint-Lazare*), 1877 [cat. 57]
Oil on canvas
Signed and dated lower right: *1877 Claude Monet*
29 ¾ × 41 in. (75.5 × 104 cm)
Third Impressionist Exhibition, Paris, 1877
RF 2775
San Francisco only

Turkeys (*Les dindons*), 1877 [cat. 81]
Oil on canvas
Signed and dated lower right: *Claude Monet, 77*
68 ⅞ × 68 ⅛ in. (175 × 173 cm)
Third Impressionist Exhibition, Paris, 1877
RF 1944 18
San Francisco only

Rue Montorgueil, Paris (La rue Montorgueil), 1878
[cat. 82]
Oil on canvas
Signed lower right: *Claude Monet*
31 ⁷⁄₈ × 19 ⁷⁄₈ in. (81 × 50.5 cm)
Fourth Impressionist Exhibition, Paris, 1879
RF 1982 71
San Francisco only

The Church at Vétheuil (L'église de Vétheuil), 1879
[cat. 80]
Oil on canvas
Signed lower left: *Claude Monet*; dated lower right: *1879*
25 ³⁄₄ × 19 ⁷⁄₈ in. (65.5 × 50.5 cm)
Panama Pacific International Exposition,
San Francisco, 1915
RF 1973 18
Nashville only

The Seine at Vétheuil (La Seine à Vétheuil), 1879 [cat. 83]
Oil on canvas
Signed and dated lower left: *Claude Monet 1879*
23 ⁵⁄₈ × 31 ⁷⁄₈ in. (60 × 81 cm)
Fourth Impressionist Exhibition, Paris, 1879
RF 1998

ADOLPHE MONTICELLI

French, 1824–1886
Still Life with White Pitcher (Nature morte au pichet blanc), ca. 1878 [cat. 102]
Oil on panel
Signed lower left: *Monticelli*
16 ⁷⁄₈ × 24 ³⁄₄ in. (43 × 63 cm)
RF 1937 5

GUSTAVE MOREAU

French, 1826–1898
Jason, 1865 [cat. 5]
Oil on canvas
Signed and dated lower left: *Gustave Moreau 1865*
80 × 45 ³⁄₈ in. (204 × 115.5 cm)
Salon, Paris, 1865; Panama Pacific International
Exhibition, San Francisco, 1915
RF 2780

Galatea (Galatée), ca. 1880 [cat. 7]
Oil on panel
Signed lower right: *Gustave Moreau*
33 ⁵⁄₈ × 26 ³⁄₄ in. (85.5 × 66 cm)
RF 1997 16

BERTHE MORISOT

French, 1841–1895
The Cradle (Le berceau), 1872 [cat. 48]
Oil on canvas
22 × 18 ¹⁄₈ in. (56 × 46 cm)
First Impressionist Exhibition, Paris, 1874
RF 2849

CAMILLE PISSARRO

French, 1830–1903
Hoarfrost (Gelée blanche), 1873 [cat. 93]
Oil on canvas
Signed and dated lower left: *C. Pissarro, 1873*
25 ⁵⁄₈ × 36 ⁵⁄₈ in. (65 × 93 cm)
First Impressionist Exhibition, Paris, 1874
RF 1972 27

Self-Portrait (Portrait de l'artiste), 1873 [cat. 91]
Oil on canvas
Signed and dated lower left: *C. Pissarro, 1873*
22 × 18 ¹⁄₄ in. (56 × 46.5 cm)
RF 2837

Road to Ennery (Route d'Ennery), 1874 [cat. 92]
Oil on canvas
Signed and dated lower left: *C. Pissarro 1874*
21 ⁵⁄₈ × 36 ¹⁄₄ in. (55 × 92 cm)
RF 1973 19

Harvest at Montfoucault (La moisson à Montfoucault),
1876 [cat. 54]
Oil on canvas
Signed and dated lower left: *C. Pissarro. 1876*
25 ⁵⁄₈ × 36 ³⁄₈ in. (65 × 92.5 cm)
Third Impressionist Exhibition, Paris, 1877
RF 3756

*Corner of the Garden at the Hermitage, Pontoise (Coin de
jardin à l'Hermitage, Pontoise)*, 1877 [cat. 94]
Oil on canvas
Signed and dated lower right: *C. Pissarro 1877*
21 ⁵⁄₈ × 17 ³⁄₄ in. (55 × 45 cm)
RF 1973 20

*Path through the Woods, Summer (Chemin sous bois,
en été)*, 1877 [cat. 95]
Oil on canvas
Signed and dated lower right: *C. Pissarro, 1877*
31 ⁷⁄₈ × 25 ⁷⁄₈ in. (81 × 65.7 cm)
Fourth Impressionist Exhibition, Paris, 1879
RF 2731

*Red Roofs, Village Corner, Winter Effect (Les toits rouges,
coin de village, effet d'hiver)*, 1877 [cat. 97]
Oil on canvas
Signed and dated lower right: *C. Pissarro 1877*
21 ¹⁄₂ × 25 ⁷⁄₈ in. (54.5 × 65.6 cm)
Third Impressionist Exhibition, Paris, 1877; Panama Pacific
International Exhibition, San Francisco, 1915
RF 2735

PIERRE PUVIS DE CHAVANNES

French, 1824–1898
The Balloon (Le ballon), 1870 [cat. 31]
Oil on canvas
Signed and dated lower left: *P. Puvis de Chavannes 1870*
53 ⁷⁄₈ × 34 in. (136.7 × 86.5 cm)
RF 1987 21

The Pigeon (Le pigeon), 1871 [cat. 30]
Oil on canvas
Signed and dated lower left: *P. Puvis de Chavannes 1871*
53 ⁷⁄₈ × 34 in. (136.7 × 86.5 cm)
RF 1987 22

*Young Girls at the Seashore (Jeunes filles au bord
de la mer)*, ca. 1879 [cat. 6]
Oil on canvas
Signed lower left: *P. PUVIS DE CHAVANNES*
24 × 18 ¹⁄₂ in. (61 × 47 cm)
RF 2015

JEAN–FRANÇOIS RAFFAËLLI

French, 1850–1924
*The Family of Jean-le-Boiteux, Peasants from Plougasnou
(La famille de Jean-le-Boiteux, paysans de Plougasnou)*,
1876 [cat. 16]
Oil on canvas
Signed and dated lower right: *J F RAFFAËLLI 1876*
74 ⁵⁄₈ × 60 ⁵⁄₈ in. (189.7 × 154 cm)
Salon, Paris, 1877
LUX 730

HENRI REGNAULT

French, 1843–1871
Juan Prim, October 8, 1868 (Juan Prim, 8 Octobre 1868),
1869 [cat. 9]
Oil on canvas
Signed and dated lower left: *H. Regnault Madrid 1869*
124 × 101 ⁵⁄₈ in. (315 × 258 cm)
Salon, Paris, 1869
RF 21

PIERRE AUGUSTE RENOIR

French, 1841–1919
William Sisley, 1864 [cat. 65]
Oil on canvas
Signed and dated middle left: *A. Renoir. 1864*
32 ¹⁄₈ × 25 ³⁄₄ in. (81.5 × 65.5 cm)
Salon, Paris, 1865
RF 1952 3
Nashville only

Frédéric Bazille, 1867 [cat. 63]
Oil on canvas
Signed and dated lower right: *A. Renoir 67*
41 ³⁄₈ × 29 in. (105 × 73.5 cm)
Second Impressionist Exhibition, Paris, 1876
RF 2448

Boy with a Cat (Le garçon au chat), 1868 [cat. 61]
Oil on canvas
Signed and dated lower left: *Renoir 68*
48 ³⁄₈ × 26 in. (123 × 66 cm)
RF 1992 409

Madame Darras, ca. 1868 [cat. 85]
Oil on canvas
Signed lower left: *A. Renoir*
18 3/4 × 15 3/8 in. (47.5 × 39 cm)
RF 1965 11

The Seine at Argenteuil (*La Seine à Argenteuil*),
ca. 1873 [cat. 84]
Oil on canvas
Signed lower right: *Renoir*
18 1/4 × 25 5/8 in. (46.5 × 65 cm)
RF 1951 14

Charles Le Coeur, 1874 [cat. 87]
Oil on canvas
Signed lower left: *A. Renoir;* inscribed upper right:
ô Galant Jard
16 1/2 × 11 3/4 in. (42 × 29 cm)
RF 1961 22

*Portrait of a Woman, Thought to Be Madame George
Hartmann* (*Portrait de femme, dit de Madame George
Hartmann*), 1874 [cat. 86]
Oil on canvas
Signed and dated lower left: *A. Renoir. 74*
72 × 48 3/8 in. (183 × 123 cm)
Panama Pacific International Exposition,
San Francisco, 1915
RF 2792

Claude Monet, 1875 [cat. 66]
Oil on canvas
Signed and dated lower right: *Renoir 75*
33 1/2 × 23 7/8 in. (85 × 60.5 cm)
Second Impressionist Exhibition, Paris, 1876
RF 3666
San Francisco only

The Seine at Champrosay (*La Seine à Champrosay*),
1876 [cat. 52]
Oil on canvas
Signed lower right: *Renoir*
21 5/8 × 26 in. (55 × 66 cm)
Third Impressionist Exhibition, Paris, 1877
RF 2737

The Swing (*La balançoire*), 1876 [cat. 55]
Oil on canvas
Signed and dated lower right: *Renoir. 76*
36 1/4 × 28 3/4 in. (92 × 73 cm)
Third Impressionist Exhibition, Paris, 1877
RF 2738
San Francisco only

The Woman with a White Jabot (*La femme au jabot blanc*),
1880 [cat. 88]
Oil on canvas
Signed and dated upper right: *Renoir, 80*
18 1/4 × 15 in. (46.5 × 38 cm)
RF 1961 21
Nashville only

Algerian Landscape, the Ravine of the "Femme Sauvage"
(*Paysage algérien, le ravin de la femme sauvage*), 1881
[cat. 90]
Oil on canvas
Signed lower left: *Renoir*
25 3/4 × 31 7/8 in. (65.5 × 81 cm)
RF 1943 62

Railway Bridge at Chatou (*Pont de chemin de fer à
Chatou*), 1881 [cat. 89]
Oil on canvas
Signed and dated lower right: *Renoir, 81* [signature added
subsequently by Renoir]
21 1/4 × 25 3/4 in. (54 × 65.5 cm)
Panama Pacific International Exposition,
San Francisco, 1915
RF 3758

THÉODULE RIBOT
French, 1823–1891
The Martyr Saint Sebastian (*Saint Sébastien, martyr*),
before 1865 [cat. 14]
Oil on canvas
Signed lower right: *T. Ribot*
38 1/4 × 51 1/8 in. (97 × 130 cm)
Salon, Paris, 1865
RF 105

ALFRED SISLEY
French, 1839–1899
Dead Heron with Spread Wings (*Le héron mort aux ailes
déployées*), 1865 [cat. 64]
Oil on canvas
Signed lower right: *Sisley*
31 1/8 × 39 3/8 in. (80 × 100 cm)
RF 1971 15

Chemin de la Machine, Louveciennes, 1873 [cat. 75]
Oil on canvas
Signed and dated lower left: *Sisley. 73*
21 1/2 × 28 3/4 in. (54.5 × 73 cm)
RF 2079

The Barge during the Flood, Port-Marly (*La barque
pendant l'inondation, Port-Marly*), 1876 [cat. 53]
Oil on canvas
Signed and dated lower right: *Sisley 76*
19 7/8 × 24 in. (50.5 × 61 cm)
RF 2021

Under the Snow: Farm Courtyard in Marly-le-Roi (*Sous la
neige: Cour de ferme à Marly-le-Roi*), 1876 [cat. 79]
Oil on canvas
Signed and dated lower right: *A. Sisley 1876*
15 1/8 × 21 7/8 in. (38.5 × 55.5 cm)
RF 1972 34

Snow at Louveciennes (*La neige à Louveciennes*), 1878
[cat. 78]
Oil on canvas
Signed and dated lower right: *Sisley 78*
24 × 19 7/8 in. (61 × 50.5 cm)
RF 2022

ALFRED STEVENS
Belgian, 1823–1906
The Bath (*Le bain*), ca. 1867 [cat. 49]
Oil on canvas
Signed lower right: *A. Stevens*
29 7/8 × 36 5/8 in. (76 × 93 cm)
Exposition Universelle, Paris, 1867
INV 20846

JAMES TISSOT
French, 1836–1902
Portrait of Miss L.L. (*Portrait de Mademoiselle L.L.*), 1864
[cat. 10]
Oil on canvas
Signed and dated lower right: *J. James Tissot Fev. 1864*
48 7/8 × 39 1/8 in. (124 × 99.5 cm)
Salon, Paris, 1864
RF 2698

The Dreamer or *Summer Evening* (*La rêveuse* ou *Soirée
d'été*), ca. 1876 [cat. 56]
Oil on panel
Signed upper right: *J. J. Tissot*
13 3/4 × 23 3/4 in. (34.9 × 60.3 cm)
An Exhibition of Modern Art by J. J. Tissot, London, 1882
RF 2254

ANTOINE VOLLON
French, 1833–1900
Saltwater Fish (*Poissons de mer*), ca. 1870 [cat. 26]
Oil on panel
Signed lower right: *A. Vollon*
32 5/8 × 47 in. (83 × 119.5 cm)
Salon, Paris, 1870
RF 118

JAMES ABBOTT MCNEILL WHISTLER
American, 1834–1903
*Arrangement in Gray and Black, No. 1: Portrait of the
Painter's Mother* (*Arrangement en gris et noir, no. 1*),
1871 [cat. 69]
Oil on canvas
Inscribed with monogram of a butterfly
56 3/4 × 64 in. (144.3 × 162.5 cm)
Royal Academy, London, 1872
RF 699

INDEX OF NAMES AND ARTWORKS

Page numbers in *italics* refer to illustrations.

PHOTOGRAPHY CREDITS

Figs. 1, 3: Jim Purcell, courtesy the Musée d'Orsay; 2, 8: courtesy the Musée d'Orsay; 4, 14, 20–21, 24, 39, 42: © RMN (Musée d'Orsay) / Hervé Lewandowski; 5: courtesy Juliet Wilson-Bareau and *The Burlington Magazine*; 6, 46: © RMN (Musée d'Orsay) / Droits réservés; 7: courtesy the Robert D. Farber University Archives & Special Collections Department, Brandeis University; 9–10, 12: Joseph McDonald, courtesy Fine Arts Museums of San Francisco; 11, 16: © RMN (Musée d'Orsay) / Gérard Blot / Hervé Lewandowski; 13, 33: © RMN / Agence Bulloz; 15, 29: Lauros / Giraudon / The Bridgeman Art Library; 17: courtesy the Frances Lehman Loeb Art Center, Vassar College, Poughkeepsie, New York; 18: © Dahesh Museum of Art, New York / The Bridgeman Art Library; 19: © RMN (Musée d'Orsay) / Daniel Arnaudet; © RMN (Musée d'Orsay) / Hervé Lewandowski; 22, 25, 30, 36: image courtesy the Board of Trustees, National Gallery, Washington; 23, 28: image copyright © The Metropolitan Museum of Art / Art Resource, NY; 26–27, 44: photography © The Art Institute of Chicago; 31–32, 37, 41: The Bridgeman Art Library; 34: © Samuel Courtauld Trust, The Courtauld Gallery, London, UK / The Bridgeman Art Library; 35: Nadar, Archives Charmet / The Bridgeman Art Library; 40: Giraudon / The Bridgeman Art Library; 43: © RMN (Musée d'Orsay) / René-Gabriel Ojéda; 45: © Musée d'Orsay, Dist RMN / Patrice Schmidt; 47: CG91 / Musée français de la Photographie Bièvres, Benoit Chain

Cats. 1, 4–6, 8–15, 17–20, 22–25, 27–28, 30–41, 45–53, 55–60, 62–63, 65, 71–75, 77–83, 85–86, 88, 90–96, 99, 101–109: © RMN (Musée d'Orsay) / Hervé Lewandowski; 2: photo Musées de la Ville de Strasbourg, A. Plisson, courtesy Musée des Beaux-Arts de Strasbourg; 3: © RMN (Musée d'Orsay) / Christian Jean; 7, 43, 54, 61, 89: © RMN (Musée d'Orsay) / René-Gabriel Ojéda; 16: © Musée d'Orsay, Dist RMN / Patrice Schmidt; 21: Giraudon / The Bridgeman Art Library; 26: © RMN (Musée d'Orsay) / Daniel Arnaudet; 29, 42: © RMN (Musée d'Orsay) / Jean Schormans; 44, 68, 98: © RMN (Musée d'Orsay) / Michèle Bellot; 64: © RMN / Daniel Arnaudet; 66, 69, 97: © RMN (Musée d'Orsay) / Jean-Gilles Berizzi; 67, 100: © RMN (Musée d'Orsay) / Thierry Le Mage; 70, 84: © RMN (Musée d'Orsay) / Droits réservés; 76: © RMN (Musée d'Orsay) / Franck Raux; 87: © RMN (Musée d'Orsay) / Gérard Blot

ACKNOWLEDGMENTS

The Parisian commissioners of the exhibition would like to thank everyone at the Musée d'Orsay who contributed to the successful implementation of this exhibition and catalogue:

Stéphane Bayard
Martine Bozon
Jeanne Brosse
Myriam Bru
Isabelle Cahn
Evelyne Chatelus
Claudine Clément
Christine Cuny
Annie Dufour
Hélène Flon
Françoise Fur
Thierry Gausseron
Amélie Hardivillier
Matthieu Leverrier
Dominique Lobstein
Isabelle Loutrel
Caroline Mathieu
Nathalie Mengelle
Anne Meny-Horn
Odile Michel
Jean Naudin
Virginie Noubissié
Anne Roquebert
Patrice Schmidt
Olivier Simmat
Antoine Tasso and his team
Denis Thibaud
Philippe Thiébaut
Araxie Toutghalian

COMMISSIONERS OF THE EXHIBITION

Guy Cogeval
Stéphane Guégan
Alice Thomine-Berrada
Musée d'Orsay

John E. Buchanan, Jr.
Lynn Federle Orr
Fine Arts Museums of San Francisco

Published in 2010 by the Fine Arts Museums of San Francisco and DelMonico Books, an imprint of Prestel Publishing, on the occasion of the exhibition *Birth of Impressionism: Masterpieces from the Musée d'Orsay.*

EXHIBITION ITINERARY
de Young Museum, Fine Arts Museums of San Francisco
May 22–September 6, 2010

Frist Center for the Visual Arts, Nashville
October 15, 2010–January 23, 2011

PRESENTING PARTNER

GRAND PATRON
Jeannik Méquet Littlefield

MAJOR PATRONS

San Francisco Auxiliary of the Fine Arts Museums
Diane B. Wilsey, *Opening Week Major Patron*

PATRONS
Athena and Timothy Blackburn
J. Burgess and Elizabeth B. Jamieson
Susan and James R. Swartz
Douglas A. Tilden

BENEFACTORS
Hope Aldrich and David Spencer
George Frederick Jewett Foundation

SPONSORS
Mr. and Mrs. John P. Rohal

Generous support is also provided by the Lois E. Kalb 1986 Revocable Intervivos Trust, with additional support provided by Dr. N. L. Ascher, Mr. and Mrs. David H. S. Chung, Ransom and Nan Cook, Bill and Sonja Davidow, Mr. and Mrs. André de Baubigny, Jr., Mrs. George Hopper Fitch, Troy and Angelique Griepp, Mrs. James K. McWilliams, Rose Fox Noll, Greta R. Pofcher, and Jeanne and Sanford Robertson.

The San Francisco presentation of James Abbott McNeill Whistler's *Arrangement in Gray and Black, No. 1: Portrait of the Painter's Mother* is made possible through a generous contribution from Hope Aldrich and David Spencer.

The San Francisco presentation of Édouard Manet's *The Fifer* is made possible in part through a generous contribution from Douglas A. Tilden.

Education programs presented in conjunction with this exhibition are generously underwritten by the William K. Bowes, Jr. Foundation and Douglas A. Tilden.

This exhibition is supported by an indemnity from the Federal Council on the Arts and the Humanities.

This exhibition is organized by the Fine Arts Museums of San Francisco with gratitude for the exceptional loan from the collection of the Musée d'Orsay.

Musée d'Orsay

FRONTISPIECE
Alfred Sisley
The Barge during the Flood, Port-Marly
(*La barque pendant l'inondation, Port-Marly*), 1876
Detail of cat. 53

Copyright © 2010 by the Fine Arts Museums of San Francisco. Layout and design © Prestel Verlag, Munich · Berlin · London · New York. All rights reserved. No part of this book may be reproduced or transmitted in any form or by any means, electronic or mechanical, including photocopy, recording, or any other information storage and retrieval system, or otherwise without written permission from the publisher.

Photography credits appear on p. 255.

Fine Arts Museums of San Francisco
Golden Gate Park
50 Hagiwara Tea Garden Drive
San Francisco, CA 94118-4502

Director of Publications: Ann Heath Karlstrom
Editor in Chief: Karen A. Levine

LIBRARY OF CONGRESS CATALOGING-IN-PUBLICATION DATA

Birth of Impressionism : masterpieces from the Musée d'Orsay / edited by Stéphane Guégan and Alice Thomine-Berrada ; additional contributions by Krista Brugnara . . . [et al.].

p. cm.

Published on the occasion of an exhibition held at the de Young Museum, San Francisco, May 22–Sept. 6, 2010, and at the Frist Center for the Visual Arts, Nashville, Oct. 15, 2010–Jan. 23, 2011.

Includes index.

ISBN 978-3-7913-5045-5—ISBN 978-3-7913-6297-7—ISBN 978-3-7913-6296-0 1. Impressionism (Art)—France—Exhibitions. 2. Painting, French—19th century—Exhibitions. 3. Painting—France—Paris—Exhibitions. 4. Art and society—France—History—9th century. 5. Musée d'Orsay—Exhibitions. I. Guégan, Stéphane. II. Thomine, Alice. III. Brugnara, Krista. IV. M. H. de Young Memorial Museum. V. Frist Center for the Visual Arts (Nashville, Tenn.) VI. Title: Masterpieces from the Musée d'Orsay.

ND547.5.I4B57 2010

759.409'03407444361—dc22

2010004629

The hardcover edition of this catalogue is published in association with Prestel, a member of Verlagsgruppe Random House GmbH.

Prestel Verlag
Königinstrasse 9
80539 Munich
Germany
Tel: 49 89 24 29 08 300
Fax: 49 89 24 29 08 335
www.prestel.de

Prestel Publishing Ltd.
4 Bloomsbury Place
London WC1A 2QA
United Kingdom
Tel: 44 20 7323 5004
Fax: 44 20 7636 8004

Prestel Publishing
900 Broadway, Suite 603
New York, NY 10003
Tel: 212 995 2720
Fax: 212 995 2733
E-mail: sales@prestel-usa.com
www.prestel.com

ISBN 978-3-7913-5045-5 (hardcover)
ISBN 978-3-7913-6297-7 (paperback)
ISBN 978-3-7913-6296-0 (hardcover boxed set)

Edited by Elisa Urbanelli
Designed by Bob Aufuldish, Aufuldish & Warinner
Typography by Bob Aufuldish and Michael Thompson
Translations by Alison Anderson and Rose Vekony
Proofread by Dianne Woo
Index by Susan G. Burke
Printed in Singapore by CS Graphics Pte Ltd